# Cinema by Design

FILM AND CULTURE SERIES

FILM AND CULTURE

*A series of Columbia University Press*

EDITED BY JOHN BELTON

*Series list continues on page 267*

# Cinema by Design

ART NOUVEAU, MODERNISM,
AND FILM HISTORY

By Lucy Fischer

Columbia University Press

New York, NY

Columbia University Press

*Publishers Since 1893*

New York    Chichester, West Sussex

cup.columbia.edu

Copyright © 2017 Columbia University Press

All rights reserved

Cataloging-in-Publication Data for *Cinema by Design*
is on file at the Library of Congress under
LCCN 2016050676.

To my husband Mark and my sister Madeleine who
accompanied me on many Art Nouveau pilgrimages
around the world and made those experiences
richer, happier, and more meaningful.

*If film must equal the other arts, it is by seeking the same degree of beauty.*

—Claude Chabrol, *The Taste for Beauty*, trans. Carol Volk (New York: Cambridge University Press, 1989), 73

# Contents

# Illustrations

PLATES

# Acknowledgments

As always with a scholarly project that ranges over many years, there are numerous people and institutions to thank for their help. At the University of Pittsburgh, I would like express my gratitude for Dean N. John Cooper who gave me a special research fund for work on this book that made travel and scholarly related purchases possible. I would also like to thank Ronald Linden of the European Union Center of Excellence for grants that funded travel abroad to visit museums and architectural sites in various countries. Similarly, the University Center for International Studies helped offset the price for the rights of various images that I needed to purchase from museums and private sources to illustrate the book, as well as the subvention cost of including a color insert in the volume. As always, I wish to thank my chair Don Bialostosky for additional funds that were granted to me through the department of English that helped me attend conferences at which I could present my work and receive feedback. Jennifer Florian, Film Studies administrative assistant, has assisted me with this project as with so many in the past—helping to keep track of my grant finances, processing my travel arrangements, handling reimbursements, scanning hordes of materials, and making sure that my unruly arsenal of library books was returned in a timely fashion. I would also like to thank my research assistant Matthew Carlin who helped to assemble bibliographies, locate print materials, check and format footnotes, proofread copy, and format images. I am grateful for the feedback that I received from film studies colleagues in

response to various talks that I presented at the University of Pittsburgh, the University of California, the Society for Cinema and Media Studies, and Birkbeck, University of London. Finally, I would like to thank Jon Lewis who invited me to edit and contribute to a book on art direction and production design for Rutgers University Press; a section of chapter 3 is derived from the first chapter of that volume.

At Columbia University Press, I wish to thank Jennifer Crewe, director and president, for her assistance squiring the manuscript through the approval process with the board, as well as to express my respect and appreciation for Series Editor John Belton. Furthermore, Jonathan Fiedler was a tremendous help in making sure that my materials were in proper shape for submission. And Paul Vincent assisted with the laborious task of copy editing.

Finally, I would like to thank my family for providing the love, calm, and support that makes all else possible. My husband Mark Wicclair has always been a champion of my career, beginning with my decision to pursue doctoral studies. I am indebted as well to my sister Madeleine Fish, who (like Mark) accompanied me on numerous European trips in which Art Nouveau was on the agenda (whether they wanted it to be or not). My son David Wicclair and his wife Brandi Leigh Wicclair provide continuing joy that rounds out my life.

Cinema by Design

# Introduction

*The emergence of cinema was part of*
*the euphoria of modernity.*
—Viva Paci, "The Attraction of the Intelligent Eye"

This is a book based upon a passion and a hunch. The passion is for the oft-maligned style known as Art Nouveau; and the hunch is that the form has an intriguing but unacknowledged relation to film history. My passion began during the Art Nouveau revival of the 1960s and 1970s when I found myself buying reproduction jewelry (without knowing the style it represented), and treasuring a set of coasters I received that were emblazoned with Alphonse Mucha poster images. This fervor continued as I became an aficionado of flea markets and found myself collecting antique Art Nouveau jewelry and artifacts (candlesticks, matchbox holders, trays, and vases). My hunch about Art Nouveau and film followed from my prior work on Art Deco and the cinema[1] (a bond that has been more established in film studies). I thought to pursue the study of design and film one generation further back—to the turn of the twentieth century. However, in searching the indexes and tables of contents of countless volumes on the subject, I found only a scant mention of Art Nouveau.

On the one hand, this was discouraging and made me think that, perhaps, my intuition was unfounded. On the other, it piqued my academic

interest and my hope that I might be the first to give the movement its due. This initiated a scavenger hunt—for cinematic traces, remains, hints, and fragments of the historic trend. And while I feel this study will prove my original instinct sound, I have learned why references to Art Nouveau in film studies have been so hard to find. The movement's presence is often partial or obscured; its account, scattered and elliptical; and its reputation, dubious—having often been relegated to the art historical abject.

Curiously, during the period in which I wrote this book, certain Art Nouveau artifacts (both fictional and real) have garnered oblique attention. Perhaps most noteworthy has been the 2012 publication of *The Lady in Gold: The Extraordinary Tale of Gustav Klimt's Masterpiece, Portrait of Adele Bloch-Bauer* by Anne-Marie O'Connor.[2] It is a novelization of actual events involving a Viennese Jewish woman whose 1907 portrait was confiscated by the Nazis and subsequently hung in Vienna's Belvedere Museum. In 2006, after a long legal battle, it was returned to one of Bloch-Bauer's relatives who sold it to the Neue Galerie in New York City where it is now exhibited. Then in 2015, a feature film, *The Woman in Gold* (directed by Simon Curtis), was released that concerned the same historical events, bringing additional notice to Art Nouveau. With this reconsideration, however, has come the usual dismissal of the style. Writing about the Klimt painting's debut at the Neue Galerie in April 2015, Ken Johnson describes its subject as constituting a "fin de siècle *decadent* dreamer." Furthermore, he opines: "For all its optical dazzle and dreamy poetry . . . [the painting] is not one of the most exciting . . . of modern times. Flattened to the point of suffocation by its decorative excess, its erotic appeal chastely muted, it has a fusty, languid feeling. Were it not for what happened to it years after its completion, the work would not be nearly so famous as it is today."[3] Clearly, his characterization of the painting as suffocating, excessive, and fusty maligns the Art Nouveau style in general.

In 2014 another novel was published that touched on Art Nouveau and the Holocaust. Ayelet Waldman's *Love and Treasure* concerns a foray into the forgotten history of Hungarian Jews occasioned by a young woman's quest for the origins of an antique Art Nouveau locket bequeathed to her. It is a journey that raises questions of inheritance and the reclamation of the spoils of World War II.[4] Interestingly, the moment that her grandfather gives her the jewelry is tinged by ambivalence. She had previously

borrowed the locket to wear on her wedding day, but that union has subsequently dissolved. Waldman describes the scene of gifting as follows: "[Her grandfather] weighed the cinched pouch of velvet in his hand . . . then . . . tipped the contents of the pouch into his palm. He caught hold of the gold chain. The gold-filigreed pendant dangled. It bore the image, in vitreous enamel, of a peacock, a perfect gemstone staring from the tip of each painted feather. She flinched when she saw it, as if it were not a pretty little art nouveau bauble but something hideous to contemplate."[5] Finally, years earlier than these recent works, the film *Titanic* (1997, directed by James Cameron) highlighted the search for an Art Nouveau object—a butterfly hair comb worn by the youthful Rose DeWitt Bukater (Kate Winslet), then returned to her as an old woman, retrieved from the shipwreck. The comb was such a popular item for fans of the movie that replicas of it were made and sold to the public. Here is how the screenplay describes the moment that the elderly Rose rediscovers her vanished treasure, now corroded by the salty ocean: "Rose picks up an ornate art-nouveau HAIR COMB. A jade butterfly takes flight on the ebony handle of the comb. She turns it slowly, remembering. We can see that Rose is experiencing a rush of images and emotions that have lain dormant for eight decades as she handles the butterfly comb."[6]

Like the lost and tainted Art Nouveau objects that circulate in these novels and films, the style itself has often lain "dormant" and disregarded within the fields of art history and film studies. Perhaps the latter neglect should not have surprised me since the topic of design and cinema has received little attention as media studies has matured. Hopefully, this is beginning to be addressed by the publication of such recent books as my own edited collection *Art Direction and Production Design.*[7] The discounting of this field has occurred for a variety of reasons. First, design fits into the vague and unwieldy category of art direction, which can include such diverse crafts as set construction, decoration, model building, sculpture, coloration, and special effects. Second, while design is a visible aspect of the cinematic text, its production history is frequently murky, unavailable, or buried in memoirs, interviews, and archives. Third, film studies has not generally paid much heed to the links between cinema and art, favoring instead its connections to literature, theater, social history, and popular culture.[8] Finally, in the film studies literature, questions of design

have often been subsumed under broader considerations of mise-en-scène (when theorists can agree on what the term means). Such discussions frequently devalue aesthetic elements to emphasize questions of narrative, symbolism, theme, and ideology. Perhaps it is time to question that approach. Here I am reminded of relevant statements by two contemporary theorists. Writing in *Mythologies*, Roland Barthes opines: "Less terrorized by the spectre of 'formalism,' historical criticism might have been less sterile; it would have understood that the specific study of forms does not in any way contradict the necessary principles of totality and History. On the contrary: the more a system is specifically defined in its forms, the more amenable it is to historical criticism. To parody a well-known saying, I shall say that a little formalism turns one away from History, but that a lot brings one back to it."[9] Similarly, Geoffrey Nowell-Smith asserts that "films mean. But they do not just mean. . . . Too many things that films do evade attempts to subsume them under the heading of meaning. . . . [It is] time to consider a return to theories of the aesthetics thoughtlessly cast aside a quarter of a century ago."[10]

## SETTING THE SCENE: AN INTERNATIONAL MOVEMENT

Art Nouveau was a European trend in the applied arts that germinated in England, burgeoned in Belgium, and flourished in France and elsewhere.[11] Some have marked the date of its ascendancy as 1895 with a group that coalesced around Parisian art dealer and connoisseur Siegfried Bing, whose shop was called L'Art Nouveau.[12] The movement peaked between 1900 and 1905 and thrived until the start of World War I. Referencing the Great War, Walter Benjamin writes that the movement was like a "dream of being awake"[13] that emerged "fifteen years before history woke [it] with a bang."[14]

While the term derives from its French incarnation, the movement had branches in numerous other countries. In Germany, it was known as Jugendstil; in Austria, Secession; in England and Italy, the Liberty Style; in Scotland, the Glasgow Style, and in Spain, Modernisme. As Patrick Bade says (invoking, in ironic terms, the movement's international currency), "like some kind of *bacillus* Art Nouveau spread from place to place."[15] Despite its various national iterations, as Dolf Sternberger remarks, it was

"a single formal universe that [was] continuous and interwoven."[16] Though unified, Sternberger argues that the movement bracketed numerous contradictions—having both "positive and negative aspects." To separate these elements, however, and to "attribute them to different trends or phases of development," would be to "lose sight of the profound and fertile ambiguity that both attracts and disturbs us."[17]

As for the movement's unsettling features, its appearance was often met with xenophobic hostility. For instance, in Germany it was also called the "Belgian tape-worm style."[18] Despite his love for the form, Bade's use of the term *bacillus* to describe Art Nouveau's international migration signals that, in the style's devotion to aesthetic display, visual excess, and sensory gratification, it was often considered the bête noire of high modernism—the trend one loved to hate. I hope to counter this aesthetic position and argue for Art Nouveau's central place within the history of the avant-garde.

While the various strains of Art Nouveau were certainly not identical, they did share certain thematic, iconographic, and stylistic patterns—as filtered through diverse traditions (Jugendstil and Arts and Crafts, for instance, were more restrained and minimalist than French Art Nouveau). In addition to linking various contemporaneous design schools, Art Nouveau also drew on important predecessors. In France, it borrowed from Rococo and Baroque styles as well as the Decadent and Symbolist movements, and in England from the Aesthetic and Pre-Raphaelite groups. The movement's influences went further afield both temporally and nationally to the Gothic, Japanese, Islamic, and Celtic modes. Nonetheless, it sought to break away from Classicism and Historicism. As Silvius Paoletti wrote in 1902: "To take the place of pitiless authoritarianism, rigid and regal magnificence, burdensome and undecorated display, we have delicate and intimate refinement, fresh freedom of thought, the subtle enthusiasm for new and continued sensations."[19] Similarly, John Heskett asserts: "A common feature [of the movement] was the intention to create wholly new forms representative of the age, and it thus marked a significant rejection of the constant reference to historical precedent which dominated nineteenth century visual culture."[20]

## STYLE, THEMES, AND TROPES

### Whiplash Curve

On a formal level, Art Nouveau was famous for the so-called whiplash curve—an intricate, sinuous, dynamic line that countered staid linearity (see figure I.1).

This "serpentine involution"[21] (or what György M. Vajda has called an "arching, undulating, wave")[22] can be seen, most famously, in the scrolled ironwork for the 141 Paris Métro entrances designed by Hector Guimard (only three of which, regrettably, survive). The system opened in 1900 in conjunction with the Paris Exposition, an event that heralded Art Nouveau's arrival.[23] It seems significant that Art Nouveau, which some have seen as the first modernist movement, is linked to the new urban technology of the subway. Supposedly, Salvador Dalí said (by way of a compliment) that, through Guimard's portals, one "descend[s] into the region

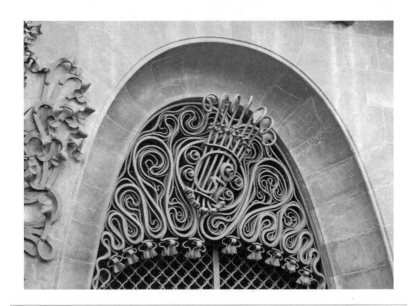

**I.1** This grill on the facade of the Güell Palace by Antoni Gaudí incorporates Art Nouveau's iconic whiplash curve. Photograph by Lucy Fischer.

of the subconscious."[24] The whiplash curve is also apparent in the floor and wall designs of Victor Horta's groundbreaking Hôtel Tassel (1893) in Brussels, and in the tangled, windblown hair of the woman in Charles-Émile Jonchery's bronze bust, *The Wind Blows* (c. 1900).

Using psychoanalytic language, historian Klaus-Jürgen Sembach sees the whiplash curve as a "sublimation" of how "every area of life seemed [then] to have been set in motion."[25] On a similar note, Albert Valbert talks of how, in the modern era, people were "not solely complicated beings but agitated ones as well."[26] Furthermore, sociologist Pitirim Sorokin writes in 1927 of living in: "a mobile age, in an age of shifting and change. . . . Objects and values incessantly move with a mad rapidity, shift, turn round, clash, struggle, appear, disappear, diffuse, without a moment of rest and stability."[27] Art Nouveau's dynamic curve was also tied to the era's modern dance—most notably, the choreography of Loie Fuller and Isadora Duncan.[28] While Art Nouveau's curves were graceful, their overlapping, interlocking swirls could also connote perversity and entrapment—indicative of the movement's "bipolar" sensibility. (In contrast, it seems no accident that phrases associated with unwavering lines signify moral righteousness: "straight-laced," "straight and narrow," and "straightforward"). In favoring the curvilinear, Art Nouveau also took inspiration from the Islamic architectural "arabesque" which was used in the exotic gate (designed by René Binet) that served as the entrance for the 1900 Paris Exposition.

Clearly, the movement's love of the whiplash curve was an aspect of its commitment to emphatic decoration—a trait that was subject to much censure. A columnist for the *New York Times* in 1921, for instance, critiques Art Nouveau's "superfluous ornamentation" and "unnecessary lines which create disturbing vibrations."[29] However, Surrealist André Breton appreciated this element, writing that in Art Nouveau: "we find . . . discordance in the details; the . . . impossibility of repetition . . . [the] delight in the never-ending curve (whether it be the growing fern or ammonite, or embryonic curl); the . . . profusion of minutiae, the contemplation of which seduces the eye away from pleasure in the whole. . . . From one point to another, in terms of plastic design, down to the very smallest feature, it is the triumph of the equivocal; in terms of interpretation, down to the most insignificant detail, it is the triumph of the complex."[30] In

Breton's final phrase, we are reminded of Ben Singer's notion that one of the major features of modernity was "sensory complexity and intensity."[31]

While some reduce such Art Nouveau features as the whiplash curve to mere surface embellishment, throughout this book they will be read for their deeper meaning. Even Siegfried Kracauer, who attacked the ornament as "an end in itself," admitted that "the position that an epoch occupies in the historical process can be determined more strikingly from an analysis of its inconspicuous surface-level expressions than from the epoch's judgments about itself."[32] We take his words to heart.

*Nature*

The natural world (in all its forms) was a dominant subject in Art Nouveau—especially its vegetative aspects (flowers, vines, trees, plants). Here, from a scientific perspective, one sees the influence of Ernst Haeckel, a German biologist, naturalist, and artist who, in works like *The General Morphology of Organisms* (1866) and *The History of Creation* (1868), described and named thousands of new species that he had discovered.[33] Similarly, Swiss botanist and artist Eugène Grasset published a multivolume influential tome entitled *The Plant and Its Decorative Applications* (c. 1898).[34] Art Nouveau's love of Nature was also influenced by Japanese landscapes and decorative objects, not surprising in an era that first saw the importation of Asian works of art.

Animals, too, were frequently pictured in works of Art Nouveau, especially colorful ones like multihued butterflies, iridescent beetles, or flamboyant peacocks. While these were highly romanticized creatures, others were selected for their disquieting auras—for instance, the bat (as in a 1903–1904 vase by Émile Gallé), the moth (as in a 1905 Daum vase), the snail (as in a Daum vase of 1910), and the spider (as in Tiffany's web-patterned lamp).[35]

It was not only high-end Art Nouveau items that bore the stamp of Nature but also more prosaic consumer goods. An "In the Shops" column from the *New York Times* of 1904 talks of buckles decorated with nocturnal beings like bats and owls,[36] while a similar column from 1902 mentions handkerchiefs decorated with flowers and stems.[37] In 1913, a *New York Times* article talks of Parisian wall coverings whose patterns range "from the

primmest, stiffest of Art Nouveau flowers, to great sprawling figures of bird, beast, flower and fruit."[38]

Beyond the opposition of benign and malign organisms, the movement's interest in Nature was otherwise two-sided. On the one hand, it had a scientific thrust, with many artists utilizing microscopes and subscribing to scholarly journals to assist them in their work. On the other, it bore a spiritual, almost pantheistic, sensibility.[39] This tension is apparent in a statue by Ernest Barrias entitled *Nature Unveiling Herself to Science* (c. 1895) which depicts a woman partially shrouded in cloth.

Clearly, within the scientific realm another influence on Art Nouveau was the publication of Charles Darwin's *The Origin of Species* (1859) and *The Descent of Man* (1871), which gave the animal and vegetable world new prominence.[40] Particularly interesting was Darwin's analysis of the role of colorful ornamentation in sexual dynamics. For most creatures, it was the male who displayed such traits to attract a mate; but in human beings, it was the female who exhibited them to entice the male. Clearly, Art Nouveau's enchantment with decoration aligned with the import of Beauty in both the biological and cultural realms.

In keeping with this, color was emphatic in Art Nouveau compositions. Vajda speaks of its "orgy of colors," of the "beauty of colors, [and] the dance of the senses."[41] While sometimes associated with a mute palette that came to be known as "greenery yallery" (and included tones like mustard, sage green, olive green, and brown), this spectrum was frequently offset by richer shades like salmon, lilac, violet, purple, and robin's egg and peacock blues. One need only think of the stained-glass windows and illuminated lamps produced by Louis Comfort Tiffany (Plate 4), or of the enamel and bejeweled brooches and pendants by Georges Fouquet to recall Art Nouveau's romance with sumptuous tones. Again, more pedestrian consumer items also reflected the movement's love of hue. A *New York Times* article of 1899 speaks of Parisian furniture with decorations "in beautiful greens, here a little dash of red, all harmonious and with a bold effect."[42] A 1903 *New York Times* "Art Notes" column praises jewelry that has abandoned the "ostentatious use of emeralds, rubies, sapphires and diamonds in favor of the employment of materials of less cost but greater delicacy of color, and above all exquisite enameling."[43] The aforementioned 1904 "In the Shops" column speaks of "art nouveau tapestries . . . in new

art colors. There are blues and greens, red browns and greens and various other good combinations of color" [including] soft olive greens."[44]

While on the one hand Art Nouveau's love of Nature would seem to have separated it from the Decadents (who valorized the artificial), as Umberto Eco points out, there was one natural form that the latter group adored— "the flower, which was even to give rise to . . . the ornamental style known in Italy as *floreale*." Thus, "Decadentism was *obsessed with flowers* . . . the way they lend themselves to stylization, to becoming ornaments, gems, arabesques, the sense of *fragility and corruption* that pervades the vegetable kingdom, within whose bounds there is a rapid transition from life to death."[45] Flowers, of course, are everywhere in Art Nouveau design, for instance in windows by Tiffany, jewelry pieces by Lluís Masriera i Rosés, glassware by Daum, and poster designs by Mucha.

Many have seen Art Nouveau's valorization of Nature as a reaction against the industrialization of the urban world in the nineteenth century—which was often viewed as ugly, soulless, and threatening. As Walter Benjamin wrote, it is "[an] attempt on the part of art to come to terms with technology."[46] For him, the movement saw Nature as an antidote to the machine; thus, it "found expression in the mediumistic language of line, in the flower as symbol of the naked, vegetable Nature that confronted the technologically armed environment."[47] Benjamin also related Art Nouveau's fascination with flowers to French Symbolism (most notably, to Charles Baudelaire's 1857 *Flowers of Evil*)—"which brings out its esoteric side."[48] Here he is referencing the style's fascination with alternative religion, exoticism, and the dream world. Indicative of this, a 2013 exhibit of Art Nouveau at the Pinocothèque in Paris included a section entitled "Mysticism and the Modern World," which presented works like Georges de Fuere's lithograph *In the Dream* (1897).

While referencing Baudelaire, Benjamin means to save the poet from the "taint" of Art Nouveau—commenting on how "Jugendstil phraseology should still be considered progressive" in Baudelaire (though not elsewhere).[49] A propos, he sees Baudelaire's poem "The Double Chamber" as a perfect description of an Art Nouveau room.[50] Likely, Benjamin was thinking of lines like the following:

A chamber that is like a reverie; a chamber truly spiritual, where the stagnant atmosphere is lightly touched with rose and blue . . .

The shape of the furniture is elongated, low, languishing; one would think it endowed with the somnambulistic vitality of plants and minerals.[51]

Benjamin also claims that the "three defining motifs of Jugendstil: the hieratic motif, the motif of perversion, the motif of emancipation" are all prefigured in poems by Baudelaire from *Flowers of Evil*.[52]

In the visual arts, perhaps the Art Nouveau practitioner most associated with Symbolism was Émile Gallé, who founded the L'École de Nancy in France at the turn of the twentieth century—which some have seen as "the centre for the richest of . . . symbolic aspects of Art Nouveau" (Plate 1).[53] Other members of the group included Victor Prouvé, Eugène Vallin, Louis Majorelle, Émile André, and Jacques Gruber. Gallé was an incredibly versatile creator, originally producing pottery before specializing in glass after one of his pieces garnered an award at the Paris Exposition of 1889. He also designed furniture adorned with elaborate and detailed pictorial marquetry favoring landscapes (as in his *Armoire Murale* of 1890). So, if Art Nouveau was concerned with producing a Wagnerian "total art" (art in all aspects of life, and creation encompassing all arts), Gallé was the total artist (as were some of his compatriots like Gruber who worked in stained glass, poster art, furniture design, bookbinding, painting, and pastel). For Art Nouveau creators, total art also meant "a cooperation among artists and art forms."[54]

Gallé took Nature as his main subject and was something of an amateur botanist but, as a practitioner of "psychological modernism," rather than portray the world realistically, he produced "vegetary phantoms."[55] He followed developments in psychology and deemed his glass creations "vessels of nervous vibration,"[56] or representations of "personal dreams."[57] In keeping with this, he titled one piece *Vase of Sadness* and another *Blue Melancholia*.[58] Furthermore, at one point he gave a speech entitled "Symbolic Décor," focusing on "the role of the irrational in the modern interior."[59] Gallé admired the Symbolist poets and even incorporated lines of their writing into some of his work. For instance, both his *Vase Tétards* (1900) and *Vase La Pluie au Bassin Fait des Bulles* (1889) include verses by Théophile Gautier. Gallé was also attracted to the feminine and erotic aspects of Nature, having a particular fascination with the orchid as suggestive of the female sexual organ.[60] Given all this, it is not surprising that some of his pieces have Surrealist overtones. In particular, one thinks of a rather bizarre wooden bed he designed in 1904 called *Dawn and Twilight Bed*, which

sported a footboard depicting two lively butterflies at dawn, and a headboard portraying one of them dying at dusk—all accentuated by marquetry, mother of pearl, and glass.

In keeping with Symbolist mysticism, Gallé thought that glass had magical, alchemical qualities and experimented with many of its features—utilizing elements often conceived as artistic flaws (e.g., surface crackling, or the presence of "contaminants"). Finally, given his obsession with Nature, he looked toward Japanese pictorialism and was an admirer of the ukiyo-e style. Consequently, he befriended artist Takashima to learn his brushstroke technique.[61]

Gallé is not the only Nancy glass artist associated with Art Nouveau. Another producer was the Daum studio, founded in 1878 by Jean Daum and later overseen by his sons Auguste and Antonin. In 1900, the company won the Grand Prix medal at the Paris Exposition, and, when Gallé died in 1904, Daum succeeded him as the primary glass maker of L'École de Nancy. Here it is important to note that glass production has been deemed the "great triumph of Art Nouveau" and the style's "perfect medium."[62] (Interestingly, even in the realm of jewelry, through the plique-à-jour technique, Art Nouveau practitioners turned enamel into transparent "glass.")

While I would not wish to push the comparison too far, there are interesting parallels between the media of glass and cinema. First, cinema uses glass to create its lenses (both for photographing and projecting). Second, both glass and film require a productive play with light and reflection. Third, Art Nouveau glass makers frequently executed realistic scenes of nature that share much with cinematic landscapes. Here one thinks of such pieces as Daum's vase of 1900 that depicts a "long-shot" of trees bending in the wind and rain; another of 1910 that portrays the countryside; and a series of bowls and vases from 1910 that present various seascapes. Fourth, Art Nouveau was especially known for stained-glass windows (e.g., by Tiffany in the United States and Gruber in France). Cinema, of course, has often been compared to a "*window* onto the world," as well as a representational medium that must be animated by light. Also, artists like Tiffany experimented with what we might consider "rear projection" in some of his pieces, as in the floor of the Fountain Court in his Long Island estate, Laurelton (now installed in the Morse Museum in Winter Park, Florida). Finally, if Gallé felt that glass had alchemical qualities, Roland Barthes found such properties in photography's use of chemical processes and the precious metal silver.[63]

While reclaiming Nature (which might seem a conservative move), Art Nouveau did so in an avant-garde style that countered facile essentialism or nostalgia. Although the movement celebrated organic beauty and sensuality (in the face of harsh and crass modernity), it did not entirely reject industry; rather it sought to merge it with art. Thus, Benjamin writes about two industrial elements that it utilized: "The new elements of construction in iron—girder-forms—obsessed art nouveau. Through ornament, it strove to win back these forms for Art. Concrete [also] offered it new possibilities for the creation of plastic forms in architecture."[64]

*The Feminine*

Related to Nature was Art Nouveau's obsession with the feminine—this, at a time when controversies roiled over the New Woman (see figure I.2).

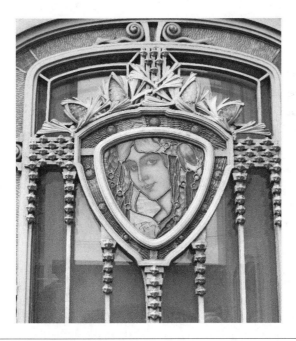

**I.2**  This detail from the facade of the Musée de L'École de Nancy (the French city that was a center for Art Nouveau production) shows the movement's obsession with the figure of Woman. Photograph by Lucy Fischer.

Here the movement shows the influence of the romanticized, other-worldly, pictorial style of Pre-Raphaelite painters like Dante Gabriel Rossetti (e.g., in *Bocca Baciata* [1859], *Beata Beatrix* [1864–1870], or *Lady Lilith* [1867]). Art Nouveau's fascination with Woman was perhaps three-sided. On the one hand, in certain works, she represents majesty (e.g., in the statue *La Parisienne* that topped the Paris Exposition's Porte Binet); in others, she signifies mystery (as in Maurice Bouval's sculpture *The Secret* [1900] where she holds a closed box); in yet others, her sexual lure morphs into malice (as in Gustav Klimt's *Pallas Athene* [1898] (Plate 2), Jules Marcel-Lenoir's *The Monster* [1897], or Lucien Lévy-Dhurmer's *Medusa* [1897]). In this latter vision, Art Nouveau drew not only on the Symbolist, but on the French Decadent sensibility associated with Baudelaire, Paul Verlaine, and Joris-Karl Huysmans. As Verlaine writes in "O La Femme!":

O Woman! Prudent, wise, calm enemy,
Showing no half measures in your victory,
Killing the wounded, plundering the spoils,
Extending flame and steel to distant toils,
Or a good friend, fickle and yet still good,
And gentle, often too gentle, like glowing wood,
That lulls at leisure, intrigues us, puts to sleep,
Sometimes draws the sleeper on to that deep
Delicious death, in which the soul dies too![65]

If one examines the *New York Times* of the era (especially the "In the Shops" columns), innumerable references to the female image appear in discussions of Art Nouveau artifacts. One from 1901 talks of an umbrella handle with "graceful damsels in draperies of two colors" and a "head of [a] . . . maiden . . . in . . . tones of gold and . . . silver."[66] Another speaks of a writing seal (done "according to the new art standards") whose handle includes "lotus flower be-decked damsels . . . and willowy, wind-blown maidens."[67] Columns of 1902 and 1903 continue this theme. They speak of a lamp with "art nouveau maidens,"[68] brooches with "art nouveau [women's] heads,"[69] a magnifying glass that "shows the figure of a woman in one of the art nouveau designs,"[70] a candlestick with "the head of a woman with flowing locks,"[71] and a plate "with female figure in relief in the 'art nouveau' manner."[72]

Clearly, its focus on Woman was an aspect of Art Nouveau's invocation of eroticism. One might even argue that the curved lines and rounded volumes that characterized the style had broad sexual overtones. While they "might appear to be based on plants and landscapes . . . they often also resonated with the profile of limbs, breasts, buttocks, and phalluses."[73] In Art Nouveau's view of Woman, be it benevolent or malevolent, her sensuous, oft-nude figuration was a contrast to prim Victorian representations. Demonstrating a conservative streak, Benjamin was critical of this image which, for him, bespoke an "unnatural mother." As he writes, disparagingly: "The fundamental motif of Jugendstil is the transfiguration of infertility."[74] Interestingly, he saw Henrik Ibsen's heroine, Hedda Gabler (a dangerous New Woman), as an archetypal Art Nouveau female.[75] "She is the theatrical sister of those . . . dancers who, in floral depravity or innocence, appear naked and without objective background on Jugendstil posters."[76]

Aside from making Woman a favored subject of its creations, Art Nouveau was often conceived as a "feminine" style, perhaps due to its Romantic subjects and championing of "caprice against male rationality."[77] Marc Restellini even asserts that, when the whiplash was denigrated as the "noodle" style, "its opponents suggested a notion of limpness" (which might be read as impotence, an affliction of the "feminized" male).[78] But Art Nouveau had more concrete relations to the feminine realm—given that (in France at least) the crafts it lauded were supported by upper-class women who, as Debora Silverman notes, had "a special role and responsibility . . . in regenerating the national applied arts."[79] Also, women's concern with interior decoration provided a market for the kind of upscale objets d'art produced by the movement. Finally, turn-of-the-century Paris saw two exhibitions of the Arts of Women (in 1892 and 1895).

Regrettably, however, even now, when the "greats" of Art Nouveau are catalogued, there is rarely a female name mentioned; however, there were several important figures. Margaret Macdonald (known largely for her large gesso panels) worked with her husband Charles Rennie Mackintosh as part of the Glasgow School. Mary Watts created bas-reliefs, pottery, metalwork, and textiles in Great Britain and is best known for the beautiful Watts Mortuary Chapel in Compton (see figure I.3).

Furthermore, Sarah Bernhardt was an accomplished modernist sculptress (creating, for example, a plaster *Self-Portrait* [1885]), and Clara Driscoll conceived many glass patterns produced by the Tiffany Studio.

I.3  Detail from Mary Watts's Mortuary Chapel in Compton, England. Photograph by Lucy Fischer.

Perhaps another reason that Art Nouveau has dubious "feminine" associations is its link to ornamentation; hence Silverman speaks of its "highly worked surfaces"[80] and Benjamin deems it the "stylizing style par excellence."[81] Here another term used by those who disparaged Art Nouveau comes to the fore. As Tag Gronberg points out, when Austrian writer August Lux wanted to critique elaborate architectural facades he spoke of the buildings as engaged in a "masquerade"—a term that, in recent years, has come to be associated with the feminine.[82] Given this gendered view, it seems no accident that one of Art Nouveau's most cherished crafts is jewelry making (primarily a means for adorning women). As Alexandre Cirici notes, "Historically, woman is denoted by her richly ornamental costume, it establishes her as the personification of beauty and worldly riches."[83] In its focus on decoration (accomplished by artifice), Art Nouveau reveals yet another contradiction—since it also celebrates the natural.

Beyond its links to the feminine, ornamentation was devalued for its ties to the ethnic Other—an association noted by Rosalind Galt.[84] Clearly,

Art Nouveau had strong Orientalist overtones, finding inspiration in North Africa and the Far East.

## CRITIQUES OF ART NOUVEAU

*Ugliness, Tastelessness, Madness, Deformity, and Hermeticism*

At the turn of the century, condemnations of Art Nouveau were rampant—both in the popular press and more elite sources. In the *New York Times*, for instance, one finds a plethora of jabs and attacks. An article of 1902 about furniture asks "L'Art Nouveau and what are you going to do about it?" and wonders whether "Grand Rapids [is] about to adopt it and dump on us 'L'art nouveau' chairs, lounges, sideboards, and desks by the carload."[85] A 1906 piece on bookbinding applauds those who "will not bow to new-fangled ideas of Art Nouveau which . . . are shaping leather and tooling it in fantastic arabesques."[86] Similarly, a letter to the editor in 1915 (acer-bically titled "The Workshop of Ugliness") bemoans the "hopeless paths of so-called 'Modernism' or 'Art Nouveau' that have shipwrecked many men of talent." The writer regrets "the pernicious and monstrous developments, or rather perversions, which the misguided schools of painting and sculpture have undergone in recent years" and calls for "classes in which good and bad taste should be demonstrated, where beauty and grace should be defined, in contradistinction to the ugly."[87] Finally, speaking retrospectively in 1924, an author remarks on how "the old 'nouveau' had as much against it as any single generation could bring about."[88]

A *New York Times* columnist covering the European scene reports similar negative responses to Art Nouveau. He describes how English newspapers protested in 1901 when the Kensington Museum acquired works in that style, since British cabinetmakers (who feared "corruption" by the form) disdained its "meaningless curves and combinations."[89] In 1902, a writer states that in Paris Art Nouveau has received "violent attacks" and "has more enemies than friends."[90] Likewise, in 1923, an article reports that a resident of Prague said: "The modern buildings [here] . . . are some-what weird . . . 'Art nouveau' is about the worst thing we Bohemians do."[91]

For many, the perceived "deformation" of Art Nouveau lines and dizzy-ing loops had connotations of madness. As Valbert wrote, "[Today] we love

to contort ourselves, to twist and straighten ourselves, to torment . . . our thoughts."[92] For Benjamin (alluding to both modernity and physiognomy), "in the typical Jugendstil line—conjoined in fantastic montage—nerve and electrical wire not infrequently meet."[93] Not coincidentally, the movement came into popularity around the time of the "new psychology" pioneered by Jean-Martin Charcot in Paris and Hippolyte Bernheim in Nancy.[94] As Silverman describes it, this science involved "the exploration of the interior of the human organism as a febrile, mechanistic system of nerves," as well as "the examination of visual dimensions of the thought process, with particular emphasis on the role of dreams."[95] Charcot, as it happens, was especially attuned to the pictorial arts (though he decried the avant-garde), and employed colored discs and signs to induce hypnosis.[96] He also sketched his patients and drew diagrams of their illness, "creating a new visual language of diagnosis."[97] Beyond that, he was an artist and interior designer and was interested in how painters like Goya, Raphael, and Da Vinci represented insanity, publishing a book on the topic in 1889.[98] Linking him specifically to Art Nouveau, Silverman writes that "the visual 'trope' in Charcot's system of correspondences between outer physicality and inner pathology was the curve." He felt that mental illness was caused by "physical equivalents in the irregularity, asymmetry, contortion and curvature in the patient's comportment."[99]

Some in Art Nouveau circles were dedicated to "joining the practice of interior decoration to the *unstable* fluidity of the chamber mentale."[100] In fact, Surrealist Salvador Dalí praised Art Nouveau for bespeaking insanity—favoring "lunatics" and "erotomaniacs."[101] Others, however, saw Art Nouveau as a calming counterforce to the jarring, crowded, industrialized world. Thus, they emphasized interior design as providing "private intimacy against public monumentality."[102]

Though admitting that Art Nouveau addressed the individual, some (like Umberto Eco) have seen it as having antibourgeois tendencies as well, albeit "dictated more by the desire to scandalize the middle classes . . . rather than to overturn the established order."[103] Similarly, Henry F. Lenning argues that "*Art Nouveau* was consciously and hopefully launched in the 1890s as a concrete expression of 'social conscience.' It was to combat the lingering romantic tradition of the nineteenth century and reflect in all the arts the new 'realistic' attitude toward man and his relation to

society in which he found himself on the eve of the twentieth century."[104]
Walter Benjamin, however, viewed Art Nouveau as quintessentially bour-
geois and retrograde—conceived in the shadow of capitalism. As he writes:

> For the private citizen, for the first time the living-space became distin-
> guished from the place of work. The former constituted itself as the inte-
> rior. The counting-house was its complement. The private citizen who in
> the counting-house took reality into account, required of the interior that
> it should maintain him in his illusions. . . . From this sprang the phan-
> tasmagorias of the interior. This represented the universe for the private
> citizen. In it he assembled the distant in space and in time. His drawing-
> room was a box in the world-theatre.[105]

In many respects, Benjamin was correct about Art Nouveau's tendency to
create illusion. As Belgian architect Henry van de Velde once wrote, the
regeneration of art occurs with "the annihilation of the actual."[106]

In particular, Benjamin associated Art Nouveau with the champion-
ing and aestheticization of private (vs. communal) space, since the bour-
geois individual "had no intention of adding social preoccupations to his
business ones."[107] As he continues: "The transfiguration of the lone soul
was [Art Nouveau's] apparent aim. Individualism was its theory. . . .
There appeared the house as expression of the personality. Ornament was
to such a house what the signature is to a painting."[108] But, as Gronberg
points out, the move to the interior had causes other than hermetic nar-
cissism. As she notes (in speaking of Austria): "Disillusioned by the failure
of liberal politics, later nineteenth-century writers and artists withdrew
from the public sphere and turned their attention inwards." Further-
more, for the Jewish bourgeoisie (many of whom commissioned Art
Nouveau works), there were other factors involved. As Gronberg contin-
ues: "The anti-semitic Christian Socialist Karl Lueger was voted mayor
of Vienna in 1897; there were anti-semitic student riots at the University
in 1897 and 1905; Otto Weininger's highly regarded . . . anti-semitic
book *Geschelecht und Charakter* was published in 1903."[109]

Benjamin also chastised Art Nouveau for its association with collec-
tors who, ignoring societal needs, purchased precious (but impractical)
things from the likes of Siegfried Bing or Julius Meier-Graefe (who ran

La Maison Moderne). As Benjamin comments, "The collector dreamed that he was in a world which was not only far-off in distance and in time, but which was also a better one, in which to be sure people were just as poorly provided with what they needed as in the world of everyday, but in which things were free from the bondage of being useful."[110] Among the typical Art Nouveau artifacts were decorative boxes—objects which, as we have seen, Benjamin regarded as emblems of bourgeois existence. As he notes, "The interior was not only the private citizen's universe, it was also his casing. . . . Coverings and antimacassars, boxes and casings, were devised in abundance, in which the traces of everyday objects were moulded. The resident's own traces were also moulded in the interior."[111]

Related to collecting is the fact that Art Nouveau (like Art Deco to follow) emerged at an international exposition (Paris 1900)—an institution that Benjamin despised.[112] As he comments, "World exhibitions were places of pilgrimage to the fetish Commodity."[113] Furthermore, he associates such events with "the sibylline book of la publicité."[114] This had particular implications for Art Nouveau since, for Benjamin, "advertising [was] emancipated in Jugendstil."[115] Here, of course, one thinks especially of the poster art of Alphonse Mucha. Benjamin also blames commercial graphics for its "integration of the human body into advertising"—a trope that can be seen in Mucha's representations of Woman.[116] Going further, Benjamin denigrates the international exposition for cheapening art. As he writes, "industrial exhibits [are] secret blueprints for museums." Art becomes "industrial products projected into the past."[117] The Museum of Modern Art's eventual exhibition of items like the Olivetti typewriter proves Benjamin right—though this move has come to be celebrated, not bemoaned.

But what can be said about Benjamin's appraisal? As for the claim that the style bespoke individualism, he might as well have pilloried modernity in general, since, as Ben Singer has noted, this was one of its signal characteristics.[118] Implicit in Benjamin's criticism is the assertion that all of Art Nouveau's goals were bourgeois, yet there were those practitioners with wider aspirations. Émile Gallé was a socialist and political activist, and Hector Guimard was a liberal whose conception of architecture was democratic and community-oriented. In his Paris building, the Castel Beranger (1896), there is an entrance courtyard in which residents can gather;

furthermore, all apartments are the same size with no distinction be-
tween higher and lower floors.[119] Nonetheless, some Parisians disparagingly
deemed it the "Castel Deranger."[120] Finally, between 1895 and 1899, the
Belgian architect Victor Horta, then a socialist, designed the Maison du
Peuple in Brussels, a complex of buildings for the progressive Belgian
Workers' Party.[121]

Much of Benjamin's critique of Art Nouveau also seems based on the
fact that it is an applied versus "fine" art movement. As Henry van de Velde
once lamented, "Suddenly [applied arts] were called arts of the second
rank, then decorative arts, then the minor arts and lastly the industrial
arts." Rejecting this view, he argued, "We can't allow a split which aims at
single-mindedly ranking one art above the others, a separation of the arts
into high art and a second class, low industrial art."[122] The Jugendstil art-
ists agreed, making similar claims in their journal *Ver Sacrum*.[123] In partic-
ular, as John Heskett notes, Art Nouveau's aim was to make "each article
of personal use . . . a work of art, to 'transfor[m] . . . everyday life, in
all its aspects. To achieve this, nothing was too great or too small to be
worthy of aesthetic concern, and the applied arts consequently became
[its] central concern.' "[124] Thus, Josef Hoffman (of Vienna's Wiener
Werkstätte) saw fit to design kitchen cabinets, previously thought beneath
artistic consideration.

Clearly, Benjamin's objection to the movement's production of saleable
goods would apply to all design trends—not simply Art Nouveau—and may
reveal an elite preference for "art for art's sake." (Adolf Loos, for instance,
in his 1908 diatribe against Art Nouveau addressed his remarks specifically
to "cultivated people.")[125] Benjamin's comments also ignore the fact that
fine art is much engaged in commerce, having long been underwritten and
bought by museums, galleries, religious institutions, as well as the wealthy
and aristocratic—the latter of whom adorn their homes with esteemed
paintings and sculptures, just as the bourgeoisie do with objets d'art.

Some of Benjamin's criticisms may also reveal an antifeminine bias.
For, as Wendy Steiner notes, "Ornament . . . joined woman as a mod-
ernist outlaw."[126] Moreover, that Benjamin belittles the "unnatural
mother"[127] as an icon of Art Nouveau presumes the norm of fertility; and
his disdain of domestic or interior space is a denunciation of the sphere
conventionally associated with the female.

For Benjamin, Art Nouveau's ultimate insult is its association with the marketplace. Interestingly, it is particularly its use of the female form in hawking products that Benjamin finds so troubling, as in Mucha's posters for Job cigarette papers (Plate 3).

Finally, though Benjamin does not directly state this, one suspects that he is wary of the sumptuous *beauty* of Art Nouveau—given that this quality has conventionally been associated with surface indulgence rather than the intellectual depth. As Steiner has noted, in high modernism, "The perennial rewards of aesthetic experience—[including] pleasure . . . were largely withheld, and its generous aim, beauty, was abandoned."[128] Here it is intriguing to note that architect Antoni Gaudí (whose work will be examined in chapter 3) was proud of the fact that his name derived etymologically from the word "pleasure."[129] We should also recall that André Breton (who valued Art Nouveau) used the word "seduction" in relation to the mode—a term that positions the spectator as powerless to resist its charms. As Steiner comments, "the ornamental is . . . taken as a black magic of utility and power associated with deception and the meretricious. Ornament is thus at the heart of deep-seated anxieties about beauty's relation to freedom."

Beyond Benjamin's disdain, the movement was disparaged by others. For instance, he quotes art critic Adolf Behne as finding Jugendstil "ridiculous."[130] He also mentions architect Loos, one of the movement's earliest detractors, who vilified Art Nouveau's decorative impulses. Thus, Loos speaks of the "yoke" and "epidemic" of the ornament and claims that "the evolution of culture is synonymous" with its removal.[131] He mentions the "great damage and depredations" caused by the ornament and claims that its use is "unhealthy."[132] He even asserts that a "lack of ornamentation is a sign of intellectual strength."[133] Finally he considers the production of ornaments a "crime"—a "waste of human labor, money, and materials."[134] Taking this one step further, a 1904 article in the *New York Times* paraphrases the president of the Royal Institute of Architects as stating that the movement's "disfiguring buildings . . . are an immoral influence and lead to crime."[135]

## Kitsch, Camp, and Decadence

From a more contemporary perspective, the most vitriolic assault on Art Nouveau surrounds its identification with "kitsch" (a word for "garbage"

in German). A propos, even a positive *New York Times* review of the massive 2000 Art Nouveau exhibition at the National Gallery was titled "Beyond Kitsch."[136] In general, kitsch objects are considered to be:

> pretentious, vulgar, or otherwise designed to please and flatter the masses by means of promulgating false, self-congratulatory sentiments. With the exception of occasional exploitations of kitsch in avant garde art . . . kitsch objects—which may be everything from tacky Monet coffee mugs to fake Greek colonnades—are usually fixtures in our ordinary life, and hence related to methods of mechanical reproduction and to the social dynamics of mass production and consumption. . . . A typical kitsch object exploits generic emotional themes—sadness, serenity, love, and so on—or plays at being beautiful in a manner which is instantly and effortlessly identifiable. The unreflective, conventional take on such themes, associated with kitsch, renders them universal in the sense of appealing to the audience's most common denominators; hence, arguably, it fails to enhance or expand the audience's sensitivities or knowledge about these matters. . . . Kitsch seldom seems particularly imaginative or susceptible to aesthetic characterizations, and it is usually taken to negate truth in art, as well as creativity and profundity.[137]

So how has this term come to be linked to Art Nouveau, and is that association valid?

Given the movement's love of Nature and Woman, it is easy to see how some may feel that its artifacts are too "generic," or appeal to crass "sentiment." However, this view entirely ignores how these motifs are often employed in a disturbing manner (e.g., references to female vampires; nightmares, psychosis, bats, snakes, and beetles). That Art Nouveau objects are beautiful may also make them seem too "easy" to some—courting the "masses," "flattering" them with the "illusion" that they appreciate art. The elitism of this complaint should be obvious—reserving art for the schooled and intellectual. Such condescension is apparent in one of the earliest meditations on kitsch by Clement Greenberg—despite his attention to class difference: "There have always been on one side the minority of the powerful—and therefore the cultivated—and on the other side the great mass of the exploited and poor—and therefore the ignorant. Formal culture has always belonged to the first, while the latter have had

to content themselves with folk or rudimentary culture, or kitsch."[138] Then there is the question of mechanical reproduction—an issue that Greenberg stresses by citing Norman Rockwell magazine covers, Maxfield Parrish prints, and Tin Pan Alley recordings as prime examples of kitsch. He contrasts these with the precious "handmade article."[139] Again, crass mechanical reproduction was not typical of Art Nouveau. While some objects produced were not entirely unique but made in series, they were not cheaply fabricated or routinely available to the "masses." Rather, they were often high-end, artisanal pieces purchased by the same class of people who supported the established arts. Furthermore, their reproduction shares nothing with a Monet coffee mug that simply imposes a renowned artwork (poorly rendered) onto a mundane and irrelevant consumer object. Though saleable, Art Nouveau articles were artworks. Even when wares were mass-produced and available in department stores like Liberty of London, they bore no relation to the Monet mug, which "dumbs down" a previously created masterpiece. Only *after the fact* did Art Nouveau design take on the aspect of kitsch: for instance, in the souvenirs sold at museum shops (bookmarks, scarves, pendants, tote bags, t-shirts, etc.). Moreover, nothing could be less true of Art Nouveau than that it "seldom seems particularly imaginative or susceptible to aesthetic characterizations." As a movement that sought to overturn previous styles and infuse the world with "total art," it had a highly original and creative thrust. Finally, Greenberg contrasts the representational nature of kitsch (e.g., the work of Russian painter Ilya Repin) with the abstract quality of "true" art.[140] But, certainly, as we have seen, much of Art Nouveau design is nonmimetic and nonfigurative—hence falling more into the second category than the first.

More justified would be the related claim that Art Nouveau is Camp—a sensibility popularized in the 1960s and elegantly outlined by Susan Sontag. Her essay (dedicated to Oscar Wilde) is, on some level, a valentine to the mode, but she admits that, while she is "strongly drawn to" it, she is also "offended by it." Primary among Camp's qualities is its will to view the world "as an aesthetic phenomenon" and to privilege that which is artificial and exaggerated. Camp is also highly "theatrical"—a notion related to recent theories of spectacle. Not surprisingly, Sontag mentions Art Nouveau as a prime example of Camp—noting how it attaches to such

then popular objects as Tiffany lamps and Aubrey Beardsley drawings (but, it would seem, only retrospectively in their reproduction). On the other hand, she realizes that the Camp label is not adequate to the totality of the movement, especially in the era of its birth:

> A full analysis of Art Nouveau, for instance, would scarcely equate it with Camp. But such an analysis cannot ignore what in Art Nouveau allows it to be experienced as Camp. Art Nouveau is full of "content," even of a political-moral sort; it was a revolutionary movement in the arts, spurred on by a Utopian vision (somewhere between William Morris and the Bauhaus group) of an organic politics and taste. Yet there is also a feature of the Art Nouveau objects which suggests a disengaged, unserious, "aesthete's" vision. This tells us something important about Art Nouveau—and about what the lens of Camp, which blocks out content, is.

Contrary to viewing Camp as marking only articles of popular culture, Sontag controversially sees the mode in such high-culture gems as opera and ballet, compositions by Wolfgang Amadeus Mozart, and novels by Henry James.

For Sontag, Camp is "playful" and "anti-serious"—never invoking the tragic. Moreover, it is "innocent" and "naïve"; it must *believe* in its excessive practice, rather than employ it satirically.[141] Camp is also democratic. As she writes, "The experiences of Camp are based on the great discovery that the sensibility of high culture has no monopoly upon refinement."[142] Not surprisingly, Camp is associated with groups traditionally excluded from the upper echelons—Jews and homosexuals.[143] Finally, Camp embraces pleasure, since its "taste is, above all, a mode of enjoyment, of appreciation—not judgment. Camp is generous. It wants to enjoy."[144] Though Sontag has asserted that Camp annoys and delights her in equal measure, her essay tips in favor of the latter.

But there is another claim about Art Nouveau to address—that it was decadent. Even champions of the movement have employed this term. As contemporary scholar Alexandre Cirici writes, "The movement was a manifestation of . . . *La Belle Epoque*, well suited to the elite minorities . . . at ease in its own decadence."[145] But detractors of Art Nouveau foregrounded this issue as well; thus, "by 1911, many critics openly attacked it

as being . . . debauched."[146] In part, the style's association with moral tur-
pitude stemmed from the fact that Art Nouveau blossomed at the same
time as the Decadent movements in France and England, which were
largely associated with literature versus the visual arts; in fact, a journal
entitled *Le Décadent* was founded in 1886 by Anatole Baju.[147] In particular
Decadence was known for its valorization of artifice, and its great themes
"all revolve[d] around the idea of a Beauty that springs from the *alteration
of natural powers*."[148] It was also linked to abnormality. As Richard
Gilman notes, the "new sensibility [was] tuned to . . . the grotesque
and unworldly."[149] Thus, Decadence was tied to "neurasthenia and sexual
perversity; boredom . . . [and] nostalgia for the corrupt."[150] Signifi-
cantly, Gilman sees the Decadents as "facing *away* from the bourgeois
age"—not toward it.[151] While Art Nouveau practitioners were not literally
part of the Decadent group, its influence was in the air and often imbued
their work; but, as Gilman notes, the term (emptied of its original his-
torical reference) eventually came to have an entirely pejorative sense.

There were, perhaps, other reasons for Art Nouveau's association with
Decadence. First was its championing of decorative beauty, of art for art's
sake. Writing in the journal *Jugend*, for instance, Georg Simmel penned a
tongue-in-cheek, satirical piece recommending the cult of Ugliness as an
alternative:

A devil must have invented beauty in order to make life a torment for us.
Oh, how tender, stable, and lovely is the ideal of ugliness! With what inner
satisfaction would our eye register the world, with what undisturbed
harmonies would this world gratify our ear, if we were to measure it by the
desire for complete ugliness instead of complete beauty! Then between ideal
and reality there would no longer be any dissonance to hurt our ears, and
we would no longer read any unfulfilled expectations between the lines of
the world; instead, we would see the natural development of men and things
quietly and steadily reaching their ideal, certain that what is not managed
today will be reached tomorrow. A calm, sated peace will greet a world which
ceases to treasure appearances by the erroneous dream of beauty and in-
stead by the clear absoluteness of the ugly, no longer asking with perverse
intransigence what appearances cannot grant and instead reverting to their
unequivocal meaning. Only when we no longer make ourselves suffer under

the insolent demand for the beauty of things can we construct our ideals in such a way that reality will find a place for—and our inner pilgrimages validate—the all-holiest of the ugly and the all-ugliest of the holy. Then the world will really belong to us and we will enjoy the spectacle of a reality which no longer lags behind the ideal, and sometimes even that of an ideal which trails reality.[152]

In particular, Art Nouveau beauty was of a highly sensual kind and, as Pierre Bourdieu has emphasized (through reference to Kantian aesthetics), Western society has made a distinction "between the 'taste of sense' and the 'taste of reflection' and between facile pleasure, pleasure reduced to a pleasure of the senses, and pure pleasure, pleasure purified of pleasure, which is predisposed to become a symbol of moral excellence and a measure of the capacity for sublimation which defines the truly human man."[153] In the minds of many critics, Art Nouveau was associated with the former (the "taste of sense" and "facile pleasure") rather than the more "elevated" forms of art.

Another reason for Art Nouveau's air of Decadence was its production of expensive goods—clearly an unpopular orientation for Marxists like Benjamin. However, one could argue that its modernist buildings were available (at least at street level) to all those who passed or entered them. In fact, German Jugendstil architect August Endell had as his "goal . . . an artistic culture for everyone," and in essays and lectures "discussed the beauty in everyday life [since] in his view, art and culture [did] not belong in museums [but] should be lived and experienced each day."[154] Here a 1902 Paris law is relevant, which, in the name of beautification, "grant[ed] greater artistic license to the architect . . . in order to facilitate a greater variety of approaches to the design of façades."[155] However, as Gronberg has noted, "the problem seemed to be how to conceive of façades that epitomised 'individuality'—differentiation—without lapsing into the [alleged] excesses of Art Nouveau historicism or overblown ostentation."[156] One building subject to controversy was the Hôtel Lutrétia, built in 1910 by architects Louis-Charles Boileau and Henri Tauzin. According to Gronberg, "[Its] attempt to solicit . . . an urban gaze through rich surface decoration was in many instances . . . deemed a monstrous failure. Critics invoked the Hôtel Lutrétia as evidence of the results of the

1902 law as well as embodying everything that was undesirable about le style moderne (Art Nouveau): 'with its decorative pastry, [the Hôtel] resembles an enormous soft cheese with bizarre blisters.'"[157] Of course the major way in which Art Nouveau trickled down to the middle classes was through the birth of the department store, the same institution that later sold the public Art Deco. In Paris, three were built in an Art Nouveau architectural style: Printemps (1865), La Samaritaine (1869), and Galeries Lafayette (1893). In Great Britain, when Harrods redesigned its Meat Hall in 1902, it included wall decorations by Art Nouveau creator William James Neatby. Liberty of London (founded by Arthur Lasenby Liberty in 1875) was especially identified with the movement and mass-produced signature goods made with cheaper materials than high-end ones. In particular, the store was known for its fabrics that appeared hand-crafted but were not. Many Art Nouveau artists designed for Liberty (though they were not credited for doing so)—including Archibald Knox and Mary Watts. The store became known as the art lover's retailer. Hence, as William Curtis notes, "Art Nouveau did not always remain the aloof creation of an avant-garde. Indeed, the style was quickly popularized."[158]

Once more, an examination of the *New York Times* from the era reveals references to innumerable consumer articles that were marked by an Art Nouveau aesthetic. A column from 1899 praises "the really newest thing in furniture [which is] not wrongly called 'l'art nouveau.' It has the most delightful decoration in the most artistic effects in color and design of free-hand painting."[159] Another from 1902 describes a pocketbook as follows: "The frame of the metal is in uneven lines, the curved art nouveau lines in one bag waving down at one side and up at the two sides. One tires of hearing of the new art, but it enters into so many things that only by reference to it can an accurate idea be given."[160] Another talks of an Art Nouveau clock, with "graceful waving lines in which we are familiar in the new art."[161]

There are also columns that speak of Art Nouveau pottery, punch bowls, table linen, toiletry accessories, clothing, hair combs, picture frames, and inkstands. In jewelry, what was especially noted was the focus on design rather than on valuable gems. As one columnist wrote, "with [its] popular use of semi-precious stones in jewelry people are getting an artistic standard in their ornaments that was not possible when only the intrinsic

value of the stone was regarded."[162] Some articles also touted the affordability of items (though of course the reader of the *New York Times* was likely more flush than those of other papers). An "In the Shops" column of 1904, for instance, claims that "for little money the woman with artistic instincts can have very fine portières[163] and window hangings."[164]

Despite its having influenced quotidian culture, Art Nouveau continued to be associated with Decadence; and perhaps, there is a reason for this that is not often mentioned. Some prominent individuals associated with the movement were Jews—a population frequently (and unfairly) linked to depravity (as in the later Nazi era).[165] Among the influential were such Jewish collectors and entrepreneurs as Bing and Meier-Graefe, and theatrical designer Léon Bakst. Furthermore, Sarah Bernhardt (a Jewess) became a kind of "poster girl" for Art Nouveau because of the graphics, stage sets, and jewelry she commissioned from Mucha (the most famous being his advertisement for her play *Gismonda* [1894]). Significantly, Bade quotes racist (and misogynist) remarks by a critic of the era, Arsène Alexandre, who said that Art Nouveau "reaks [*sic*] of the . . . drug-addicted Jewess."[166] More on this topic is discussed in chapter 4.

## INTERMEDIALITY AND THE CINEMA

Like Art Deco, Art Nouveau left its imprint on a variety of crafts and media. In architecture, one thinks of Gaudí in Spain, Endell in Germany, and Louis Sullivan in the United States. In painting, one thinks of Gustav Klimt in Austria, Victor Prouvé in France, Jean Theodoor Toorop in Holland, and Miquel Utrillo, Santiago Rusiñol, and Ramon Casas in Spain. In sculpture one thinks of François-Raoul Larche and Louis Chalon in France, Lambert Escaler in Spain, or Charles van der Stappen in Belgium. In illustration, one thinks of the Englishmen Aubrey Beardsley or Walter Crane, the Czech Mucha, the Frenchmen Henri de Toulouse-Lautrec and Georges de Feure, the German "Alastair" (von Voigt), or the Spaniard Alexandre de Riquer. In glassware, one thinks of Daum and Gallé in France, Tiffany in the United States (Plate 4), and Christopher Dresser in Great Britain. In jewelry, one thinks of René Lalique and Georges Fouquet in France, Lluís Masriera in Spain, and Charles Robert Ashbee in Great Britain. In pottery one thinks of companies like Van

Briggle and Rookwood in the United States, Sèvres and Massier in France, Villeroy and Boch in Germany, and Rozenburg in the Netherlands. In furniture, one thinks of Majorelle in France, Charles Rennie Mackintosh in Scotland, Arthur Mackmurdo in England, Carlo Bugatti in Italy, Joan Busquets i Jané in Spain, or Koloman Moser in Austria. In metalwork one thinks of Maurice Bouval, Charles-Émile Jonchery, or Alexandre Clerget in France, Georg Jensen in Denmark, Archibald Knox in Great Britain, and the Orvitt factory in Germany. In textiles one thinks of Charles Voysey and William Morris in Great Britain.

Of course, many of these individuals worked in multiple media. Aside from fabricating glass, Tiffany painted and designed jewelry; aside from creating jewelry, Lalique produced glass; aside from being a graphic artist, Grasset was an architect, interior designer, furniture maker, ceramicist, metalworker, and textile worker. Perhaps one of the best examples of this multidisciplinarity is Mucha's "total art" work, Georges Fouquet's jewelry shop (now housed at the Musée Carnavalet in Paris—every inch of which he created [including statuary, wall reliefs, tables, stained glass, wallpaper, etc.]) (Plate 5).[167] Significantly, he also designed jewelry for Fouquet.[168] Beyond this, in his 1901 publication *Decorative Documents*, Mucha provided designs for furniture, silverware, cornices, mirrors, etc.—showing that his interests had no limits.[169] Such intermediality—typical of Art Nouveau—prepares us for the movement's connection to cinema.

But the style proved interdisciplinary in yet other ways. For as Vajda has commented, "by way of analogy" (a comparison to other media), "the common characteristics of . . . the arts can be established."[170] While primarily associated with the applied arts, Art Nouveau also influenced some performance modes. A *New York Times* article from 1915 speaks of a play in Boston done with "stage art nouveau tendencies,"[171] and one from 1916 reviews a German musical comedy with "art nouveau trimming."[172] Yet another from 1916 complains about "L'art nouveau and Shakespeare!" and asks, "Could anything be more grotesque?"[173] Finally a piece from 1918 discusses an opera performance that employed " 'art nouveau' lighting from overhead."[174] Hence, it is no surprise to find the style migrating to the movies.

In truth, Art Nouveau was born with film. As Sembach writes, "The 1890s gave the world two innovations: cinema and Art Nouveau."[175] For

him, Art Nouveau and the motion picture "started from the same prem-
ises, their aims were comparable and they shared similar yearnings."[176]
Among their bonds were ties to industry (for cinema, the studio; for Art
Nouveau, artisanal production), and an invocation of dynamic mobil-
ity (for cinema, literal motion; for Art Nouveau, "stylistic animation").
Finally, as previously noted, Art Nouveau artists were fascinated with
glass and the play of light—elements that further link the movement to
the cinema.

Interestingly, when I executed a keyword search for the phrase "art nou-
veau" in early international film magazines, I realized something else. In
French publications that term attached to discussions of the cinematic
medium itself. In a 1912 *Ciné-Journal* piece entitled "La Cinématographe,"
G. Dureau writes, "The cinematographic spectacle is not a pale imitation of
theater, it is a spectacle apart . . . a new art [*un art nouveau*]." Later in the
article, he reiterates how "the cinema must be affirmed as a new art [*un art
nouveau*] . . . and must resist being considered a simple reproduction of
the theater."[177] So the emergent medium of film was labeled with the phrase
"new art"—an epithet identical to that which was affixed to a nascent
modernist style.

Historically, film and Art Nouveau intersected dramatically at the Paris
Exposition that opened on Easter Sunday 1900—an event with national-
istic overtones that sought to champion French creativity. The Exposition
was a massive and extravagant affair that drew some 240,000 daily
visitors—about 50 million total. It lasted for 212 days and was a trade show,
centennial retrospective, and occasion for the Olympic Games. It gener-
ated some 7 million French francs and saw the construction of the Petit
and Grand Palais as well as the Alexandre III Bridge. Various "congresses"
took place at the event, among them ones on photography (which included
cinema) and the decorative arts.[178]

While most of the buildings in the Exposition were constructed in tra-
ditional Beaux Arts manner, or reflected the national styles of their
sponsors, a few were modernistic—the Pavillon Bleu (designed by Gustave
Serrurier-Bovy), the theater (designed by Henri Sauvage), the Pavillon
de l'Union Centrale des Arts Décoratifs, the pavilions of two department
stores (La Louvre and Bon Marché), and Art Nouveau Bing (designed by
André-Louis Arfvidson with exterior work by Georges de Feure featuring

"ornate, flowing designs of female figures that embodied the very essence of the high style").[179] Bing's pavilion was opened some time after the Exposition began, and Gabriel Weisberg opines that it may have been a last minute addition "after the selection committee realized how much international attention Bing's Parisian based style of decorative arts was attracting."[180] Bing's pavilion was organized like a model home with six rooms (dining room, bedroom, sitting room, woman's boudoir, parlor, and foyer). Among the major designers who fabricated the interior were de Feure, Eugène Gaillard, Edward Colonna, and José María Sert, all supervised by Léon Jallot.[181] Theirs were original creations in which furniture, objects, and architecture constituted an integral whole.[182] Beyond home furnishings, Bing also exhibited jewelry, ceramics, and glass by some of these designers—as well as by Marcel Bing and René Lalique.[183] There were few published reviews of Bing's pavilion, in part because it opened late, but also, as Weisberg suggests, "because *art nouveau* remained above the head of the average reader, if not the newspaper critic as well."[184] The pavilion, however, was especially popular with foreign visitors.[185] One review spoke of the building's "voluptuous elegance; soothing and soft slender shapes; dreamlike flora, and gilded settees"—all constituting an "enveloping interior retreat."[186] Here we sense an affirmation of Benjamin's notion that Art Nouveau emphasized private space—but without the negative associations. Art Nouveau works (French practitioners like de Feure, Gaillard, Guimard, Gallé, Charpentier, Majorelle, Grasset, Lalique, Carriès, and Lachenal) also appeared in the Decorative Arts Palaces, in various national pavilions, in private buildings (the department stores Le Printemps and Le Bon Marché), and in the Pavillon de l'Union Centrale des Arts Décoratifs.[187]

It is important to remember that the cinema was only five years old when the 1900 Paris Exposition occurred, so it was still in its infancy. As Emmanuelle Toulet notes, the Exposition offered "the cinema the possibility and chance of official international recognition. It [was] also a field of experimentation of its diverse applications for a very large public."[188] Movies were shown at numerous venues, though they were not a financial success in comparison with other attractions.[189] Not surprisingly, special focus was given to work by the French pioneers of the medium, the Lumière brothers. Their films were screened in the massive Salle de Fêtes

in the Galerie des Machines (a holdover from the 1889 Exposition). Programs lasted for some twenty-five minutes and included fifteen *vues* (though a total of 150 were alternated).[190] About 1,400,000 spectators watched them over the course of the Exposition's run.[191]

Open-air film screenings also took place in front of the Eiffel Tower and several theaters (charging separate admission) were located on the Rue de Paris. Some showed sound films. Le Phono-Cinéma, for instance, screened Sarah Bernhardt in *Hamlet* and Coquelin in *Cyrano de Bergerac*.[192] Others, like the Théâtroscope, used film in relation to "mixed media" (optical illusions, music, etc.). Even a theater generally dedicated to stage plays, the Théâtre du Grand Guignol, showed films at certain times of the day, including works by the American Biograph Company.

We know of other film events. A series called "Visions d'Art" presented documentaries about the various regions of France.[193] Furthermore, the Library of Congress lists the following Edison films as screened at the Exposition: *Breaking of the Crowd at Military Review at Longchamps*, *Champs de Mars*, *Champs Elysees*, *Eiffel Tower from Trocadero Palace*, *Esplanade des Invalides*, *Palace of Electricity*, *Panorama from the Moving Boardwalk*, *Panorama of Eiffel Tower*, *Panorama of Place de L'Opera*, *Panorama of the Paris Exposition from the Seine*, *Panoramic View of the Champs Elysees*, *Panoramic View of the Place de La Concord*, *Scene from the Elevator Ascending Eiffel Tower*, *Scene in the Swiss Village at Paris Exposition*, and *Swiss Village, No. 2*. As is clear from their titles, many of these actualities focused on the Exposition itself (including its revolutionary moving sidewalk—an opportunity for a cinematic "phantom ride").[194] Like Edison, Georges Méliès shot documentaries at the Exposition (though, of course, he is known more for his trick films). Among his titles are *The Monumental Gate*, *Panoramic View Taken While Boating on the River Seine*, and *Panoramic View from the Electric Railway*.

Perhaps the most spectacular (but short-lived) cinematic attraction of the Exposition was the Cinéorama, which combined the features of the traditional panorama (represented by such Exposition sights as the Stéréorama and the Maréorama) with film.[195] It was created by Raoul Grimoin-Sanson and, according to Mark Trompeteler, the spectator's experience simulated a hot air balloon ride over Paris.

> Visitors climbed up onto a platform that essentially reproduced the effect
> of being in a large hot air balloon basket with rigging and the lower part of

the hot air balloon above them. Up to 200 visitors could be in the basket for the ascent and descent. Beneath them was a projection room with 10 synchronized 70 mm movie projectors, projecting onto 10 9x9 metre screens arranged in a full 360° circle around the viewing platform. At the appropriate moment the synchronised projectors showed an especially made film shot from the basket of a balloon rising over Paris and at another appropriate moment, the film was projected in reverse to simulate the return and descent of the balloon. The film was shot using a camera rig of 10 cameras with a single central drive locking them together in synchronisation. The film was made from a balloon that ascended to a height of 400 feet above the Tuileries Gardens in Paris.[196]

Despite its spectacular effects, the Cinéorama closed after only three days when its operator fainted from extreme heat, and officials feared that it would cause a fire. Trompeteler asserts that Abel Gance was aware of the Cinéorama and that it may have influenced his vision for *Napoleon* (1927).

However, while coming of age in the same period as cinema, Art Nouveau had little obvious influence upon it—clearly, one factor in the movement's invisibility in film history. The reasons for its absence are numerous. First, Art Nouveau's sway was brief—peaking just as the movies were maturing and turning to the feature film. The movement's truncated reign was due to many factors: (a) the ascendancy of abstract styles like Cubism, Futurism, and Constructivism; (b) the burgeoning of Art Deco—a less ornate (but related) design style, more amenable to mass production; and (c) the onslaught of World War I, which made the quest for Beauty seem irrelevant. Second, early film (though a modern medium) tended to appropriate conservative forms of the Victorian era—both in its penchant for traditional melodrama (consider D. W. Griffith's recycling of the stage play *Way Down East* in 1920) and in the staid look of its mise-en-scène. Here we think of the traditional-looking apartments in such French films of 1908 as *The Runaway Horse* (directed by Louis Gasnier) or *Troubles of a Grass Widower* (directed by Max Linder).

However, there were random moments in which Art Nouveau erupted in film—for instance in the end title of Lois Weber's *Suspense* (1910) (see figure I.4).

**I.4** This closing title card from Lois Weber's *Suspense* (1910) bears an elaborate Art Nouveau design.

It also appeared in a few films by Alice Guy Blaché. In *At the Hypnotist* (1898), we find it in the room in which a man mesmerizes a woman. In Guy's sound film, *Félix Major Performs "The Trottin's Polka"* (1905), it is visible when the singer stands before an Art Nouveau stage curtain. We also find traces of Art Nouveau design in several films by Jean Durand. In *Calino Wants to Be a Cowboy* (1911), it is seen in the bathroom décor; and in *Zigoto's Outing with Friends* (1912) in a bar's design (see figure I.5).

Finally, Art Nouveau appears as well in works by Louis Feuillade. In *The Trust* (1911) we find it in the wallpaper pattern of a flat described as a "shady location," and in the hall outside the front door. Interestingly, it is within this apartment that a woman is drugged. Similarly, another room in the film bears traces of Art Nouveau decor. Finally, just as Art Nouveau borders often adorned title cards in silent film, so similar pictorial frames surrounded photos of movie stars in fan magazines—as in a portrait of Ethel Clayton in *Motion Picture Story Magazine* of February 1914.[197]

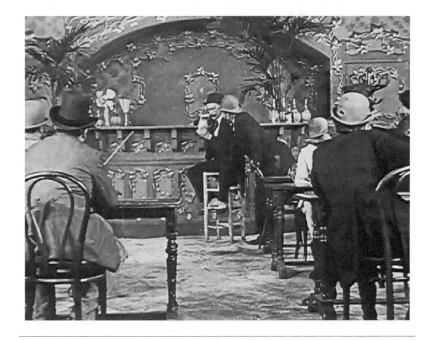

**I.5** The mise-en-scène for this bar scene in Jean Durand's *Zigoto's Outing with Friends* (1912) reveals an Art Nouveau influence.

While the films I have mentioned evidence mere "drive-by" instances of Art Nouveau design within works that are otherwise unremarkable for their mise-en-scène, future chapters will examine movies in which the mode takes precedence. Though admittedly few and far between within the history of cinema, they are nonetheless significant. In general, historians of Art Nouveau have ignored such occurrences. This is evident in the huge exhibition of the style organized by London's Victoria and Albert Museum in 2000. It included only one film—a serpentine dance attributed to Loie Fuller.[198] This was an obvious choice since she had performed at the 1900 Paris Exposition housed in her own modernist theater that saw some 81,000 visitors.[199] It was designed by Henri Sauvage and adorned with sculptures of her by Pierre Roche; furthermore, its facade has been described as an "undulating stage curtain."[200] Moreover, Fuller's flowing gowns had often been compared to whiplash curves, and were immortalized

in a painting by Toulouse-Lautrec (*At the Music Hall*, 1892), a sculpture by Bernhard Hoetger (1901), and a lamp by François-Raoul Larche (1900). She also used "botanical themes" in her presentations, which were characterized by "ephemeral floral beauty."[201]

But given film studies' recent focus on early cinema and the revival of aesthetic approaches, the scholarly blind spot toward Art Nouveau is lamentable. Yet with few exceptions (references by Angela Dalle Vacche, Rosalind Galt, Sumiko Higashi, Tom Gunning, Thomas Elsaesser, and Scott Bukatman), the breach remains.[202] This book is an attempt to fill the gap and to assert the movement's import to cinema.

In light of this, we might ask: Why are themes like the unconscious, the perverse, the erotic, and the personal so celebrated in film studies when attached to Surrealism, but ignored in Art Nouveau, especially when several Surrealist artists militantly celebrated it? Might this dismissal have to do with the assignment of decorative arts to a lower status than fine arts (an irony for film scholars whose own field was discounted for so long)? Moreover, could Art Nouveau's unabashed delight in Beauty be subject to the same kind of puritanical "denial of pleasure" that once characterized feminist film studies (but was later rejected)? For as Restellini states, in Art Nouveau "to enjoy oneself was no longer taboo."[203] Finally, as Steiner and Galt have asked, is the fact that the decorative impulse of Art Nouveau is also linked to Woman and the ethnic Other another reason for its denigration?

These questions will resonate in the pages that follow.

# CHAPTER 1

# Art Nouveau and the Age of Attractions

~~~~~~~~~

*Beauty is always bizarre . . . I mean that it always contains a bit of strangeness.*
—Charles Baudelaire, "Exposition Universelle de 1855"

*I believed in all kinds of magic.*
—Arthur Rimbaud, "II Deliriums: Alchemy of the Word"

## THE TRICK FILM

To fully explore Art Nouveau's role in motion pictures, one must examine the period of the medium's inception—the turn of the twentieth century. This era was characterized by the "cinema of attractions" which, as defined by Tom Gunning, is based upon the acts of showing and exhibiting—conceiving movies as a series of displays. As he notes, this type of film "directly solicits spectator attention, inciting visual curiosity, and supplying pleasure through an exciting spectacle."[1] The viewer of such works is imagined to react with shock, surprise, titillation, or fascination to the images on-screen, becoming overwhelmed by the cinematic experience. In theorizing early cinema this way, the medium is meant to be placed alongside other popular forms of the day—circus, vaudeville, comics, prestidigitation, and magic lantern. But it is not commonly linked to modernist movements like Art Nouveau; yet that is precisely what I will endeavor to do in this chapter.

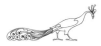 

Attempts to relate early cinema to art, however, are not entirely absent. Arguing against the ubiquity of the visceral "cinema of attractions" model, Charles Musser proposes a cinema of "contemplation" or even "discernment" in the initial years of film history. As he notes, "Not all instances of early cinema generated shocks and displayed qualities that were the antithesis of traditional artistic values. There were also ways in which cinema reaffirmed and *even fulfilled the artistic agenda that had been a feature of art and painting since the mid-eighteenth century*."[2] Here Musser remarks on how certain film posters of the era depicted movies projected into traditional picture frames—making the association of the two media clear.[3] Perhaps he is talking about a poster like one used to advertise Edison's Vitascope (see figure 1.1).

In discussing certain pastoral actualities, Musser notes how reviewers likened them to painted landscapes. Thus, *The Horses at Their Morning Drink* (1896) is compared by one writer to a canvas by Rosa Bonheur.[4] Musser also quotes another writer who praised the pictorial qualities of *Feeding the Doves* (1896): "[It is] a typical farm scene showing a beautiful girl and

**1.1** A poster for Thomas Edison's Vitascope imagines a movie projected within a traditional picture frame.

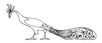

her baby sister dealing out the morning meal to the chickens and doves. The doves and chickens form a beautiful spectacle as they flutter and flock around the givers—*a beautiful picture.*"[5]

What is significant in the first review is the parallel made to painting. Musser then extends the comparison by citing the theatrical practice of "living pictures" (by which actors struck frozen poses on stage, comprising *tableaux vivants*). As one critic commented (about a vaudeville show) in 1894, "The tableaus were disclosed in a large gilt frame. . . . The pictures were for the most part excellently posed and lighted and were shown with much artistic effect. The most of them were reproductions of paintings and a few were original arrangements."[6] As we know, this technique continued on in the silent cinema and we find a *tableau vivant* at the end of D. W. Griffith's *A Drunkard's Reformation* (1909). For Musser, motion pictures were simply a technological augmentation of this stage practice and, by extension, of painting. Perhaps this is why the reviewer of *Feeding the Doves* had recourse to the language of aesthetics (the claim of beauty) to describe such a "primitive" work.

It is this focus on aesthetics that I wish to bring to the work of a Spanish trick filmmaker of this era, Segundo de Chomón, with special emphasis on his ties to Art Nouveau. This is not to say that Chomón's work with its dazzling special effects is outside the "cinema of attractions." It is simply to assert that, among the attractions not commonly catalogued is the pull of arresting beauty—a feature of Chomón's oeuvre and of Art Nouveau practice. An image from his *Metempsychosis* (1907) makes the gorgeous, modernist quality of his compositions clear (Plate 6).

Before examining Chomón's trick films, a word about the import of magic in nineteenth-century France, the very era in which Art Nouveau and the movies blossomed there. Magic was a significant topic in French literature of the time, as witnessed by Émile Cailliet's scholarly study, *The Themes of Magic in Nineteenth-Century French Fiction*. Furthermore, magic was a motif in French Symbolist poetry, which likewise influenced Art Nouveau. Stéphane Mallarmé, for instance, wrote in the *National Observer* of January 28, 1893, "Who . . . will deny me a similarity between the circle perpetually opened and closed by rhyme and the circles, in the grass, of the fairy or magician."[7] As Joshua Landy explains, for Mallarmé "poetry . . . resembles magic by setting up a protected space . . . that delimited by end

rhymes—and by using it in order to create something out of nothing. The difference is that poetry evokes the *idea* of an object . . . whereas magic ostensibly brings forth an *actual* object."[8] Landy goes so far as to pair Mallarmé with the famous French stage magician Jean Eugène Robert-Houdin—whose influence on filmmaker Georges Méliès is widely known—thus, emphasizing the connection between Symbolist literature, cinema, and prestidigitation.[9]

But the figure of Robert-Houdin has broader significance for French culture, given that his prominence and transformation of stage trickery into bourgeois entertainment led to nationalistic claims of France being "the birthplace of modern magic."[10] Even as recently as the 1990s, French "culture brokers in the magic world were able to use Robert-Houdin's legacy to associate magic with France's national cultural patrimony—a strategy that convinced the French Ministry of Culture to invest many millions of dollars in an ill-starred National Center for the Arts of Magic and Illusion."[11] Beyond becoming an icon of France, Robert-Houdin proffered the notion of magician as artist. As Graham Jones notes, "In his memoirs, Robert-Houdin connects his individual reputation to the status of magic as a medium whose . . . similarity to fine arts . . . he consistently emphasizes."[12]

There is one additional aspect of Robert-Houdin's practice that is noteworthy—the fact that he presented himself as an illusionist rather than as a supernatural being. Here his signature costume (a sober evening suit) is a crucial element of demystification. As Landy notes, Robert-Houdin "generally considered himself an active force for *dis*enchantment, a champion of enlightenment in its continuing struggle against credulity." Therefore, he presented himself more as a professor conducting stage experiments than as a shaman.[13] Nonetheless, Landy argues that Robert-Houdin (as well as poets like Mallarmé) ultimately "contributed to the re-enchantment of the world via the *illusion* of wonder and the *illusion* of science itself."[14] His act was a *"model for the construction of a belief system that recognizes itself as illusory"*—playing on the audience's "capacity to let [it]self be deceived, knowingly and willingly."[15]

Similarly, we can regard Art Nouveau as another mode of reenchanting the world—augmenting industrial, scientific, rational reality with its evocative and mysterious splendor. Significantly, the words "magic" and

"magical" appear in many discussions of the movement; for instance, a 2012 article in the *Guardian* is entitled "Art Nouveau—a Magical Style."[16] Furthermore, when scholars describe practitioners of the form, the word frequently surfaces. Victor Arwas mentions the "magic realis[m]" of painter Jules Marcel-Lenoir,[17] and Klaus-Jürgen Sembach cites the magic fragility of Tiffany glass.[18] Jeremy Howard notes magical symbolism in the work of painters Aladár Kriesch and Sándor Nagy,[19] while Karla Nielson remarks on Art Nouveau motifs that "celebrate the pre-Medieval era of magic."[20]

Even more to the point, one can view the trick films of Segundo de Chomón with their Art Nouveau aesthetic as literal forms of magical re-enchantment. In fact, an 1897 book on magic has an entire chapter de-voted to "The Projection of Moving Pictures."[21] Clearly, however, while Chomón could create even more astonishing magic performances than were possible on stage (due to cinema's special effects), the film specta-tors of his time were likely more aware of the crafted nature of his on-screen trickery than of stage illusion because it was no longer performed live, in a shared space. Rather, it was a "canned" event—occurring in the past, somewhere else—registered and reconstituted on film.

That one of the first genres of cinema was the trick film should not sur-prise us since theorists of the medium have long associated it with presti-digitation. For Stanley Cavell, the wonder of the movies is that it satisfies our desire "without [our] having to do anything, satisfying it *by* wishing. In a word, *magically*."[22] He also uses the word "magic" to describe the man-ner in which cinema re-creates the world and allows us to be unseen spectators of it.[23]

## SEGUNDO DE CHOMÓN

Chomón was born on October 17, 1871, in Aragon, Spain.[24] In his twen-ties he traveled to Paris where he met his wife-to-be, Julienne Mathieu, an actress in Parisian light opera and vaudeville. In 1897, they moved to Barcelona where Chomón joined the Spanish army and was dispatched to Cuba. With the war ending in defeat, he returned to Paris in 1899 where his family was waiting. During his absence, Mathieu had begun to work as a hand colorist for the nascent film industry. This involved a process

by which tint was added to positive black and white prints on a postpro-
duction basis in order to highlight sections of costume, landscape, or in-
teriors. It was an expensive practice and most films were shown without
benefit of it. In a famous review of a Lumière program of 1896, Maxim
Gorky complained of the eeriness of black and white screen images: "Last
night I was in the Kingdom of Shadows. If you only knew how strange it
is to be there. . . . Everything there—the earth, the trees, the people, the
water and the air—is dipped in monotonous grey. Grey rays of the sun
across the grey sky, grey eyes in grey faces, and the leaves of the trees are
ashen grey."[25] From the film studios' perspective, however, color was val-
ued not for its normalizing effect but for its commercial possibilities—as
an added lure for the cinema patron.

Perhaps influenced by Mathieu's new profession, Chomón decided to
work in the film industry, but moved his family back to Barcelona. At that
time, the city was the Spanish capital of Modernisme, and one associated
with the avant-garde architectural work of Antoni Gaudí, whose style is
often linked to Art Nouveau. (Barcelona and its modernist artists will be
discussed in detail in chapter 3.) Between 1901 and 1902, Chomón es-
tablished a small studio in Barcelona for coloring film strips and trans-
lating foreign intertitles into Spanish. With connections abroad, he soon
began to distribute French films as well as to produce movies of his own
(particularly actualities of Barcelona and other Spanish cities).

Sometime around 1904 he returned to Paris and began to work for
Pathé Frères, then one of the largest film companies in the world. There he
(along with Gaston Velle) was employed as an "operator" on trick and ani-
mated films, becoming known as the "Spanish Méliès." He remained in that
position until 1910 when he returned to Barcelona and set up his own (ul-
timately unsuccessful) production house, the Chomón-Fuster Company.

His contact with Pathé continued until 1912 when he was hired by
Italia Films in Turin, where he worked until 1922. Significantly, in the
latter part of his career, he was associated with two landmark productions
known for their aesthetic innovations—the Italian *Cabiria* (1914, directed
by Giovanni Pastrone) and the French *Napoleon* (1927, directed by Abel
Gance). Chomón died on May 2, 1929.

It is, however, Chomón's time as a filmmaker with Pathé in Paris that
is central here. Given that filmmaking in this era was an assembly-line

process with minimal attribution of directorial role, one might ask (as has scholar Joan Minguet Batllori) whether it makes sense to look for a "Chomón style."[26] Batllori concludes that it does and that "there are a number of constants, such as references, actors, placement of sets and themes, which give a certain consistency to [Chomón] films from the Pathé period."[27] On a personal note, I can affirm Batllori's observation. For decades, whenever I wanted to cite or teach a single trick film, I would choose the one I thought to be most magnificent—*The Red Specter* (1907)—which was then attributed to Ferdinand Zecca when, in reality, it was made by Chomón.[28] The print that circulated had a Spanish title (*El Espectro Rojo*) that might have been a clue that Chomón had been involved—but I did not pick up on this since I was unfamiliar with his work. So before I even knew Chomón's name, I had selected his work as singular (from myriad trick films, including those by Méliès). Similarly, when recently watching a DVD anthology of Pathé "fairy tale" films (many of which lacked directorial attribution), I was immediately able to pick out those made by Chomón. Finally, I could even detect his work when I perused single-frame enlargements from lost films in a special collection of the George Eastman House archive.[29] The moment I viewed one from *Magic Dice* (1908)—with its lush colors and modernist design—I correctly sensed the hand of Chomón.

*Color*

Beyond simply examining Chomón's work in this period, I will consider how it is related to Art Nouveau. It is important here to realize that Chomón was known especially for his coloration, since this is a crucial aspect of the Art Nouveau mode. Furthermore, as someone who had lived in Barcelona, Chomón may have been familiar with the tiled, polychrome walls and roofs of structures created by Gaudí (e.g., the Casa Battló or the Park Güell) or Lluís Domènech i Montaner (e.g., Palau Musicá)—arch practitioners of Spanish modernism.

Furthermore, Chomón's first filmmaking projects at his Barcelona studio had to do with hand coloring—one of his earliest assignments being postproduction work on Méliès's *Bluebeard* (1901). Already by February 1902 a local newspaper had lauded Chomón as a "renowned film illuminator."[30] Throughout his career, he experimented with color processes, including

fabricating his own Cinemacoloris method (devised between 1911 and 1912).[31] Then, in 1923, he made a movie that highlighted the sensuality of color: *Nature Color*, and was later involved in filming color sequences of Gance's *Napoleon* (shot with the Keller-Dorian system).

The play of hue, so central to Chomón's vision and the Art Nouveau aesthetic, is everywhere apparent in the surviving color prints of his films, whose pictorial quality seems more artful than that of Méliès.[32] Of course, cinematic color in this era (which was not yet photographic), functioned as yet another spectacular and exotic element of the film experience. As Batllori remarks, rather than being associated with realism, it was "a call to enter an unreal world of dreams and fantasy."[33] Joshua Yumibe has observed that as the use of color developed in the silent period it moved away from saturated tones to subdued ones that were seen as more lifelike and tasteful.[34] Hence, for some, the palette of Chomón's early films may eventually have come to seem garish and crude. Might reframing his oeuvre through the lens of Art Nouveau instead reposition it as a prime instance of vernacular modernism? Here it is important to note that, since his color movies were done by hand or stenciled,[35] they were artisanal products (marked by the human body) and consonant with Art Nouveau's blending of industry and craft. Moreover, their mode of production meant that, in a certain sense, each film print was one of a kind, not entirely devoid of the aura usually denied to works of mechanical reproduction.

## ART NOUVEAU MOTIFS

### Whiplash Curves

Chomón's films show traces of other elements of an Art Nouveau aesthetic. He invokes the whiplash curve in producing his own version of Loie Fulleresque choreography in *Creation of the Serpentine* (1908), which presents a magician conjuring a fabric-draped woman who multiplies into numerous dancers—"Fuller squared," as it were. Here it is important to recall that Fuller had her own building at the 1900 Paris Exposition, designed by Art Nouveau architect Henri Sauvage.

In Richard Abel's single application of "Art Nouveau" to Chomón's work, he correctly cites a decorative, painted stage frame that surrounds

the action in *The Wonderful Mirrors* (1907).[36] Inside of it there is a matching magic cabinet and it too is colored in "greenery yallery" and adorned with twisted curves. Here it is well to remember that beyond the extraordinary frames that often enclose Chomón's films were the more ordinary ones that Pathé used for titles and intertitles (themselves often decorated with Art Nouveau patterns).

## *Nature*

In *The Wonderful Mirrors* the cabinet and frame are embellished with flowers, emphasizing a second characteristic of Art Nouveau—its fascination with Nature (see figure 1.2).

We find this imagery, for instance, in Ernst Haeckel's print *Astiniae* (1898), which pictures tendriled undersea creatures;[37] in Tiffany's "Wisteria" lamp (1902);[38] in Georges Fouquet's "Winged Serpent" corsage ornament (1902);[39] in René Lalique's "Iris" bracelet (1897);[40] and in Lucien Gaillard's hair ornament embellished with birds (1900–1902).[41] Alexandre Cirici asserts that a dedication to Nature is true of the Spanish branch of the movement as well: "The vegetal theme dominates to an

**1.2** In *The Wonderful Mirrors* (1907, Segundo de Chomón) the proscenium and internal frame are decorated with flowers, icons of Art Nouveau.

extraordinary degree and, in it, the floral. . . . Among the animals we find those which carry connotations of beauty, such as the butterfly, fragile and ephemeral or the peacock, triumphant and proud."[42]

Many of Chomón's films relish organic iconography of various types. Botanical design is prevalent in *The Magic Roses* (1906), in which a male sorcerer stands before a metal, sinuous frame decorated in olive and yellow foliage and dotted with pale blue flowers. He makes a bouquet appear and later turns some blooms into a huge vine that leaps onto the lattice to make a lush bower. The magician also conjures a woman who reclines on a seashell. Colorful floral imagery is also present in *The Living Flowers* (1908), which begins with "Chinese"[43] men picking yellow blossoms (see figure 1.3). Significantly, as Marketa Uhlirova points out, it was almost a "rite of passage" at this time for magicians to travel to the East.[44] Eventually, one of the flowers transforms into a woman who produces additional blooms (tinted light blue and pale green). They too morph into flower-women who dance and then exit the frame.

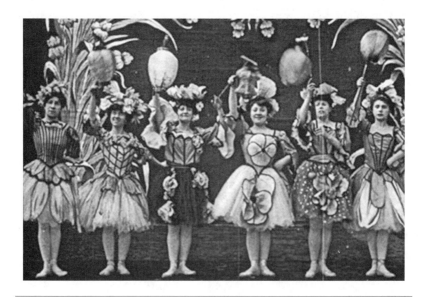

**1.3** *The Living Flowers* (1908, Segundo de Chomón) displays bold colors and a botanical theme.

It is interesting to note that many Art Nouveau creations featured combinations of women and flowers (in fused form). In speaking of the Decadents (who we have seen influenced the practitioners of Art Nouveau), Umberto Eco observes that what they loved in a woman was "the altered nature of her femininity." For Baudelaire, in particular, the "women of [his] dreams" were often "flower-wom[e]n."[45] This hybrid also appeared in numerous works of decorative arts, for instance in Maurice Bouval's "Obsession" and "Dream" candelabras (c. 1898) or of Auguste Flamand's "Poppies" lamp (1900).

The set for *Tulips* (1907) displays a beautiful arbor, tinted gold and green. A multicolored fountain appears in its black center, followed by a series of women who create lovely tableaux among the garlands. Eventually, abstract patterns fill the center of the frame, and finally some women in transparent capes materialize and dance.

We have already mentioned the seashell that appears in *The Magic Roses*. Yet another one can be found in *The Fantastic Iris*, again with a woman reclining on it. Interestingly, the nautilus shell (with its spiral curves) was a favored icon in Art Nouveau and was used, for example, as a shade for a Moritz Hacker lamp of 1900.[46] A further natural element is located in *Easter Eggs* (1907) starring Chomón's wife Julienne Mathieu, who appears before an elaborate frame of gold-olive hue. From it, she produces giant eggs that materialize into dancers (ranging from showgirls to ballerinas to butterfly-women). She then conjures more eggs from which several babies emerge. Here we think of the Russian branch of Art Nouveau and the famous House of Fabergé, known for its enameled and bejeweled eggs, some of which were shown at the 1900 Paris Exposition.

The title of *The Bee and the Rose* (1908) makes clear that insects as well as flowers populate the film. From a hive center frame, female bees (in striped costumes) emerge to dance around some blossoms. The queen bee appears, fluttering her wings. Eventually, a giant flower is turned into a rose-woman. The queen falls asleep and a spider weaves its web above her. More bees come to her rescue. *Japanese Butterflies* (1908) and *The Golden Beetle* (1907) meanwhile, also use the iconography of bugs (see figure 1.4).

Likewise, *Metempsychosis* features a butterfly (in the form of a woman) standing in the center of a modernist frame with wings transitioning

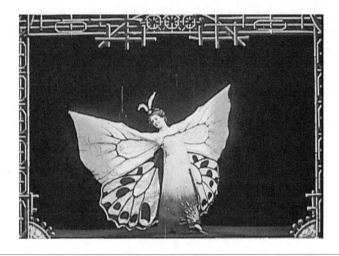

**I.4**  The focus in *Japanese Butterflies* (1908, Segundo de Chomón) on insect-women demonstrates Art Nouveau's love of Nature.

through numerous sumptuous colors and Art Nouveau fabric designs.[47] Here we should note that many Art Nouveau objects presented such hybrid human/insect forms, for instance a Lalique dragonfly/female brooch (1897–1898), Paul Berthaud's "Butterfly-Woman" vase (1900), and a sculpture by Louis Chalon (1900). Finally, Chomón's *The Gold Spider* (1909)—a more sophisticated multishot narrative—presents an arachnid that produces coins as it spins its web, and a fly that fabricates a butterfly. Significantly, insects are everywhere in other Art Nouveau forms—for instance, in a hornet brooch by Fouquet (1901);[48] a Daum Frères glass cup (1905) garnished with a bee;[49] and a dragonfly pin (1902) by Philippe Wolfers.[50] As for the latter creature, it is interesting to note that, in 1915, the Russian ballerina Anna Pavlova choreographed a dance called "The Dragonfly" (performed to music by Fritz Kreisler) in which she appeared in a gossamer-winged costume—evoking the insect/human creatures of Art Nouveau. She later trained as a sculptress and crafted a porcelain self-portrait of her role in the ballet.

It is not, however, until some five decades later that we find echoes of Chomón's and Pavlova's depictions of dancing insect/women in another

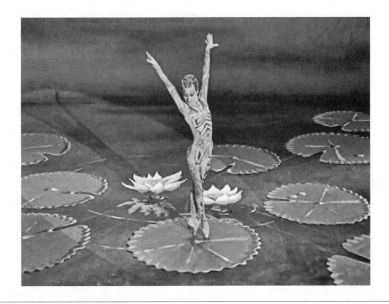

**1.5** Moira Shearer in *Tales of Hoffman* (Michael Powell and Emeric Pressburger, 1951) performs "The Enchanted Dragonfly" ballet.

film, specifically a scene from *The Tales of Hoffman* (directed by Michael Powell and Emeric Pressburger, 1951). There, Moira Shearer (as Stella) performs "The Enchanted Dragonfly Ballet" (see figure 1.5).

Rendered in lush Technicolor, the set (consisting of water, lily pads, and the moonlit sky) is overlaid with a dreamy Art Nouveau aura, as are the abstract costumes of Shearer and her male partner, Frederick Ashton (also dressed as a bug).[51] In this film the Art Nouveau insect world lives on.

## Woman

Extending his organic imagery, Chomón's films rely on the figure of Woman; and the female magician in *Easter Eggs* seems to validate an argument I made in 1979 that the trick film often draws on male envy of pregnancy and birth.[52] As previously noted, the image of Woman was an obsession in Art Nouveau. Such females could be perverse, as in Edvard Munch's lithograph *Madonna* (1895) or Giovanni Buffa's stained glass panel

*Medusa* (1900).[53] But in Chomón's work, they are generally benign (akin to those graceful females in Lalique vases and figurines, or in lamps by Émile Muller [1900], Charles-Émile Jonchery [1901], and Agathon Leonard [1903]).[54] Significantly, several posters for the Paris Exposition featured women—as in one by Georges Leroux (1900) for the Palace of Optics, displaying a lovely lady holding an illuminated electric globe.[55] In their benevolent incarnation, Art Nouveau women were often nude, but, if clothed, they wore flowing gowns (à la Loie Fuller).

Women's dress is also central in Chomón's films and, as Uhlirova observes, costumes "gained an unprecedented status . . . within productions that aimed at visualizing fantastical worlds, championing above all the power of unrestrained Imagination in achieving it."[56] She continues: "Both the féerie and the magic theatre embraced the visual impact of animated costumes . . . as a way to awe and unsettle [viewers]. Costume was frequently deployed as a phantasmagorical device, evoking the dark, supernatural forces of the baroque and romantic imagination such as ghosts, evil spirits, devils and vampires. Attired in voluminous veils, capes, cloaks or wings, actors produced sinister silhouettes of birds, dragons and bats by simply stretching out their arms."[57] In clothing its actresses, Pathé relied both on its own staff as well as theatrical designers like Maison L. Granier.[58] Of course, the function of costumes in Chomón's films was amplified by his chromatic sense. As Uhlirova notes, he had a sharp "understanding of how colour changes can help intensify the sensation of moving costumes."[59] Finally, costuming helped create the kind of opulent beauty that was another element of the "cinema of attractions." As Uhlirova remarks, "It is the splendor of costumes that often helps these [on-screen] women not only to dazzle but also to stun. . . . These are the first cinema women to purposefully employ artifice in order to 'cast the glamour' as a dual form of witchcraft and physical allure, to enchant and deceive the senses."[60] Thus, their costumes were "a 'screen' on which the emergent medium could parade its own possibilities and test spectatorial desire."[61]

As Rosalind Galt has noted, it is not surprising that women were favored subjects in Art Nouveau since, through the ages, females had been associated with ornamentation (a keynote of the style) and devalued for that connection.[62] As though to literalize this link, in *The Magic Mirror* (1908), a female magician opens a jewelry box and removes a series of

ornaments (a decorative belt and two tiaras), then conjures women directly from them. But (as mentioned in the introduction), there was also a positive valence to the bond between Art Nouveau and Woman, since the modernization of crafts in nineteenth-century France involved recognition of the central role that women had played in the creation and perpetuation of the applied arts.[63] Here we might also recall that it was largely females (of the working class) who hand-colored silent films.

Not only is Woman a pivotal figure in Chomón's work but, in contrast to her placement in Méliès's films, she is more frequently cast as a powerful magician, a role usually reserved for the male.[64] Hence she is invested with the kind of authority she holds in Art Nouveau design (whether positive or negative). We have already discussed female conjurers in *The Fantastic Iris, Easter Eggs,* and *The Magic Mirror,* but two more appear in *The Wonderful Mirrors,* where they are able to create both women and men. Some female wizards even triumph over their male counterparts, as in *The Red Specter* and *The Golden Beetle.*

## Orientalism

As previously noted, Art Nouveau was marked by rampant Orientalism—be the source Japanese, Chinese, or North African.[65] Ann Jackson, for instance, compares the style of an eighteenth-century Japanese sword guard with that of an 1897 Lalique buckle.[66] Clay Lancaster asserts that in the Art Nouveau porcelains of Sèvres and Royal Copenhagen we find nearly verbatim "the exquisite shapes of Sung, Ming and Ch'ing" ceramics.[67] Likewise, Francesca Vanke speaks of the influence of Persian swan-necked vases on ones created by Tiffany, and of the use of the Islamic arabesque in Art Nouveau architecture (e.g., the Paris Exposition's Porte Binet).[68] It is not surprising that such foreign touches were denigrated in Art Nouveau since, according to Galt, the cultures associated with ornamentation were often considered backward and inferior in comparison with the Western elite.[69]

*The Fantastic Iris* (1912) begins with an exotically dressed woman wearing "Arabic" garb parting a curtain to reveal a floral dell. She then reemerges from fern leaves and conjures a fountain and foliage. Soon a decorative frame descends above her (bearing whiplash curves resembling Arabic

letters) as an Oriental-style grill is shown. The film ends with a floral-female tableau as the lead actress closes the drapes.[70] We find another "Arab"[71] woman in *Easter Eggs*, and in *Ouled-Naid's Dance* (1902), a belly dancer whose movements mimic the sensuous swirls of Art Nouveau lines. Significantly, depictions of Salome, Salaambô, and the Sphinx were popular in the era (e.g., in the painting *Salome Dancing* [1874–1876] by Gustave Moreau, the sculpture *Salaambô chez Matho* [1900] by Théodore Rivière, and the canvas *The Caresses of the Sphinx* [1896] by Fernand Khnopff[72]). Finally, Arab conjurers appear in other Chomón films, for instance *The Golden Beetle* (1907).[73]

"Chinese" characters populate *The Living Flowers*, and *The Chinese Shadows* (1908) has an ornate, circular Oriental set from which "Chinese" women with parasols produce animated pictures. Alternately, Japanese imagery can be found in *Kiri-Kis* (1907), a trick film in which "Japanese" men do impossible stunts through a variety of cinematic techniques. Finally, *Japanese Butterflies* (1908) begins with an Oriental set as male and female magicians present a variety of illusions. Eventually, a drawing of a caterpillar transforms into a beautiful butterfly with olive-, blue-, and mustard-colored wings. It then morphs into a butterfly-woman and finally into a serpentine dancer whose flowing drapery is tinted in multiple hues.

## Magic and the Occult

While all of Chomón's films are self-referential by dint of their being fantastic, some have special significance in relation to the history of the occult. *In the Land of Gold* (1908) presents a magician that miraculously turns metal into gold. Significantly, one of the coins produced is an oversized version of a Spanish one from 1870 that depicts a reclining woman sculpted in Art Nouveau style. Beyond this formal element, in Chomón's nod to alchemy here we recall that, according to Urszula Szulakowska, "By the early twentieth century [the] superhuman image of the Renaissance alchemist and magician had been transferred onto the artist."[74] Thus, one might argue that in the wondrous images of *In the Land of Gold* Chomón not only turns base into precious metal, but "primitive" cinema into art. Here we also might recall that (as mentioned in the introduction), Roland Barthes found alchemical properties in photography—which, after all, is

the root of cinema—focusing on its employment of chemical processes and silver.[75] Alchemical references, of course, are only part of Chomón's broader focus on magic—a fact that squares with Catalan Modernisme's love of "marvellous ephemerality."[76]

But, as we have seen, it was not only the Spanish avant-garde that was interested in magic, it was the French as well—especially the Surrealists who championed Art Nouveau long after it was passé. André Breton was especially intrigued by alchemy, which he saw as a metaphor for poetic creation. As Jean Snitzer Schoenfeld has remarked, it confirmed his belief in "the potential for transmutation in everyday reality"—a notion relevant to the trick film (with its fiery regenerations and astonishing appearances from urns and crucibles).[77] According to Anna Balakian, alchemy also emphasized the female (a fact that ties it to the trick film and Surrealism). As she notes, "Woman, whose elements are fire and water in the hermetic cult, is said to be in closer contact with the motive-transforming agents of the universe. To love them is to be through her [sic] closer to magical power."[78] Balakian also argues for Breton's wider interest in magic:

> For André Breton, the modern Merlin of Breton descent, magic is inherent in all reality; it is in fact a condition of reality, and the concept and nomenclature of "magic" betray the fact that the normal character of nature has been mistaken for the supernatural. The principle of cause and effect is not an inherent law of the universe but an affectation of the mental limitation that man has imposed on himself. . . . Beneath the monotonous, regular processes that the rational mind applies to its environment, there is a secret chain of events.[79]

Thus we might ask: What else is the trick film but a denial of "cause and effect" logic, a narrative portraying a "secret chain of events"?

Several statements by Breton make his love of magic clear. In *Crazy Love* he proclaims that "convulsive Beauty will be veiled-erotic, fixed-explosive, magical-circumstantial or will not be"; and in the 1924 *Manifestoes of Surrealism* he states that "only the marvelous is beautiful."[80] In the same publication he bemoans the fact that "at an early age children are weaned on the marvelous, and later on they fail to retain a sufficient virginity of mind to thoroughly enjoy fairy tales."[81] In contrast, he asserts, "There are fairy tales

to be written for adults."[82] Perhaps trick films (and their sister genre, fée-ries) are precisely such works. In line with this interest, Surrealists were known for having championed the work of Méliès.[83] (Films by Chomón were less well known at the time.)

Here it would be well to return to one of the first works by Chomón that I ever saw, *The Red Specter*, which casts the magician as devil. As Émile Cailliet notes, "magic came to bind its fate to that of the Prince of Evil and Hades" and the idea of Satanism became "inseparable from that of magic."[84] Relevant too is literary Symbolism and the poetry of Charles Baudelaire in which "Satanism of the nineteenth century probed the very depths."[85] Finally, critics like György M. Vajda have linked Art Nouveau to "satanism and black magic."[86]

What immediately impressed me in *The Red Specter* was its glorious, antic, self-reflexivity. As previously mentioned, a poster for Edison's Vitascope depicts a movie projected into an old-fashioned picture frame (instead of onto a movie screen). Building on this, *The Red Specter* takes the trope a step further by combining cinematic special effects and live action. One

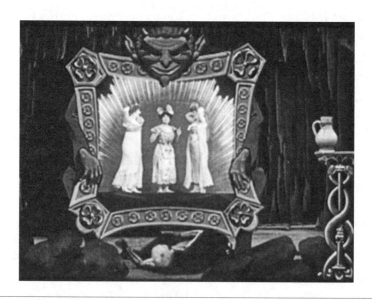

**1.6** In *The Red Specter* (1907, Segundo de Chomón), a devil-magician mattes moving images of women into an Art Nouveau frame.

sequence presents the devil standing before a picture frame posed on a serpentine, Art Nouveau pedestal. Initially, it displays a graphic image of the Pathé rooster (the company's trademark); then, at the hands of the fiend, panels are rotated and a motion picture image of a woman appears on the flip side. Another sequence depicts a more ornamental Art Nouveau picture frame into which other moving images of females are matted (see figure 1.6).

What is extraordinary about these moments is not only the creation of an apt metaphor for ties between cinema and painting, but the visualization of precisely what I am attempting to accomplish in this chapter—placing Chomón's filmic work within an Art Nouveau "frame."

## THE BARCELONA CONNECTION

We should recall that Chomón lived for a period of time in Barcelona—the most populous, industrialized, and sophisticated Spanish city of the time, and a hub of avant-garde activity. In fact, as William H. Robinson and Carmen Belen Lord note, "any understanding of modernist culture in Spain must begin with Barcelona."[87] As previously mentioned, Salvador Dalí (another Barcelona resident) was a champion of Art Nouveau and, throughout his essay on the topic (to be discussed in chapter 3), he singles out for praise his Catalan compatriot, architect Antoni Gaudí.

Interestingly, Gaudí, Chomón, Modernisme, and Art Nouveau ultimately come together in Barcelona in a venue seemingly unknown to many film historians—the Sala Mercè, a theater and experimental arts center designed by Gaudí in conjunction with painter Lluís Graner i Arrufí, which opened on November 3, 1904, in the Ramblas neighborhood and survived until 1913 (see figure 1.7).[88]

In 2002, its existence was highlighted in research by Antoni González. Only a few photographs of the space survive, but through computer graphics it has been "posthumously restored."[89] Significantly, the Sala Mercè's "spectacle hall" showed movies—even "sound films" with actors from playwright Adrià Gual's company speaking from behind the screen.[90] Gual was also a visual artist who produced works that conjoined Symbolism and Art Nouveau.

**1.7** A photograph of the Sala Mercè, an experimental theater designed by Antoni Gaudí that opened in Barcelona, Spain, in 1904.

With presentations at the Sala Mercè aimed at the cultured, urban bourgeoisie, films screened there included documentary portraits of Catalan artists and literary figures.[91] The spectacle hall was also used for "musical visions"—staged or recited texts written for the occasion, accompanied by music and set decoration.[92] Beyond this, the Sala Mercè aspired to Wagnerian notions of total art, the merging of music, theater, painting, sculpture, and dance.[93]

The theater was electrically powered, and its light bulbs were covered in colored gauzes that created "incandescent changing spotlights of different tones." The walls of the hall had a "rocky" texture and were tinted in "earth" and "cooked mud" hues. Press articles of the time likened the theater to a grotto, a frequent trope in Gaudí's architecture (as in columns in the Park Güell), and one that reminds us of later theoretical parallels asserted between the cinema and Plato's cave.[94] Interestingly, on the floor below the spectacle hall Gaudí built another space that was referred to as the "Fantastic Caves" or "Grottos." Here we recall that underground sites are favored locales of the trick film (e.g., in Chomón's *The Red Specter*).

According to Batllori, Chomón sometimes projected movies at the Sala Mercè—at least some of which were Pathé releases.[95] Thus in Barcelona's Sala Mercè, built when the pedestrian nickelodeon was the standard screening space of the day, cinema, Modernisme, and Art Nouveau coincided in a singular and unlikely fashion—a theater designed by Gaudí, sometimes staffed by Segundo de Chomón, and dedicated to a synthesis of the arts, including the new medium of film. While it is not clear whether Chomón projected his own movies there, they would have been a perfect complement to the space.

## THE THEATER AS ATTRACTION

Our discussion of the Sala Mercè reminds us that not only films but their *theatrical venues* could be an "attraction" to film patrons. The Sala Mercè earned this status by dint of its extraordinary architecture as well as its unique and experimental presentational mode. But few movie theaters erected when Art Nouveau blossomed had any ties to the movement—given that cinema was still in its infancy and its exhibition halls were modest buildings, often mere renovated storefronts. In the early years of film history, traveling cinemas were often set up at fairgrounds. At least one of these was built in the Art Nouveau mode—Jean Desmet's Imperial Bio Grand Cinematograph in the Netherlands. It made its debut in the summer of 1907 and sported a stylish Art Nouveau facade reminiscent of the architecture of Victor Horta. Not only was its exterior lavish but its interior surpassed the standards for other such mobile exhibition halls.[96]

As for permanent structures, one rare early Art Nouveau movie theater stood (and still stands) on a back street in Lisbon, Portugal: the Animatógrafo do Rossio. Opening on December 8, 1907, at 229 Rua dos Sapateiro, it was owned by the brothers Ernesto and Joaquim Cardoso Correia.[97] A small theater—its auditorium contained only twelve rows of seats with a screen mounted on a back wall—it had no foyer, and a simple curtain separated the auditorium from the entrance door.[98] It is on the Rossio's facade, however, that its "attraction" resides, in the form of panels of Art Nouveau Azulejos tile created by M. Queriol and Jorge Pinto. In typical fashion, they depict two women, hair entwined, surrounded by fruits and flowers.[99] Ornamental carved wood scrolls frame the tiles, theater sign, film posters, and other elements of the frontage. After showing

films for many years, the Rossio reopened as a children's playhouse and later as a dramatic theater for adults.[100] In 1984 the Portuguese Association of Filmmakers tried to have the Rossio named as an historic landmark, but did not prevail.[101] Since the 1990s the Rossio has reverted to a cinema—this time screening pornography and sexploitation movies.[102]

As the art of cinema matured and grew as an industry, the age of the "picture palace" eventually dawned and coincided with the development of the feature film. Unlike the Animatógrafo do Rossio, such theaters were large edifices (often seating thousands) that sought to create a plush and chic atmosphere for the average moviegoer. Many of the most famous were located in the United States—for instance, Los Angeles' Egyptian and Chinese Theatres, New York's Roxy and Radio City Music Hall, and Atlanta's Fox Theatre. While the architectural styles of these buildings were Moorish, Romanesque, Beaux Arts, Aztec, or Art Deco, few American movie theaters of any distinction were erected in the Art Nouveau mode (though I refer to news reports of some that were in chapter 3). Their absence is not surprising since most of the "palaces" were built in the 1920s and 1930s—well after the heyday of the Art Nouveau movement. Furthermore, as previously noted, the style met with resistance in the United States, so may have been shunned for projects of this kind. There is, however, a noteworthy American theater achieved in the Art Nouveau mode that, while originally constructed for stage plays, eventually housed a cinema: the New Amsterdam Theatre on West 42nd Street in New York City (Plate 7).

## THE HOUSE BEAUTIFUL

At the time it opened in 1903, the New Amsterdam was considered a building of major import—one that would "mark an epoch in the history of art."[103] It was so significant as to be written up in a 1904 issue of *Architectural Record*[104] as well as a 1908 volume of *New York Plaisance*, a copiously illustrated publication dedicated to entertainment spots in the city.[105]

The theater was owned by producers Marc Klaw and Abraham Erlanger, and conceived by architects Henry B. Herts and Hugh Tallant who had attended the 1900 Paris Exposition.[106] Many other artists (most of whom had studied in France) were engaged in the project: painters E. Y. Simmons and Robert Blum; sculptors George Gray and Enid Yandell; and

designer Albert G. Wenzel.[107] While the building's exterior was done in the Beaux Arts mode (with mere touches of Art Nouveau), its interior (whose decoration was overseen by F. Richard Anderson) took the latter style to extremes—creating a remarkable "attraction." As historian James Traub has remarked, "the New Amsterdam was intended to *dazzle* even the most blasé theater-goer."[108]

Deemed "The House Beautiful"[109] at the time of its premiere, the New Amsterdam was the only public space in the United States (theatrical or otherwise) whose interior was realized completely in the Art Nouveau idiom. As a *New York Times* writer observed upon its opening, "in the New Amsterdam, Art Nouveau, first crystallized in the Paris Exposition of 1900 is typified on a large scale in America."[110] Comparing it to old-fashioned venues, another *Times* critic, Charles De Kay, said that "to enter [the New Amsterdam] is to get a horror of the red plush effects that still linger at the opera and in many a theatre."[111] (Here, for once, the word "horror" was associated with retrograde rather than modernist décor.) The theater cost about $1.5 million to construct (equivalent to $39 million in today's dollars) and seated 1,702. One writer called it "a vision of gorgeousness" and evidence of the "New Art."[112] As he continued (highlighting the theater's status as visual spectacle), its appeal to the eye issued from "all that plastic art, sinuous line, and the blended harmonies of form and color."[113]

De Kay's piece offers a better picture of the theater's arresting design; and all its components scream Art Nouveau. He speaks of how "the line of the proscenium arch is accompanied by a chain of conventionalized peacocks modeled in relief by St. John Issing, a decorative motif repeated in the ceiling and elsewhere."[114] In particular, he praises the theater's "neutral" tonality, one associated with the palette of the "New Art."[115] It is "the most beautiful color scheme to be found in any theatre of the city. It is a silvery green ground with tender pinks, mauves, lilacs, red and gold produced by flowers either woven into the green stuffs of carpets, fauteuils and curtain, embroidered on textiles, or modeled on the wall. The result is a subdued yet gay effect, like a meadow in Springtime sowed with daisies, violets, and flowers of slightly stronger hues."[116] De Kay also describes in detail the theater boxes, which advance the theme of Nature: "Their fronts are treated separately by the decorator with a motif of a special flower for each. The lily, buttercup, violet, goldenrod, etc."[117] He conceives

the space in decidedly "feminine" terms, indicative of an Art Nouveau sensibility.[118] For him, it "caters especially to the fair sex" and constitutes "an assembly place for . . . maidens."[119] Furthermore, he states that "as a background for a gayly dressed auditorium of women, the color scheme . . . could not have been better chosen."[120]

It is noteworthy that De Kay (not a fan of modernism) praises the New Amsterdam since, in a section entitled "A Touch of L'Art Nouveau," he launches into a broad critique of the mode, mentioning its "senseless curves," "haphazard fantasticallity [sic]," and "grotesque decoration."[121] Clearly, for him, the New Amsterdam is an exception to the rule, and he admits that "little by little . . . the poorer things [about Art Nouveau in general] can be eliminated or remade."[122]

There are other Art Nouveau elements of the New Amsterdam's décor that De Kay does not mention, for instance, the arched mural above the proscenium designed by Blum.[123] It is a quintessential work of the movement with its swirling, entangled jumble of figures: nude women, animals (lions, deer), plants (vines, flowers, and tree roots), and theatrical personae (Greek men with lyres, a court jester). As Bruce Weber comments, an Art Nouveau influence is "reflected in Blum's strong accentuation of shape and outline, his reliance on symbolic content expressed with little regard for creating an illusion of depth in space. As was typical of Art Nouveau, the rhythmic, varied, placement of figures, flowers and other objects served to create several figure groups of different meaning. . . . Other stylistic links with Art Nouveau are the elongation of figures, the predominance of female types, and floral motifs."[124] Weber also observes that "here, as in works by other artists working in the Art Nouveau manner, ornament served to structure the composition."[125]

There are still more emphatic Art Nouveau features of the theater: the arched floral and avian constructions above the boxes; the wall sconces in the shape of female heads, crowned by electric lights; the ornate ceiling fixtures in the ticket lobby that Joel Lobenthal describes as "a fantasy in themselves";[126] the metal elevator doors with their flower and vine imagery and curvilinear patterns resembling those of Charles Rennie Mackintosh; the Grand Promenade ceiling adorned with lily, lotus, and diverse botanical emblems; the green glazed terra-cotta balustrades of the two staircases (designed by Thorbjorn Bassoe), embellished with plants, flow-

ers, abstract forms, and animals (as rendered by Blanche Ostertag); and, finally, the fuchsia ladies lounge redolent with roses, stems entwined. Even the design of the paper program that the New Amsterdam used for many years was indicative of Art Nouveau, with its muted color scheme, its floral borders, its natural scenery, its whiplash curves, and its female portraiture.

The Art Nouveau design of the building is extended in a second theater constructed atop the New Amsterdam and accessed by elevator. While many establishments had similar aerial venues, that of the New Amsterdam was grander and involved a full-size theater seating 600 and opening onto a rooftop garden.[127] The Art Nouveau aspects of the space included: a rose/green color scheme; a floral pattern in the proscenium and stage curtain; a peacock feather design in the orchestra rail; a whiplash curve scheme in the balcony rail; and a curvilinear botanical motif in the metal stair railing. The elevator facade depicted the same Mackintosh-inspired pattern as on its lobby counterpart, but above it was a different panel depicting an elaborate bouquet.

On opening night of the New Amsterdam Theatre the main stage offered a production of Shakespeare's *A Midsummer Night's Dream*, a work which, in its themes of romance, fantasy, and dream set in a woodland populated by female sprites, seems suggestive of Art Nouveau imagery. This is clear in a critic's description of the drama: "The stage was thronged with fairies beautiful in face and figure, beautiful in the richness and daintiness of their costumes. . . . Electric bulbs twinkled in endless profusion among the flowers and the woodland glade and Titania's bower were symphonies of soft light and subdued color."[128] Marking a parallel between the theater's conception and the play performed, another writer deemed the building "the most airy, fairy beautiful thing in the way of a playhouse that the New York public has ever seen."[129] This analogy was not accidental, as the architects had the atmosphere of Shakespeare's play in mind in planning the theater.[130]

## THE *ZIEGFELD FOLLIES*

From the perspective of Art Nouveau, one particular aspect of the theater's history is striking. Between 1913 and 1927, it was the home of the

*Ziegfeld Follies*, a stage revue (or "girlie show") initiated in the period when the movement thrived. As Heather Hester notes, Florenz Ziegfeld (its creator) "drew on ideas from the *Lebensreform* movement and the Art Nouveau style, both prominent in Europe from the late 1890s."[131] Similarly, Elizabeth Haas observes that "*The Ziegfeld Follies* offered a hybrid: high-brow artistic endeavor reflected . . . in the Art Nouveau sets . . . and near vulgarity evidenced by skimpy, even gaudy, costuming."[132] Beyond using the New Amsterdam's main stage, Ziegfeld renovated the building's rooftop facility into a dazzling nightclub to house his *Midnight Frolics* (1915–1921).

Much of the *Follies*'s mise-en-scène was crafted by Joseph Urban who started working with Ziegfeld in 1915,[133] and also designed the rooftop nightspot. Ziegfeld was first made aware of the set designer when he saw Urban's work in *The Garden of Paradise*.[134] Though Urban was initially wary of working for Ziegfeld, whom he associated with crass shows, he eventually was convinced to join his ranks.[135] No snob, he later stated that "you can make your fun and pleasure and your diversions artistic" in the same way as serious drama.[136] That the set designer's name became synonymous with Ziegfeld's revues is clear from the words of a writer who spoke (in punning fashion) of "the *urbanity* of the Follies."[137]

Urban hailed from Austria where he had been associated with the Viennese Secession. As Christopher Innes notes, the movement's influence can be detected in the "sensuous, sinuously flowing lines" of the designer's work.[138] Innes also observes that theatrical mise-en-scène, as an applied art, "allowed Urban . . . to bridge the gap between industrial draftsmanship and the 'fine arts' of painters and sculptors who populated the Art Nouveau . . . circles."[139] In Vienna, Urban had been a part of the Hagenbund artisan group formed in 1899 as "an offshoot or extension of the 1890s Art Nouveau."[140] According to John Loring, he was "a brilliant practitioner" of the style.[141] In light of this, in 1900 Urban was sent as an architectural delegate to the Paris Exposition.[142] As Loring observes, Urban's designs showed a "dazzling command of Art Nouveau, with its relentless affinity for the curvilinear and florid, coupled with neo-Medievalist tendencies. They also indicate a thorough knowledge of the work of architects of the Art Nouveau movement . . . whose accomplishments were contemporary with Urban's."[143] Loring talks, especially, of a children's

book that Urban illustrated (with H. Lefler—another member of the Hagenbund)—called *Kling Klang Gloria*, published in 1907.[144] As Loring comments, "The book is a Secessionist—Art Nouveau-Symbolist masterpiece containing many visual themes—the canopy of an overarching tree, outsized flowers, Byzantium-inspired patternings, colorful geometrics, gildings, ethereal formal gardens, cropped images—that would emerge in Urban's later stage designs."[145] In particular, Loring sees the book as influencing Urban's floral set for the *Ziegfeld Follies of 1915*.[146]

Traub singles out a spectacular set Urban created for the *Follies of 1917* that illustrates his aesthetic sense as well as his fascination with Oriental iconography. In truth, the scene Traub describes would not have been out of place in a film by Segundo de Chomón: "Urban created a Chinese lacquer setting, which dissolved in showers of Colored water, followed by three sets of crossed red and gold ladders. Sixty girls in Chinese costumes climbed up and down in unison while the ladder rungs glowed in the dark. . . . An opalescent backdrop was laced with what seemed to be thousands of pearls."[147] A *New York Times* critic of 1916 raves about another Urban set for the *Midnight Frolic*: "Even the most florid adjectives pale in attempting to describe Mr. Urban's radiant color combinations, but those familiar with his art will be able to imagine the beauty of the new background when it is stated in words that great crystal columns rise into bowers of gold, from which two huge orange transparencies are suspended, and back of all this . . . an empyrean blue sky."[148] That Urban's sets were attractions in and of themselves is clear from the words of a writer who said at the time that "the [*Follies*'s] audience which had come for frivolous entertainment was quite unconsciously absorbing the beauties of color and light, line and mass."[149]

Beyond a designer, Traub calls Urban a "cinematographer" (and, of course, he later was a motion picture art director). One can see the effect of his experience with Ziegfeld in Urban's work on the film *Beauty's Worth* (1922), directed by Robert G. Vignola and starring Marion Davies as Prudence—a sheltered Quaker girl who is invited to a fashionable seaside resort and becomes a modern fashion plate. Especially noteworthy are scenes in which she appears in a stage "charade" whose Orientalist sets by Urban and uncredited costumes look like ones that might have appeared on the boards of the New Amsterdam (see figure 1.8).

**1.8** A scene from *Beauty's Worth* (1922, Robert G. Vignola) picturing Marion Davies in a set designed by Joseph Urban.

Like those in *Beauty's Worth*, the costumes for the *Ziegfeld Follies* in this era were consonant with an Art Nouveau aesthetic. Here one thinks of the famous peacock outfit worn by "Dolores" in the 1919 edition of the *Midnight Frolic* (designed by Pachaud of Paris). Significantly, Dolores (born Kathleen Marie Rose) was an English working-class girl who had achieved fame as a stately model for British couturier Lucile (Lady Duff Gordon); she came to the United States in 1910 when the designer opened a shop in New York. Duff Gordon went on to be associated with Ziegfeld herself, starting to work for him in 1914. Though Lucile and Urban had a tense relationship, they collaborated on the *Follies* for five years—producing numerous Art Nouveau-inspired extravaganzas.

Even before working with Ziegfeld, Lucile's style was consonant with that mode. As historian Randy Bryan Bigham notes, "Romance was the keynote" of her idiom. Furthermore, words like *sensuous, foamy, flowing*, and *diaphanous* were frequently associated with her couture, and she herself used the term *shimmering transparency* to characterize it (Plate 8).[150]

Her fashions were also linked to the push toward sexual freedom en-
acted by the New Woman—a feature that would have endeared her to
Ziegfeld. For example, she shocked the world by creating provocative and
attractive lingerie. As she once noted, "I was particularly anxious to have
a department for beautiful underclothes as I hated the thought of my
creations being worn over the ugly nun's veiling which was all that the
really virtuous woman of those days permitted herself. So I started making
underclothes as delicate as cobwebs and as beautifully tinted as flowers."[151]
This aesthetic was also apparent in her famous tea gowns—flowing "at
home" robes known for their "ethereal, seductive simplicity" falling "in
sinuous folds from a classic high waistline and covered by a full, often
sheer wrap."[152] The fact that they were worn without corsets was seen as
making sexual encounters more feasible. Beyond its erotic allure, Lucile's
clothing fostered women's liberation. As a fashion critic of 1935 remarked,
"Bridging the gulf between simpering coquette and feisty flapper, [Lucile]
was creating for women an identity not just a frock. The Lucile label
reflected the evolving modern woman, one who desired feminine frills
but who demanded physical mobility, social freedom and . . . political
equality."[153] Clearly, Lucile's aesthetic was consonant with the tone of
sensuality and spectacle in the *Ziegfeld Follies*. Bigham describes the fol-
lowing costumes she created for numbers in the *Follies of 1917*:

> There were scenes like "A Girl's Trousseau," in which a bevy of fair sprites
> stepped through life-size Lucile fashion sketches in diminishing states of
> undress. . . . Lucy outfitted Cleopatra and her maidens in bejeweled semi-
> nudity for a romp on the Egyptian queen's barge. It was a full-on Lucile
> pageant in "Ladies of the World" when ten showgirls draped in the fine,
> flimsy fabric descended a crystal staircase. And in "Garden of Girls," florid
> females garbed by Lucy "in the glory of the posy they represent," blossomed
> through a trap door on stage, rising slowly into a white spotlight.[154]

He also mentions her creations for the "Episode of the Chiffon" and for
the "Arabian Nights" scene.[155]

As for a later edition of the *Follies*, a sketch in the archives of the Museum
of the City of New York shows a costume Lucile produced for Marilyn

Miller in the "Syncopated Cocktail" number of *Follies of 1919*, and it displays the loose, curving lines typical of Art Nouveau fashion.

The New Amsterdam mounted theatrical productions through 1937, the last being *Othello*. Significantly, among them were plays that eventually were adapted to the movie screen: *The Merry Widow*, *Madame X*, *Monsieur Beaucaire*, *Whoopee!*, *The Admirable Crichton*, *The Bandwagon*, *Ben Hur*, etc. Furthermore, many performers who had significant film careers also trod upon the boards of the New Amsterdam: Eddie Cantor, W. C. Fields, Will Rogers, the Astaires, Bela Lugosi, Bob Hope, George Murphy, Fred MacMurray, Allan Jones, Sydney Greenstreet, etc. Finally, as previously mentioned, set designer Joseph Urban went on to have a career in Hollywood between 1920 and 1931.

## MOVIE THEATER

In 1937 ownership of the New Amsterdam was transferred to Max Cohen who repurposed it as a movie theater. Significantly, the first film shown there was *A Midsummer Night's Dream*, a 1935 picture directed by William Dieterle and Max Reinhardt. It was the same title as the first drama ever mounted at the New Amsterdam Theatre back in 1903. Interestingly, aspects of the movie show the influence of Art Nouveau in set and costume design—not surprising since, according to Wilhelm Hortmann and Michael Hamburger, Reinhardt's "zest for experimentation was boundless."[156] Specifically, an Art Nouveau sensibility attends to the magical sequences that take place in the forest—with art direction by Anton Grot, costumes by Max Ree, and choreography by Bronislava Nijinska. As Reinhardt once said of the play, "In the beginning was the wood."[157]

However, before the studio-shot forest scenes begin, there is a series of documentary images of nature (a hallmark of Art Nouveau)—trees, flowers, clouds, deer, owls, frogs, waterfalls. Gradually, onto a misty woodland scene, luminous fairy maidens appear, superimposed over the foliage wearing white, gauzy robes. A tree is enveloped in a "whiplash curve" of mist, up which the sprites parade (see figure 1.9).

They also periodically fly through the air, reminding us of the many winged females in Art Nouveau iconography (especially the butterfly-

**1.9** A scene from *A Midsummer Night's Dream* (1935, William Dieterle and Max Reinhardt) in which sprites parade up a tree enveloped in a "whiplash curve" of mist.

dragonfly-women). Soon Titania (the fairy queen) appears, as does Oberon (the fairy king)—whose black outfit contrasts with her white. The entire forest sparkles in soft focus. Evidently, cinematographer Hal Mohr used Vaseline filters on the camera lens and shot through sequined diffusion frames designed by Ree to achieve this effect.[158]

Representing more baleful aspects of Art Nouveau, troll figures and bat-men populate the woods as well. Indicative of Art Nouveau, these scenes take place in a site of desire, dream, and illusion; and a natural object (a plant) is the means by which the lovers are tricked into adoring the wrong partners (Titania, a donkey [instead of Oberon] and Lysander, Helena [instead of Hermes]).

Significantly, Max Reinhardt had previously produced *A Midsummer's Night Dream* on the stage some twelve times and had directed a spectacular production of it at the Hollywood Bowl in 1934. In discussing a 1913 version he mounted in Berlin, Hortmann and Hamburger observe, "Under the influence of Art Nouveau the magical forest . . . assumed human shape."[159] Similarly, the *Encyclopedia Britannica* entry on Reinhardt states:

He was a true eclectic whose more than 500 productions represented virtually every style. . . . Believing that the director must control every facet of a production, Reinhardt worked closely with his designers. . . . After beginning with a three-dimensional, drab naturalism, he adapted the abstract solids that [Adolphe] Appia had inspired and later applied surface decoration derived from contemporary art movements such as Art Nouveau, the Vienna Sezession [sic], and Munch's Expressionism.[160]

By the end of the New Amsterdam's life as a movie theater it had radically deteriorated (as had many such properties on 42nd Street). Its original color scheme was lost as its interior was painted chocolate brown to reduce reflection from the screen; its gorgeous floral boxes were eliminated in order to facilitate Cinemascope projection. The movies shown there were mostly B pictures on double bills; it never, however, became a "porno house."

In the late 1970s, efforts began being made to award the New Amsterdam landmark status. In 1979 it received that ranking from New York City, and in 1980 it was added to the National Register of Historic Places. Despite this, the theater closed in 1982 and stood empty until 1994. Toward the end of that period, the Walt Disney Company began looking for a new theatrical venue in New York City to house their staged musicals and became interested in the New Amsterdam. Ultimately, in conjunction with the Port Authority, New York State, and New York City, Disney launched a renovation of the space. It ultimately cost some $34,000,000 to accomplish an "interpretative renovation" that restored the theater to its 1920s appearance.[161]

Fittingly (since its savior was the chief executive officer of a film company), the New Amsterdam reopened in April 1997 with the screening of a movie—Disney's animated feature *Hercules*.[162] And indeed it had been a Herculean task to bring the theater back to its Art Nouveau glory. Beyond the spectacular Disney productions that are now presented there, the theater itself is an attraction. Tours are given daily and a "biography" of its life and times has been written by Mary C. Henderson and published by Hyperion.

# CHAPTER 9

## Art Nouveau and American Film of the 1920s

PRESTIGE, CLASS, FANTASY, AND THE EXOTIC

While there was evidence of the Art Nouveau style in "primitive" film, its influence was not truly felt until the 1920s. Ironically, this was when the popularity of the movement was in decline; but cinema tended to be "behind the curve" in this regard. Despite Art Nouveau traces in several silent features, it was by no means a dominant trend in either costume or set design. Nonetheless, it is important to highlight the works in which it does appear and to analyze the narrative, thematic, industrial, and ideological reasons for its presence.

Not surprisingly, a perusal of American newspapers and trade publications of the era unearths few references to Art Nouveau within the context of cinema. The term does come up repeatedly in *Variety* ads for Fredericks Scenic Studio in New York City, which offer "Cretonne, Art Nouveau, Futuristic, Plush Satin and Velvet Drops."[1] It also surfaces in a film review from June 1918 in *Moving Picture World* that mentions a movie set that includes an "art nouveau boudoir done after the manner made famous by Alphonse Mucha."[2] Furthermore, the term emerges (in a negative fashion) in a celebrity piece about actress Olga Petrova that states, "In spite of her enormous income, Olga Petrova does not care for ostentation. It is the fine things in life, not the expensive things which appeal to her. Her Christmas will be spent *not* on an enormous estate with a showy house, copied from an old castle or *furnished with ultra-modern nouveau art embellishments,*

but in a simple seven-room cottage."[3] A similarly pejorative valence at-
taches to the term in a column about actor King Baggot whose fine acting
is said to *avoid* "die-away [and] lounge-lizard art nouveau effects."[4] But
the term's application to the screen world is largely absent.

## AN AMERICAN ART CINEMA

When Art Nouveau surfaces in the American film context, it does so in
relation to discussions of the comparative reputations of US versus Euro-
pean cinema. Starting with the release of Giovanni Pastrone's *Cabiria* in
1914, Continental film became known for producing lavish, inventive ep-
ics that upstaged US productions. Writing in the *New York Times* that year, a
critic notes that *Cabiria* had been such a success that it was the first picture
to play uninterrupted on Broadway for three months with a dollar ticket
price (high for the time).[5] Even seven years later (during its revival in
1921), the *Times* column "The Screen" described it as a "cinematographic
sun on the motion picture world," and opined that "in some of its particu-
lars [*Cabiria*] has never been equaled and in others it has never been sur-
passed."[6] Interestingly, the article remarks that only recent German films
could approach *Cabiria*'s majesty—thus citing another foreign tradition.

There were other impressive European epics made in this period—
though lesser-known—including *L'Atlantide* (1921), a three-hour French-
Belgian extravaganza directed by Jacques Feyder. Filmed in the deserts of
Algiers, it concerned a mysterious and ageless queen (played by Stacia Na-
pierkowska) who rules the hidden kingdom of Atlantis, murdering all
men who come under her spell. While *Cabiria* failed to show an Art Nou-
veau influence, *L'Atlantide* did—as attached to the queen's Oriental domain:
her flowered costume, as well as the curvilinear background and patterned
walls of her lair. Its poster by Italian illustrator Manuel Orazi is ultra-Art
Nouveau and promises more, in that regard, than the picture delivers (see
figure 2.1).

In 1924, noting the competition from the European art film, George
McAdam writes in the *New York Times* of "a flurry, almost a panic, among
American photoplay producers . . . because of a threatened invasion of
the home market by European producers."[7] Of course, Hollywood had
nothing to worry about economically in relation to European cinema (de-

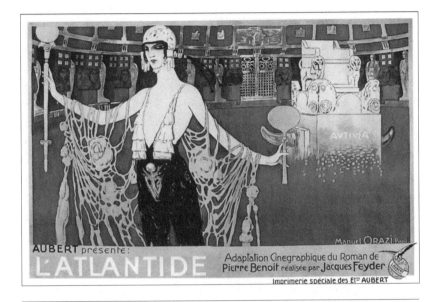

**2.1** Art Nouveau poster for *L'Atlantide* (1921, Jacques Feyder) designed by Manuel Orazi.

spite Germany's status as its greatest rival). In fact, throughout the 1920s the European film-producing nations tried to fight US hegemony in order to survive. In 1926, for instance, Martha Gruening writes in the *Times* about their organizing a "revolt against our films."[8]

But it was perhaps a slight to the pride of American producers that their films were viewed more as commerce than art. In 1922 Benjamin De Casseres writes pejoratively in the *Times* of how the "two outstanding features of the American motion picture have been . . . [the] total absence of epical and poetic imagination," concluding that "the American mind is not imaginative."[9] Moreover, he sees American film as entirely formulaic. On the other hand, he notes the artistry of *The Cabinet of Dr. Caligari* (1920), commenting on how "this astounding product of motion picture has jolted the average American motion picture mind more than all the other foreign pictures combined." He continues: "No American producer would have dared it. But its influence is already apparent in some of the pictures we are making."[10]

## DeMille, Iribe, and the Urban Melodrama

Given De Casseres's hopes for an American art cinema, it is noteworthy that both Sumiko Higashi and Robert Birchard[11] have mentioned Art Nouveau elements in works directed by Cecil B. DeMille (e.g., *The Cheat* [1915], *Male and Female* [1919], and *The Affairs of Anatol* [1921]). This is not surprising, given that DeMille's secret for success was reputedly "sex, sets, and costumes."[12] Hence, Art Nouveau was used to add a sense of wealth, trendiness, and visual allure to rather conventional dramas. The style of DeMille's lush Jazz Age movies stood in contrast to his earlier realist mode—logical given that an amplification of artistry often leads to a minimization of verisimilitude. In *Male and Female* (with production design by Wilfred Buckland) we discern an Art Nouveau touch in a scene in which actress Gloria Swanson reclines on an ornate, curvilinear bed. We also sense it in the film's costumes (designed by Clare West, Mitchell Leisen, and Paul Iribe). Central here are moments in which Swanson is pictured

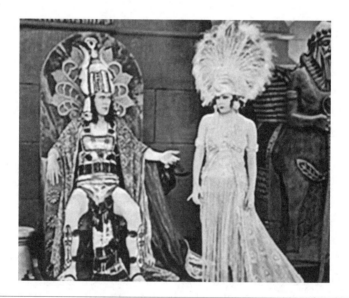

**2.2** Gloria Swanson pictured in an ornate costume in an imaginary scene from *Male and Female* (1919, Cecil B. DeMille).

in cutting-edge contemporary outfits, as well as in imaginary scenes (illustrating an ancient Babylonian legend) (see figure 2.2).

According to Deborah Nadoolman Landis, Leisen had a whole crew working on the pearl gown and headdress that Swanson wore in this sequence.[13] Even some advertising posters for DeMille films of this period evince Art Nouveau features (e.g., those for *The Cheat* and *Adam's Rib* [1923]). Similarly, his title cards often sport Art Nouveau borders.

Particularly interesting was Paul Iribe's collaboration with DeMille, since Iribe was a French illustrator and designer of an avant-garde bent. In Paris, he had been hired by couturier Paul Poiret in 1908 to create an album of the designer's creations that served as both catalog and art book. In it, Iribe pioneered the use of the pochoir technique that involved using bold coloration. Earlier, Iribe had collaborated with Jean Cocteau on the magazine *Schéhézade*.[14] In general, Iribe came to be known for transitioning the Art Nouveau style into a Deco aesthetic—the line between the two notoriously difficult to demarcate (as is the case with some of DeMille's work).

But perhaps DeMille's most interesting movie from this perspective is *The Affairs of Anatol*, on which Iribe served as art director (this is noted in an opening title, lending prominence to his name and reputation). Though Iribe is not officially credited, he also designed the film's costumes (along with Clare West). The movie (which broke box-office records upon its Los Angeles premiere)[15] concerns the marriage of a wealthy, newlywed, urban couple, Anatol (Wallace Reid) and Vivian (Gloria Swanson) Spencer. Anatol is prone to rescuing young women in distress and becoming overinvolved with them (though we never see him willfully "cheat"). Nonetheless, he spends a great deal of time away from home—giving the appearance of philandering. Vivian is displeased at this behavior but long-suffering. An intertitle states: "You got to keep your temper if you want to keep your husband." The first woman who piques Anatol's interest in the film is Emilie (Wanda Hawley), whom he knew years back as an innocent girl. She is now a performer "kept" by the elderly, rich theatrical backer Gordon Bronson (Theodore Roberts). Anatol tries to reform her, but to no avail and, to make matters worse, she falls in love with him. When he realizes that she remains beholden to Bronson, he trashes her apartment and storms out. He soon becomes disgusted with the entire "hypocritical [city]

crowd" that he and Vivian circulate in and suggests to her that they so-
journ in the country. She is unenthusiastic and wary of the "milk maids."
Sure enough, Anatol finds another woman to redeem there, this time a
farmer's wife, Annie Elliott (Agnes Ayres), who attempts suicide after
revealing that she has stolen church funds to buy herself fashionable
clothes. Anatol rescues her from the river, but when his wallet drops from
his jacket, she steals it. Vivian, who has gone in search of a doctor for the
woman, returns just as she is kissing Anatol. Vivian leaves for the city in a
huff and Anatol realizes that he has been duped by the country woman.
When Anatol returns to the city late that evening, he finds Vivian out on
the town. Deciding to entertain himself, he goes to a famous rooftop café
where Satan Synne (Bebe Williams) performs a tableau vivant entitled
"The Unattainable." She gives him a card identifying the address of "The
Devil's Cloister"—her apartment. Even though he assumes she is a vamp
(she wears a perfume called "Le Secret du Diable," after all), upon her re-
quest he lends her $3,000. He later learns that she is really the devoted
wife of a hospitalized World War I veteran who requires money for his doc-
tor bills. After the two drink absinthe (a substance banned in the United
States in 1915), Anatol goes home to find that Vivian has stayed out all night
with their friend Max (Elliott Dexter). When she returns, Anatol jeal-
ously condemns her conduct, but she boldly asserts the right to behave as
he does. Soon, the couple makes up—ostensibly wiser for their troubles.

Given the setting of the film (the world of the metropolitan upper
class), it is not surprising that it draws upon an Art Nouveau aesthetic—
an avant-garde style available mostly to those with funds for pricey fash-
ion and home décor. For Higashi, DeMille's films often advance "com-
modity fetishism" in keeping with an era in which the Modern was
associated with consumer culture.[16]

We immediately sense the role of aesthetics in the film with its open-
ing title, colored by the Handschiegl process (and many intertitles to fol-
low are similarly adorned).[17] Numerous scenes are also tinted in diverse
tones (amber, bronze, and blue). Here, of course, we note the import of
hue in the Art Nouveau movement. From the moment we see the Spen-
cers' apartment, we find it replete with Art Nouveau touches. (Higashi de-
scribes the style as outré, which gives a sense of its outlandish nature.)[18]
There is a floral-patterned, Japanese-inspired screen that leads to Vivian's

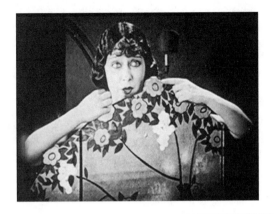

**2.3** Vivian (Gloria Swanson) peers out from behind an Art Nouveau screen in *The Affairs of Anatol* (1921, Cecil B. DeMille, with art direction by Paul Iribe).

bedroom. When we get a glimpse inside, we see her maid tending to her, but only see Vivian's foot poking out from another flowery screen. A few moments later, Vivian coyly peers out from behind a third screen—one that is curvilinear and ornamented with foliage (see figure 2.3.). Here, as ever, Art Nouveau is associated with Nature and the seductive Feminine.

There are other less dramatic or noticeable Art Nouveau elements in their flat: a floral lamp shade, a chair, and a stained glass circular window. When the couple ventures to a nightclub ("The Green Fan"), its stage is fashioned in an Art Nouveau style, which is all the more evident in closer shots of Emilie and Anatol dancing together against a Maxfield Parrish-inspired backdrop (see figure 2.4).

That evening, as Emilie confesses to Anatol that she has been "dazzled" by Bronson's "fairytale of wealth," we cut to an Art Nouveau-inspired image (either a flashback or imaginary scene) of her sitting on an ornate, floral swing next to her benefactor. Furthermore, she shows Anatol some of the jewels that Bronson has given her, including a floral gemstone necklace.

For the requisite Orientalist touch, we have Nazzer Singh, Hypnotist (Theodore Kosloff), who appears at a tea to which Vivian has taken her husband. Singh puts Vivian in a trance, asking her to imagine that she is

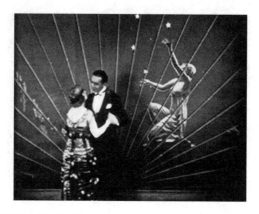

**2.4** Emilie (Wanda Hawley) and Anatol (Wallace Reid) dance in a nightclub against a Maxfield Parrish-inspired backdrop in *The Affairs of Anatol* (1921, Cecil B. DeMille, with art direction by Paul Iribe).

wading in a stream (her fantasy is visualized on the screen). Anatol, however, becomes upset when Vivian takes off her shoes and stockings, thus "undressing" in public. Similar to the Spencers' apartment, the tea room contains small background details that bespeak the Art Nouveau style: a modernist vase, for instance, is seen behind Anatol as he converses with an acquaintance.

The country sequence constitutes an Art Nouveau-free zone, as one might expect—suturing the association of the mode with urban space (despite its reliance on Nature as icon). But when Anatol returns to the city and meets up with Satan Synne, the style reappears with a vengeance. There is her boudoir, with its batwing vanity mirror, as well as a second room that is similarly adorned (see figure 2.5).

Furthermore, there is her curvilinear bed (under which she keeps a tiger). But most excessive is her octopus headdress, gown, and cape, which reminds us that this sea creature (with morose overtones of strangulation) sometimes figured into Art Nouveau jewelry, as in brooches by Wilhelm Lucas von Cranach and Louis Aucoc, both from around 1900.

Other modernist outfits appear in the film, including the ones that Emilie wears in the "fairytale of wealth" sequence, and later at a party at

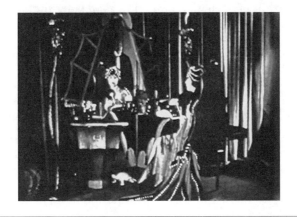

**2.5** Satan Synne's (Bebe Williams) sinister boudoir in *The Affairs of Anatol* (1921, Cecil B. DeMille, with art direction by Paul Iribe).

her house. Striking as well is a dress worn by a woman at the rooftop club that Anatol visits, and the club's floral wall covering. Within the Exotic realm, nothing competes with the ensemble worn by Satan Synne's maid who is dressed like an Egyptian slave (Art Nouveau's Egyptomania being well documented). Finally, there is the dramatic dress worn by Vivian on her return home after her night out with Max; otherwise her attire is ultrastylish but sedate.

What fashion and décor in the film reveal is that the mark of Art Nouveau attaches *selectively* to women (or the space that they inhabit)—a point I made regarding Art Deco in *Designing Women: Cinema, Art Deco and the Female Form*.[19] Of course, this is logical since Art Nouveau was deemed a "feminine" style, but (as we have seen) it was also a controversial one, sullied by associations of excess and decadence. As Rosalind Galt has noted, there is a "link[age] of the depraved woman with . . . Jugendstil."[20] To one degree or another, females in *The Affairs of Anatol* are "questionable" figures, a fact that underscores Higashi's point that in DeMille's Jazz Age films "set decoration and costumes provide a more reliable sign of personal ethics" than other aspects of the text.[21] When introduced, Emilie (a rich man's mistress) is labeled as "a bobbed-headed Jazz Girl," and Satan Synne's name says it all (despite the fact that her devilish behavior is revealed

as an act). While, in general, Vivian is a good wife, she is a pampered, superficial socialite (who publicly undresses in a trance), and her most modern gown is worn on the one night that she defies marital propriety and stays out with another man (albeit a platonic companion). Hence, there is some ambiguity to the women's characterization throughout.

In sum, DeMille and Iribe's *The Affairs of Anatol*—a sophisticated, light, urban melodrama—is a most appropriate film for employing an Art Nouveau aesthetic. The style embellishes and modernizes the storyline, while drawing on the movement's association of Woman with (at worst) dissipation and (at best) extravagance.

### Nazimova, Rambova, Beardsley, and the Experimental Film

One of the strongest and most obvious specters of Art Nouveau in American silent cinema can be seen just a year after *The Affairs of Anatol* in *Salome* (1922), a production whose driving force was the actress/producer Alla Nazimova— an early champion of the art cinema. As she stated in *Motion Picture Story Magazine* in 1912, "Mark me . . . in an incredibly short time every stage artist, no matter of what renown . . . will be appearing before the lens and shutter, for they will realize that only by so doing will they be able to make any enduring mark upon the artistic scrolls of their time."[22] Some five years later, she reiterated the point. As her interviewer Lillian Montayne wrote in *Photoplay Classic*, Nazimova "talks of creative principles as serious as does the sculptor, painter or composer. She actually calls [cinema] an art."[23] Not surprisingly, the press often referred to Nazimova as an "aesthete."[24]

A collaboration with costume and production designer Natacha Rambova, *Salome* was an experimental work that not only announced itself as art cinema, but drew directly on Art Nouveau aesthetics. At one point Nazimova even said that she conceived it "in the style of the Russian ballet."[25] But it was most indebted to Oscar Wilde's play and the Aubrey Beardsley illustrations that accompanied its 1894 publication.

Born Mariam Edez Adelaida Leventon in 1879 to a Jewish family in Yalta, Nazimova established herself as a renowned actress in Russia, appearing at the Moscow Art Theatre, gaining fame for her portrayals of Ibsen's heroines (Nora in *A Doll's House* [1897], Hedda in *Hedda Gabler* [1890], and

Hilda in *The Master Builder* [1892]). In 1905, she immigrated to the United States and appeared in Russian-language theater productions. In 1910 she took over the Thirty-Ninth Street Theatre, which was renamed the Nazimova. She later appeared on stage in works like Anton Chekhov's *Cherry Orchard* (1928) and Eugene O'Neill's *Mourning Becomes Electra* (1931).[26]

In the late 1910s she turned her eye to cinema, wanting to transform it into a serious medium (versus a popular amusement). Working under contract with Metro Pictures Corporation between 1917 and April 1921, her company, Nazimova Productions, produced seven feature-length films: *Eye for Eye* (1918), *The Brat* (1919), *Stronger Than Death* (1920), *The Heart of a Child* (1920), *Madame Peacock* (1920), *Billions* (1920), and *Camille* (1921).[27] In 1921 she decided to partner with United Artists—the organization founded in 1919 by Hollywood royalty (Charles Chaplin, Mary Pickford, Douglas Fairbanks, and D. W. Griffith). Her first project there was an adaptation of *A Doll's House* (1922, directed by Charles Bryant), in which she played the lead part; unfortunately, it has been lost.

Her second venture *Salome* (the film we will analyze) also had literary roots—and was a work in which she would again star. Official directorial credit for *Salome* was given to her common law husband Charles Bryant, but scholars uniformly deem her the film's auteur. She also wrote the screenplay, signing it as Peter M. Winters. Relating the film to contemporary Continental cinema, one critic remarked that "following on the success of the 'artistic' European films and experimental avant-garde productions . . . *Salomé* was the boldest, and most expensive American attempt in stylization" (the last term a code word for Art Nouveau).[28]

Oscar Wilde wrote *Salome* in Paris in 1891, while associating with the Symbolist, Aesthetic, and Decadent groups (which, as we have seen, had ties to Art Nouveau). In 1893 the drama was published in French, and an English translation followed in 1894 with illustrations by Aubrey Beardsley. The nature of those drawings outraged some. A writer for *The Times* described them as "fantastic, grotesque, unintelligible . . . [and] repulsive . . . portrayed in the style of the Japanese grotesque as conceived by a French *decadent*."[29] A London stage premiere was planned for 1892 with Sarah Bernhardt in the lead part. However, rehearsals were halted when the Lord Chamberlain's licensor of plays banned it for portraying biblical characters on stage. The drama was eventually performed in Paris in

1896, but, by then, Wilde was imprisoned in an English jail, having been convicted of the crime of sodomy in 1895.

The biblical tale of Salome concerns the daughter of Herodias and step-daughter of Herod Antipas, tetrarch of Galilee (a region in Palestine):

> According to the Gospels of Mark (6:14–29) and Matthew (14:1–12), Herod Antipas had imprisoned John the Baptist for condemning his marriage to Herodias, the divorced wife of his half-brother Herod Philip (the marriage violated Mosaic Law), but Herod was afraid to have the popular prophet killed. Nevertheless, when Salome danced before Herod and his guests at a festival, he promised to give her whatever she asked. Prompted by her mother, Herodias, who was infuriated by John's condemnation of her marriage, the girl demanded the head of John the Baptist on a platter, and the unwilling Herod was forced by his oath to have John beheaded. Salome took the platter with John's head and gave it to her mother.[30]

Nazimova's interest in *Salome* seems logical since, according to Petra Dierkes-Thrun, the character "has much in common with Ibsen's Nora Helmer, Hedda Gabler and Hilda Wangel."[31] Furthermore, like several of those protagonists, Salome has a "markedly decadent or perverse streak."[32] In fact, she is a femme fatale (a kind of vamp), one of the central female tropes of the silent era. As Inga Fraser notes, "Of all the historical and mythical" women of this kind, "it was Salome that, with her perverse eroticism, became the most widely exploited stereotype."[33] We are not surprised by Fraser's assessment, given the overtones of castration in Salome's decapitation of John. Since the film was made in the 1920s, a strong female figure (though generally understood more benignly) would also resonate with the New Woman and Jazz Age flapper. (Gavin Lambert claims that during the production of one of Nazimova's films, she sat in a chair labeled "Jazzimova.")[34] The story of Salome also spoke to the era's obsession with Orientalism, offering ample opportunity for exotic visual elements. Because it was to be an independent production, Nazimova committed $250,000 of her own funds to the project. Ultimately, the film cost $350,000 and, because it was financially unsuccessful, she never recouped her investment.[35]

Scholars consider the film a very faithful adaptation of Wilde's text, one that embraced the author's homoerotic subtext (though censors cut a scene suggesting a romantic relationship between two soldiers).[36] One reviewer, for instance, remarked on the "effeminacy" of the male cast.[37] Similarly, Lambert refers to the film's "hallucinatory ambisexual costumes."[38] That Nazimova preserved the work's queer theme is understandable, given that she was bisexual.[39]

In general, critics of the era praised the consummate artistry of Salome's mise-en-scène, with one noting "the screen is all the while filled with vivid beauty, animated by costumes outré and bizarre . . . yet richly endowed from a keen and splendid imagination."[40] Another opined that it was "the most extraordinarily beautiful picture that has ever been produced."[41] Credit for its visual magnificence is given to production and costume designer Natasha Rambova (wife of Rudolph Valentino and reputed lover of Nazimova). Born Winifred Kimball Shaughnessy in Salt Lake City, Utah, in 1897, she was a dancer who toured with the company of Theodor Kosloff (a former member of the Ballets Russes), sometimes designing costumes for them. When Kosloff (also her lover) was hired by DeMille (he played the hypnotist in *The Affairs of Anatol*), she came to Hollywood with him. She served as a designer on DeMille's *Why Change Your Wife?* (1920) and then encountered Nazimova on the production of Ray Smallwood's *Billions*.

The two later collaborated on *Camille*, a film that gives early evidence of Rambova's talent. Visually striking, it displays elements of Art Nouveau, though they are formulated in a more geometric fashion typical of Art Deco. (Lambert says that it was the two women's first attempt to "bring the European art film to Hollywood.")[42] The movie's hybrid iconography is apparent in the home of Marguerite (Nazimova), with its curvilinear forms, female decorative icons, and floral motifs. But a purer Art Nouveau aura attaches to Marguerite's outfits, as well as to other elements of the décor (e.g., a flowery curtain) (see figure 2.6).

One of the film's early intertitles makes clear the cultural linkage between Woman and embellishment, as it deems Marguerite "a useless ornament" (as critics labeled the creations of Art Nouveau). But, Woman is also associated with more pernicious elements in the film, like the spider's web, another image favored by Art Nouveau designers for its

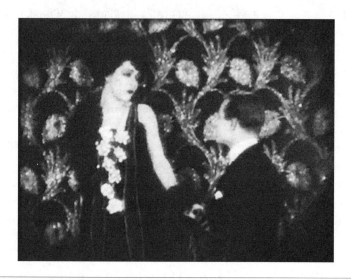

**2.6** Marguerite (Alla Nazimova) wears a flowery dress and stands against a floral background in *Camille* (1921, Ray C. Smallwood).

morbidity as well as its delicate, intricate lines.[43] In general, such modernist imagery in cinema (as I have argued in *Designing Women*) attends to perilous, sexually liberated women who live beyond the restraints of bourgeois morality. In the case of *Camille*, the heroine is also consumptive, which gives her even more of a dissipated mien. Significantly, for the film's publicity stills (as well as those for the later *Salome*), Nazimova hired Arthur Rice who created images that would become archetypal modernist glamour shots. As David S. Shields notes, Nazimova "was the one person in Hollywood who had firsthand knowledge of his ability."[44]

Rambova's primary source for the art direction of *Salome* was the avant-garde, Japanese-inspired illustrations of Beardsley (who is credited in the film). In fact, his drawings had already influenced the design of Nazimova's first costume in *Camille*.[45] The utilization of Beardsley graphics for *Salome* directly tied the production to Art Nouveau since that aesthetic characterized the artist's work. What is especially interesting about this linkage (given Nazimova's earlier performances of Ibsen's plays) is that Walter Benjamin (discussed in the introduction) pointedly associates Art

Nouveau with that writer. As he states, "In Ibsen, Jugendstil produced one of the greatest technicians of the drama."[46] He sees *The Master Builder* (1892) as, in fact, "tak[ing] the measure of 'the style.'" Speaking of its protagonist, the architect Solness, Benjamin asserts, "The consequences of Jugendstil are depicted in Ibsen's *The Master Builder*—the attempt by the individual on the strength of his inwardness to vie with technology leads to his downfall."[47] Furthermore, Benjamin sees Ibsen as "pass[ing] judgment on [Jugendstil's] female type" in his plays; thus, Hedda Gabler "is the theatrical sister of those *diseuses*[48] and dancers, who in floral depravity or innocence, appear naked, and without objective background on Jugendstil posters."[49] Benjamin even names Wilde and Beardsley as both portraying "depraved" women who stay "clear of fertility," who "don't sleep with their men."[50] While Benjamin views Ibsen as critiquing both Art Nouveau and the liberated female, Nazimova seems to have had a different interpretation of his work—embracing, as she does, modernism and the New Woman. Among the three strains of Jugendstil that Benjamin names in his discussion of the movement is that of Emancipation (in addition to the Perverse and the Hieratic).[51] However, he tends to focus on the latter two, while Nazimova seizes upon the first.

Beardsley and Wilde circulated in the same groups that included those in the Symbolist, Pre-Raphaelite, and Aesthetic movements. (The last arose in the 1860s and was known for its embrace of contemporary living and its opposition to design styles of the past.) Beardsley's drawings were based upon codes of Art Nouveau that transformed Nature into ornament. He favored the "rhythmic, curvilinear, 'maidenhair'" line (the last term revealing the style's feminine valence).[52]

Opposing those who see Art Nouveau as conservative, Chris Snodgrass views Beardsley's work as "attack[ing] bourgeois sensibilities" as well as countering "the long-standing logocentric prejudice that considered style as something added to 'content,' ornament (or illustration) being a superfluous overlay of 'substance.' . . . The etymology of *ornament* suggests that it has always been *both* essence and enhancement, its meaning lying between 'order' and 'adorn,' the one indicating fundamental organization, the other signifying an addition to an existing order."[53] Clearly, this is a response and counterclaim to those who charge Art Nouveau with being superficial and vacuous.

Beardsley's iteration of Art Nouveau was seen to have a nefarious sensibility. He was said to have created "conceptually threatening hybrids" combining vegetable and animal, male and female—"destabiliz[ing] customary signification, to disseminate ambivalence, undecidability, paradox."[54] Furthermore, his use of complex lines was said to have a smothering effect, "accentuat[ing], not ameliorat[ing], the sense of suffocation and imprisonment."[55] Thus, his ornaments frequently "entangled human beings . . . in some proliferating organic prison."[56] While the spiral form was conventionally "a characteristic shape of budding life," Beardsley's "stylized floral arabesques come to symbolize the blind omnivorous sexual dynamic of incessantly reproductive nature."[57] In his tendency to allow illustrations to overrun the picture frame, the viewer was seen to be "threatened with being swallowed in the maze of curves whose superabundance saturates the gaze and whose omnivorousness envelops, eclipses, and transmogrifies all solid entities."[58]

Nazimova's *Salome* has been thoroughly analyzed in a variety of ways: in relation to its originary literary text (by Dierkes-Thrun),[59] in its status as a work of queer cinema (by Patricia White),[60] and as an instance of experimental discourse (by Marcia Landy).[61] But, curiously, it has not been fully examined within the *specific* context of Art Nouveau. While Beardsley is axiomatically named as the film's pictorial source, the style from which it derives is barely referenced. Though *Salome* has been called America's first art film, that it is an *Art Nouveau* film has not been emphasized. Neither has its creation by two women been highlighted—countering the male dominance of the Art Nouveau design field.[62] Recently, buried in a trunk in an attic in Columbus, Georgia, a young man found a cache of costumes from *Salome*. He contacted Martin Turnbull, cofounder of the Nazimova Society, who said that he hoped the discovery of these artifacts will revive interest in a long-forgotten masterpiece. Significantly, even when *Salome* was revived in the 1960s (along with a renewed interest in Beardsley) the film was disparaged. In 1967, Bosley Crowther deemed it Camp and "one of the silent movies' more notorious Tiffany lamps."[63]

Relevant to *Salome*'s Art Nouveau ambience is the narrative's aura of decadence. An opening title informs us: "Profound was the moral darkness that enveloped the world on which the Star of Bethlehem arises." We are told that the Court of Herod is "rotting within" and that it is a chaotic

time of "crime and wickedness." Quite fittingly, Nazimova herself was identified with such then-taboo practices as lesbianism, Bohemianism, and feminism, and, as White has observed, her "vaguely Orientalized persona veiled her identity as a Jew."[64]

Moreover, it is a female figure who is at the center of the drama—reflecting Art Nouveau's obsession with Woman and, more specifically, with Salome (as seen in a sculpture by F. Goldscheider or in a painting by Gustave Moreau). While Salome is first described as innocent ("an uncontaminated blossom in a wilderness of evil"), she later morphs into a fierce femme fatale—frightening for her perversity (her forbidden desire for Jokanaan, her resolve to have him decapitated,[65] her necrophilic urge to kiss his lifeless lips). As we have seen, the Art Nouveau Woman straddles the divide between benign and malignant. Of course, the view of Woman as dangerous is also propagated by Jokanaan, who spurns Salome's sexual advances (in favor of religious asceticism) and decries her lascivious "abominations." Jokanaan's vision of her conforms to the frequent portrayal of Woman in Art Nouveau as malign (as in Klimt's *Pallas Athene* [1898]; see Plate 2). This is especially evident when Salome (like a fearsome, ghostly, Kabuki flapper) appears in a blonde, bobbed (fright-) wig for her famous dance. This modernization of Salome was prefigured in Beardsley's drawings, since some of them depict her in contemporary dress or setting (e.g., "The Black Cape," "The Toilet of Salome").

Beyond the figure of the femme fatale, gender trouble (also indicative of Art Nouveau) is apparent in the male characters. Upon *Salome*'s release, reviewers William Tydeman and Steven Price described the "fey" nature of Prince Narraboth, "with [his] stylized curly wig and huge bead necklace."[66] Significantly, Beardsley's original proposal for the title page of *Salome* (rejected by its publisher) depicted a full-breasted figure with male genitals. Furthermore, as Jennifer Horne has noted, Nazimova herself was "famously androgynous,"[67] and one reviewer remarked on how Nazimova had "the figure of a boy."[68]

In particular, it is the film's set for the cistern that is most audaciously Art Nouveau—with its whiplash curves, flowers, and scroll-like background. Given that critics have seen Beardsley's use of line as entrapping, it is crucial that Jokanaan is imprisoned below this site (see figure 2.7).

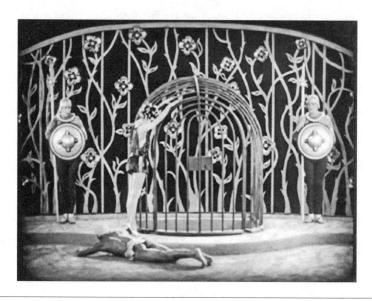

**2.7** The cistern set from *Salome* (1922, Charles Bryant) with its whiplash curves, flowers, and scroll-like background, indicative of Art Nouveau.

In other sequences, the curvilinear floral decoration is continued on the walls; and, on an urn, we see a circular motif that is derivative of Beardsley's illustration "The Climax."

While all of Rambova's costumes for the film are bizarre (with fabrics for their making ordered from Maison Lewis in Paris[69]), the outfit of Salome's mother, Herodias, has a particular Art Nouveau valence in the abstract floriated pattern of her body suit. She is another malevolent female who has choreographed the death of Jokanaan as a punishment for his insulting her. Of course, in Salome's Dance of the Seven Veils, we also have an ersatz incarnation of Loie Fuller (a performer associated with Art Nouveau), whose movements created twisting curves in her robe (see figure 2.8).

In fact, Fuller herself had performed a version of *Salome* in both 1895 and 1907.[70] As Gaylyn Studlar has pointed out, the first decades of the twentieth century saw a huge Salome dance craze, with Nazimova the "ultimate High Art Dance Vamp."[71] She also became a broader icon of

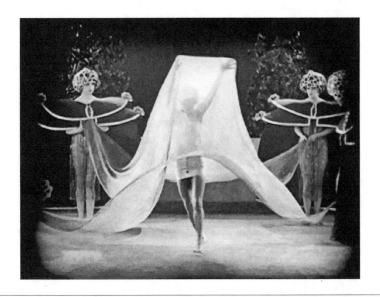

**2.8** In Salome's (Alla Nazimova) "Dance of the Seven Veils" in *Salome* (1922, Charles Bryant), we sense the ghost of Loie Fuller.

modernism (as I have argued did Greta Garbo some years later).[72] Hence, a *Vanity Fair* celebrity cartoon of 1921 depicts her wearing avant-garde clothing. Evidently, for Salome's dance, Rambova first designed "a pearl-studded gown composed of several layers of semitransparent white silk, with a long train," but Nazimova rejected it in favor of a "sheathlike tunic . . . with a rubber lining (specially made by a manufacturer of automobile tires) that clung to her body."[73] The only flowing fabric in the number trails from her veil.

When Herod offers Salome jewels to spare Jokanaan's life, we see her outfitted like a chorine in the *Ziegfeld Follies* (also influenced by Art Nouveau with costumes by Lucile) (see figure 2.9).

And, at the moment when Salome most emphatically demands Jokanaan's demise, she wears a highly modernist cape and holds a sword. Later, it is this robe that she wraps around herself to hide her kiss on the expired Jokanaan's lips. Again, in Beardsley's illustration "John and Salome," we find a prototype for her outfit.

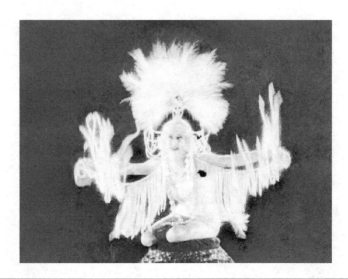

**2.9**  In *Salome* (1922, Charles Bryant), when Herod offers Salome (Alla Nazimova) jewels to spare Jokanaan's life, she is suddenly outfitted like a chorine in the *Ziegfeld Follies*.

As others have noted, throughout the film the act of looking is central—a fact that underscores the movie's devotion to visuality and further associates Salome with danger. It is her regard of Jokanaan that fuels her shameless desire. "I WILL KISS THY MOUTH!" she boldly proclaims through an intertitle. Furthermore, male characters are often warned against gazing at her. A page tells Prince Narraboth, "You look at her too much," as though jealous of his attentions to a woman. Finally, the powerful Herod, when not salaciously leering at Salome as she dances, hides his eyes when she heartlessly demands Jokanaan's death. It is only another woman (Herodias) who is joyful at her daughter's resolve, since Jokanaan has offended her.

When Herod offers Salome a peacock (to abandon her demand for Jokanaan's head), we cut to a graphic of the bird (reminiscent of the print medium). This is followed by a live-action shot of Salome in profile, adorned with a gorgeous peacock headdress (see figure 2.10).

Significantly, one of Beardsley's illustrations for Wilde's play depicts Salome in a "peacock skirt," and the cover of one edition of the book is

**2.10** In *Salome* (1922, Charles Bryant), when Herod offers Salome (Alla Nazimova) a peacock to spare Jokanaan's life, she appears in a peacock headdress.

decorated in the creature's ornate feathers.[74] But Salome's peacock imagery in fact harkens back to an earlier Nazimova film, *Madame Peacock*, in which she also starred. It was produced in 1920 by Nazimova Productions and was directed by Ray Smallwood, with a scenario adapted by Nazimova from a story by Rita Weiman. The plot, as briefly summarized in the *AFI Catalog of Feature Films*, is as follows:[75]

> Jane Goring (Nazimova), a ruthlessly ambitious actress, forsakes her life as a wife and mother for the stage. Returning home from a performance one night, Jane is disgusted to find her husband Robert McNaughton (George Probert) victimized by a tubercular cough and so banishes him and her young daughter to a sanitarium in Colorado. Years pass, finding Jane still estranged from her family. On the opening night of her new play, Jane finds herself upstaged and outperformed by Gloria Cromwell (Nazimova), a rising young actress, who, unknown to Jane, is her abandoned daughter. Returning home, Jane is haunted by visions of her husband and child and begins to sob. Looking up from her pillow, she is

startled to see her husband with Gloria. Discovering that the girl is actu-
ally her daughter, Jane realizes the error of her ways, and the family is
reconciled.[76]

The film's Art Nouveau atmosphere is impressive. Though its art direc-
tor is credited as Edward Shulter, the *AFI Catalog* states that Nazimova de-
signed the costumes and suggested set details. The entrance hall of Jane's
home is done in a somber Orientalist mode—with a Chinese-inspired light
fixture and three circular background panels that appear to depict Japa-
nese landscapes. Her boudoir is more ornate and contains a graphic self-
portrait (à la Aubrey Beardsley), as well as three decorative sections based
on the peacock theme (see figure 2.11). This image system is carried
through to her bed with its peacock headboard.

When Jane goes to the theater to rehearse a new play, its proscenium
arch and boxes augment the peacock imagery, as does her dressing room.
The use of plumage extends to her head coverings. One of them seems to

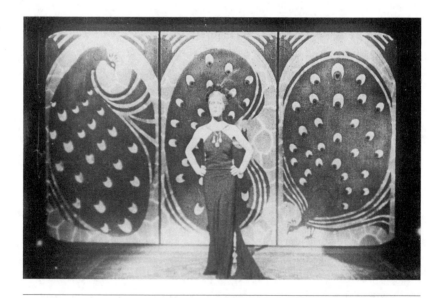

**2.11** Jane (Alla Nazimova) stands in front of her peacock-themed bedroom screen in
*Madame Peacock* (1920, Ray Smallwood).

be decorated with a peacock feather, but another seems adorned with those of an ostrich (also a popular accessory in this era).[77] Nazimova previously wore an amazing peacock hat in *The Red Lantern* (1919), an Orientalist film fantasy.

Here, we should note that, according to Inga Fraser, the peacock was the "preferred guise of the vamp" in this era (a characterization for which Jane Goring qualifies). It is an animal whose "complex symbolism" included fertility, rebirth, and beauty.[78] More importantly, the peacock (associated with the East) was a favored icon of Art Nouveau (Plate 9). As Christine E. Jackson writes, "Japanese wares, pottery, ivory and bronzes had been shown at the Paris Exhibition of 1862, after which the peacock became the symbol of fashionable and conspicuous opulence, the perfect motif for the Aesthetic Movement . . . and Art Nouveau."[79] Here we might note that French Art Nouveau ceramist Auguste Delaherche fashioned a peacock feather vase in 1889.

The peacock motif also inflected architecture and interior design. The walls of an Art Nouveau house designed by Paul Cauchie in Brussels were adorned with such imagery. Similarly, New York's Amsterdam Theatre employed a peacock feather design for its orchestra rail. Moreover, Alphonse Mucha's elaborate décor for Georges Fouquet's jewelry shop in Paris included a large peacock sculpture (Plate 5).

Fashion also evinced this iconic influence. An historical study of costume and style points to a so-called peacock dress crafted in Paris in 1910. In it, "the blue and green of the printed and embroidered peacock's body and feathers . . . are picked up in the waist sash, sleeve ends, and deep hem."[80] Similarly, a cape of 1915 is said to be adorned with a feather peacock pattern.[81] Likewise, a Lanvin gown of 1920 is described as having, in the center of its roundels, two embroidered peacocks facing each other.[82] Such imagery also inflected theatrical costume design, for instance a famous peacock outfit (designed by Pachaud of Paris) worn by "Dolores" in the 1919 edition of Ziegfeld's *Midnight Frolic*.

For Charles Darwin, the peacock feather was the prime example of the stunning plumage with which male birds attracted females. But, of course, in humans, the situation was reversed, with the female deemed the more spectacular—historically aided by artificial means of embellishment (jewelry, makeup, clothing, etc.) to serve as sexual enticements.[83] It

is for this reason that, when the Waldorf Astoria Hotel opened in New York City in 1893, the colonnade between the two parts of the building was known as Peacock Alley—a place where people paraded, showing off their couture and their membership among the elite. Not surprisingly, an illustration of the alley in its heyday primarily depicts fashionably dressed women.[84]

As a protagonist, Jane Goring in *Madame Peacock* is among the least sympathetic figures one can imagine. A "she-devil,"[85] according to Carl Sandburg, she is a narcissistic, ambitious, cruel diva who deserts her child and spouse to pursue her career. (Her last name, which draws on the word "gore," is significant.) When her husband is nearby, she not only rejects him but seems positively repulsed by him—and, taking heartlessness one step further, holds her ears when he emits a consumptive cough. Moreover, her own mother (Georgie Woodthorpe), first pictured as a long-suffering Whistler's Mother, resides in Jane's home as a mute servant. So not only is Jane an unnatural mother (a metaphoric version of the "infertile" Art Nouveau woman that Walter Benjamin deplored), but she is disrespectful of her own matriarch.

Even on a professional level, Jane is nasty. She arrives late for her drama rehearsal, holding everyone else up; complains that a star has not been placed on her dressing room door; demands that the playwright change some dialogue; mocks a young actress (unbeknownst to Jane, her daughter—played by Nazimova as well); and claims to be too tired to read her lines. After a short while, she exits for a dinner engagement, leaving the rest of the cast in the lurch. So, again in *Madame Peacock*, any woman associated with Art Nouveau is suspect.

Jane is allied with other themes prevalent in Art Nouveau discourse, among them theatricality (or spectacle). She is a stage performer, but even her home has curtains through which she makes grand entrances. If Art Nouveau was attacked for being self-consumed (a version of the charge of "art for art's sake"), so is Jane—repeatedly shown staring at herself in mirrors. This trope was, in fact, a popular one in Art Nouveau jewelry design, as was the figure of Woman as a base for mirrors. If Art Nouveau was attacked for being hollow, so is Jane. At the end of the drama (immediately before her reunion with her daughter), she returns home from the theater—despondent and lonely. A title tells us: "Her pride now abated,

the emptiness of her existence appeared to her." Finally, if Art Nouveau was criticized for being upper-class, so is Jane. She wants her stage character to be dressed in silk, despite the fact that (as the playwright explains) she is a poor worker.

Like so many films of the era, *Madame Peacock*'s denouement offers the viewer the requisite but feeble happy ending—with the family reunited and Jane contrite for the sins of her past. Here the film may seem to abandon an Art Nouveau sensibility, which delights in the subversive. But, we must recall that Nazimova plays a *double* role here (embodying both the innocent Gloria *and* the jaded Jane), reminding us that opposites are often one and the same. In articulating images of both the benign and the malevolent, Art Nouveau similarly walked a fine line between the saccharine and the depraved—veering seamlessly from one to the other.

Certainly, Nazimova taps ready-made notions of Art Nouveau to attach to her New Woman protagonist, making Jane Goring appear to be a negative symbol of the movement. On the other hand, unlike the virtuous but suffering heroines of so many contemporaneous melodramas (think *Way Down East* here), Jane is a strong, defiant, creative, female—unafraid to be self-centered in order to free herself of the cultural demands of femininity, marriage, and motherhood. Furthermore, she is an *artist* (like Nazimova) and the star's affection for her is implicit in Jane's linkage to the film's stunning costumes and décor—part of a mise-en-scène that asserts that beauty is not the stuff of a decadent lifestyle, but, rather, a requisite of life. Finally, Art Nouveau attaches not only to Jane but to Nazimova, herself, through the various films she made inspired by the mode—making her a virtual emblem of the style in the 1920s.

## A NOTE ABOUT FASHION

In discussing Art Nouveau's influence on the films above, we have mentioned women's costumes. While there is no type of fashion that "officially" bears the label "Art Nouveau," scholars have associated the style with certain types of couture from the era of the movement's ascendancy. For instance, *Fashion: The Definitive History of Costume and Design* points to a "swirling art nouveau pattern" in a dress of 1903 designed by Munich artist Elisabeth Winterwerber, as well as to Art Nouveau shapes on the

back and hem of one created in 1900 by Belgian architect Henry van de Velde.[86]

Moreover, Clare Rose of the Royal School of Needlework has created a website connecting fashion to the movement.[87] In it she includes several dresses from the House of Worth (run by Charles Frederick Worth and his sons), for instance an evening dress (1898–1900) with a lacy, black floral design, and another from 1912 ("L'Arlesienne") worn by Queen Maud of Norway for her wedding. She also lists the "Dress Sorbet" designed by Paul Poiret in 1912—with its circular, tubular effect. According to François Baudot, in 1908 Poiret introduced his "Directoire" line: "Skirts fell straight from the waist to within two inches . . . of the ground, while the waist rose to just below the bust, encouraging women to abandon their corsets in favour of high-fitting boned belts. Once the initial shock had been absorbed, it took only two years for the new softer look to be universally accepted."[88] Furthermore, Poiret created a "Salome" gown in 1914 for the Russian actress/dancer Ida Rubenstein, demonstrating the attraction of the heroine to Art Nouveau creators; moreover, he later designed a couture "Salome" coat and dress.[89] Poiret's "Danaé" evening cape also has an Art Nouveau appearance.[90] Finally, in a 1912 cover illustration for the fashion magazine *Les Modes* entitled "Chez Poiret" (and drawn by Georges Barbier), it is not only the outfits that have an Art Nouveau flair, but the background graphic.[91]

Another design house associated with modernism was that of Margaine-Lacroix, which, according to Baudot, "introduced the *robe-sylphide* (sylph-like dress) with its sinuous Art Nouveau curves."[92] Similarly, Nancy J. Troy mentions Art Nouveau in relation to couturier Jacques Doucet, who (like Poiret) was a knowledgeable art collector.[93] Here, it is important to note that some important architects and artisans associated with Art Nouveau also created clothing (albeit on a limited basis); for instance Josef Hoffmann of Austria (and, as we have seen, van de Velde).

A Spanish designer linked to Art Nouveau was Mariano Fortuny y Madrazo, "renowned for his Art Nouveau textiles that included fine-pleated silk gowns, lustrous silk and velvet scarves."[94] His influence was strongly felt in France as is clear from Marcel Proust's frequent mention of him in *A Remembrance of Things Past*. As he writes, "Of all the indoor and outdoor gowns that [women] wore, those which seemed most to respond to

a definite intention, to be endowed with a special significance, were the garments made by Fortuny y Madrazo from old Venetian models. . . . Is it . . . the fact that each one of them is unique that gives them so special a significance that the pose of the woman who is wearing one while she waits for you to appear or while she talks to you assumes an exceptional importance?"[95] Finally, London's Victoria and Albert Museum (a premier design institution) labels several outfits "Art Nouveau": collars designed by Jessie Newberry in 1900, a "Mantle" designed by Jean-Phillipe Worth in 1909, and a wedding dress designed by London's Liberty department store in 1905.

The mention of the Liberty emporium reminds us that, while originally pitched to the elite, Art Nouveau fashion trickled down to the middle-class consumer and, in particular, this establishment (founded in 1875) was linked to the movement. Hence, Art Nouveau in England came to be known as the Liberty Style. As Oscar Wilde is reputed to have said, "Liberty is the chosen resort of the artistic shopper."[96] Mention of Wilde reminds us of the Aesthetic movement which, in dress "reform," bore parallels to the later Art Nouveau style. As Kim Wahl observes, "Aesthetic Dress was characterized by its looseness and lack of structure, natural waist and disavowal of the corset, and the use of artistic details. . . . Such details often included puffed or gathered sleeves, looped or trained skirts or panels extending from the waist or shoulders of gowns, and the use of artistic forms of embroidering and gathering, such as wool crewel-work, or smocking."[97] The Liberty department store "registered 'Art Fabrics' as a trademark. It had its own artistic . . . costume studio, specialising in free-flowing . . . gowns in dusky colours."[98]

Art Nouveau fashion was similar to Aesthetic dress. According to the Sainsbury Centre for Visual Arts (which treats the styles as interchangeable), it can be described as follows:

> The flowing lines and organic forms of the Art Nouveau style are reflected in the clothes of the era, especially in ladies' dresses, the skirts of which were full and bell shaped, flowing out like blossoming flowers. The early Art Nouveau silhouette in some ways echoed the fussy and decorative look of the early Romantic period, with full, puffed sleeves and flared, moderately full skirts. However, the hour-glass figure with its erect posture, stiffly boned collar band, and high shoulders suggested a somewhat more formidable

image than had gone before. By the 1900s, the style relaxed and the silhouette changed with the introduction of a new 'S' shaped corset. The materials became softer and gauzier, with lace decoration and were very lightweight. The sinuous lines and soft materials and colours were consistent with the Art Nouveau style. In contrast to the fashion at the time, Aesthetic dress rejected any kind of restrictive corsetry. Initially there were few people who wore it, but over time it became popular amongst middle class intellectuals and artistic and literary people. Usually made of wool, Liberty silks or velvet fabrics, such a dress was cut looser and was unstructured in the style of medieval or Renaissance garments with larger sleeves. The dress appeared loose compared with figure hugging fashion garments of the era. Loose waisted corset free women were considered to have loose morals and it did not help that many of the Aesthetic women were thought slightly Bohemian and beyond the normal social conventions and morals of the time.[99]

Given the popularity of Art Nouveau couture in the early twentieth century, it is no surprise that it wended its way into costuming for the movies—since the cinema was known as a barometer of fashion.

## ART NOUVEAU AND THE FANTASTICAL EPIC

As we have seen, following the release of *Cabiria* Hollywood produced more grandiose movies, among them biblical and historical spectacles like D. W. Griffith's *Judith of Bethulia* (1913) and *Intolerance* (1916), or DeMille's *The Ten Commandments* (1923). But it is an epic of another sort—a fantasy/fairy tale—that is most relevant to a discussion of Art Nouveau, specifically *The Thief of Bagdad* (1924), which was directed by Raoul Walsh with production design by William Cameron Menzies and costumes by Mitchell Leisen. Interestingly, Siegfried Kracauer who, as we have seen, disparaged Art Nouveau, celebrated the fairy tale form (mentioning the particular collection from which *The Thief* was derived). As he writes in *The Mass Ornament*, "There is profound historical significance in the fact that *The Thousand and One Nights* turned up precisely in the France of the Enlightenment and that eighteenth-century reason recognized the reason of the fairy tales as its equal. Even in the early days of history, mere nature was suspended in the fairy tale so that truth could prevail. Natural power is

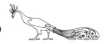

defeated by the powerlessness of the good; fidelity triumphs over the arts of sorcery."[100] Significantly in Kracauer's Germany in the 1920s there was a filmmaker who celebrated fairy tale discourse and merged it with avant-garde cinema: Lotte Reiniger, who shot *The Adventures of Prince Achmed* between the years 1923 and 1926. It is reputedly the first animated feature film, a work done with silhouetted cutouts moved against painted backgrounds. Reiniger's husband Carl Koch worked on the film as did Walter Ruttmann. Two things are interesting from our perspective: (1) it takes on a similar subject to *The Thief of Bagdad*, at about the same time; (2) it employs a delicate, ornamental Art Nouveau style to do so, drawing on the style's affinity with Eastern motifs (Plate 10).

We have already located American Art Nouveau Orientalism in *The Affairs of Anatol*, *Madame Peacock*, and *Salome*, but it was also present in a film of 1920—*Kismet*—based on a play by Edward Knoblock and set, like *The Thief of Bagdad*, in the Arab world. Directed by Frenchman Louis Gasnier (who had been sent by Pathé to the United States in 1912), it was an independent production of Waldorf Photoplays and starred Otis Skinner, a popular American actor of stage and screen. Several of the elaborate sets merge traditional Eastern décor with more modernist tropes, some of them redolent of Art Nouveau.

But the mode fully erupts in *The Thief*, which (like *Prince Achmed*) draws upon a collection of West and South Asian folk tales compiled in Arabic during the Islamic Golden Age. Its first English translation appeared in 1706 under the title *Arabian Nights*. The subject had long appealed to filmmakers; Georges Méliès made a version of it in 1905.[101] But there is an important intertext positioned between Méliès's and Walsh's movies—the production of *Scheherazade* by the Ballets Russes in Paris in 1910. Based on the story of a legendary queen from *The Thousand and One Nights*, the spectacle boasted costumes and sets by Léon Bakst, a Russian Art Nouveau creator highly influenced by Eastern design (and sometimes considered "decadent" in his homeland) (Plate 11).[102] Bakst's creations were also known for their sense of movement, and a writer in 1913 mentions him in the same breath as Loie Fuller—an icon of Art Nouveau.[103] *Scheherazade* (starring Vaslav Nijinsky) created a sensation: "Bakst's costumes are an imagined orientalist amalgam of Ottoman and Persian styles, pale and diaphanous silk harem pants for the *almées* contrasting with strongly coloured,

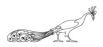 

embroidered and intricately structured silk and velvet costumes for the lead male characters. . . . Against the set's emerald green walls and red carpets, the massed costumes of dancers in frenzied motion created a moving spectacle of colour intensifying towards the ballet's orgiastic and violent climax."[104] Within short order, Bakst's styles filtered down into women's fashions. One of Paul Poiret's extravagant parties (given in 1911) was called "The Thousand and Second Night," with guests required to don Eastern garb, especially the *jupe-culotte* and harem trousers that dominated his spring 1911 collection.[105]

Not surprisingly, Bakst's Orientalism (and the Ballets Russes) also had an influence on film narrative, costume, and set design. Thus, in 1917, an American film *The Dancer's Peril* (directed by Travers Vale) appeared that told the story of a Russian ballet troupe that travels to Paris—a thinly disguised parallel to Diaghilev's company. As Mary Simonson points out, the film "was released by World Pictures in March of 1917, just as the second Ballets Russes tour was winding to a close."[106] Significantly, the dance that the fictional company performs is *Scheherazade* and its fictional ballet master is played by Alexis Kosloff (brother of Theodore, who had appeared with the Russian company). The heroine of the narrative is Vasta (Alice Brady), a young woman who, unbeknownst to her, is the orphaned child of the Grand Duke (Philip Hahn) and his wife (Alice Brady in a dual role). Vasta has been raised by the headmistress of the Russian Ballet and has become its star ballerina. When she goes to Paris to perform, she encounters her mother (who was banished there years earlier), and also learns the identity of her father. Furthermore, she falls in love with a young painter who has been commissioned by the ballet to sketch her. While the décor of the film is not done in the Art Nouveau style, certain title cards are. Furthermore, the costumes worn for *Scheherazade* are reminiscent of those designed by Bakst for Diaghilev. Finally, the fact that an artist paints a costumed Vasta seems reminiscent of Bakst's famous illustrations of his theatrical designs—masterpieces in and of themselves. In a self-reflexive move, at the end of the film Vasta fools her lover by posing by an empty canvas in the manner of the portrait he has already completed; she then surprises him by "coming to life."

A fantastical epic, *The Thief of Bagdad* tells the story of a bandit who scales the palace walls to steal jewels, but, in the process, becomes enamored of

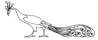

the Princess. After being jettisoned from the palace, he vows to return, posing as one of many princely suitors competing for the Princess's hand. Among the other hopefuls are the Princes of India, Persia, and the Mongols. The Thief (accompanied by his sidekick) steals a horse and fancy clothing and returns as "Ahmed, Prince of the Isles of the Seas and of the Seven Palaces," and the Princess chooses him to wed; but the Mongol Prince reveals that the bandit is a fraud. The Caliph (the Princess's father) orders the Thief flogged, but soon after the Princess bribes the guards to let him escape. When the Caliph asks the Princess to choose another mate, she stalls, asking each suitor to bring her a treasure. Hearing this, the Thief vows to find bounty of his own and, after getting advice from a wise man, goes in search of a magic chest. This quest leads to many adventures in dangerous and supernatural locales: the Cavern of Enchanted Trees, the Valley of Fire, the Valley of the Monsters, the Abode of the Winged Horse, the Citadel of the Moon, and the realm of the Old Man of the Midnight Sea. Eventually, the Thief returns to the castle and uses his magic to battle the forces of the Mongol Prince who is attempting to take over Bagdad and force the Princess to marry him. The Thief's tricks work and he wins her coveted hand. It is clear how this narrative offers costume designers and art directors a plethora of exotic opportunities, and those working on *The Thief* took them all.

It is interesting, given the focus of the film on a thief (coupled with its recourse to Art Nouveau), that a column appeared in *Shadowland* in 1923 making a parallel between theft and that style. In writing about the famous Paris flea market, a columnist asserts: "Between art nouveau which has stolen indiscriminately from many sources and the thieves' market there is an obvious analogy."[107]

The costumer for *The Thief of Bagdad*, Mitchell Leisen, was born in Michigan and trained as an architect; but his first major job in the movie industry was for DeMille. Eventually, he moved on to set design, and later to film direction. Though, of course, Bakst's vibrant colors are missing in the outfits we see in *The Thief* (photographically a black and white film), we do find evidence of his design mode in Leisen's Orientalist creations—interestingly, more in the case of those for male versus female characters (unusual for the cinema, which generally makes women the primary spectacle). This is not surprising for, as Gaylyn Studlar has noted in her

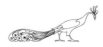

**2.12** The Thief (Douglas Fairbanks) and his sidekick wear luxurious costumes in *The Thief of Bagdad* (1924, Raoul Walsh), reminiscent of those designed by Léon Bakst for the Ballets Russes.

discussion of the influence of the Ballets Russes on *The Thief*, Bakst's costumes "adrogynized, if not outright feminized" youthful male dancers: "See-through gauze pantaloons, iridescent halter-tops, colorful turbans, robes of intense color juxtaposition with oversize patterns were given shape in sensuously textured materials that frankly displayed the male body as a decorative object rather than as the functional subject."[108] At the beginning of the film, the Thief is dressed in patterned pantaloons and his head is draped in a long, flowing scarf. Later, when he masquerades as a prince, he is no longer bare-chested and wears a luxurious outfit (decorated at the waist and hip), as does his sidekick (who also sports an ornate, feathered hat) (see figure 2.12).

Both men wear pearl jewelry. At the end of the film, when the Thief takes his bride on a magic carpet ride, his clothing is the most sumptuous of all with its flowing brocade cape. The costumes of the Princes of India, Persia, and the Mongols are also highly ornamental, the last the most modernist with its circular, tiered hat. Similarly, the Caliph and his slaves are clothed in a decorative fashion, and the costumes of palace guards seem derived from the Ballets Russes, as do those of the male citizens of Bag-

dad. Beyond "femininity," one wonders if the association of the male with ornate dress in the film marks the Orient as "backward-looking" (elaborate male fashion having been linked to the West only in the past). Overall, the women's dress is less extravagant. The Princess (whose culture requires modesty of her) is covered in filmy veils, while her ladies in waiting wear more fanciful, revealing, and extravagant outfits.

Art direction in the film is incredibly plush and, as Studlar remarks, was influenced by Bakst as well.[109] Recognizing its sophistication, design historian Cathy Whitlock says that *The Thief* "marks the pinnacle of the silent era epic";[110] likewise, Robert Sennett asserts that it signals "the birth of film design as star."[111] More to the point, the sets display an Orientalist aesthetic.

The sense of *The Thief* as an "art film" was noted at the time of its release. In a review, poet Carl Sandburg wrote, "Probably no one photoplay since the motion picture business and art got going has been greeted so enthusiastically in the circles known as highbrow and lowbrow. . . . In *The Thief of Bagdad* . . . there is both intelligence and fine art quality."[112] Likewise, Vachel Lindsay deemed it "an advance"—"the greatest movie so far in movie history."[113] Highlighting its artistic elements, he wrote that it was "completely packed with imagination"—composed of "architecture-in-motion moments and painting-in-motion moments."[114] As opposed to other contemporaneous films, *The Thief* was "pure movie"; it contained "no literary effects, no stage effects, no vaudeville effects, and . . . nothing [was] told with a literary intent."[115] In achieving this standard, *The Thief* (like other films we have discussed) realized the dream of French critic Louis Aragon, who argued in 1918 that "it is vital that cinema has a place in the artistic avant-garde's preoccupations. They have designers, painters, sculptors. Appeal must be made to them if one wants to bring some purity to the art of movement and light."[116]

Significantly, art director William Cameron Menzies saw the movies as consonant with what he believed to be a growing respect for aesthetics in the broader culture. As he said, "The pictorial beauty of the modern photoplay is an indication of the more general appreciation and the greater demand for beauty that is characteristic of modern life."[117] Furthermore, he thought that "good art is good business" and called misguided "the idea . . . that the artistic picture is destined to be unpopular."[118] In the case of *The*

*Thief*, he was right. (As testament to this, some eighty-four years after the film's production, the American Film Institute deemed it the ninth best fantasy film ever made.[119])

While aware of the European tradition, Menzies was a homegrown talent, born in Connecticut in 1896 (during the first years of film history). He was to become one of the premier production designers in cinema history, his work spanning both silent and sound eras. He is probably best known for his work on *Gone with the Wind* (1939), for which he was the first to receive the title of "Production Designer." He was also among the few in his craft to become a film director (most famous for the Art Deco *Things to Come* [1936]). Educated at Yale and the Art Students League of New York, he first worked in advertising and then as an illustrator of children's books. His introduction to cinema came through the mentorship of art director Anton Grot. Menzies saw production design as entailing wide-ranging skills, once having said (in a 1929 lecture delivered at the University of Southern California) that the practitioner "must have a knowledge of architecture of all periods and nationalities." Furthermore, "He must be able to picturize and make interesting a tenement or a prison. He must be a cartoonist, a costumier, a marine painter, a designer of ships, an interior decorator, a landscape painter, a dramatist, an inventor, [and] a historical . . . expert."[120] He also saw cinema as primarily a visual art—"a series of pictures" or "fixed and moving patterns."[121]

*The Thief*, an independent production, was a star vehicle for Douglas Fairbanks, who also served as its producer. Reputedly, he spent some $2 million on the project—most of that for design.[122] Shot in about thirty-five days,[123] the film necessitated massive sets, which were built on six acres on North Formosa Street in Los Angeles.[124] To assist him, Menzies brought in Grot as an "Associate Artist."[125] According to the recollections of his wife, Menzies (about twenty-eight years old at the time) landed the commission in the following way: "Doug [Fairbanks] saw Billy [Menzies] and said he was too young for the job. So he came back and made a real show of what he could do. He worked and worked on these paintings day and night, then he asked for another appointment. He went over carrying all these drawings on his head because they were heavy, and he walked into Douglas Fairbanks's office with these boards balanced on his head and said he'd come to show him that he wasn't too young. He got the

job."[126] This remembrance is contradicted by Sennett, who claims that Grot did many of the charcoal drawings for the film.[127] The catalog for a 1980 exhibition on art direction at London's Victoria and Albert Museum compares the styles of the two designers: "Menzies' canvas was broader [than Grot's] and his brush more daring. He was an imaginative inventor of complete cinematic ideas, and it was perhaps inevitable that he should become a film director in his own right."[128] Evidently, for Menzies, creation of the storyboard was as central to a film's design as the set: "He would start with rough thumbnail sketches in his notebook and develop them, or have them developed by others, into detailed colour artwork. Often on later films these sketches would be propped next to the camera or carried as constant references. The sketches showed every scene including its set, props, lighting, style, camera angle and the disposition of the actors. The method has since become a commonplace of production design."[129] So what, specifically, is noteworthy about Menzies's sets for *The Thief*, and how do they engage Art Nouveau? First, it is important to note that, according to James Curtis, "Fairbanks had likely seen Edmund Dulac's Art Nouveau illustrations for Laurence Housman's retelling of *Stories from the Arabian Nights*, a 1907 edition" and "Menzies, too, had likely seen and been influenced by Dulac's intricate drawings."[130] So the style was on both men's minds. As for the film's nod to the East (also typical of Art Nouveau), in his book *Architecture for the Screen*, Juan Antonio Ramirez claims that the movie—with its "resonances of Islamic art from Iran and North India casually rub[bing] shoulders with the Alhambra Palace in Granada"—opened the doors to Hollywood Orientalism.[131] But, of course, we had already seen evidence of this trend in the depiction of Babylonia in *Intolerance* and *Male and Female*.

To fully analyze production design in *The Thief*, it is necessary to divide the settings into various locales. First there is the city of Bagdad itself—outside the palace walls and within. The buildings on the streets are majestic and massive, creating a bold contrast between the scale of edifices and people (as do such oversized objects as vases, stairways, and windows). The walls of the palace (which loom over the city) have many minarets and towers, and are decorated in tile (with repetitive geometric shapes characteristic of Islamic style). Furthermore, some objects (e.g., a gong) are inscribed with Arabic calligraphy. The city, overall, has numerous arabesque

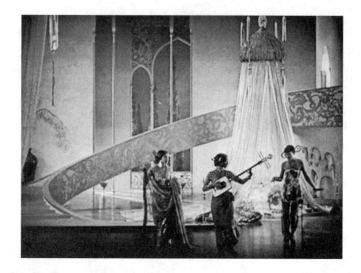

**2.13** The princess's bedroom in *The Thief of Bagdad* (1924, Raoul Walsh) shows an Art Nouveau influence in its curvilinear stairway with its delicate, sinuous, latticework designs.

arches—also typical of Islamic architecture. This motif is carried out in the walls of the interior palatial court. The look of the palace grounds is characterized by more of an Art Nouveau aesthetic (with curvilinear lines, and a statue of the requisite peacock)—though aspects of Art Deco are also apparent.

Given that Art Nouveau was often seen as a "feminine" style, it is not surprising that it is in the Princess's quarters that we find its most emphatic use—for instance in the curving sweep of her bedroom staircase with its scroll-like banisters (see figure 2.13).

This motif is repeated on numerous screens and grills throughout the palace—some of which sport the style's famous whiplash curve. Art Nouveau was also known for its organic imagery, favoring (among other things) floral designs. Again, the props and latticework in *The Thief* are consonant with this sensibility.[132]

In particular, the delicate brand of Art Nouveau design utilized in the film shares much with the style of Viennese architect August Endell, as seen in the facade he created for Munich's Atelier Elvira (1900), with its

whiplash, curvilinear "ornament larger than anything anyone had seen, unconstrained and beholden only to itself, dominating" its frontage.[133] The shop's metal door, based on a subtle web motif, combines sharp points with mellow curves—indicating, again, Art Nouveau's oppositional elements. It is this "lacey" style that one finds evident in many sequences of *The Thief*.

A particularly decorative sense is attached to the most evil figure in the film, the Mongol Prince, indicative of how, as Galt has noted, ornament is often associated with the racial Other. His palace is incredibly elaborate and beautiful, and a scepter that he uses to poison people is tipped with a gorgeous Art Nouveau globe (Plate 12).

The film's Arab setting is resonant with Art Nouveau iconography, which drew upon Islamic architecture and design. For instance, the canopied gate that served as entrance to the Paris Exposition of 1900 (at which the style "debuted") took the form of a baldachin with open latticework executed in an Islamic manner. The souvenir program booklet for *The Thief* even talked of burning incense in the movie theaters in which it was shown—a further homage to the East.

Menzies's art direction had to emphasize the narrative's dreamlike, ethereal aura and, again, this squares with Art Nouveau's otherworldly sensibility. (Vachel Lindsay said that in *The Thief* "the dream world comes true.")[134] To achieve this, Menzies utilized highly polished black reflective floors, special lighting techniques, gauze as a light diffuser, and buildings lit from below.[135] Netting is also a design element in the Princess's bedroom—used as a means to hide the Thief and veil her face. Here we should recall that the figure of the Arab woman was popular in the Art Nouveau period, as in the painting *Salome Dancing* (1874–1876) by Gustave Moreau and the sculpture *Salaambô chez Matho* (1900) by Théodore Rivière.

As Lindsay opined, "all the magic of *The Arabian Nights*, all the fairy tale element is . . . conveyed in *The Thief of Bagdad*."[136] These narrative components erupt in the Thief's fantastical adventures in pursuit of a treasure for the Princess. (Here, it is difficult to understand Kracauer's point that fairy tales involve a triumph over sorcery, as it is the Thief's use of enchantment that wins him his lover.) In these sequences, Menzies marries production design with special effects. As the film's souvenir program states, Fairbanks "conscripted all the artistic, mechanical and imaginative talents of many people" to achieve the outcome he desired. Perhaps the

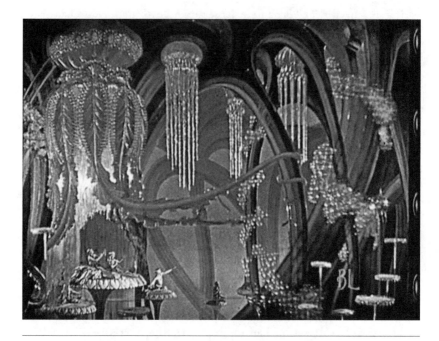

**2.14** The underwater landscape that the Thief encounters in *The Thief of Bagdad* (1924, Raoul Walsh) resembles a glass "wonderland" as imagined by René Lalique.

most spectacular setting is the realm of the Old Man of the Midnight Sea that members of the Art Department created, spending months blowing ornate glass.[137] Here, we recall that delicate, milky glass decorative objects were the signature product of Art Nouveau designer René Lalique—so this scene appears to take place in a Lalique wonderland (see figure 2.14).

Menzies discusses how other aspects of the sequence were accomplished: "We took a set and cut seaweeds out of buckram, and had a series of them hanging down in several places. A wind machine was put on so the seaweeds flapped but as the scene was taken in slow motion, they undulated when shown on the screen. The camera had a marine disk over the lens and was turned over. Mr. Fairbanks was let down into the scene and went through the motions of swimming under water. The scene had the appearance of water."[138] Miniatures (often combined with process shots) were used for various fantasy sites (e.g., the Valley of Fire, Valley of

Monsters, and Abode of the Winged Horse). Models were combined with process shots to render the Cloak of Invisibility,[139] and live action and process shots were used for the Thief's ride through the sky. Contrary to these, the flying carpet effect was created in quite a material fashion— by securing a three-quarter-inch-thick piece of steel rigged by sixteen piano wires anchored to the top of a crane.[140] The crew also had to arrange for a moving camera (which Menzies asserts "is another thing the art director is involved in") and "a platform [was] built for the cameraman which travelled with the crane."[141]

Menzies used the tinting and toning of footage in various sections to augment the movie's sense of whimsy. As the souvenir program asserts, "a roseate glow [was used] for the romantic moments; a garish green where the terrifying monsters appear; a soft uranium sepia where the beautiful golden haze glows about the dream city of Bagdad and throughout all the fantasy a rich Maxfield Parrish blue" (see figure 2.15).

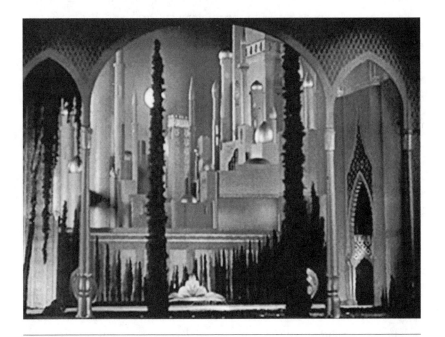

**2.15** This decorative, Orientalist vision of the "dream city of Bagdad" in *The Thief of Bagdad* (1924, Raoul Walsh) was originally tinted a "Maxfield Parrish blue."

As for the reference to Parrish, his style has been claimed (or disclaimed) by both aficionados of Art Nouveau and Art Deco. Interestingly, while the souvenir program does not mention Menzies in its text, it does cite the film's poster artists—Anton Grot and Willy Pogany. The latter was a book illustrator who specialized in creating Art Nouveau plates for volumes of myths and legends; for instance, *The Rubaiyat of Omar Khayyam*. He also worked in advertising and designed posters for the Ballets Russes.

In sum, despite Art Nouveau's decline in the design world by the mid-1920s, its influence was still felt in American cinema. This was true of Hollywood mainstream film where, in the work of Cecil B. DeMille, the style enhanced his Jazz Age dramas about the New Woman, the upper classes, sexual freedom, and consumer desire. It also had an effect on experimental and independent productions. The box-office hit *The Thief of Bagdad* capitalized both on the famous tale and its notorious dance adaptation by the Ballets Russes, thereby creating an artful, epic, Orientalist fantasy. The more radical (and less successful) *Salome* (which followed on Alla Nazimova's appearances in the modernist *Camille* and *Madame Peacock*) translated Wilde's scandalous play to avant-garde cinema, along with its links to decadence, the exotic, and the femme fatale.

## ART NOUVEAU AND THE 1920S PICTURE PALACE: TUSCHINSKI THEATER, AMSTERDAM

In chapter 1 we discussed an early American Art Nouveau theater—the New Amsterdam—originally built for stage plays (not cinema) in 1903, but used for film exhibition after 1937. We explained the absence of grand movie theaters at the turn of the last century by the fact that picture palaces were generally not erected until the 1920s when the feature film dominated. But, by then, the Art Nouveau style was on the wane.

A survey of American publications of the era did, however, unearth a few references to Art Nouveau movie theaters. By now, unfortunately, the ones referenced are all defunct. A volume of *Motion Picture News* from 1914 describes plans for a St. Louis theater whose "interior wall decorations will be . . . ornamented in hand painted designs in art nouveau style."[142] In 1915, the same magazine discusses the Avenue Theatre in Chicago whose "walls are decorated in old rose and ivory, in art nouveau style, worked

out in soft, delicate greens, browns and crimsons."[143] A 1916 *Moving Picture World* talks of the exterior facade of a theater made "of photographers' glass, surrounded by a decorative border of stained glass, the whole set in a concrete front adorned with *Art Nouveau* modelings." The article also notes how "the interior of the house follows the art nouveau mode and bright and discordant colors have been eliminated. Instead there are soft hues of mauve, blue and green with an occasional touch of orange. The indirect lighting fixtures harmonize in design and color with the decorations."[144] Finally, a 1913 article in *Motion Picture News* about the Lyceum Theatre in Newark, New Jersey, mentions how "the interior . . . will be highly decorated in plaster and stencil ornament in the Art Nouveau style, dark red, gold and cream for the theatre."[145] We also find occasional references to Art Nouveau movie houses in Europe. An issue of *Cinema* from July 1912 reports that many theaters in Sophia, Bulgaria (the "Modern," "Nouveau Americain" and "Odeon"), are decorated in the "modernist or 'Art Nouveau' style."[146]

For a surviving theater of this type, we must return to Europe—in particular to the Tuschinski Theater (now the Pathé Tuschinski) in Amsterdam (Plate 13).[147] It was opened in 1921 by Abraham Icek Tuschinski (1886–1942), a Polish Jewish immigrant to Holland who fled the pogroms in his homeland. (Nonetheless, he had the Polish eagle worked into the lobby carpet pattern.) He started out as a tailor, but eventually went into the movie business, first constructing theaters in Rotterdam. His initial venture there was the luxurious Thalia, which opened in 1911; within ten years he had a cinema empire. He next decided to erect a theater in Amsterdam but it took him four years to do so. The first foundation stone was laid on June 18, 1919. Named the Tuschinski, it was designed by Hijman de Jong at a cost of 4 million guilders. However, disagreements led to the job being taken over by William Kromhout. In addition to Art Nouveau and Jugendstil, the theater drew on Art Deco and the Amsterdam School (which was linked to Expressionism). Some critics (e.g., Menno ter Braak of the Filmliga) deemed the theater a vision of bad taste.[148]

The Tuschinski (which originally seated 1,600) sought to provide a glamorous space for the general public. To ensure their comfort, he installed a cooling system of fans blowing over blocks of ice. He provided high-quality orchestral music to accompany silent films and eventually imported a Wurlitzer organ from the United States. More than a cinema,

the Tuschinski also featured a cabaret, La Gaité, which offered revues, plays, and dance performances.[149]

The designer of the theater's interior was Pieter den Besten, who gave it numerous Art Nouveau touches. In both the lobby and the first balcony landing, ceiling domes painted in abstract patterns change color as the lighting shifts—drawing on Art Nouveau's love of hue and biomorphism.[150] Furthermore, on the first balcony landing are images of birds of paradise; and the silk ceiling lampshades loosely suggest three other natural forms: cocoons, caterpillars, and butterflies.

Extending this imagery, a series of butterfly-women are painted on the corridor walls (reminding us of figures in Chomón's magic films, Masriera jewelry, and Reinhardt's *A Midsummer Night's Dream*). Furthermore, a light panel in the lobby reinforces this theme and the light bulbs surrounding the balconies are positioned to mimic butterflies. Clearly, lighting was central to the theater's ambience and it boasted some 1,600 bulbs.

On the wall of the lobby there are images of peacocks, which are also found on myriad other surfaces throughout the theater including stairways, walls, the auditorium proscenium arch, and the second balcony. In fact, the huge light fixture on the cavernous auditorium ceiling is said to represent the inside of a peacock's feather. On the walls of the second balcony are paintings of women, though these are done in more of an Art Deco style. One of the women, however, is painted in a fashion reminiscent of Gustav Klimt.

There is a strong Orientalist theme to the Tuschinski Theater with its huge decorative standing lamps that resemble Chinese lanterns, or its gold-leaf wall designs that take the shape of Japanese kimonos. Evidently, the original cloakroom (called the Japanese Room) included a Buddha statue.[151] Once again, such an Eastern motif was consonant with both Art Nouveau and Art Deco. Related to this, off the corridor of one level of the theater is the Moorish Room, which is decorated with illustrations from *The Thousand and One Nights*—the very same text that inspired Art Nouveau creations like the ballet *Scheherazade* and the film *The Thief of Bagdad*.

In addition to advancing modernism in his theater, Tuschinski also commissioned cutting-edge Dutch artists to design his program booklets, as is clear from one done in Jugendstil style by Elias Ott (1883–1969) in the early 1920s (Plate 14).[152]

By the early 1930s, Abraham Tuschinski had amassed ten movie the-aters: the Royal Cinema, Grand Théâtre, Olympia, Scala, Studio '32, and the Thalia in Rotterdam; the Passage in Schiedam; and the Roxy, Passage, and Tuschinski in Amsterdam.[153] In the mid-1930s, however, he began to face financial problems, in part because his son Will spent a great deal of money producing a film by Max Ophuls that was unsuccessful (*The Trouble with Money* [1936]). Furthermore, Tuschinski had purchased an expensive piece of property in The Hague that he failed to develop into a cinema. Ultimately, the N.V. Tubem Company took over the management of the Tuschinski group, making its founder a mere employee.[154]

Abraham Tuschinski stands as one of a group of European Jews who supported Art Nouveau and modernist architecture. When World War II broke out and Germany occupied Holland, the Jewish members of the Tubem Company were fired, and the Tuschinski Theater was renamed the Tivoli. Tuschinski and most of his family were rounded up and sent to Auschwitz where they died.[155]

The Tuschinski Theater was one of the few picture palaces in the 1920s influenced by the Art Nouveau style. While Tuschinski himself perished in the Holocaust, his theater (restored between 1998 and 2002) remains as a tribute to his vision and to the grandeur of cinema.

# CHAPTER 3

# Architecture and the City

BARCELONA, GAUDÍ, AND THE CINEMATIC IMAGINARY

~~~~~~~~~

*No collective effort has managed to create a world of dreams as pure and disturbing as these art nouveau buildings, which by themselves constitute, on the very fringe of architecture, true realizations of solidified desire, in which the most violent and cruel automatism painfully betrays a hatred of reality and a need for refuge in an ideal world similar to those in a childhood neurosis.*
—André Breton, "The Surrealist Situation of the Object"

Cinema and the city have long been linked, from early American actualities, like Edison's 1903 *Sky Scrapers of New York City*, to city symphonies like *Nothing but Time* (1926, directed by Alberto Cavalcani), *Berlin: Symphony of a Great City* (1927, directed by Walter Ruttmann), and *The Man with a Movie Camera* (1929, directed by Dziga Vertov). These films have been discussed on numerous levels, most notably around issues of modernity (urbanization, flaneurism, anomie, capitalism or socialism). They have also been analyzed around questions of genre (as variations of the documentary) and style (as forms dependent on montage). But rarely have two other parameters been addressed in these studies: *the nature of a city's architecture* (as captured on screen) and what we might deem the city's *poetic characterization* (its cinematic "Imaginary," as it were). Paris, for instance, is known as the City of Light (though originally that meant knowledge), and it is no accident that one of its stock photographs depicts its most famous architectural construction—the Eiffel Tower—illuminated at night. Similarly, New York City's political and economic

power is registered in the Empire State Building, whose name (as Andy Warhol realized in his titling of a film), says it all.[1]

However, another city is worthy of consideration in this regard—Barcelona—a locale already discussed in chapter 1 as the sometime home of Segundo de Chomón, and one in which Catalan architect Antoni Gaudí built an experimental film theater, the Sala Mercè. So the relationship between Barcelona and Art Nouveau has already been referenced. In this chapter, however, the focus will be on the use of the city's modernist architecture as filmic mise-en-scène, and how that man-made environment has been appropriated by various directors.[2] According to Mireia Freixa and Joan Molet, it was architects who shaped Barcelona as a "*modernista* city," transforming it into "one of the icons of Art Nouveau in Europe." Similarly for journalist and novelist Julie Burchill, "In Barcelona, it's the architects . . . who are the objects of admiration."[3] Indicative of this, the city's undisputed global emblem is Gaudí's church, La Sagrada Família.

The rise of the Catalan avant-garde in the visual arts blossomed at the end of the nineteenth century.[4] Some mark its beginning with the publication in 1884 of the avant-garde journal *L'Avenç* (the *Progressive*).[5] As Teresa-M. Sala has noted, "the magazine [was] seen as a regenerative project for serious, committed art that would be the cultural motor of cosmopolitan Barcelona."[6] Furthermore, between 1892 and 1899, a series of modernist festivals were launched in the nearby coastal town of Sitgas.[7] Others, however, claim that the era of Modernisme was signaled by the city's launching of the Barcelona Universal Exposition of 1888—its first world's fair.[8]

This cultural explosion was due, in part, to Barcelona's economic prosperity in the era and its status as one of the first industrialized cities in Spain (with a focus on textiles).[9] But it can also be traced to the Catalan Renaissance, a revival of the region's political and social identity in opposition to the dominance of Madrid. For Maiken Umbach, the local character of Catalan culture invokes the conceptual opposition between "*place*—as concrete, immutable, and authentic—and *space*—as abstract and utopian." In this view, "modernity is . . . predicated on space, evident in the visual abstractions of modern architectural functionalism."[10] He suggests, however, that "modernism had much more room for the sentiment of place than is commonly acknowledged" and that the "decades around 1900 involved . . . a creative re-imagination of place within a modern

environment."[11] Here, Catalonia was central and represented a "sense of place that was simultaneously rooted in the past, and celebrated progress."[12]

According to Borja de Riquer i Permanyer, Catalan nationalism was "exacerbated by the colonial disaster of 1898," whereby Spain lost possession of Cuba, Puerto Rico, Guam, and the Philippines to the United States.[13] This led to a "loss of faith in the idea of Spain as a unified nation. The Catalan Modernistas, consequently, were open to everything new that was happening in Paris" (where several of them lived and studied),[14] as well as in Berlin, Vienna, and London. As Lourdes Figueras remarks, "Each center of expression became a center of dissemination as well, facilitating the aesthetic innovations of art nouveau. In fact, the chronological parallels and the constant exchange of information were so extensive that [one might describe] this long period . . . that includes the evolution of Catalan Modernismo—as a 'historical unit.' "[15] While on one level, the Catalan Renaissance sought to restore the region's past glory, it did not promote nostalgia. Instead, modernism became "shorthand for an amalgamation of all that was youthful, contemporary . . . and modern, in opposition to the entrenched, old-fashioned, and out-of-date."[16]

As with Art Nouveau elsewhere, the Catalan movement expressed itself in a variety of arts and crafts. In painting, one thinks for instance of Santiago Rusiñol's *The Allegory of Poetry* (1894), which pictures a woman in a garden, and of Ramon Casas's *La Sargantain* (1907), a portrait of a quasi-malevolent female. In illustration, one gleans an Art Nouveau influence in the romanticized vision of Woman contained in Gaspar Camps's illustration "Allegory of the Month, January" (1901), where a woman is surrounded by swirling, abstract designs. As for poster art, the ubiquitous female appears again in Alexandre de Riquer's "Salon Pedal" (1897)—this time as a "modern" on a bicycle, surrounded by flowers, and set against an abstract pastoral background. We also see similarities to the work of Toulouse-Lautrec in Ramon Casas and Miguel Utrillo's poster "Shadows, Quatre Gats" (1897)—an advertisement for a café that opened that year, in which Modernistas met and socialized.[17]

Modernist furniture designers produced ornate pieces like Gaspar Homar's sofa-display case with "La Sardona" marquetry panel (1903), which sported a curved seat back and shelf inserts, as well as a floral design and image of dancing women. There is also Joan Busquets i

Jané's 1900 mahogany cabinet with inlaid profiles of women on its doors.

In ceramics, one thinks of Josep Maria Jujol, whose colorful tiles adorned the benches and Hypostyle Hall of Gaudí's Park Güell. And for pottery, one considers Antoni Serra's *Large Vase* (1907) with its subtle gold and green coloration and design, or Lambert Escaler's *Jardiniere* (c. 1903) with its female head ominously encased in whirls of hair. Escaler is also known for numerous sculptures of female subjects.

In the realm of silverware and gold jewelry, there was no equal to Lluís Masriera (the Spanish equivalent of Tiffany), whose *Isolde* (1900) and *Insect Woman* (1916) pendants are representative of his Art Nouveau-inspired work (Plate 15). Similarly, his paperweight (1901–1906) and cup and saucer (1900–1904) both take advantage of Art Nouveau's love of the sinuous female form.

But the prime consideration here is architecture, and, in this regard, Barcelona is a quintessential Art Nouveau city with most of its modernist buildings located in the Eixample district, which was under construction at the turn of the last century. While our focus will be on the work of Antoni Gaudí (the city's most renowned practitioner), and its employment as filmic mise-en-scène, several of his contemporaries are worthy of note. In all cases, Modernista architecture was conceived "as a vehicle for the delivery of man-made paradises" through an "aesthetic of the 'picturesque.'"[18]

One of the most stunning buildings of the era was the Palau de la Música (1905–1908), designed by Lluís Domènech i Montaner as a home for the Orfeó Català, a choral group. The concert hall boasts a central skylight portraying the sun and hundreds of decorative motifs depicting flowers, palms, fruit, and jewels (Plate 16). Another of its rooms, Lluís Millet Hall, contains stained-glass windows embellished with flowers, wide, floral-patterned brick work, and ceramic arches. Another building by Domènech stands on the same street as Gaudí's Casa Batlló—the Casa Lleó i Morera (1902), which was originally a family residence and office building. Here is how it is described: "The façade and the mezzanine were decorated with different types of ornamentation, of which the sculptures by Eusebi Arnau depicting two couples of female figures were the most notable. . . . An explosion of modernism is found in

the interior . . . stained-glass windows, mosaics, ceramics, sculpture, wood, marble, sgraffito."[19] Interestingly, the female sculptures on the exterior of the building represent various aspects of modernity—gramophone, electricity, and, most significantly, photography. On the same block (the Passeig de Gràcia), a third modernist monument stands. Casa Antoni Amatller (1900), designed by Josep Puig i Cadafalch, is a building that transforms neo-Gothic style through the inclusion of a colorful, ridged facade inspired by houses in the Netherlands.

Art Nouveau architecture is such an emphatic feature of Barcelona's image that recently a book was published entitled *Modernisme Route: Barcelona*, which provides the visitor with a block-by-block guide to all the relevant buildings (grand and pedestrian) that are marked by the style.[20] Significantly, the foreword by Josep M. Huertas Clavería is entitled "Modernisme, Between Love and Hate," which, once again, makes clear that, even in Barcelona, Art Nouveau has sometimes constituted the abject.[21] He talks of how in the past there were calls to demolish the Palau de la Música "because [people] considered it an architectural aberration." As he notes, "this example is the tip of the iceberg of [a] clearly anti-Modernista way of thinking that had a decisive influence on Catalan thought between the twenties and the fifties."[22] Evidently, one of Puig i Cadafalch's buildings, the Casa Trinxet, was torn down in 1968. (Fortunately, the building that houses the Quatre Gats, which he also built, still stands.) Even Gaudí's creations were subject to scorn. For instance, some have claimed that the word "gaudy" derives from his work, but this is not supported by evidence, since the word was already in use some fifty years before Gaudí was born.[23]

Alexandre Cirici wrote in 1948: "When we ask the people who promoted it about Modernisme, except on rare occasions we are given the evasive answers of shame, a kind of repentance that wishes to bury the past."[24] Clavería claims that "in 1968, with a major exhibition and the publication of *Arquitectura Modernista* by Orio Bohigas and Leopold Pomès, the situation began to change. . . . Modernisme had aroused love and hate that had to be overcome in order to contemplate it as it is, a great moment of artistic and ideological creation."[25] One also wonders whether a 1957 show of Gaudí's architecture at the prestigious Museum of Modern Art in New York City had a role in reviving Modernisme's reputation.

Since several Gaudí architectural sites will appear in the films discussed here, it is necessary to briefly describe them and relate their history. In so doing, Henry-Russell Hitchcock's catalog for the Museum of Modern Art exhibit will be most useful. Gaudí's first commission from the wealthy textile manufacturer Eusebi Güell (who would become his sponsor) was the Güell Palace, a mansion in the heart of Barcelona. It takes the traditional form of this type of grand dwelling, but bends it to the dictates of modernism. Thus, no element of either Beaux-Arts or Second Empire influence is evident. Hitchcock describes it as "exuberant" and "flamboyant" and finds particular interest in its Art Nouveau ironwork, which he deems "a masterpiece of decorative art of this period."[26] Here, it is interesting to note that Gaudí's father was a coppersmith and boilermaker, so metalwork was his trade.

Gaudí also collaborated with Güell on one of the latter's real estate ventures, which led to the creation of the Park Güell (built between 1904 and 1914). It contains numerous discrete spaces, among them the Dragon Stairway (curvilinear, branching, and decorated with colorful shards of pottery), the Hypostyle Room (composed of columns, as well as tile ceiling medallions), the Greek Theatre or Nature Square (an esplanade lined with curving benches overlaid "with a mosaic of the most heterogeneous bits and pieces of broken faience . . . like conglutinations of the waves of the sea"), and the Portico (with slanted columns [reminiscent of elephant legs] that together create the shape of a great wave).[27] As Hitchcock remarks, the park as a whole is characterized by "a strange biological plasticity [that] turns . . . structures into malleable masses as in some Gulliverian dream of vegetable or animal elements grown to monumental size."[28]

While working on the park, Gaudí began constructing an apartment building, Casa Battló (1905–1906), on the elegant Passeig de Gràcia. As Hitchcock notes, "The upper stories of the façade glitter with an abstract plaquage of broken coloured glass."[29] Furthermore, "the entire wall surface seems to be in motion and all edges waver and wind."[30] Hitchcock's mention of the surface is crucial since, in Gaudí's work and that of Catalan architects like Puig i Cadafalch, the surface, "not the three-dimensional form," was "its point of departure." Furthermore, according to Umbach, "nothing could be further from the truth . . . than to assume that this surface had no meaning. On this surface memory could be inscribed, not as

logical reconstruction, but as an enchanted program of playful allusions" that told "allegorical stories." Thus, "the surface replaced the structural grammar of architecture as the principal carrier of meaning."[31]

Commenting on the interiors, Hitchcock observes that they "seem to have been hollowed out by the waves of the sea."[32] He finds the rear facade of the building amazing with its "sinuous balconies."[33] Finally, he remarks on the incredible roof of the edifice with its "coxcombs" or "chimney-pots [that] provide a range of abstract sculptural features covered with polychrome tiling."[34] Here, once more, we see the dominant role of embellishment in the Art Nouveau style. For, as Sala observes, "The artist-decorator or designer became a sort of 'composer of ornament' . . . an 'assembler of images' who at times, in seeking synthesis, simultaneously fragmented it."[35]

With Casa Battló nearing completion, Gaudí built another apartment complex on the same street between 1905 and 1910—the Casa Milà (also known as La Pedrera, meaning "the stone quarry"). This was commissioned by a wealthy woman, Roser Segimon i Artells (who later married a man named Milá). According to Isabel Segura Soriano, "a very large number of women were interested in this new architectonic language [i.e., Art Nouveau]. They employed and financed the most modern architects to dress their houses for them." Furthermore, "they also opted for Art Nouveau culture."[36] Like Gaudí's other projects, the building is curvilinear and organic. The facade, according to Hitchcock, "curl[s] like paper at the edges" and resembles stone that has been subject to erosion.[37] Moreover, there are "no straight lines . . . and in the forms of the piers that rise from the ground to support the balconies of the first story [Gaudí] suggested natural formations. . . . These elements look as if they had been produced by the action of sea and weather rather than by the chisel."[38] Hitchcock finds "a marine note" in the building's ironwork. "Strewn over the balcony parapets and across many openings, like seaweed over rocks and sand of the seashore, the railings and grills are full of intense organic vitality." As for the interior, no two floors are alike and "the main rooms flow into one another while the watery curves of the plaster ceilings and the shell-like forms of the door trim echo the irregular shapes of various interior spaces."[39] Here, it is important to note that Gaudí also designed Art Nouveau furniture, which was used in many of his dwellings.

Many would consider Gaudí's greatest work to be one of his churches, the aforementioned La Sagrada Família, on which he toiled from the mid-1880s until his death in 1926—leaving it unfinished. Though marked by a Gothic influence, it has many modernist touches. The interior is light and airy, and the massive pillars look more like tree trunks than conventional columns. Furthermore, although the Nativity Facade that he executed beginning in 1903 depicts traditional Christian religious figures, it is "otherwise either very naturalistically floral or meltingly abstract."[40]

While celebrating Gaudí, Hitchcock makes several comments that alert us to the fact that the architect's work was often denigrated. He says that "a Gaudí building is like a ten-course dinner taken in one gulp" and may be "indigestible to all but the strongest stomachs."[41] And he observes that while "the architecture of Gaudí certainly makes a powerful impression on even the most casual observer," the impression is "quite as likely to be unfavorable as favorable."[42]

However, one of the champions of Gaudí and Art Nouveau in general was Salvador Dalí, a Catalan artist and sometime Barcelona resident who lauded the style and singled out his compatriot for praise. In fact, one of his paintings *The Enigma of Desire—My Mother, My Mother, My Mother* (1929) is said to pay tribute to the architect.[43] A few years after painting it, Dalí wrote on the topic in a piece entitled "Concerning the Terrifying and Edible Beauty of Art Nouveau Architecture," published in the journal *Minotaure* in 1933. He emphasizes the "irrational dynamism" of Art Nouveau, with its "profound depreciation of intellectual systems [and its] very accentuated decline of the reasoning faculty."[44] Similarly, he applauds Art Nouveau for its oneiric elements (like "condensation and displacement").[45] For Dalí, Art Nouveau even bespeaks insanity (for him, a good thing)—favoring "lunatics."[46] Interestingly, as we have noted in the introduction, Debora Silverman foregrounds ties between the style and the contemporaneous research of Jean-Martin Charcot that focused on hysteria, hypnosis, and hallucination, as well as on "the examination of visual dimensions of the thought process, with particular emphasis on the role of dreams."[47] Charcot's views were consonant with Art Nouveau's supreme appeal to the senses and the unconscious realm, as well as its goal to join "the practice of interior decoration to the unstable fluidity of the *chambre mentale*."[48] Ultimately for Dalí, Art Nouveau summons a "Return to Beauty" and the

need for "hyperaesthetic originality"—an antidote to the alleged ugliness of contemporary industrial society.[49] Thus, he celebrates Art Nouveau's "ornamental confusion."[50] In discussing works that portray Barcelona on-screen and draw on Gaudí's constructions for their production design, Dalí's analysis of Art Nouveau will prove both insightful and relevant.

## THE CINEMATIC IMAGINARY

When it comes to Barcelona in the movies, there are a few early documentaries. Some (*Barcelona and Its Park at Twilight* [1911]) were shot by Segundo de Chomón. Otherwise, there is *Barcelona by Tram* (1908)—a "phantom ride" down the Passeig de Gràcia, one of the city's most affluent boulevards. But, unfortunately, even though the street is one on which two of Gaudí's famous buildings stood or were being constructed at the time (Casa Milà and Casa Batlló), the film does not show either of these sites.

Actually, the most productive route for examining modernist Barcelona does *not* derive from the era of Art Nouveau's popularity, but rather from the contemporary epoch. Thus, there are a group of films by Spanish, American, and Italian directors that invoke Art Nouveau specifically through their emphatic use of the architecture of Gaudí as an element of their mise-en-scène. They include *Biotaxia* (1968), *The Passenger* (1975), *Costa Brava* (1995), *Gaudí Afternoon* (2001), *The Spanish Apartment* (2002), and *Vicky Christina Barcelona* (2008). Given this list, it is no surprise that the Catalan equivalent of the Oscar is called the Gaudí and is shaped like one of the sculptural towers on the roof of Casa Milà.

What is noteworthy about these Barcelona films is not simply how they plant Gaudí's monuments within their fictional worlds, making his edifices the "co-stars" of their dramas, but how, to one degree or another, their narratives invoke themes that are aesthetically embedded in Gaudí's work, as well as in the poetics of Art Nouveau. Thus, despite Art Nouveau's association with superficial ornamentation, these Gaudí locales do not simply garnish the films; rather, they are central to their underlying metaphysical concerns, which involve such issues as impossible love, identity crisis, sexual confusion, irrationality, social disruption, enigma, and fantasy.

The most renowned and challenging film of the contemporary group is *The Passenger* (directed by Michelangelo Antonioni, with screenplay by Mark Peploe and Peter Wollen and art direction by Piero Poletto). On a personal note, I recall seeing the film when it opened in New York, and the only things I subsequently remembered about it were the astonishing sequences shot in Gaudí locales—though I had no idea who the architect was at the time. I like to think that it was this sensory viewing experience (brewing within me for some four decades) that led to my writing this chapter.

The film concerns David Locke (Jack Nicholson), a television reporter working in North Africa who finds that, while staying there, a fellow European hotel guest has died. Seemingly on a whim, he switches identity with the deceased (who resembles him) and "becomes" David Robertson—telling the staff that the dead man is David Locke (i.e., himself). He then sets out on a meandering journey that takes him through diverse geographical settings: North Africa, Munich, London, and Barcelona. In the process he meets a nameless young woman (Maria Schneider) with whom he has an affair, and she joins him on his aimless, escapist voyage. When he tells her, "I used to be someone else but . . . [I] decided to trade him in," she wryly responds that she is now "talking to someone who might be someone else." There are more plays on identity, as when Locke tells her that he fears someone will recognize him, and she coyly responds (having just met him), "*I* don't recognize you." By the end of the film the real Locke lies dead in a rural Spanish hotel room—his ruse having become reality.

Significantly, the woman whom Locke meets is an architectural student, a detail whose import should not be underestimated. He initially sees her in London on the steps of a famous architectural site: the modern Brunswick Centre in Bloomsbury. But he first converses with her in Barcelona when, fleeing some men who are following him, he ducks into Gaudí's Güell Palace and finds her sitting on a bench reading (see figure 3.1).

Their conversation is incredibly strange. He confronts her by saying, "Excuse me, I was trying to remember something." When she asks if it is important, he says, "No," and adds that he came into the building "by accident." She then responds that the man who built the edifice was "killed

**3.1** David Locke (Jack Nicholson) in *The Passenger* (1975, Michelangelo Antonioni) ducks into Antoni Gaudí's Güell Palace in Barcelona where he meets a mysterious young woman.

by a bus." (When Locke inquires of whom she is speaking, she responds, "Gaudí," who was in fact run over in traffic.) Thus, their conversation (seemingly a series of non sequiturs) is as unexpected as the look of the Güell Palace itself. It is important to note that the Güell Palace is an early work by Gaudí (1888)—which, while having modernist elements (e.g., its strange, abstract roof sculptures and its whiplash facade grill), is equally marked by neo-Gothic forms. The woman plans to visit other Gaudí buildings because, as she opines, they are "good for hiding in" (a feature appealing to Locke, who is on the run). Later, he tracks her down at Casa Milà (see figure 3.2).

He ascends to its roof—with its bizarre chimneys and vents—and wanders around it, as though through a maze, a modernist Wonderland, or on a roller coaster (see figure 3.3).[51] (On the DVD release audio commentary, Jack Nicholson remarks on how the roof constructions look like totems or hooded men.)[52]

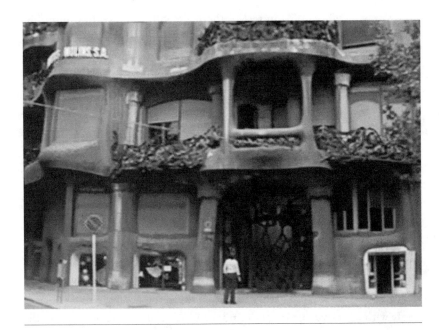

**3.2** David Locke (Jack Nicholson) in *The Passenger* (1975, Michelangelo Antonioni) standing before Antoni Gaudí's Casa Milà in Barcelona.

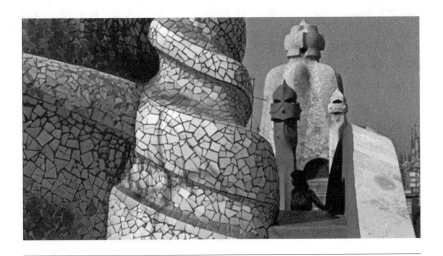

**3.3** The Woman (Maria Schneider) in *The Passenger* (1975, Michelangelo Antonioni) on the fantastical roof of Antoni Gaudí's Casa Milà in Barcelona.

By now, *The Passenger*'s interest in the malleability of identity should be clear, but what does this and the film's other concerns have to do with Gaudí's corpus or Art Nouveau in general? Here, we will draw on the tendency of critics to see the architect's work not as purely formalistic, but as highly "metaphorical."[53] Antonioni talks of how the Gaudí towers are perfect for "reveal[ing] . . . the oddity of an encounter between a man who has the name of a dead man and a girl who doesn't have any name" at all—the perfect scenario for the burgeoning of *l'amour fou*.[54] His words signal a broader interest in architecture and its use in making semiotic statements. As Frank Tomasulo writes, "No European filmmaker epitomizes the metaphorical and dialectical use of modern architecture more than does Michelangelo Antonioni."[55] Not surprisingly, Antonioni entitled his book of musings on the cinema *The Architecture of Vision*. Beyond the built environment, of course, location in general is paramount in the director's style. As he notes, it "is the very substance of which the shot is made."[56]

Dalí talked of Art Nouveau's replacement of the boring and rigid right angle with a "convulsive-undulating formula" and remarked on how "the curved line" had become "the shortest . . . route between one point and another."[57] Not only does the "undulating curve" seem to mimic Locke's mobile subjectivity, but Dalí's statement on trajectory seems to parallel Locke's ambling spatial route. Significantly, Locke's journey starts in North Africa, whose architectural arabesques were a primary influence on Gaudí's designs, and moves through England and Germany—two sites where Art Nouveau blossomed. Further, as Ned Rifkin has observed, "The shattered segments of marble" that line the structures on the roof of Casa Milà "are pointed and sharp looking, creating a rather poignant correlative of this man . . . trying to piece together remnants of two lives so that they fit."[58]

For Dalí, Art Nouveau (like Locke) seeks to annihilate history. (Recall that one of Locke's first statements to the woman is that he is "trying to remember something"). As Dalí notes, "architectural elements of the past . . . [are] submitted to a frequent and complete convulsive-formal grinding that will give birth to a new stylization."[59] Furthermore, Dalí, like others, sees the character of Art Nouveau as entirely eclectic—denying fixed categories and wildly conjoining Moorish, organic, medieval, Baroque, and Indian influences.[60] As he writes, "In an Art Nouveau building, Gothic is transformed into Hellenic, into Far-Eastern . . . into Re-

naissance."[61] Thus, he celebrates the movement's "terrible impurity."[62] He also praises Gaudí's ornamentation, which "freezes the convulsive transitions of . . . the most fleeting metamorphoses," and lauds the architect for his "proud decorative amnesia."[63] All of these qualities (fluid identity, historical erasure, intentional memory loss) seem to apply to David Locke as well, who is attempting to escape his past, profession, and person.

Another theme of *The Passenger* is the sense of irrationality that attends to much of its dialogue, as well as to Locke's decision to switch identities. We learn that he is a well-respected journalist working on an important story in North Africa about how the so-called Independent Liberation Group is supplied with arms. As Locke learns later, Robertson (the man whose identity he steals) was a gunrunner; so taking on his persona is a dangerous and inexplicable enterprise. There are vague references to "trouble" in Locke's marriage, but few details are given. Neither does there seem to be a good reason for the woman to accompany him on his peripatetic trek; even he doesn't comprehend why she is with him. It is precisely this "irrational dynamism" that Dalí appreciates in Art Nouveau.[64]

Another way of phrasing Locke's behavior would be to say that he is insane. And here we note that, in talking to the woman, Locke asks whether Gaudí, himself, was crazy. Again, for Dalí, Art Nouveau invokes madness (a state to be valued), and he associates the following terms with the style: "lunatic," "psychopathological," "hysterical," "deluded," "perverse," "megalomaniacal," "frenzied," and "exhibitionist."[65] A more measured critic like Arthur Drexler also sees Gaudí's work "against the background of psychoanalysis" and wryly remarks on how other architects may have preferred "to dissipate" their disturbing impulses "on the analyst's couch."[66] The general connection between architecture and the builder's psyche has also been made by Nikos Sideris in *Architecture and Psychoanalysis: Fantasy and Construction*. In it he quotes historian William P. Curtis as saying, "A great architectural creation is like a symbolic world with its own empires of imagination, its own mental regions and its own inner landscapes"—a statement that might well be applied to the work of Gaudí.[67] Related to this, as we have seen, Dalí sees Art Nouveau as having "oneiric elements."[68] Following his line of thought, it would not be a stretch to see the sprawling, elliptical, purposeless narrative of *The Passenger* as a prolonged dream.

For André Breton, Art Nouveau with its lush sensuality is the "realization of solidified desire," and for Dalí involves "the majestic birth into unconscious erotic . . . tendencies." Thus, for the latter, an Art Nouveau dwelling is "a house for erotomaniacs" with its biomorphic columns of "feverish flesh."[69] Here we recall that in changing identities Locke has abandoned his wife and pursued his ardor for a beautiful young woman—an obscure object of desire, if ever there was one.

As we have noted, Art Nouveau is iconographically linked to the feminine. So a Gaudí building would be an ideal place to meet a female lover. A propos, Tomasulo notes Antonioni's "use of Gaudi's phantasmagoric Art Nouveau structures" and comments on how they "replicate the sensuality of the unnamed [female] character."[70] Similarly, in speaking of Gaudí's architecture, one critic opines that his "rooms and caves are archaic with female swellings,"[71] conjuring a womb-like space; and another remarks that Barcelona, itself, "is a very . . . female city."[72]

But desire is not always sexual and can, instead, seek human liberation, as in the desires of the fictional North African guerillas in *The Passenger* and the real Catalan nationalists who long sought separation from Spain. Gaudí himself was beaten by police for participating in a Catalan-language literary event called the Jocs Florals in 1920. Again, in 1924, when he was seventy-two years old, he was struck for refusing to speak Spanish during a protest against the banning of the Catalan language. In fact, Alfred Bosch asserts that the four towers of the facade of La Sagrada Família represent the four stripes in the Catalan flag.[73]

Clearly, in fleeing his life, Locke is searching for "liberty"—a quality that Dalí associates with Art Nouveau.[74] Even Walter Benjamin admitted that one of the movement's major motifs was "emancipation"—though he considered it a "false liberation."[75] The fact is crucial that, in *The Passenger*, the protagonist's real name (Locke) has implications of imprisonment, a point emphasized by the bars on the window of his final hotel room. This view is underscored by Antonioni himself who says that Locke is "fascinated by the promise of the liberty that he expects will follow [his identity change]."[76] William Arrowsmith, too, views Locke's move from the Güell Palace to the Casa Milà in pursuit of the woman as a move against restriction. While the Güell Palace is a kind of "birdcage," characterized by "religious gloom [and] the sense of the medieval past in [its] dark enclosing tex-

tures," in the Casa Milà "the sense of the architectural birdcage abruptly vanishes. It is open space, not enclosing interiors and cubicles."[77] Alternately, some critics have seen Locke's search as precisely a religious one—a point tied to Gaudí through the architect's own spirituality and work on the monumental La Sagrada Família. Theodore Price sees Locke's quest as one for "the meaning of life." As he notes, "Locke's death takes place in a hotel (the Hotel de la Gloria) near a bullring, where we hear a trumpet sound. (Earlier in the film Locke is shown in a Rococo German church, with the Stations of the Cross prominently displayed behind him.)"[78]

*The Passenger* also tells a highly confusing story.[79] It starts in medias res with a then-unidentified man (Locke), in what looks like North Africa, making contact with an unidentified native for an unidentified purpose. It proceeds via ellipsis as sudden cuts take us (without any cues) from one locale to another. Such leaps also whisk us from one time period to another, as when flashbacks—that only retrospectively can be identified as such—suddenly intrude. In some sequences we are unsure of the temporal status of the images we are watching, as when we view a close-up of an African man being executed, only to learn from a full shot that the footage is from the past—now being viewed on a Moviola.[80] Even acoustic elements are purposely perplexing. In the North African hotel sequence, we keep hearing a loud, insistent, off-screen motor buzz that only later is tied to a close-up of a whirring ceiling fan. All this leaves the spectator feeling dizzy and baffled, as though we, too, were rambling through Gaudí's roof maze or twisting around one of his spiral towers.

Once again, the style of Art Nouveau is identified with these sensations. Filmmaker Hiroshi Teshigahara, who made a documentary about Gaudí, says that upon entering Casa Milà he "was overpowered by a sensation . . . like vertigo."[81] Similarly, in another film set in Barcelona, *The Spanish Apartment*, prospective lovers meet atop La Sagrada Família where the woman proceeds to faint—a fact never addressed or explained within the narrative.

Finally, buried in *The Passenger* is a discourse on Beauty. When Locke and the woman arrive at their final destination, she looks out the window and he asks her what she sees. Among other things, she mentions dust, and comments on how terrible it would be to be blind, which seems another concept invoked by the window bars. Again, Art Nouveau and the work of Gaudí are known for their abundant visuality—their unapologetically

gorgeous, exuberant, "exhibitionist" aesthetics composed of arresting, whimsical forms, bold colors, and elaborate decoration. Dalí, who speaks of Gaudí's "intangible ornamentation," compares his edifices to fancy confectioner's cakes and claims that he'd like to eat them.[82] To achieve this splendor, Gaudí (with the assistance of Jujol) often tiled the surfaces of his buildings with multihued, iridescent pottery shards, or what Henry-Russell Hitchcock called "agglutinated rubble."[83] Thus, like cinema, Gaudí's art is often compiled of light-capturing fragments, conjoined in montage.

For Dalí, Gaudí and Art Nouveau represent a "Return to Beauty."[84] Like a true surrealist, Dalí applauds Art Nouveau's "aesthetic unconsciousness" and "ornamental automatism"; and here we might note that Gaudí's designs were often so intuitive that they could not be translated into formal plans.[85] Clearly, Antonioni stands as another modernist esthete—a director who painted trees and plants white when filming *The Red Desert* (1964), a work whose heroine lives in an antiseptic, modern house and is depressed by the grim, soulless, industrial world around her, precisely the kind of universe for which Gaudí's dazzling buildings served as a corrective.[86] Interestingly, in *The Passenger*, a flashback finds Locke speaking with Robertson in Africa, as the latter comments on how he finds that places he travels to all look the same. For Antonioni, it is the unique that rules his production style. As he notes, "every sequence in [*The Passenger*] uses its own particular technique. I can't even say whether there is a coherent, uniform style. . . . I felt the need to present myself, afresh, in a free way, in confrontation with every new part of the film. In shooting, this system has allowed me a feeling of great joy."[87]

At the end of *The Passenger* Locke tells his female companion a story, whose theme is vision, in the moments before he takes his own life. He speaks (in the manner of a parable) of a blind man who regained his sight after forty years—regrettably finding the world visually poorer than he had recalled. Encountering dirt and ugliness everywhere, he killed himself. As Locke finishes, the camera pans up the wall to a framed landscape painting—a reminder of the potential glory of the natural world—though pictured here in banal, cliché form.

There can be no doubt that Gaudí's creations (strategically present in *The Passenger*) unapologetically seek to add adornment to the dull, built

environment—making it more palatable. They may not have saved the film's protagonist, David Locke, or the man in his parable, but they may yet redeem us—if we are open to their power. This perceptual process seems registered in the famous final nine-minute mobile shot at the end of the film. The camera moves slowly into the barred window and "miraculously" passes through (or transcends) it. In truth, we have barely noticed that the window bars slowly part, allowing the camera an unimpeded view as it traverses the space between inside and out.[88]

While Antonioni's *The Passenger* is the most interesting and complex of the films that employ Gaudí's architecture as mise-en-scène, there are others that help make the broader case that the use of these sites draws on the poetics of Art Nouveau. *Biotaxia* is directed by José María Nunes—born in Portugal but immigrating to Spain at age twelve and remaining there throughout his life.[89] It is another "Art Film" and hits all the marks of the genre as described by David Bordwell in *Narration in the Fiction Film*: plotlessness, character subjectivity, a protagonist in crisis, musings on the meaning of life, and innovative visual and acoustic strategies.[90] In fact, as we watch the film, we are constantly reminded of works by other modernist directors like Jean-Luc Godard or Antonioni himself. The meaning of the term *biotaxia* ("the systematic classification of living organisms") is provided in a title at the start of the movie and will have implications for the drama.

To the extent that there is any story line at all, the film concerns two figures: María López (Núria Espert), a wife, mother, and actress who is dissatisfied with her life and marriage, and Pablo Busoms (José María Blanco), a writer with whom she has an affair. In actuality, throughout the film we are barely aware of their names, and they are presented rather anonymously, much like the woman in *The Passenger*. Furthermore, María's husband is never seen, except on one occasion as an amorphous shape under blankets in bed. Because the film keeps shifting from present to past, and because, at the outset, we are unsure of which time period we are witnessing, the narrative can only be reconstructed ex post facto.

The experimental nature of the film is apparent from the opening shot—a close-up of María staring at the camera (and thereby at us) for about four and a half minutes as an unidentified male narrator catalogs her defining features (she is married, has a scar, etc.) and talks of her life

as a collection of "dead days." Only later do we realize that this is the voice of Pablo—her lover from the past. Soon a woman's voice (which we subsequently learn is María's) is heard as well, speaking of her need to open doors and windows. A long shot reveals her to be in an upscale apartment in which she obviously feels suffocated.

We then see brief visions of María and Pablo walking on the street or sitting in a café, and we infer that these are flashbacks to a time earlier than the opening of the film (its "present tense") when the two were paramours. In voice-over narration, Pablo asks whether María wants to change her life, and she speaks of "recalling but not remembering" their affair.

The film follows this confusing pattern, intermixing present and past moments. Generally, it employs voice-over narration and moments of roughly synchronized dialogue (never fully convincing)—lending the film a distanced quality. Other Art Film techniques are utilized: segmenting María's body into diverse, corporeal close-ups; posing the couple in an abstract, unidentifiable space (in which they glide down a slide, or climb "monkey bars" in a black void); providing imaginary sequences (of María on stage taking off her wig, or of a man announcing that she will not perform); including metaphorical shots (of María, her face pressed against glass to portray being "caged"). While, on one level, the film tells a familiar tale of a bourgeois woman entombed in a conventional loveless marriage who is enticed by a romantic lover (as in novels like *Madame Bovary* [1856] or films like *A Married Woman* [1964]), *Biotaxia* was made during the Franco era, so it has an additional layer of meaning attached to its vision of social constraint.

The film's major interest, however, lies in the location highlighted in its first title, "Shot in Gaudí's Barcelona," and, at various points in the narrative, the couple or a character individually is seen in one of the architect's famous sites. The first of these depicts María and Pablo at La Sagrada Família, and we see the building from various perspectives: at street level, from a hill above, in pan shots of its spires and facade. While there, Pablo tells María that it was made by a "man of faith" and that she should fully apprehend it. He asks whether she loves her art or is content with banality, and says that he wants to "shake her up." Clearly, for him

the site represents the pinnacle of creativity and integrity, and he is using it as a counterexample to what he sees as her tedious, traditional life.

In a subsequent scene, we find Pablo in the Park Güell telephoning María, who is in bed. He wants them to run away together and requests that they meet. Interestingly, in several shots in this sequence, the camera enacts dizzying circular pans and there is sometimes a mismatch between him (shot in daylight) and her in bed (ostensibly at night). Also, in one unrealistic shot, we see them both on the telephone in the same space, separated by one of the columns of the park's Hypostyle Room. We later learn that María acceded to his entreaty and left home to meet him. Hence, we see her descending a gorgeous Art Nouveau staircase and opening a modernist front door. We learn, however, that Pablo never showed up—having been convinced against doing so by his friend Joaquín (Joaquim Jordà), who thinks the affair will destroy him.

A later sequence (that we retrospectively identify as "the present") shows María on the street at night trying to track Pablo down some years after their romance has ended. She goes to the apartment of a woman he used to date who lives in the Casa Milà. While we don't see the exterior of the edifice, we do see María wander through its arched, cavernous attic as though she is trapped in a labyrinth—clearly a trope for her unsatisfying life situation. Interestingly, Pablo's ex-girlfriend is associated with his nonconventional temperament; he has earlier described her as free, irresponsible, a jazz lover, and a teenager at heart. Again, by inference, this sense of liberty becomes identified with the Art Nouveau site in which she lives and opposed to the staid bourgeois conformity of María's life.

Intercut with shots of María in the arch maze questioning the terms of her existence are flashbacks to her and Pablo on the roof of the Casa Milà—with its bizarre sculptural chimneys and vents. Here, Pablo speaks of talent (his and hers)—again an issue that relates to Gaudí's inventiveness. In another flashback taking place there, Pablo accuses María of speaking in clichés, a charge impossible to make regarding Gaudí. There are also flashbacks to the couple by the dragon-shaped metal gate at Gaudí's Güell Estate (St. George and the Dragon being Barcelona's foundational myth). Again, they speak of talent—a significant topic given the ingenuity associated with Gaudí and Art Nouveau.

María continues to meander around Barcelona at night—wandering being another characteristic of the Art Film. Intermittently, there are flashbacks of the couple's affair, and we see them playing hide-and-seek in Park Güell's Hypostyle Room—another representation of their inability to connect. Again, Pablo's voice-over speaks of wanting to shatter María's hypocritical facade and re-create her. In fact, he wishes to remake the universe (something that Gaudí did with his experimental architecture). In yet other, seemingly imaginary, scenes Pablo interviews people on the streets of Barcelona, asking them what they would want from a refashioned world—a dangerous question in the Franco era.

In sum, *Biotaxia* utilizes the architecture of Gaudí not simply as a stunning location for a film set in Barcelona. It also seems identified with various themes that have relevance to Art Nouveau as imagined by Dalí and others: *l'amour fou*, fluid identity, creativity, passion, and freedom—all opposites of the kind of dry, taxonomic classification implied in the film's title. Taking an alternate perspective, Anna Cox, in her dissertation on the "Barcelona School" of filmmakers, focuses more on the Franco-era context when directors like Nunes struggled to make experimental movies while the administration favored socialist-realist works identified with Madrid.[91] Thus, she sees Nunes's works as reflecting the "problems of urban space under Franco, showing how characters . . . struggle to learn to act in their own new ways under such governance."[92] Furthermore, she feels that in utilizing Gaudí sites Nunes "plays on the fact that these are spaces that have been appropriated by the dictatorship for tourism" and asserts that "this is why he uses them as the settings of a thwarted sexual encounter."[93]

Clearly, it is crucial to understand the implications of the time in which the film was made; and Pablo's desire to "re-create the world" has political inferences beyond the love affair depicted (although presented in a rather veiled way). But almost all Art Films of this era, whether made under Fascism or not, concern the impossibility of heterosexual relations, especially within marriage. Thus, Antonioni's *The Red Desert*, Godard's *A Married Woman*, Federico Fellini's *Juliet of the Spirits* (1965), and Ingmar Bergman's *Persona* (1966) all critique matrimony and are works made in alleged democracies. Though perhaps tainted by Fascist attempts to promote tourism, the Gaudí sites depicted in *Biotaxia* are not entirely sub-

**3.4** The opening title of *Costa Brava* (1995, Marta Balletbò-Coll) depicts the facade of Antoni Gaudí's Casa Milà in Barcelona.

sumed by them, and still manage to represent a more utopian stream of Catalan existence. Of course, all utopias are destined to fail—whether inside or outside of Fascist states.

Interestingly, tourism itself is at the heart of another film set in Barcelona, though in the post-Franco era—*Costa Brava*, directed by Spanish filmmaker Marta Balletbò-Coll. It is an innovative, independently made romantic comedy, which was shot in fourteen days with donated 35-millimeter film stock. It concerns Anna (played by the director), who is a tour guide in Barcelona, and we intermittently see her on a bus talking to tourists, who always remain off-screen. Ironically, we do not have any extended sequences of her leading tours to famous Gaudí sites, which are usual stops on this kind of trip. Throughout the film, however (as well as in the opening title sequence that depicts Casa Milà), we get other brief glimpses of the architect's creations: Casa Batlló, Casa Milà, the Park Güell (see figure 3.4).

The one site that receives considerable attention is La Sagrada Família, which we see intermittently in fleeting images, but also more regularly from the rooftop of Anna's residence. In addition to being a tour

guide, she is a playwright; and throughout the film we see her perform original "monologues" on her roof—part of a work she has entitled "Love Thy Neighbor." In the background, obscured by clothes hanging on lines and TV antennas, we see the spires of La Sagrada Família.

When we first witness Anna enacting a monologue (by speaking directly to the camera), we do not realize that it is a theatrical piece and that she is performing a role. Later on, we see people filming her and holding cue cards, so we begin to understand the context. The title of her play is rather ironic, since in these scenes she often complains about her lesbian neighbor. She is surprised, for instance, that the woman is in finance and not a sports figure ("They're everywhere!" she exclaims). In another rant, she is shocked that the woman does not conduct orgies and opines that her lesbianism may be due to deficient hormones. In these sketches Anna also talks about her husband Carlos. In fact, Anna is unmarried, and her vignettes are entirely fictional and tongue-in-cheek. At least at the onset of the film, not much love is lost on her fellow apartment dwellers.

Despite teasing us by invoking Gaudí's buildings while withholding them from sight, the film makes them a central part of the film's setting and atmosphere—not surprising for a work about tourism. What is interesting is that, like *The Passenger* and *Biotaxia*, the film foregrounds issues of fluid identity and opposition to the restrictions of habitual bourgeois life. As we have seen, these are themes associated with Art Nouveau.

In the course of Anna's professional duties, she meets a younger Israeli woman who has grown up in the United States, Montserrat (Desi del Valle). On the day of her tour, Montserrat develops a headache; Anna tells her to wait behind and hands over her pocketbook, which contains aspirin. When Montserrat looks inside the handbag she also finds a copy of Anna's monologues, which she peruses. When Anna returns, Montserrat asks if she can finish reading the manuscript, to which Anna replies: "Do you like to read between the lines?" (the same thing we have had to do in apprehending Anna's rooftop soliloquies).

The two women become friends and socialize occasionally. Montserrat is an engineer who is teaching and researching at a local Barcelona institution. She tells Anna about her troubles with men—how something is always missing with them despite her enjoying the sex. Realizing from Anna's play that she is a lesbian, Montserrat asks her when she "knew" her

sexual orientation. Montserrat then reveals that she once had a relation-ship with a woman. On a trip the women take to the Costa Brava, they become romantically involved.

Their affair proceeds with ups and downs. At one point, Montserrat says that their relationship cannot work because, in the science commu-nity (unlike the arts), things are conventional. She recounts how, at re-ceptions she attends, there are only heterosexual couples. "Our society isn't ready for this," she proclaims. Nonetheless, Montserrat moves in with Anna, but her doubts continue. She tells Anna that she has not entirely given up thoughts of sleeping with men; Anna responds that loving a bisexual woman is like having indigestion.

Anna's rooftop monologues continue with a focus on her fictional les-bian neighbor. She describes stopping by the woman's apartment and hav-ing trouble meeting her eyes. When she does, she has "cramps": "I want something but don't know what I want because I'm not a lesbian." In an-other speech, she describes a dream she had. Her neighbor was atop La Sagrada Família while Anna was atop the Eiffel Tower asking why women had lower salaries than men. Her neighbor said it was due to the "enor-mous satisfaction you're supposed to get from orgasm by penetration." "I don't understand," Anna retorts. "The orgasm achieved through pene-tration is statistically insignificant." In another monologue, Anna says that her neighbor lectures her about the male-oriented world of psychoanaly-sis, as well as its pragmatics and syntactics—peppering her talk with the word "phallus." Critiquing the woman's academic jargon, Anna uses a simple metaphor: male anatomy is like having a big car and needing to worry forever about where to park it. In a final monologue, Anna speaks of having a drink with her neighbor and later finding herself in a shower with her. "I never knew sex could be so tender," she says, and continues, "You know, I love Carlos, but [with him] it's kind of rudimentary. With her it's great." So now, the title of Anna's play "Love Thy Neighbor" truly fits, though it has been transformed from referencing a moral parable to a sexual tryst. Though Anna sends her play to numerous venues in Barcelona, it is rejected by all. One important producer tells her that a housewife's monologue is "of no interest whatsoever."

Her fictional soliloquies do, however, say something important about the kind of identity flux that we have seen in *Biotaxia* and *The Passenger*, though

here it pertains to sexual preference and object choice. Of course, the theme also has relevance to the "real" figure of Montserrat, who is unsure of her sexual makeup. Even when Anna lists her own dilemmas, she mentions having "identity problems up [her] ass." Confusions about conventional gender roles also come into play when Montserrat accuses Anna of acting like she "has a penis" because she is so goal-oriented and ambitious. On the other hand, Anna reminds Montserrat that it is she who does all the housework (more traditionally associated with women).

Throughout the film there is mention of a Tramontane wind blowing, which generally means gusts from "over the mountain." Beyond referencing a weather condition, the term has come to signify something "strange" or "foreign" in general. This becomes a working metaphor both for lesbianism (with which Montserrat and Anna's fictional persona must struggle) and, perhaps, also for Montserrat's Judaism (which is signaled by Middle Eastern music that plays in scenes depicting her alone). There is a running joke throughout the film that whenever one of her male coworkers asks her out, she tells him it's a Jewish holiday. On a more serious note, Montserrat reveals that her ancestors lived in the Catalan town of Girona (which had a Jewish ghetto in the Middle Ages), but fled during the Nazi era, hiding out in the nearby monastery of Montserrat (her namesake). After being fired from her research job, Montserrat visits the town and we see her looking at ancient Hebrew tablets and exploring old streets. Of course, there is an even longer history of Spanish persecution of Jews, dating back to the Inquisition of the fifteenth century. So, for Anna (ostensibly born a Christian), Montserrat represents the Other, and she jokes about the two eating bagels together in New York. In a sense, the women must traverse a "brave coast" (a *costa brava*) in more ways than one.

The end of the film is rather unsatisfactory. Montserrat gets a job in San Francisco and Anna is devastated. Though her play has been rejected by all local funding sources, a San Francisco group, the Next Stage Company (a gay and lesbian theater association) accepts it for an upcoming tour. Thus, she can join Montserrat in the United States and the two women can continue to live together and be "happy ever after." Anna has prayed for this occurrence and has been shown meditating in a church.

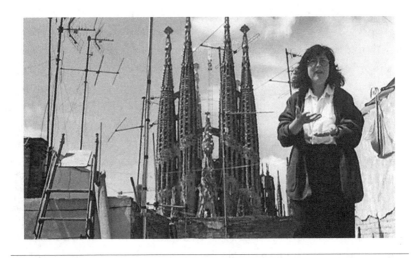

**3.5** When Anna (Marta Balletbò-Coll) delivers her monologues on her Barcelona apartment building rooftop, Antoni Gaudí's La Sagrada Família is seen in the background.

She believes not in a god, but a goddess, who is "50% Jewish, 50% Catholic and understanding of Catalan people."

Throughout the film, when the spires of La Sagrada Família appear in the background of rooftop scenes obscured by laundry and antennas, the shots seem to have an ironic tone (see figure 3.5).

After all, like many tall buildings, they are iconographically phallic, and church doctrine hardly supports homosexuality (the "sacred family" after all is not composed of a same-sex couple). Furthermore, sometimes during Anna's monologues, the noise from the church (either crowds, tour guides, or chanting) interrupts her performance. At the end of the film, when Anna's prayers are magically answered—we are disappointed that the earlier religious critique seems muted. In fact, the final shot portrays the blissful couple merrily running down a street with Gaudí's church in the distance.

Another film shot in Barcelona—*Gaudí Afternoon,* directed by Susan Seidelman—is a light-hearted comic mystery. It concerns Cassandra Riley (Judy Davis), a translator of Latin American literature who resides there. She is struggling over the text of the novel *La Grande,* which concerns a

troubled mother-daughter relationship. At the beginning of the film, we see her typing at her computer while images on-screen periodically break in with live-action footage to illustrate the novel's story line, which is set in a jungle but actually shot in a Barcelona arboretum. Soon, a strange woman named Frankie Stevens (Marcia Gay Harden) appears on her doorstep and asks Cassandra to track down a missing person—her gay ex-husband, Ben. Not being a detective, Cassandra declines at first, but eventually accepts the job because she is short on cash. For the assignment, she adopts the pseudonym of Bridget O'Shaunessay—one that is almost identical to a character from the classic film noir *The Maltese Falcon* (1941). Frankie shows Cassandra where Ben lives (the Casa Milà) and asks her to photograph everyone who leaves the building so that she can identify Ben. At some point, a woman, April (Juliette Lewis), shouts out Ben's name to a couple exiting the building, and Cassandra furiously takes pictures of the man, assuming that he is the one she is seeking. When the couple drives off, she follows April to the Park Güell where we hear a tour guide lecturing on Gaudí's monument and see its stairway entrance and pavilion with tiled benches (see figure 3.6).

**3.6** Cassandra (Judy Davis) in Antoni Gaudí's Park Güell in Barcelona in *Gaudí Afternoon* (2001, Susan Seidelman).

As April encounters the couple there, we learn that Ben is not the man we have seen, but the woman—Bernadette Harris (Lili Taylor)—who is dressed in masculine "butch" clothing. She and April are lovers, and the man is a homosexual magician friend, Hamilton Kincaid (Christopher Bowen).

Later, Cassandra meets Frankie at a bar and, following her into the ladies room, finds her standing to urinate, revealing that she is actually a biological male, now a "pre-op" transsexual. Ben is the woman to whom Frankie was married, and Frankie now wants to find her in order to gain guardianship of their daughter Delilah (Courtney Jines). The rest of the story, with its twists, turns, and antic chases, revolves around the couple's custody battle over their child.

Clearly, like *Costa Brava*, *Gaudí Afternoon* is about identity flux of a sexual kind—but in a more exaggerated form. Again, both the blurring of categories and the focus on desire are elements that Dalí sees as inherent in Art Nouveau and the work of Gaudí. We have already mentioned a sequence that takes place in the Park Güell, and a later chase takes place there as well. Furthermore, while we see the exterior of Casa Milà in certain shots, when we see the apartment inside (inhabited by Ben, Hamilton, April, and Delilah), it is actually the interior of the Casa Batlló, and a nighttime chase takes place on its multicolored sculptural roof. Yet another rendezvous point for Frankie and Cassandra is a chapel built by Gaudí for the Colonia Güell outside of Barcelona in Santa Coloma de Cervello (though it doubles for La Sagrada Família here). Interestingly, in this scene, when Frankie promises to pay Cassandra for her work, she pledges "Girl Scouts' Honor." Cassandra points out, however, that she has given the Boy Scout salute instead.

The sense of magic that we saw at play in the Art Nouveau films of Segundo de Chomón is also evident in *Gaudí Afternoon*. At one point in her search, Cassandra visits the Presto Club where Hamilton is performing. Though she demurs, he pulls her on stage, puts her in a coffin-like box, pulls a red curtain over it, and makes her disappear—only to have her reappear later on. While on stage (wearing heavy makeup reminiscent of Joel Grey as the master of ceremonies in *Cabaret* [1972]), Hamilton lip-synchs a Dean Martin song accompanied by a chorus of male drag performers in tropical Carmen Miranda garb. The song is "Sway," which seems to imply oscillation and change.

Soon Cassandra is implicated in the theme of sexual confusion as well—accused of this by her upstairs neighbor, Carmen (María Barranco), who is troubled by the kind of people involved in the case Cassandra is handling. In one sequence, there is also a veiled lesbian "flirtation" as April massages Cassandra's feet and tells her to "let go." At the very end of the film, which takes place in the airport as Cassandra leaves for the United States (to repair her troubled relationship with her mother), she encounters April who asks her to "give girls a chance." Playfully, Cassandra kisses her lightly on the lips. Significantly, a moment before this happens, Cassandra has been toying with a postcard emblazoned with a photograph of Gaudí.

In the director's commentary on the DVD release, Seidelman admits that the movie was "inspired by [Gaudí's] designs," and that the credit sequence was meant to invoke the Art Nouveau style with its "sensual curves."[94] Given the look, locale, and themes of the film, it is not surprising to learn that, in making it, Seidelman employed a crewmember who had worked with Pedro Almodóvar (her title designer—who created some of Almodóvar's film posters) (see figure 3.7).

Of course, one of Almodóvar's own movies, *All About My Mother* (1999), also takes place in Barcelona and includes shots of La Sagrada Família and other Art Nouveau buildings not designed by Gaudí. Furthermore, like *Gaudí Afternoon*, which entails a complex maternal discourse (as represented by the novel Cassandra is translating, her own struggles with her mother, and Frankie's transsexual parenthood), *All About My Mother* concerns a woman

**3.7** The Art Nouveau title design for *Gaudí Afternoon* (2001, Susan Seidelman).

whose deceased son was conceived by a cross-dressing male and a novitiate nun. Once more, muddled sexuality reigns supreme.

There is also an Almodóvar connection in the cast of Woody Allen's *Vicky Cristina Barcelona* through the appearance of Penélope Cruz, who performs in *All About My Mother* as well as in Almodóvar's *Volver* (2006). The same is true of Javier Bardem, who acted in the Spanish director's *High Heels* and *Live Flesh* (both 1991). Furthermore, there is the obvious fact that both performers are Spanish.

For the past twenty years, Woody Allen (having played out his love affair with New York City) has made films in European locales. Of course, he may also have been motivated to leave the United States by his controversial romance with (and later marriage to) Mia Farrow's stepdaughter, Soon-Yi Previn, as well as by charges of child molestation brought by another of his stepchildren. In 1996 he made *Everyone Says I Love You* in Paris and Venice; in 2005 he made *Match Point* in London; in 2011 he made *Midnight in Paris* in France; in 2012 he made *To Rome with Love* in Italy; and in 2014 he made *Magic in the Moonlight* in France and England.

*Vicky Cristina Barcelona* is not only set in Barcelona, but one of its heroines, Vicky (Rebecca Hall), has come to the city as an American graduate student focusing on Catalan identity, much as the woman in *The Passenger* has come there to study Catalan architecture. As part of Vicky's program (which she hopes will train her to teach or curate), her project is to investigate the work of Gaudí. Vicky is accompanied by her friend Cristina (Scarlett Johansson), who dabbles in poetry, film, and photography—so both women have ties to the visual arts. While Vicky is a stable and rational young woman who is engaged to a man at home, Cristina is impulsive and prone to risky behavior—especially where romance is concerned.

Early on in the film, a male voice-over narrator tells us that the friends "drank in the architectural treasures of the city." (For Vicky, part of her work; for Cristina, pleasurable sightseeing.) We then see the women in La Sagrada Família and on the roof of the Casa Milà (the same locale that is used in *The Passenger* and *Biotaxia*). The focus on Catalan art continues in other ways. We see the women standing by a sculpture by Joan Miró and later, after visiting an art gallery, they encounter a painter at a restaurant who had also attended the show. He is Juan Antonio (Javier Bardem). Brashly he proposes that the women accompany him to Oviedo, where he owns a house, and that they engage in a ménage à trois. Given their

opposing characters, Cristina is game, but Vicky is reluctant, although she finally agrees.

Once in Oviedo however, Cristina, who seems primed to have an affair with Juan Antonio, falls ill and must stay in bed. This leaves Vicky to tour with Juan Antonio alone. Continuing Vicky's artistic journey, the two visit Antonio's poet father, listen to Spanish guitar music, and look at Juan Antonio's paintings. Vicky confesses that she "fell in love" with Gaudí's work at the age of fourteen and that "one thing led to another" (meaning her interest in Catalonia). But "one thing leads to another" in a second sense when she and Juan Antonio become amorous, kissing furtively in the bushes. Already we have witnessed a sense of switched identities as the conservative Vicky seems to "become" the daring Cristina. Furthermore, we have the impression that the creative spirit of Barcelona (including the work of Gaudí) has transformed Vicky in a fashion that Dalí would associate with Art Nouveau (becoming less "rational" or perhaps more "erotomaniacal"). When Vicky's fiancé telephones and proposes that he join her in Barcelona to get married, she seems ambivalent (because of her attraction to Juan Antonio), but finally agrees to his visit.

When Cristina recovers, the narrative takes the more expected route, with her and Juan Antonio as a couple tooling around town. He takes her wine tasting, to his studio, and then to his home to make love. In a scene that depicts Vicky alone in Barcelona (ostensibly working on her master's project), she is shown at Gaudí's Park Güell, where, significantly, she runs into Juan Antonio sketching. It seems no accident that it is at a Gaudí site that she reencounters the man who has challenged her social and sexual stability. She admits to him that she was upset when he did not call her after they had kissed, and he says that, because she was engaged, he feared he would be rejected. The subject of the Park Güell comes up at a later point in the film when Vicky meets a student from her Spanish-language class who says that he has been to the park "in search of Gaudí." Vicky confesses that her weekend in Oviedo has changed her life.

When Vicky's fiancé Doug (Chris Messina) arrives, we see the couple exiting the Casa Milà. He later tells her that she seems different and that perhaps it is something in the "Barcelona air." Eventually, the two marry and take a honeymoon in Seville. Meanwhile, Cristina moves in with Juan Antonio, but their twosome is complicated by the arrival of his neurotic

and tempestuous ex-wife Maria Elena (Penélope Cruz), who is suicidal and has landed on his doorstep for help. Soon the three become the ménage à trois that had failed to develop earlier in the film. But after a while, Cristina tires of the situation and leaves for France. Left on their own, the relationship between Maria Elena and Juan Antonio deteriorates and she abandons him.

At this point Vicky, still in Barcelona, confesses to a friend that she loves Juan Antonio and the latter arranges for them to meet again. When Vicky accompanies him to his studio for a romantic tryst, Maria Elena appears with a gun and fires at them, injuring Vicky's hand. She flees and lies to Doug about her injury.

At the end of the film, Vicky and Cristina are seen at the Barcelona airport (having come full circle). Vicky is returning to the life she had planned but as a much more complex and unsettled person, while Cristina continues her long-standing search for passion and adventure. For one woman, Barcelona has been transformative. For the other, its atmosphere has simply confirmed her carefree and adventurous impulses.

## AFTERWORD: SENSIBILITY AND THE CITY

Walter Benjamin saw Paris not simply as a geographical locale but as an emblem of Surrealism, a movement he much preferred to Art Nouveau. As he writes, "At the centre of this world of things," which the Surrealists imagined, "stands the most dreamed-of of their objects, the city of Paris itself."[95]

As our discussion has shown, one might similarly characterize Barcelona as an icon of Art Nouveau. Its urban landscape was and is infused with the spirit and traces of that movement in Catalonia—one that not simply valorized beauty, but bespoke a permeable border between reality and fantasy, stability and flux, art and commerce, conformity and resistance, nature and technology, life and death, purity and decadence, rationality and the unconscious. Thus, Barcelona stands as a ready-made film set for any artist open to the city's evocative Imaginary.

# CHAPTER 4

# Art Nouveau, Chambers of Horror, and "The Jew in the Text"

*The rhetoric of beauty tells the story of those beholders who, like [Leopold von Sacher-Masoch's] victim, contract their own submission—having established, by free consent, a reciprocal, contractual alliance with the image. The signature of this contract, of course, is beauty. . . . This vertiginous bond of trust between the image and the beholder is private, voluntary, and a little scary.*
—Dave Hickey, "After the Great Tsunami"

The detractors of Art Nouveau frequently used harsh words to characterize it. A writer in the *New York Times* of November 20, 1904, complained about its "*horrid* forms, inharmonious colors, and injurious sights,"[1] while another of July 17, 1927, referred to its "*horrors* of bad taste."[2] A more extensive meditation on the theme was articulated by a writer in the *Times* of January 1907 in an article about modernist bookbinding. The author speaks of a designer who "has followed the spirit of *l'art nouveau*, and has created an *ignis fatuus*" (a horror show). He continues: "In his search for the new [the designer] has found the *grotesque*. Serpents crawl over human skulls and wriggle in and out of his border lines or with protruding tongues stare out at us from behind foliage or through a crevice in some of his designs."[3] It is no accident that numerous writers employ "horror" when describing what they see as a loathsome design movement—a word that signifies dread, fear, disgust, and terror. Furthermore, as we noted in the introduction, Walter Benjamin

invoked a similar word, "phantasmagoria," to describe the dreadfulness of the Art Nouveau interior—thus referencing a type of nineteenth-century magic lantern show that projected eerie images of ghosts, specters, and the dead.[4]

## THE GRAND GUIGNOL

Given the linguistic tendency to associate Art Nouveau with fright, it should be no surprise that we sometimes find it linked to the horror genre—be it on stage or on screen. In fact, in Paris, in the same era in which Art Nouveau surfaced, there was a dramatic form of that type, the Grand Guignol, performed at a theater that bore its name. A description of the genre by historian Mel Gordon might in fact serve as one for Art Nouveau: "A product of *fin-de-siècle* France, the Grand Guignol managed to outrage its public as it explored the back alleys of unfettered desire, aesthetic impropriety, and nascent psychological trends."[5] Here, we should remember that, according to György Vajda, Art Nouveau was influenced by Freud's sense of *unbehagen* (anxiety).[6]

The Grand Guignol Theatre was opened by Oscar Méténier in 1897—not coincidentally around the same time as the birth of cinema itself; the two media shared a taste for sensationalism, violence, and melodrama. In 1898, Méténier sold his interest to Max Maurey, who is considered the true "father" of the Grand Guignol. As Gordon indicates, plays produced there focused on "slice of death" plot lines: "Every social taboo of good taste was cracked and shattered. This formula would attract the French public that slaked its blood and lust fascination with the morbid devouring of pulp novels and unlikely tabloid exposés."[7] The Grand Guignol's audience was quite diverse and included members of the Parisian avant-garde.[8] Significantly, the theater was used to show films during the Paris Exposition of 1900—the fair in which the Art Nouveau style was highlighted.[9]

Ultimately, under the leadership of another man, André de Lorde (who collaborated with Maurey and was known as "the Prince of Terror"), the Grand Guignol ascended from a local entertainment to a worldwide phenomenon—with international visitors flocking to Paris to see it and performances exported to other cities (e.g., New York—where Alla Nazimova appeared in one 1923 production).[10] Versions of the Grand Guignol

**4.1** A 1920 British poster by Aubrey Hammond advertises Grand Guignol films. Victoria and Albert Museum.

appeared on-screen as well. De Lorde wrote eleven silent films between 1911 and 1914, including *Dr. Gaudron's System* (1913). And a British poster of 1920 literally advertises the genre as translated to the screen (see figure 4.1).

Tom Gunning sees the Grand Guignol as opposing traditional film and stage melodrama. As he notes, it "often inverts melodramatic traditions, returning to a Sadean universe in which vice is rewarded and virtue suffers horribly."[11]

The Grand Guignol reached its apogee after World War I and continued to exist in some form until 1962.[12] It seems fitting, then, that some of the posters for the Grand Guignol were done in the Art Nouveau manner, for instance that for *The Garden of Torture* (1922). Furthermore, posters for dramas similar to those performed at the Grand Guignol were also

rendered in an Art Nouveau style, for instance one for *The Ghouls* by André Galland (1905), as were advertisements for serialized novels, like Henri Privat-Livemont's "The Mask of Anarchy" (1897), which depicts the working class hacking the bourgeoisie to death.[13]

## MAD DOCTORS AND SYMPTOMATIC DÉCOR

In film history there has never been a dearth of texts that draw on the discourse of Grand Guignol. Gunning, in fact, has highlighted works from the 1960s and 1970s "which rediscovered a visuality of horror through physical effects and a sensational approach which produced truly grisly works of art."[14] An example of one is *The Abominable Dr. Phibes* (1971),[15] directed by Robert Fuest with Art Nouveau-inspired production design by Bernard Reeves. Its title and deranged doctor protagonist hark back to de Lorde's *Dr. Gaudron's System*, as well as *The Cabinet of Dr. Caligari* (1920). And its choice of adjective to describe Dr. Phibes reminds us that, in 1904, the president of the Royal Institute of Architects deemed Art Nouveau an "abominable affectation."[16] The film was released by American International Pictures, a B-movie production house founded in 1954 by Samuel Z. Arkoff and James H. Nicholson, and associated with Roger Corman, who served as both a producer and director.

The film stars Vincent Price (as Dr. Anton Phibes), an actor ubiquitous in low-budget horror films. The drama, set in London of the 1920s (and shot in Great Britain), concerns a series of murders whose victims are all physicians. In attempting to tie the enigmatic and grim events together, police learn that all the men were linked to an unsuccessful surgery on a particular woman—Victoria Regina Phibes, who died on the operating table. This leads them to suspect her husband, Dr. Anton Phibes, a famous organist who might have wanted revenge. But he is also deceased.

As the film opens, none of the murders have yet taken place. We find a black-caped man (seen from behind) playing a red pipe organ, which sits atop a flight of steps. It is Dr. Phibes, who has apparently risen from the dead. He is surrounded by a life-sized mechanical band (shades of Robert-Houdin's automatons). The location of the scene is ambiguous: it seems to take place indoors, but Dr. Phibes is flanked by leafless trees on which

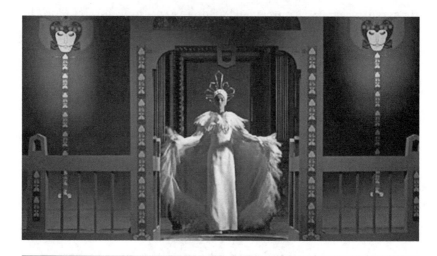

**4.2** Vulnavia (Virginia North) in *The Abominable Dr. Phibes* (1971, Robert Fuest) looks like a female figure out of the Viennese Secession.

are perched motionless birds. In Dr. Phibes's status as a macabre organ-ist, we are reminded of the Phantom of the Opera—the subject of a 1925 horror film marked by touches of Expressionism.

The initial set seems more influenced by Art Deco than Art Nouveau, but the latter mode emerges as the sequence continues. Some doors open in a wall decorated with a Jugendstil graphic and a woman comes forward. She is dressed in a white, ethereal, gauzy gown consonant with Art Nouveau fashion. She is Dr. Phibes's assistant Vulnavia (Virginia North). In later scenes (e.g., when she drives the doctor's car), she resembles Viennese women painted by Gustav Klimt (see figure 4.2).

Continuing the musical theme, Dr. Phibes and Vulnavia dance to-gether, and the floor on which they perform has a curvilinear, decorative pattern in the manner of Charles Rennie Mackintosh. So far, no dialogue has been spoken, which gives the drama the feel of a silent film with a syn-chronized score. Of course, silent movies were made in the era of Art Nouveau.

This muteness continues well into the narrative, including the scene of the first murder. In fact, we will learn that Dr. Phibes can no longer

speak. In order to be audible, he must attach a mechanism to his neck that broadcasts the movements of his vocal chords through the horn of a phonograph. In a sense, he is like a filmstrip whose sound must be amplified before it is heard by the audience. The phonograph horn also has a floral appearance that bears traces of Art Nouveau design. So does a lamp on his vanity table, as well as a sculpture behind it. In the place where the vanity's mirror should be is a large photograph of his beloved Victoria.

The home of the first victim, Dr. Dunwoody (Edward Burnham), has some Art Nouveau elements, including a mirrored armoire and Tiffany-style lamps. He is killed when Phibes and Vulnavia drive to his house and lower into it some deadly bats, which savage his body. Inspector Trout (Peter Jeffrey) and Sergeant Schenley (Norman Jones) are assigned to the case, and one of them remarks that another doctor was killed a week earlier in an equally bizarre fashion. Bees stung him until he perished from deadly welts. Here, we recall Art Nouveau's iconic interest in insects—both benign and malevolent.

We witness the third murder when Dr. Phibes attends a masquerade party wearing an ornate bird headdress and gives Dr. Hargreaves (Alex Scott) a gorgeous gilt frog mask that looks like some Art Nouveau artifact, for instance a Masriera frog ring. Unfortunately for Hargreaves, the mask has a gear inside it that automatically tightens and crushes his head. The police add frogs to the list of creatures associated with the strange string of physician murders.

The fourth homicide occurs in the home of Dr. Longstreet (Terry-Thomas), which is also marked by Art Nouveau touches, for instance a Mucha-inspired female bust on a credenza, Jugendstil wallpaper, and a modernist painting (see figure 4.3).

After his housekeeper leaves for the evening, Longstreet threads a film on his hand-cranked home projector and lasciviously watches a black and white "blue movie" depicting a woman in Arab garb undulating and removing items of clothing. We are familiar with this Orientalist figure from early films like Edison's *Fatima* (1896) and Chomón's *Ouled-Naïd's Dance* (1902). The projector malfunctions and Longstreet fiddles with it; but suddenly the movie screen turns into white fabric that is carried by a live woman—Vulnavia—who comes toward the doctor as the film is projected on her body. Longstreet seems to accept her magical appearance and

**4.3** A Mucha-inspired female bust stands on a credenza in the home of one of the murdered physicians in *The Abominable Dr. Phibes* (1971, Robert Fuest).

allows her to approach him and tie him to a chair with the remnants of the screen-like material. Once he is immobilized (ostensibly ready for some sadomasochistic sex), Dr. Phibes enters Longstreet's home with a "medical kit" and drains him of blood. When the police arrive, in addition to the body, they find a pendant that Dr. Phibes has accidentally dropped on the floor (see figure 4.4).

In attempting to comprehend the murders, the police soon realize that all of the victims once worked with a second physician, Dr. Vesalius (Joseph Cotton). He lives in an ultramodern home marked more by Art Deco and the Bauhaus than Art Nouveau. In fact, some color prints on his wall resemble those rendered by Erté. Significantly, Vesalius will be the only one to escape Dr. Phibes's curse.

When Vesalius consults his records, he finds that there was one medical case in which he and all of the victims worked together—that of Victoria Regina Phibes. The detectives take the lost pendant to a jeweler that they suspect crafted it, and he reveals that it was a part of a set of ten he made for Dr. Phibes—each with a different obscure symbol on it that he believes are Hebrew letters. The detectives are nonplussed, since they

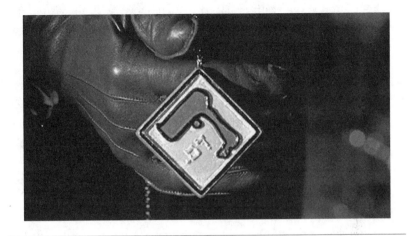

**4.4** Dr. Phibes's lost pendant with the Hebrew letter daleth and the word *dam* (daleth-mem, signifying "blood") in *The Abominable Dr. Phibes* (1971, Robert Fuest).

believe that Phibes is dead, but they begin to wonder about his involvement anyway. When the police consult a rabbi (Hugh Griffin), they learn that the pendant bears the word "blood"—one of the ten plagues that the Hebrew God visited upon the Egyptians during the Jews' exodus from that land—the others being boils, bats, frogs, rats, hail, beasts, locusts, darkness, and death of the first born. In these "anathemas," the police immediately recognize the causes of the various deaths that they are investigating, and we identify the kind of macabre animal figures sometimes associated with Art Nouveau.

Several other homicides occur in line with the biblical plagues. One physician is frozen to death by a cooling machine placed in his limousine, and when police arrive he is covered in balls of hail. Another doctor is attacked by rats as his airplane takes flight. One more is killed when a unicorn statue falls and impales him as police attempt to whisk him to a safe location.

Fearing for the life of a woman who assisted on Victoria Phibes's surgery, Nurse Allen, the police sequester her in a room covered with Art Nouveau wallpaper and station a police guard outside. But Dr. Phibes manages to drill down from the floor above and inject locusts into her chamber to devour her. When the police arrive, they find only her skeletal remains.

The police soon realize that the final curse will be visited on Dr. Vesalius in the form of the death of his son. After learning that the boy has been kidnapped, Vesalius receives a call from Phibes telling him to come to his house where he will be given an opportunity to save his child. When Inspector Trout attempts to prevent Vesalius from going, the doctor knocks him out and flees. At Phibes's home, Vesalius finds his son locked in a metal brace on an operating table. We catch a glimpse of the boy as seen through a glass pane in the Mackintosh-inspired floor. Interestingly, the Grand Guignol produced some of the first plays set in a surgical theater and, as Gunning has noted, in them "medical experiments . . . are revealed as acts of random cruelty."[17]

Phibes has implanted a key in the boy's rib cage which opens the lock to the vise that imprisons him. In six minutes, he intends to drip disfiguring acid onto Vesalius's son, unless his father frees him in time. Vesalius prevails and Phibes, defeated, descends into the basement where the coffin of his wife resides. He joins her in the casket and a mechanism simultaneously drains his blood and fills him with embalming fluid. The sarcophagus lid closes and the film ends.

There is much that can be said about this fascinating, gorgeous movie—a cinematic Grand Guignol if ever there was one. First is the manner in which an Art Nouveau ambience attaches to the home of Dr. Phibes and, to a lesser degree, to those of his victims. Clearly, here the design movement serves as a marker of decadence, perversity, and death. The last is apparent not only in the murdered physicians, but in Dr. Phibes himself, since he constitutes yet another incarnation of the Undead. Right before the end of the film, we catch a glimpse of him in his corpse-like state before he reapplies his makeup for his burial.

Another link to Art Nouveau is Dr. Phibes's association with art. He was a renowned organist who, a poster informs us, performed at such hallowed venues as the Palace Theatre and the Royal Albert Hall. Posters also reveal that among the recitals he gave at the turn of the twentieth century, was one of *Salome*—an iconic figure of Art Nouveau. Furthermore, he is an artist in another more ghastly sense. He creates busts of all the people he intends to kill, and after he has murdered them, he takes an acetylene torch to their sculptural faces in order to melt them. Interestingly, the Art Nouveau style has often been said to dissolve or liquefy linear form.

Dr. Phibes's obsession with women also seems indicative of an Art Nouveau sensibility. On repeated occasions, he morbidly stares at his late wife's photograph, reciting (with the help of the phonograph horn) paeans of love. Furthermore, at one point, again in a Phantom-like posture, he plays the organ, above which are projected photographic slides of his beloved. Evincing a more hostile attitude to women, when he drills through the floor below which Nurse Allen is sleeping, he lays down a large diagram of a naked woman and aims his bit through its face.

Phibes's assistant (whose name is reminiscent of the word "vulva") is a kind of wife-substitute with whom he dines and dances against a theatrical, Art Deco backdrop. She is also portrayed in an Art Nouveau manner. In one scene, she strikes a butterfly pose, and in another appears in a spider gown—in both cases, she reminds us of those human/insect hybrids in the films of Chomón, as well as the jewelry of Lalique (see figure 4.5).

Moreover, there is also a certain pictorial self-reflexivity in the portrayal of women in the film—one that emphasizes their status as image, as does Art Nouveau iconography. There are Phibes's photographs of Victoria (either framed or projected), and there is also the racy movie of the "Arab" woman that Dr. Longstreet screens immediately before his death.

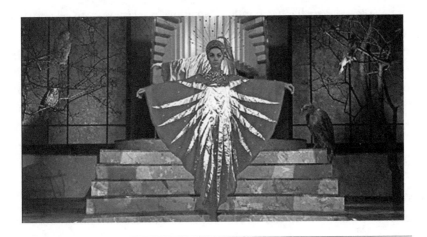

**4.5** Vulnavia (Virginia North) in *The Abominable Dr. Phibes* (1971, Robert Fuest) appears as the kind of insect-woman common in Art Nouveau.

## MODERNISM AND THE "JEWISH QUESTION"

Finally, there is the peculiar Jewish theme in *The Abominable Dr. Phibes,* which includes allusions to the Bible in the concert posters for Dr. Phibes's performances (selections from *Salome, The Song of Solomon,* and *Samson and Delilah*), as well as those in the pendants Phibes wears, emblazoned with Hebrew letters that announce the plagues that the Jewish God visited upon the Egyptians, which the murders that he perpetrates mirror. Thus, perverse magical powers in the film are associated with Jewishness. As we know from writings by Sander L. Gilman, historically the Jew was often seen as the Devil.[18] Alternatively, for Michèle C. Cone, the Jew was sometimes likened to a vampire.[19] Both figures have relevance to Dr. Phibes.

In Phibes's invocation of the plagues, we recall that Patrick Bade likened Art Nouveau to a "bacillus" spreading from place to place, and that the Germans deemed it the "Belgian tape-worm style."[20] Significantly, both epithets liken it to a disease. Again, Gilman notes that the Jew was often associated with illness, especially syphilis. We also recollect that an anti-Semitic French critic of the era, Arsène Alexandre, stated that the Art Nouveau style "reaks [*sic*] of the . . . drug-addicted Jewess." Similarly, on the American front, in 1909 architect Whitney Warren related the "failed" design trend of Art Nouveau to the rising prominence of Jews in France. As he notes, "There has been, indeed, an effort in recent years to get entirely away from the old schools and create a new one, but it has not been successful. The Art Nouveau over which so much effort has been expended in France and Belgium, not only from the point of view of architecture but from that of jewelry and even the clothes of women, does typify the times in a sense, *for it expresses the greatly increasing importance which Jewish life has taken on in France in the past ten years.*"[21]

Of course, during the Third Reich, "the Nazis considered Jewish art collectors and dealers a major force behind the success of [decadent] modernist art" in general.[22] It is true that European Jewish businessmen were influential in this regard. According to Elana Shapira, Siegfried Bing, Fritz Waerndorfer, and Emil Rathenau were Jewish entrepreneurs who "initiated, sponsored, and established a model for new design movements in the cities in which their businesses were headquartered"—Paris, Vienna, and Berlin, respectively.[23] In fact, the three men "strategically used their

special 'Jewish character' (or 'Jewishness') in order to . . . form an eman-
cipated group identity with the help of modern design."[24] Still consid-
ered outsiders in their homelands, "their promotion of modern design
allowed [them as] acculturated Jews to include themselves as part of the
French, Austrian and German national culture and at the same time al-
lowed [them as] Jews to preserve their distinct identification."[25] All three
men were associated with movements related to Art Nouveau. Bing's gal-
lery coined that precise name; textile maker Waerndorfer was a friend of
Josef Hoffman, a collector of Klimt's paintings, a cofounder of the Wie-
ner Werkstätte, a prime mover of the Eighth Secession exhibition of 1900,
and a patron of Charles Rennie Mackintosh and Mary Macdonald, who
designed his home's music room; electrical industrialist Rathenau hired
modernist architect Peter Behrens to design various projects (e.g., a fac-
tory, worker housing, household appliances, etc.) and had his portrait
painted by Edvard Munch.[26]

As for other modernist movements, Dadaism of the 1910s had signifi-
cant Jewish representation in the form of membership by Tristan Tzara,
M. H. Maxy, the Janco brothers, Victor Brauner, and Arthur Segal—all
Romanian Jews. Literary historian Daniel McGee associates the criticism
of the absurdist, linguistic strain of Dada with anti-Semitism. As he notes,

> [T. S.] Eliot identified the degeneration of language into nonsense not pri-
> marily with Africans, but with Jews. The link between dadaism and Juda-
> ism was already implicit in the proto-fascist aesthetics of Charles Maurras
> [whose essay Eliot translated for *The Criterion*]. What Maurras provided to
> Eliot . . . was not just anti-Semitism as a political project, but anti-
> Semitism as a literary theory. . . . *Maurras imagined the material properties of lan-*
> *guage as a foreign, Jewish invasion infesting Europe like plague-carrying rodents.* . . . It was
> not a language at all, but a *degeneration* of language into noise, like dada.[27]

Here, again, we find a familiar string of references: plagues, modernism,
degeneracy, and Jewishness.

In the introduction we cited several other prominent Jews associated
with Art Nouveau: Julius Meier-Graefe, Léon Bakst, and Sarah Bern-
hardt. We also mentioned that the modernist architects of Budapest were
predominantly Jewish. Even as recently as 2012, Rebecca Tinsley, writing

for the *Huffington Post*, mentions how anti-Semitism had been a factor in that city's having allowed its Art Nouveau architecture to deteriorate during the Soviet era: "There was official disapproval of Art Nouveau because of its frivolity, but there was also an anti-Semitic sub-text: many of the architects had been Jewish, as had their affluent clients. Being outside the stifling Victorian-era establishment, some successful Jewish entrepreneurs were prepared to support daring, new artistic ideas, among them Art Nouveau design."[28] In other European centers, Jews also played an important role in Art Nouveau architecture—for instance, Mikhail Osipovich Eisenstein, the father of filmmaker Sergei Eisenstein, created several fabulous buildings in Riga, Latvia. Evidently, "his projects were characterized by decorative, odd-shaped windows, often with large female head shapes, bright glazed brick or ceramic plates, glass and metal tiles."[29] Furthermore, in chapter 2 we mentioned Abraham Icek Tuschinski, a Polish immigrant to the Netherlands, who built an Art Nouveau theater bearing his name in Amsterdam in 1921.

But there were Jewish artists of the Art Nouveau camp working in other media, for example Hermann Struck, a printmaker and Zionist, was associated with the Viennese Secession. There was also the German painter/illustrator Thomas Theodor Heine (raised in a Jewish family, though he later practiced Protestantism) who specialized in caricatures appearing in the satirical magazine *Simplicissimus*.[30] His mockery of social order and the monarchy landed him a six-month prison sentence in 1898. Although *Simplicissimus* was, in general, progressive, as Henry Wassermann has shown, it was not above publishing Jewish jokes and cartoons thought "acceptable" then but offensive from today's perspective.[31] Aside from contributing to *Simplicissimus*, Heine painted, illustrated books and advertising posters, and published in the avant-garde journal *Jugend*.

Some Jewish Art Nouveau creators took on specifically Semitic imagery, most notably illustrator and printmaker Ephraim Moses Lilien and his artistic heir, Joseph Budko (both of whom studied with Struck). Budko was born in Poland, went to art school in Germany, and was influenced not only by Struck, but by Jacob Steinhardt, who was German-born and known for his Jewish-themed woodcuts. Budko's work melded Jewish tradition with a modern approach. According to Michael Brenner, Art

Nouveau inspired him, and his work "had an ornamental, filigreed style and used motifs adapted from Jewish folk art."[32]

Lilien, Budko's mentor, was born in Galicia. According to M. S. Levussove, author of a 1906 monograph on the artist, "It goes without saying that young Lilien learnt by bitter experience the indignities to which his race is, in European lands, so often subjected. His immediate kin were as much in fear of the peasant's rough treatment, as much oppressed by petty officials, as much hampered by anti-Jew laws, as were any other members of the Jewish community; and he himself suffered like all those whom he loved."[33] Despite this, Lilien managed to train in Krakow and, as a member of the Zionist movement, traveled to Palestine several times in the early 1890s. He is credited as one of the founders of the Bezalel Art School in Jerusalem, which Budko later headed. Lilien's illustrations appeared in *Jugend*, and he received its award for photography in 1896.

For Levussove, Art Nouveau and the awakening of Jewish identity went hand in hand:

> In Paris, in Munich, in Vienna, the art rebellion, the war of the Secession, is being merrily waged; the younger element is creating a new style, is producing novel beauty. Judaism has [also] thrown off its lethargy. The Zionist movement, the later Hebrew poetry, the growing Yiddish literature, the new Jewish drama, point to the renascence of the Jewish spirit. . . . And after all, are not these two movements essentially identical, essentially the same striving of the soul—the art soul or the national soul—for a larger freedom and a more complete expression? A new spirit when aroused expresses itself in manifold ways.[34]

Levussove, however, is aware of cultural assumptions that Jews are weak in the visual arts—perhaps due to the banishment of sculptural idols in the Old Testament: "Strange (is it not?) that a nation which has not before expressed itself graphically should, after ages of silence, readily manifest its national feelings in art. . . . [Their] art-sense . . . had become so disused, that the nations believed the Jews incapable of art, believed them capable only of thought. But the Jewish Renaissance expresses itself in Lilien as Art."[35] In particular, Art Nouveau came to Lilien through the

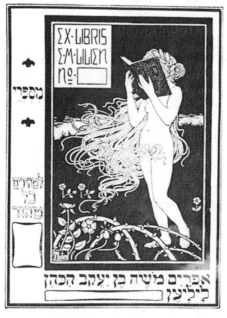

**4.6** Ephraim Moses Lilien's (1874–1925) personal bookplate depicting Hebrew lettering that reads "To the pure all things are pure" and a naked woman, her face covered by a book.

influence of Aubrey Beardsley (whose technique and imagery have been discussed in chapter 2). In fact, Milly Heyd points to Lilien's Beardsleyesque, personal bookplate, which depicts Hebrew lettering reading "To the pure all things are pure," and (surprisingly) a naked woman with her face covered by a book[36] (see figure 4.6).

Lilien's method bears comparison to Beardsley in many ways, including his use of high-contrast black and white, and his employment of ornamental, stippled line.[37] There are also iconographic parallels, for instance the intermixing of temporal references as in Beardsley's use of modern clothes for Salome, or in Lilien's importation of the Star of David into scenes of ancient Egypt. As Heyd observes, "In Beardsley, Lilien found a world view which suited his own needs. As a man of the modern

world trying to revive an old tradition, Lilien had an urgent need to fuse the past and present, and these anachronisms helped in solving his problems as a modern Jewish artist."[38] Furthermore, both Beardsley and Lilien often included hidden portraits in their work—Beardsley of himself, and Lilien of Theodor Herzl, the leader of the Zionist movement.[39] In particular, Heyd discusses Lilien's homage to the theme and composition of Beardsley's "The Return of Tannhaüser to Venusburg" (1896) in the latter's "The Jewish May" (1902). Of course, though both of the artists' styles were marked by an Art Nouveau sensibility, the ideology behind them was entirely different. As Heyd remarks, while Beardsley was an individualist, Lilien's art "was national and intimately involved with the fate of the Jewish people . . . [and] the Jewish cause."[40] Lilien's work also had ties to that of Alphonse Mucha. As Levussove writes, "if Mucha is beautiful, his beauty is of the earth and on the surface, while Lilien's is deep and far-reaching, a manifestation of the strength and beauty of the soul."[41]

Beyond his dedication to Zionism, Lilien was also a socialist champion of the working class—belying the notion that Art Nouveau is forever linked to the private bourgeois world. This is no surprise, since, as Levussove noted, Lilien's work was marked "in content [by] a profound pathos, a pathos born of Judaism, and a tremendous power of appealing directly to the imagination in expressing national suffering and national hopes."[42] In line with this, Lilien illustrated *Songs from the Ghetto* (1902)—a book of poems by Morris Rosenfeld about Jewish life in the era's sweatshops and tenements.[43] As Heyd remarks (citing the drawing of a tailor in his shop): "The illustration is a combination of styles: [there is] the realistic depiction of the Jewish tailor . . . while [on the other hand] the figure behind the tailor is symbolical and based on Beardsley's illustration for *Ali Baba* . . . a fat self-satisfied oriental type." According to Heyd, Lilien adopts the latter character in order to "symbolize the sweatshop boss. . . . He is no longer a mere aesthete [as in Beardsley's work], but an exploiter of the working class."[44] The Rosenfeld poem that accompanies the drawing bears out this point of view:

Pray, how long will the weak one [the tailor] drive the
Bloody wheel? Who can tell me his end? Who
Knows the terrible secret?

Hard, very hard to answer that! But one thing
Is certain: when the work will have killed him
Another will be sitting in his place and sewing.[45]

A final issue in the submerged link between Jews and Art Nouveau
is the movement's attraction to "Oriental" styles (Japanese, Islamic,
Chinese). For it was at the time of Art Nouveau's popularity that Zionism
gained strength in Europe—a trend that would turn Jews' attention to the
East. Yaron Peleg points out that although Jews had lived on the Conti-
nent since Roman times, they continued to be viewed as aliens ("racially
inferior, sexually deviant") and frequently persecuted as such.[46] This
problem was exacerbated by the rise of European nationalism, since Jews
were not considered part of the new nation-states. Ironically, as Peleg
indicates, they were viewed as a country unto themselves: "Jews were per-
ceived as a cohesive 'national' group long before the rise of nationalism.
Yet Jews did not conform to the modern definition of a nation because
their diasporic existence both predated and transcended it."[47] We have al-
ready seen the tendency to view Jews as a nation in the rhetoric of Levuss-
ove. One of the successful tactics of Zionism (counterintuitive as it may
seem) was to embrace the Jews' foreign status and envision them as heirs
to the East—their biblical home—thus owning their "Oriental" charac-
terization. As Peleg observes, "Zionism suggested utilizing the age-old
Jewish difference as a catalyst for reform. Adding territory to the other
criteria Jews had shared for centuries, Zionists propagated the establish-
ment of an actual Jewish polity in Palestine with all the trappings of a
modern state."[48] As evidence of this, Peleg quotes a description of The-
odor Herzl by one of his Jewish colleagues that demonstrates the desire to
see the term *Oriental* not as pejorative, but as honorific. For Erwin Rosen-
berger, Herzl was "the prototype of a handsome Oriental. The cut of his
features, the dark hair, the dark beard and moustache, the dark eyes all
proclaimed eloquently that here sat a son of the East. . . . He would look
perfectly at ease on the throne of a Babylonian king."[49] Hence, on some
level, Art Nouveau's "Orientalism" might have seemed especially apt to
Jewish artists of the era.

Of course, in *The Abominable Dr. Phibes*, while Jewish motifs are attached
to Art Nouveau, they have none of the positive overtones that Jewish

artists might have wished for them. Rather, here, Jewishness and Art Nouveau are allied by their shared valence of perversity and Otherness— themes rampant in the rhetoric of the Grand Guignol.

Significantly, we will find echoes of this Judaic theme in the next film considered.

## CINEMA, ORNAMENT, AND CRIME

Another contemporary master of cinematic Grand Guignol (in its Italian *giallo* mode) is writer-director Dario Argento—known especially for his use of lush, stunning, mise-en-scène as well as his emphasis on spectacle.[50] A work of his that directly engages Art Nouveau design is *Deep Red*, made in 1975 with inventive production design by Giuseppe Bassan.

Plotwise, the film is a fairly standard product of the genre, with psychoanalytic overtones added in the manner of Alfred Hitchcock's *Psycho* (1960). As the main narrative begins, a well-known parapsychologist, Helga Ulmann (Macha Méril), is mysteriously killed in her Rome apartment after giving a lecture at a conference where she sensed "something strange" and heard disturbing voices speaking enigmatically about a "house" within the context of "death" and "blood." All we see of her murderer is a brown coat sleeve, a hand covered in a black glove, and masculine shoes. Right before the attack, however, Ulmann has heard a cheerful musical theme, one that the audience is already familiar with from the film's prologue, which had cryptically depicted another murder that an unidentified child witnesses. For most of the film, however, the viewer has no way to connect the prologue to the rest of the drama.

Musician Marcus Daly (David Hemmings), a resident of Ulmann's building, observes her death through a window while chatting in the square below with his friend Carlo (Gabriele Lavia). After rushing up to Ulmann's flat, Daly looks out the window and sees a figure in a brown raincoat fleeing. At the suggestion of journalist Gianna Brezzi (Daria Nicolodi), who is covering the murder, Daly assists her in attempting to solve the crime. As a first step, the two attend Ulmann's funeral. As the investigation proceeds (with police engaged as well), numerous other people are slaughtered in the same perplexing, bloody fashion, including Ulmann's friend, the psychiatrist Dr. Giordani (Glauco Mauri). In each

case, only fragmentary glances of the murderer are provided to the viewer. In all instances, the victim first hears the same lilting tune.

Clearly, Argento has not gained critical popularity for the originality, profundity, or brilliance of his storylines, but instead for his films' hyperbolic stylization: their cinematography (here, incessant camera movement—often from the perspective of the unnamed killer) and art direction (here, both gorgeous high-tech and antique décor). Argento is also known for his gruesome iconography (here, decapitated dolls' heads, grotesque puppetry, satanic figures, desiccated corpses, and shrieking birds).

For our purposes, however, it is one location that deserves special attention. In Daly's search for Ulmann's killer, he is reminded that she mentioned a house as part of the mysterious words she channeled at the conference. Because of this, someone suggests that Daly research a book entitled *The Modern Ghost and Black Legends of Today*, available at the Library of Folklore and Popular Traditions. Daly goes there and accesses the volume, authored by Amanda Righetti (Giuliana Calandra). One chapter in particular sparks his interest: "The House of the Screaming Child," about a sinister mansion from which neighbors hear the strains of a child's song. A photograph of the dwelling is included, and Daly surreptitiously tears it from the book and pockets it. Unfortunately, before he is able to contact Righetti, she is killed by the phantom murderer in the same fashion as the other victims.

Daly, however, manages to track down the house pictured in the illustration through researching its exotic foliage. He learns from a caretaker that the house (known as the "Ghost House") was once owned by a man named Schwartz, who died falling out of a window. It is now for sale, but rumor has it that it is inhabited by spirits. When Daly goes there he finds an abandoned, derelict, Art Nouveau estate. Here we are reminded of Gunning's observation that Grand Guignol "display[s] a vertiginous image of order destroyed."[51] The house is surrounded by an ornate Art Nouveau gate through which Daly must pass. The exterior of the house is also marked by a similar aesthetic: there are curvilinear intricate concrete moldings and windows with whiplash mullions (see figure 4.7).

He enters through the front door, which is characterized by an Art Nouveau glass and wood design, an element echoed in its many windows

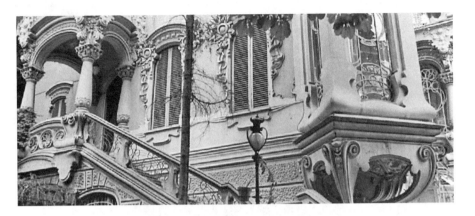

4.7 The exterior of the mysterious Art Nouveau "Ghost House" that Marcus Daly (David Hemmings) explores in *Deep Red* (1975, Dario Argento). It is actually the Villa Scott (1902), built in Turin by Pietro Fenoglio.

(see figure 4.8). In one instance, he peers out of one of them and is pictured framed by the Art Nouveau shape.

As he wanders through the building's endless halls and stairways, the camera continually tracks or pans along with him—mimicking the curves of the building with the movement of the apparatus. Daly becomes covered with dust, cobwebs, and plaster, and discovers on one wall a splash of red coloring, as though the house were bleeding. Inquisitive, he chips away at the spot with a shard of glass and uncovers a childlike drawing that depicts a wounded man and a boy holding a knife, reminding us of the film's prologue. In unearthing the picture, Daly cuts himself and he too bleeds—linking his body with the house and the scene depicted on its wall. The caretaker, who is outside the building, announces that it is time to go, and Daly leaves.

Back home, Daly again looks at the photograph of the mansion and realizes that it shows a window that he failed to notice when visiting. Curious, he returns to the house on his own and notices that the window has been plastered over. He attempts to break into the manor by crawling up its exterior wall and almost falls off a ledge. Ultimately, he saves himself by balancing on an ornate three-dimensional Art Nouveau detail on its

**4.8** Marcus Daly (David Hemmings) silhouetted against an Art Nouveau window in the mysterious "Ghost House" in *Deep Red* (1975, Dario Argento).

facade. Once inside, he walks down a corridor and notices a rectangular marking on the wall where a picture once hung.

With his chisel, he hacks away at the spot, making a hole large enough for him to see a hidden room within that contains some dilapidated furniture and a petrified corpse—mouth open in a scream-like grimace. Suddenly, someone knocks him over and, the next thing he knows, he is lying on the lawn below with Brezzi standing over him. The mansion has been set on fire, and (guided by a note he left telling her his whereabouts) she has followed him there and rescued him.

When, later on, Daly and Brezzi speak to the caretaker, Daly notices a picture in the man's house that resembles the one he found on the manor wall. He learns that the caretaker's daughter drew it. When questioned, the girl says that she saw a similar one in the archives of her school. Daly and Brezzi venture to the Leonardo da Vinci School, which boasts an Art Nouveau-inspired gate, and break into its archives, where, under the label "Design," they find files of student art. At the very moment that Daly unearths the picture he seeks, he hears strange noises and, in investigating them, finds Brezzi stabbed. He tells her that he knows who the murderer is. A moment later, Carlo appears in the archives holding a gun on

Daly. The police arrive in the nick of time, and Carlo escapes; but as he flees into the street he is run over by a truck and expires.

While visiting Brezzi in the hospital, Daly realizes that Carlo could not have been Helga Ulmann's killer since he was with him in the square below her apartment at the time of the murder. Deciding to return to the scene of the crime, Daly goes to Ulmann's apartment and there is confronted by the real assassin—Carlo's mother (wearing black gloves, a brown raincoat, and masculine shoes). We then get a flashback to a scene paralleling the movie's prologue, depicting Carlo's mother as a young woman speaking with her husband about her recent hospitalization (which we infer was at a mental institution) and her refusal to return there. She picks up a knife and stabs him, whereupon he stumbles into the next room, pulls the knife from his body, and drops it on the floor. His young son Carlo picks it up and holds it. Here, we have the source of the childhood drawing that Carlo later creates at school. While, in *Psycho*, it is the disturbed child who commits the crime (in the name of the mother), in *Deep Red* it is the psychotic mother who transgresses, with her son attempting to protect her.

Clearly, *Deep Red* draws upon Art Nouveau for its production design, and its unrelenting camera movement is a nod to that form's dedication to curvilinear dynamics. Interestingly, in his book on Argento, L. Andrew Cooper does not mention Art Nouveau in relation to *Deep Red* (though he cites it in discussing *Suspiria* [1977]).[52] In particular, *Deep Red* uses a famous Art Nouveau building, the Villa Scott, built in Turin in 1902 by architect and engineer Pietro Fenoglio, who was responsible for overseeing some 150 projects between 1889 and 1912.[53] Interestingly, the house is located near the former home of filmmaker Giovanni Pastrone, director of the influential epic *Cabiria* (1914) and one of the pioneers of cinema in Turin in the first years of the twentieth century.[54] One website describes approaching the Villa Scott as follows: "A sinuous flight of steps leads to the entrance from the garden that surrounds the villa. [It] is rich in floral concrete and wrought [iron] decorations."[55] In the building's style, one sees the influence of Victor Horta and Hector Guimard.[56]

But why is this site so important in the film—central enough for Argento to dedicate some eighteen minutes of screen time to its visual exploration (about 17 percent of the film's length)? Though it is not clear

from the narrative whether Carlo and his family ever lived there (a lapse in the plotline that the film's suspense is meant to cover over), it is here that Daly discovers the child's drawing etched on a wall, which holds the key to solving the recent serial murders, as well as the trauma of Carlo's childhood. As we recall, before her death, Ulmann had heard ethereal voices make mention of a strange house, and it is in this one that finally embodies a sense of the *unheimlich* (uncanny)—a German term whose root is "home." The child's picture portrays a scene of evil carnage that is apparently buried in the disturbed minds of Carlo and his mother. Hence crime, in the film, is associated with a decrepit Art Nouveau estate—giving a new spin to the title of Adolf Loos's famous 1908 article "Ornament and Crime," in which he denounces decoration as a "symptom of . . . or degeneracy."[57] Similarly (and more literally), in a *New York Times* article of 1904 the president of the Royal Institute of Architects decries Art Nouveau's "squalid . . . inharmonious colors and injurious sights [that] contribute their quota to the sum of *degenerate moral tendencies, of which recurring acts of crime are the inevitable outcome.*"[58]

Given the import of screams in *Deep Red* (those of the child in the prologue, of the various murder victims, of "The House of the Screaming Child," of the open-mouthed corpse in the villa's secret room), we think of the famous series of works by Edvard Munch entitled *The Scream*. Furthermore, Cooper even asserts that some grotesque drawings on the wall of Ulmann's apartment resemble Munch's work.[59] While people often link that artist's paintings to Expressionism, György Vajda asserts that they are more tied to the Art Nouveau movement that predates it.[60] Similarly, Laura Lombard writes that Munch's work is "permeated with Art Nouveau style."[61]

Significantly, as with *Dr. Phibes*, *Deep Red* reveals pointed and curious references to Judaism. When Daly and Brezzi attend Ulmann's funeral, it is a Jewish ceremony with Hebrew verse recited by numerous men in yarmulkes. There is also a peculiar glass tabletop in her apartment that is adorned with a Star of David, which projects the symbol in shadow form onto the floor below. Even the "Ghost House" is marked by Judaism. When Daly first speaks to the caretaker about the abandoned mansion, he is told that it was once owned by a Mr. Schwartz, a name associated with diasporic German Jews. No particular reason is given for such details—which makes

them all the more odd. While they may seem gratuitous, upon further reflection, they bear meaning. Since Ulmann is a parapsychologist and Schwartz (perhaps a suicide case) is associated with a haunted house, these features connect Jews with Otherness, anomaly, and abnormality.

Thus, in both *The Abominable Dr. Phibes* and *Deep Red* we find that when contemporary filmmakers require a space to signify horror, they often turn to Art Nouveau—thus replicating negative attitudes toward the style from the era of its ascendancy. In *Deep Red*, the Ghost House further signifies a lost, crumbling, and buried past that comes back to haunt the present. Might the edifice not, in fact, stand as the very *emblem* of Art Nouveau and its fate in critical circles—abandoned, deteriorated, belittled—but still there to be explored?

Finally, it should be obvious that, in the two films, we find what critic Linda Nochlin has deemed "The Jew in the Text"—a submerged reference to the group.[62] In the case of each work, Jews are linked to a world of depravity, death, and the Occult—themes also tied to Art Nouveau. In a sense, the films enact "a return of the repressed"—both in terms of modernism and racial bias—sentiments that we thought were as deeply interred as the corpse within the wall of the Ghost House. Instead, they stand ready to be exhumed.

## ABSTRACTION, HALLUCINATION, AND SLAUGHTER

Perhaps this is why yet another modern horror film (with intimations of entombment) has ties to Art Nouveau, *The Strange Color of Your Body's Tears* (2013), a Belgian, French, and Luxembourgian coproduction directed by Hélène Cattet and Bruno Forzani.[63] Many have seen it as an homage to the Italian *gialli* of the 1960s and 1970s—the specific genre in which Argento worked.[64] Significantly, however, it makes the latter director's films seem understated and restrained, as *Strange Color* is a bacchanalia of extreme violence, sumptuous production design, and spectacular cinematic trickery. One writer calls it a "taut fantasia of suspense" while another deems it "a chilly, dizzying trip into [the thriller] genre."[65]

As the words "fantasia" and "dizzying" imply, the film's narrative is perplexing and, ultimately, makes little sense. One writer summarizes the plot as follows: Dan (Klaus Tange) "returns home to find that his wife,

Edwige [Ursula Bedena], is missing. With no signs of struggle or break-in and with no help from the police, Dan's search for answers leads him down a psychosexual rabbit hole."[66] For Michael Atkinson, wise viewers "don't search for a diegetic life buoy to hold on to. [They] just let the conjuring act roll on."[67]

Why the film is of interest here is that the apartment building in which Dan resides is an Art Nouveau jewel. The credits reveal that it is a composite of historic sites in Brussels, a city known for such architecture, especially the work of Victor Horta. Among the buildings used in the film are the Maison Cauchie, Hôtel Solvay, Hôtel Hannon, Solvay Library, and the Palais de Justice. As we shall see, Art Nouveau décor will again be associated with crime, transgression, sexuality, and insanity.

As the film begins, Dan's journey home (photographed in color) is intercut with black and white, step-printed shots of a woman being subjected to sadomasochistic sexual practices; thus we see images of her bound hands, a knife at her throat, and her nipple nearly eviscerated. At times, it is hard to discern whether the accompanying moans on the abstract soundtrack are signs of pleasure or pain.

When Dan enters his apartment building, we see the first signs of its exquisite Art Nouveau design—its elaborate windows, its painted frescoes, its stained-glass panels (see figure 4.9). Later we see other

**4.9** A beautiful Art Nouveau fresco on the wall of Dan's (Klaus Tange) apartment building in *The Strange Color of Your Body's Tears* (2013, Hélène Cattet and Bruno Forzani).

decorative features, including a skylight, a light fixture, and an ornate hallway.

When Dan discovers that Edwige is missing, he presses the buzzers of other apartments to query tenants about her disappearance, but only one person responds: an old woman who tells him to come to her flat. It is a mysterious abode, and all we see of her is high black boots and lace-gloved hands. She tells Dan that years ago her husband also disappeared, and a flashback representing that moment is ushered in—one of many stories-within-stories that populate the film. One night while the elderly couple slept in their Art Nouveau bedroom, her husband, a physician, heard strange noises and began to investigate them. He placed his stethoscope to the ceiling (decorated with a painting of maidens) and listened. Detecting some noise above, he began to drill a small hole in the ceiling; when he inserted then removed his finger, it was blood-stained. Miraculously (given the tiny size of the opening), we later find that he entered the ceiling space and peered down at his wife below. When we return to the present moment, the old woman tells Dan that she saw in her husband's eyes "hatred, madness, and fear."

Soon, a detective arrives at Dan's door to investigate Edwige's disappearance, despite the fact that Dan has not reported the crime. The detective, too, has a grisly (though incomprehensible) story to tell about his own wife; and another flashback ensues, once more filled with Art Nouveau traces, including a woman's hand touching an Art Nouveau mural, and a decorative jewelry box. Dan, as confused as we are, asks the detective what his tale has to do with Edwige's abduction.

More enigmatic occurrences plague Dan: he receives phantom phone calls, meets a naked woman on the building's rooftop, listens to a mysterious tape recording of a voice speaking of the desire to "get rid" of him ("My pleasure will make him suffer"). Interestingly, the tape is wrapped in a paper on which there is childish drawing, reminding us of the one in *Deep Red*. Periodically, we return to black and white, step-printed images of bound women subjected to sadistic erotic acts. In one shot, a woman lying on a bed has her hair splayed out like the subjects of Art Nouveau paintings. In another, a hand seems to push a wall out from within.

At some point, Dan enters the apartment of a mysterious young woman. He has sex with her, and we notice that her apartment boasts a peacock

stained-glass window (Plate 17). The two engage in rough sex: glass shards cut his chest, creating a large wound into which he inserts his fingers.

The narrative proceeds in this hallucinatory manner and, on numerous occasions, we find Dan waking up, as though previous scenes have been dreams. At one point, he thinks Edwige is back in bed with him, but later finds only her hair and scalp. At another, he is plagued by a doppelganger. On numerous occasions, Dan senses a male intruder in his apartment threatening him. He finally locates the man on the other side of a tiled wall and, like Daly in *Deep Red*, breaks through it. The man tells him that all the apartments in the building are connected and that old walls stand behind new ones. The man knows the secrets of people who live there, as did Edwige—especially those of a woman named Laura. He says that, for Edwige, investigating secrets started as a game, but that she "pushed the limits of her body to see what was hiding inside." Not content simply to peer behind the wall, Dan enters the space and, significantly, in doing so passes by a series of Art Nouveau stained-glass windows. Furthering the sense of fantasy, these panels are transformed in a prismatic, kaleidoscopic fashion.

As the movie comes to a close and Dan lies dead, its denouement proves nonsensical. We learn that the strange old woman that Dan met early on is an incarnation of the infamous Laura, but there may be other versions of her, including his wife. Hence in *Strange Color*, as in so many other films associated with Art Nouveau, Woman bears the sign of evil—which reminds us that the peacock stained-glass window (a symbol of femininity) is in the flat of the woman who tortures Dan with violent love play. Furthermore, in both *Dr. Phibes* and *Strange Color* men drill through pictures of women to access a space behind a partition: in the former Dr. Phibes drills down to drop insects on a woman sleeping below and in the latter an old man drills up to enter a bizarre ceiling crawl space.

Our confusion at the narrative's end is no surprise, as there have been several self-reflexive clues that have prepared us for it. At one point, someone opens a box and finds nested matryoshka dolls within—a representation of the film's embedded story lines. Furthermore, Dan periodically plays with a plastic word game whose arrangements of letters are a jumble until the puzzle is solved (which it never is).

Clearly, the film privileges form over content, and unless one is prepared to go along for the visual-acoustic ride (which includes tinted shots,

solarized imagery, negative footage, split-screen effects, and camera trickery), one will be dissatisfied. But, like the other horror films discussed in this chapter, the movie's style is not random, but is redolent of Art Nouveau. Again, this choice solicits our interpretation.

While in *Deep Red* the edifice in question is a dilapidated Art Nouveau mansion, and in *Dr. Phibes* the physician's modernist abode, in *Strange Color* it is an antique luxury apartment building—well-preserved and still inhabited. Nonetheless, as in all the films, it is a locale for scenes of terror—both in the past and the present. In all the texts, characters must pierce barriers within buildings to disclose dreadful secrets or commit heinous acts. Dr. Phibes drills through a ceiling, Dan fractures a tiled surface, and Daly hacks at a wall—all to reveal the buildings' interstices. Furthermore, in all the works, parallels are made between Art Nouveau structures and human anatomy. In *Dr. Phibes*, the mad physician is a living cadaver. In *Deep Red*, walls hide a corpse and a picture of a bloodied man; furthermore, Daly bleeds in the process of accessing it. In *Strange Color*, the bodily references are myriad. Dan puts his fingers inside his wounded body much as he does through a tiled wall. Similarly, an elderly doctor holds a stethoscope to the ceiling—as though to hear its heart—and inserts his hand in its crawl space. Later on, a hand pushes out from inside a wall, as though to break through; and we are told that Edwige tried to plumb the depths of her body to discover its secrets. Finally, in all three movies, madness affects those touched by Art Nouveau—Dr. Phibes; Carlo, his mother; and Dan.

In sum, according to cultural clichés, Art Nouveau remains "horror-id"—metaphorically linked to serial murder, the undead, and sexual perversity. It is further tied to the frightening interior realm that lies hidden beneath the exterior surface, revealing a cultural loathing of certain facts of life: that natural beings are subject to death, rot, and deterioration; that bodies have innards, replete with blood and guts. As Antonin Artaud once wrote, "When you will have made him a body without organs, then you will have delivered him from all his automatic reactions and restored him to his true freedom."[68] However, no such "freedom" exists for humans, and even buildings (when done in an Art Nouveau style) seem marked by corporeality in films that solicit horror.

To make clear how ubiquitous is this association, even cross-culturally, I end by briefly citing an entirely different kind of film—a Bollywood

**4.10** In the Bollywood film *Om Shanti Om* (2007, Farah Khan), the film studio in which the heroine dies is marked by Art Nouveau details.

musical—*Om Shanti Om* (2007, directed by Farah Khan). An aspect of its narrative involves the murder of a screen actress who is burned to death by her lover in a studio fire. She later reappears there as a ghost, haunting the premises and seeking vengeance. Significantly, Art Nouveau design attaches to the mise-en-scène of the studio in which she perishes, to the shape of its windows and door frames, the patterning of its ceilings and floors, and the style of her dressing room furniture (see figure 4.10). It appears nowhere else in the film except in this maudlin building—yet another space for Grand Guignol.

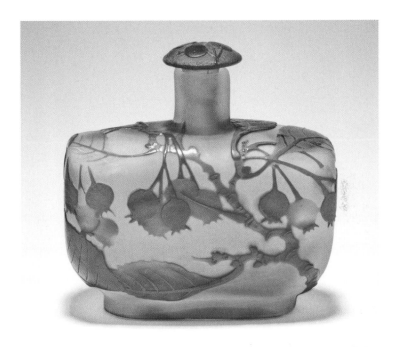

1 Bottle made by the firm of Émile Gallé (1906–1907); layered glass. In its vegetative design, the bottle shows Art Nouveau's interest in Nature. Courtesy of the Philadelphia Museum of Art.

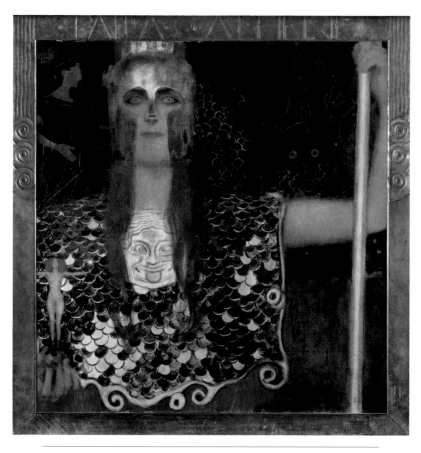

**2** *Pallas Athene*, Gustav Klimt (1898); oil on canvas. Here we see one of Art
Nouveau's malevolent females. Art Resource.

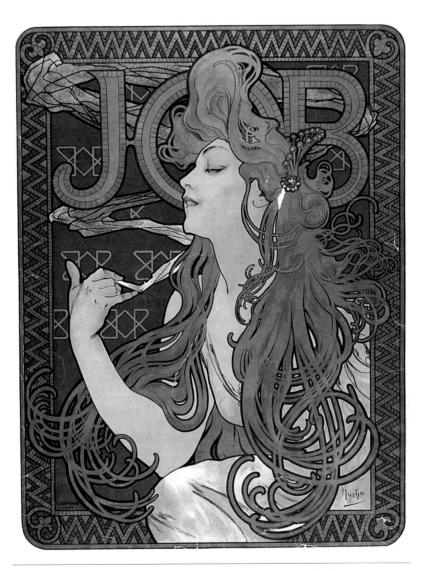

**3** Poster advertising Job cigarette papers by Alphonse Mucha (1898). Illustrates the use of the female image in Art Nouveau advertising. Courtesy of the Victoria and Albert Museum.

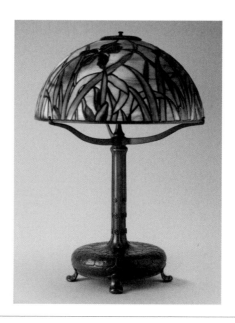

4 Lamp, Tiffany Studios (c. 1910); bronze and glass. This colorful, floral lamp is typical of Tiffany Studios Art Nouveau designs. Courtesy of the Philadelphia Museum of Art.

5 Boutique Fouquet designed by Alphonse Mucha (1900); installed in the Musée Carnavalet, Paris. Not only did Georges Fouquet's Paris jewelry shop sell gems, it *was* a gem due to Mucha's plush designs. Photograph by Kala Barba-Court.

6 *Metempsychosis* (1907, Segundo de Chomón). Here the butterfly-woman, a common figure in Art Nouveau, is encased in a gorgeous decorative frame.

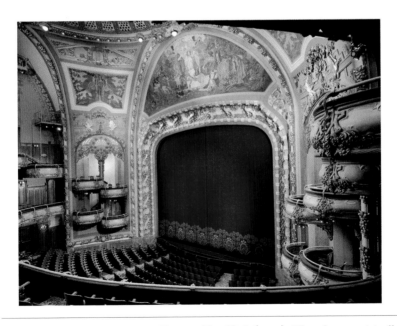

7 Auditorium, New Amsterdam Theatre, New York (1903). Though not originally built for showing movies, this historic Art Nouveau theater was later used for film exhibition. Photograph by Whitney Cox.

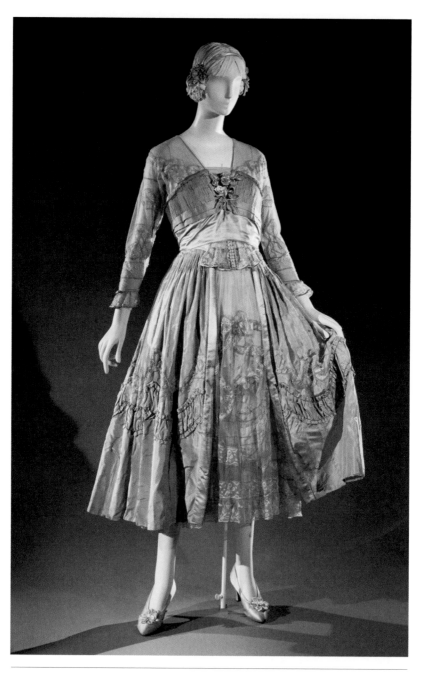

**8** *Woman's "Happiness" Dinner Dress*, designed by Lucile (Lady Duff Gordon) (Fall 1916); silk taffeta, satin, tulle, and chiffon with lace, lace insets and appliqué, ribbons, and silk flowers. Lucile designed both haute couture (as pictured here) and costumes for the *Ziegfeld Follies*. Courtesy of the Philadelphia Museum of Art.

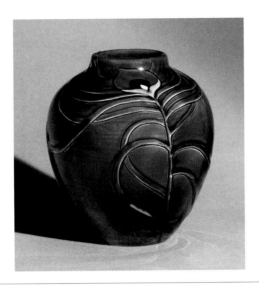

9 Vase made by Rookwood Pottery, Cincinnati, Ohio, and decorated by Matthew Andrew Daly (1899). This vase, in its green and aqua glaze, as well as its design, reflects the era's fascination with the figure of the peacock. Courtesy of the Philadelphia Museum of Art.

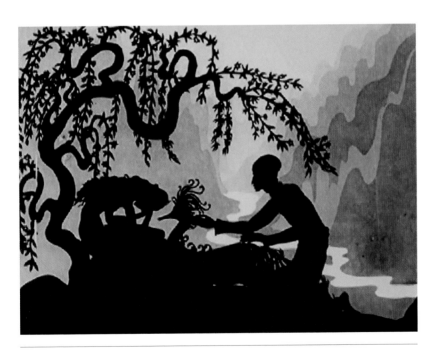

10 *The Adventures of Prince Achmed* (Lotte Reiniger and Carl Koch, 1926). In the colorful, finely wrought imagery of this film, we sense an Art Nouveau iconographic touch, and in its subject matter a precursor to *The Thief of Bagdad* (Raoul Walsh, 1924).

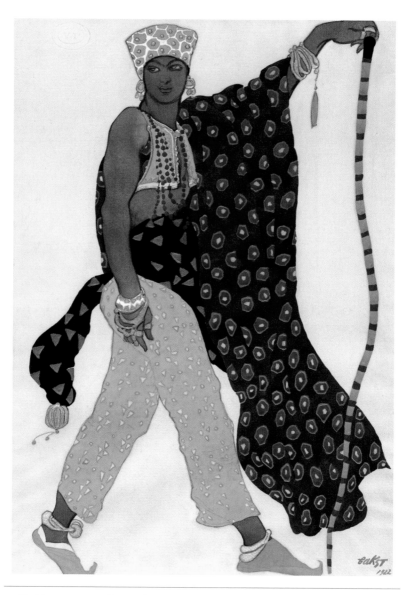

**11** *The Pilgrim*, costume designed by Léon Bakst for the ballet *The Blue God* (1912); opaque watercolor, metallic paint, and graphite on laid paper. Bakst's exotic designs influenced both high fashion and cinematic costume design. Courtesy of the Philadelphia Museum of Art.

**12** *The Thief of Bagdad* (Raoul Walsh, 1924). The palace of the Mongol Prince is especially beautiful and representative of the ornate Art Nouveau style.

**13** Pathé Tuschinski, Amsterdam (1921). One of the only remaining Art Nouveau picture palaces in the world. Photograph by Bas Uterwijk.

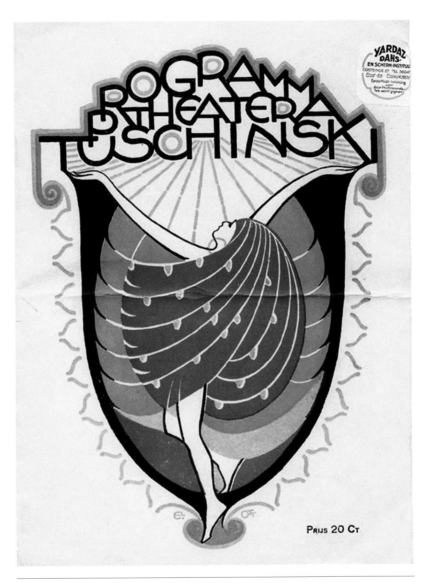

**14** This program for the original Tuschinski Theater is done in an Art Nouveau graphic mode.

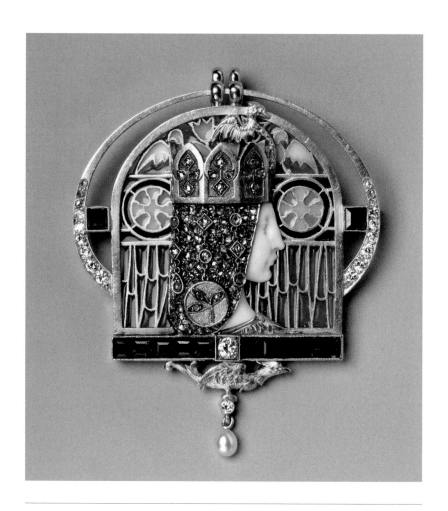

**15** *Isolde* pendant brooch by Lluis Masriera i Rosés (c. 1900); gold, ivory, enamel, diamonds, sapphires, and pearl. Masriera was one of Barcelona's great Art Nouveau jewelry designers and producers. Art Resource.

**16** Detail of Palau de la Música, Barcelona, by Lluís Domènech i Montaner (1905–1908). Tile wall with sculptures of female musicians. Photograph by Lucy Fischer.

**17** *The Strange Color of Your Body's Tears* (Hélène Cattet and Bruno Forzani, 2013). In this stained-glass window in Dan's (Klaus Tange) apartment building, one sees Art Nouveau's fascination with color and the figure of the peacock.

**18** *Figure from a Series of the Four Seasons* by René Lalique & Co. (1939); molded glass with matte finish. Many Art Nouveau works invoke the seasons as part of their focus on Nature. Courtesy of the Philadelphia Museum of Art.

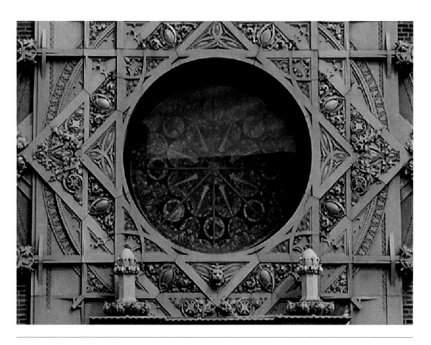

**19** *Sullivan's Banks* (Heinz Emigholz, 2000). An ornate window and decorative emblem on the exterior of Louis Sullivan's Merchants' National Bank in Grinnell, Iowa.

**20** *Klimt* (Raúl Ruiz, 2006). In this scene, Midi (Veronica Ferres)—Klimt's lover—is transformed into a gold-leafed canvas by the artist.

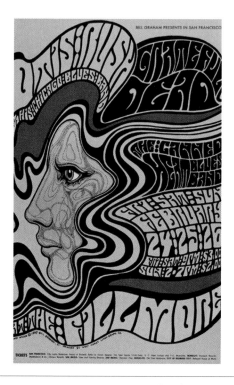

**21** "Bill Graham Presents . . ." poster by Wes Wilson (1967). In the psychedelic posters of the 1960s, such as this one advertising a concert featuring Otis Rush and His Chicago Blues Band, the Grateful Dead, and Canned Heat Blues Band, Art Nouveau was reclaimed for a new age.

**22** *Yellow Submarine* (George Dunning, 1968). In its bold colors, sinuous designs, and nods to "flower power," the film recycled Art Nouveau tropes.

# CHAPTER 5

# Art Nouveau, Patrimony, and the Art World

I n previous chapters we examined the presence of Art Nouveau ico-
nography in trick films, melodramas, fantasy epics, romances, art
films, and horror movies, respectively. Though, in all these works,
Art Nouveau elements were tied to the meaning and sensibility of the
film—the texts did not always name the design movement they employed
or address the broader art world in which it was situated.

All of the films discussed in this chapter deal with issues of patrimony
and the art world, and all reference the Art Nouveau style in their mise-
en-scène. The first, a mystery, does not mention Art Nouveau, but posi-
tions the nefarious realm of galleries and auctions within its environs. The
second, a drama, focuses on artifacts of the movement and their familial
legacy. The third, an experimental documentary, chronicles the fate of
several forgotten Art Nouveau buildings. The fourth, a biopic, concerns
a famous Art Nouveau practitioner and the struggles he encountered dur-
ing the final decades of his life.

## *UNCOVERED*: ART NOUVEAU AND THE GALLERY

The thriller *Uncovered* (1994), directed by Jim McBride, is set in Barcelona,
so it is no surprise that Gaudí's architecture once more pervades the film.
The drama concerns Julia Darrow (Kate Beckinsale), a professional art
restorer who works from her apartment. As the film opens, she is repairing
a fifteenth-century Dutch painting by Van Huys[1] for art dealer Menchu

(Sinéad Cusack), who will sell it on behalf of its bankrupt, elderly, and ailing owner Don Manuel (Michael Gough). The painting portrays a duke and knight sitting around a chessboard as a duchess stands in the background, and we learn that those pictured are Don Manuel's ancestors. As part of the conservation process, Julia has the painting x-rayed and, to her surprise, finds a message uncovered beneath it which asks "Who killed the knight?" She assumes that the painting was made to provide clues to solving a murder that involved the people depicted. Here, we note again, a concern with evils that lurk below the surface.

Curiously, however, a series of deaths and homicides begin to afflict the contemporary Barcelona art world and the victims include Alvaro Ortega (Art Malik), Julia's former professor, Don Manuel, his niece Lola (Helen McCrory), and Menchu. Comforting and advising Julia is her homosexual guardian Cesar (John Wood). In order to solve the puzzle of the painting's message and, by extension, the community's recent deaths, Julia enlists the help of Domenec (Paudge Behan), a "gypsy" street hustler and chess expert—on the assumption that the moves on the painting's chessboard relate to the order of the recent murders. As though to confirm this, enigmatic packages containing chess pieces arrive at her doorstep right before someone dies. At the end of the film, it is revealed that Cesar is the killer. In truth, he is the long-lost brother of Don Manuel—banished from the family for being gay—so he has claim to the painting. His motive in killing the others has been to assure that Julia inherits the artwork after his death—thus guaranteeing her financial security. Once discovered, he kills himself and the film ends with the painting being sold at auction.

Clearly, the artwork central to the narrative has no relation to Art Nouveau—but its placement in the drama means that its plot will focus on the art world. In some sequences, we get close-ups of Julia, tools in hand, restoring the canvas's surface and, in others, we even "enter" the space of the painting through live-action dramatizations of its scene. Furthermore, we visit a conservation lab when Julia brings samples of paint to be analyzed there.

What does, however, concern Art Nouveau is the architecture in which the film's perverse mystery unfolds, reminding us of the use of such settings in horror films. In an early episode, when Julia complains to Cesar

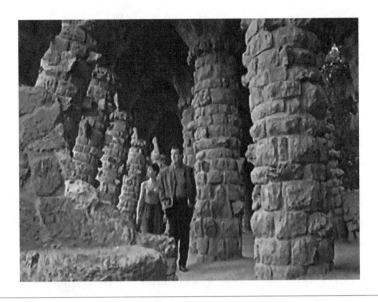

**5.1** In *Uncovered* (1994, Jim McBride), Julia (Kate Beckinsale) and Cesar (John Wood) stroll in Antoni Gaudí's Park Güell in Barcelona.

about gaining weight, he tells her that she is "all curves and lighter than air," like a Gaudí building. Later, the two stroll in Gaudí's Park Güell, the site at which she first meets Domenec and later reencounters him (see figure 5.1).

Interestingly, another chess player in the park is a look-alike of Salvador Dalí—a Catalan champion of Art Nouveau. Later, when Domenec and Julia meet on the street and talk of a "curse" being cast on the painting she is restoring, Gaudí's La Sagrada Família is seen in the background, as it is in another shot taken from high on a mountain surrounding the city. Furthermore, Cesar lives in Gaudí's Casa Battló, and several scenes take place there that feature his Art Nouveau furniture, knickknacks, and wallpaper (see figure 5.2).

Moreover, as Julia approaches his building one evening, prostitutes are seen lurking outside. So in these women, in Cesar (a gay man and murderer), and in Domenec (a "gypsy"), Art Nouveau is linked to marginality, criminality, and homosexuality—a trifecta of negative associations.

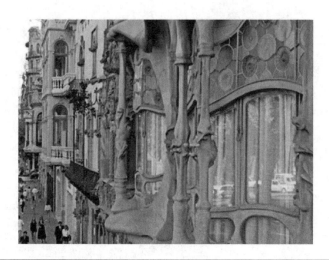

**5.2** In *Uncovered* (1994, Jim McBride), Cesar (John Wood) lives in Casa Battló, a Barcelonan apartment building designed by Antoni Gaudí.

Furthermore, when Julia goes to Professor Alvaro's apartment only to discover him dead, we see Art Nouveau décor in his bathroom.

Like others in the film tied to the movement, Alvaro is morally questionable: he had an improper affair with Julia when she was his student, and tries to rekindle it when she requests his help in decoding the painting. Furthermore, after his death the police find a photograph album labeled "Baby Album" on his shelf that actually contains pornographic shots of women he has bedded. They also see a lewd figurine there depicting someone on the toilet.

The art market in the film is portrayed as cut-throat and unscrupulous, with people's only concern the money they can make. Thus, Menchu's sole interest in the Dutch painting's enigmatic inscription is as a selling point to increase the work's value. Significantly, her office is in another modernist building. As is often the case, the art market intersects with family history. By killing Don Manuel and Lola, Cesar stands as the only remaining member of the Belmonte clan, so the painting belongs to him. He is ill and wants to pass it on to Julia, his charge since her childhood. Ironically, however, Julia also inherits Don Manuel's estate and with

it all his debts and must sell the painting to pay them. The film's final scene takes place in an auction house decorated with Art Nouveau wall tiles—and, as the credits roll, the sound of people bidding is heard— offering larger and larger sums of money.

Clearly both patrimonial lineage (that of the malign Belmontes) and the art world are corrupted—and both have been fouled by Art Nouveau.

## *SUMMER HOURS*: ART NOUVEAU IN THE HOME AND MUSEUM

As well as championing Art Nouveau, the introduction rehearsed myriad complaints against it—among them objections to its status as applied art aimed at the bourgeoisie. In the film *Summer Hours* (2008), French director Olivier Assayas implicitly counters such negative views by depicting a sympathetic upper-middle-class French family whose ancestral home is awash in artifacts of the movement.

The film has a minimal story line. Hélène Berthier (Edith Scob) is living in the countryside outside of Paris in a home that originally belonged to her uncle, Paul, a painter and art collector. At a summer party celebrating her seventy-fifth birthday attended by her three adult children and their offspring, she talks to her son Frédéric (Charles Berling) about how she wants her estate dispersed upon her death. Hélène soon dies and her children debate keeping the house for future generations, but decide to sell it for financial reasons; furthermore, they all live elsewhere (in France and abroad). As for the home's valuable decorative objects, they are advised that, to avoid huge taxes, they should donate them to the state. Toward the end of the film, appraisers enter the house to assess the paintings and objets d'art and, eventually, we see some of them exhibited in the Musée d'Orsay. As the film closes, Hélène's teenage granddaughter Sylvie (Alice de Lencquesaing) hosts a final party at the estate.

In addition to being about family, critics have interpreted *Summer Hours* as a work about art. Geoffrey O'Brien, for instance, writes, "The central dilemma about the fate of the art provides the structure of the film itself. It can be taken as a lucidly constructed debate on the meaning and function of art."[2] Such views are bolstered by Assayas's own statements that characterize the film as an "abstract reflection on what art is about, how

it lasts or not."[3] Here, it is important to know that Assayas's first calling was as a painter and he has claimed that his approach to film has been influenced by that medium.

In the critical literature on *Summer Hours*, while Hélène's decorative objects are mentioned, and sometimes identified by the creator's name, they are not "taken seriously" in and of themselves, and their style is never linked to other aspects of the narrative. As O'Brien notes, "We are given only the most fleeting glimpses of [the objects], and are never permitted to contemplate them apart from their context. The film is only peripherally about their qualities as objects. Their magnificence, such as it may be, matters only as it is part of what they mean to all those who find themselves involved with them."[4] On one level, this is certainly true. It is not until Hélène's Louis Majorelle desk is seen in the museum that the camera truly scrutinizes (or appreciates) it. While it resides in Hélène's home, it is a functional object; she uses it as a work surface and buries it in papers that obscure our view of it. But it is wrong to imply that the desk or other objects are not deeply considered in the film, even while Hélène is alive. In fact, the first part of the movie (the half hour that documents her last birthday party) entails a virtual cataloging of her possessions. In talking to Frédéric about their eventual disposition, she takes him on a tour of the house—highlighting the Majorelle desk, chair, and vitrine; an Antonin Daum vase; a Josef Hoffmann cabinet; and two decorative panels by Odilon Redon, not to mention a pair of Corot paintings (see figures 5.3 and 5.4).

Later, in discussing with her daughter Adrienne (Juliette Binoche) the table service being used for the family meal, Hélène points out a silver tea set made by Georg Jensen, and a silver tray fabricated by Christofle, both practitioners of Art Nouveau. When appraisers eventually arrive at her home, we see these items again, in addition to others: some Haviland porcelain designed by Suzanne Lalique and two glass vases attributed to Félix Bracquemond (who never actually produced such items). While we may not visually survey these objects for long, they are nonetheless foregrounded quite emphatically within the narrative. Yet Stephanie Zacharek of *Salon* writes of a vase we regard: "What matters more than" the piece itself "is the life . . . put inside it."[5] I want to argue that the vase itself matters, and it does so because it is a work of Art Nouveau—a fact that crit-

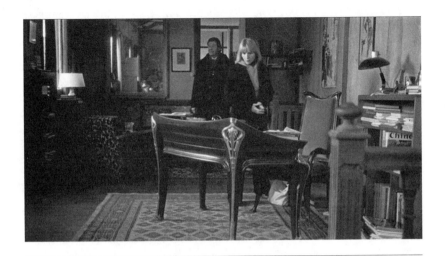

**5.3** In Hélène Berthier's (Edith Scob) country home in *Summer Hours* (2008, Olivier Assayas), there is a desk designed by Louis Majorelle.

**5.4** Hélène Berthier (Edith Scob) stands before a vitrine designed by Louis Majorelle in her country house in *Summer Hours* (2008, Olivier Assayas).

ics occasionally mention in passing as a mere plot detail, but never investigate thoughtfully.

But why does it matter? First of all, Hélène and her family are representatives of the very class of owners and collectors that Walter Benjamin demeans in his writing on Art Nouveau—the *haute bourgeoisie* who are imagined to create their decorated interiors as completely hermetic, narcissistic spaces that take no cognizance of the social world around them. Yet while the aging Hélène is by now something of a recluse, the rest of her clan are not—with jobs and residences spanning the globe. Furthermore, they are entirely sympathetic figures—not the ostentatious or shallow individuals that the term *bourgeois* may suggest. Second, some who critique Art Nouveau do so because it produces objects for quotidian use, not for pure meditation (like works of fine art). Nonetheless, in the film, Paul Berthier (who has died before the narrative begins) was both a "high art" painter and a collector of Art Nouveau objects—and one senses that both aspects of his life were equally important and worthwhile to him. Third, the fact that objects are used by characters in the film, and not simply displayed for others to admire, is shown as a positive thing. Pieces are casually scattered across various rooms as part of the décor of life—the Majorelle desk, chair, and vitrine in Helene's study, the Bracquemond vases in the kitchen, the Jensen and Christofle pieces on a garden table, the Daum vase in the living room. They are so much a part of daily life that Hélène must specifically point them out to her children who have simply grown oblivious to their being there, as one might to less precious home furnishings. Interestingly, when Frédéric offers the housekeeper something from the estate as a keepsake, she at first demurs, then chooses a Bracquemond vase because she thinks it is "ordinary"—having always used it for flowers. Even Frédéric has not realized its worth until the appraisers inform him. Here we are reminded of Georg Simmel's positive view of the applied arts (in speaking hypothetically of a vase). In particular, he sees its handle as connecting the artistic and practical aspects of the piece:

> A vessel . . . unlike a painting or statue, is not intended to be insulated and untouchable but is meant to fulfill a purpose—if only symbolically. For it is held in the hand and drawn into the movement of practical life. Thus the vessel stands in two worlds at one and the same time; whereas reality is completely

irrelevant to the "pure" work of art and, as it were, is consumed in it, reality does make claims upon the vase as an object. . . . This dual nature of the vase is most decisively expressed in its handle . . . [which] projects visibly into that real world which relates it to everything external. . . . The handles . . . also becomes components of the art form; they must be justified purely as shapes as constituting a single *aesthetic* vision with the body of the vase.[6]

In *Summer Hours* we comprehend not only the use and "exchange value" of Art Nouveau artifacts but the manner in which their beauty adds something to everyday existence. Highlighting this, Assayas says in an interview that he populated Hélène's house with more decorative objects than paintings because they are "works of art [that] are part of people's lives."[7] Clearly, Assayas's constant, graceful camera movement progressing fluidly around the rooms of the house adds an element of liveliness to the objects that it passes—literally animating them with its curvilinear trajectories while replicating Art Nouveau's favorite form.

But, so far, what has been said of Hélène's possessions might be said of all objets d'art within the bourgeois home. So why do her pieces "have to be" Art Nouveau? Here, I would argue that the movement's ties to Nature are imperative—a connection that, in its own era, led to charges of its being too sentimental, representational, and "flowery." It is crucial that the Berthier family home is not in the city but in the countryside—and from the very first shot of the film—of children engaged in a treasure hunt, mirroring Hélène's inventory of possessions—we are shown the surrounding lush greenery. Furthermore, one of the Corot paintings that the family owns is a landscape. Similarly, when Hélène takes her uncle Paul's final sketch out of the Majorelle cabinet to show Frédéric, its subject is a view of the garden from inside the house. Finally, the entire structure of the film seems to follow the seasons—starting in summer and going through the following spring, reminding us of Alphonse Mucha's "The Four Seasons," or of a series of glass figurines based on the seasons by René Lalique (Plate 18). Here it is important to note that Assayas grew up in rural France where nature was important to him. Furthermore, his maternal grandfather was a Hungarian landscape painter.

Critics have, of course, noted the importance of the countryside in *Summer Hours*. As Kristi McKim states, it is "a film less about a house, a

museum and people, and more about the landscape."[8] In particular, she focuses upon the final scene in which Sylvie and her boyfriend leave the party and roam about the field. There, Sylvie finally comprehends the reality of her grandmother's death as well as the loss of the estate, recalling how she used to pick fruit there in her youth, and how Paul Berthier had painted a picture of her grandmother as a child doing the same. After this conversation, the young couple runs off and, as McKim notes, "lose themselves in the natural world" as "we give away our look at this couple to this world writ large. We lose them in the lush sunlit trees, and the landscape shimmers accordingly."[9]

However, while the import of landscape is duly noted by critics, it is never tied to the Art Nouveau objects in Hélène's home, which as artifacts of the movement were all influenced by Nature. Clearly, the curvilinear lines of the Majorelle furniture evince the style's biomorphism, and the subject of the Redon panels (deemed Art Nouveau in the film but equally tied to the Symbolist movement) is flowers. Similarly, Haviland porcelain and Daum glass are known for their organic motifs, and the Christofle tray Hélène owns is imprinted with the actual veins of a leaf—a wonderful Bazinian metaphor for the way in which reality is "transferred" onto the film strip (see figure 5.5).

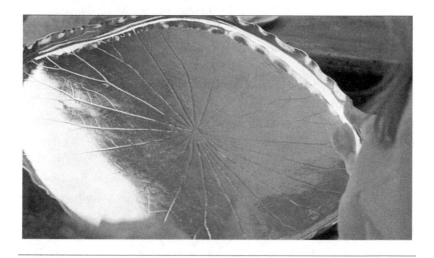

**5.5** Hélène Berthier (Edith Scob) in *Summer Hours* (2008, Olivier Assayas) owns a Christofle silver tray whose surface bears the imprint of a leaf.

Thus, landscape not only surrounds Hélène's house, but resides within it—in its Art Nouveau decor.

One of the final scenes of *Summer Hours* takes place in the Musée d'Orsay where some of Hélène's pieces are now displayed. The camera first follows a docent-led tour group into a section of the museum that contains several works of Art Nouveau—an ornate window, elaborate doors, and the Majorelle desk (see figure 5.6).

Significantly, the docent speaks of the L'École de Nancy, referencing the city in which Majorelle worked and resided, as did the Daum family and Émile Gallé. One of the tourists scurries away from the others and stands near the Majorelle desk talking on his cell phone about his evening plans, which involve seeing a movie. After the group passes, the camera takes time to survey the desk, as Frédéric and his wife enter to view it. Frédéric remarks on how "strange" it is to see it there, and opines that it seems "caged." His wife takes an optimistic view, noting how many people will now enjoy it, to which Frédéric gloomily responds that most will walk by without seeing it (as did the guy on the phone). Before leaving, they also regard a Bracquemond vase displayed in a glass case.

**5.6** A docent-led tour of the Musée d'Orsay's Art Nouveau collection in *Summer Hours* (2008, Olivier Assayas).

In a sense, both objects have always been in a "museum," since Hélène saw herself as "curator" of her uncle's collection and oeuvre at home—working hard to make sure that his name did not "fall into oblivion." And, within the film, we see her pleasure at the publication of a volume of his paintings. Of course, since the figure of Paul Berthier is fictional, Assayas had to hire an artist to devise his oeuvre given that the viewer will see pages of the book on-screen. He decided that Berthier's style should fall somewhere between that of real artists Édouard Vuillard and Pierre Bonnard.

But, of course, an institutional museum is a particular kind of space—one that, among other things, defines that which is valuable and qualifies as Art. Clearly, despite Art Nouveau's checkered critical history, it is now highly apprised and desirable. Much of this has to do with notions of authorship. Hélène's desk is only valuable because it is a Majorelle, her vase because it is a Daum, her tray because it is a Christofle, and her table service because it is by Haviland.

In particular, however, the Musée d'Orsay played a special and unusual role in the making of *Summer Hours*, which, on some level, was a commissioned film. To honor its twentieth anniversary in 2006, the museum decided to help artists create original works without requiring that they be directly tied to the collection. As it turns out, in the case of Assayas's film, it was—since the museum allowed him to use some of its celebrated objects as props. In an interview, Assayas discusses how he toured the museum to choose items that "fit [his] vision of the film" and ultimately selected works in the Art Nouveau mode—the Majorelle furniture, the Daum vase, and various other decorative pieces.[10] As for the Corot paintings and the Redon panels, they were too delicate to move, and had to be duplicated by craft persons. With these props, another set of faux artifacts and artists joins those attached to Paul Berthier's fictional oeuvre—all embedded in a second-order representational medium (cinema). Thus, we have a perplexing discourse in the film on the "work of art in the age of mechanical reproduction." In fact, one of the curators talks appreciatively of how "authentic" the museum's objects appear in *Summer Hours* and asserts that such pieces generally "look wrong" when re-created by set decorators.[11] Through Assayas's film, he is proud to have taken artifacts from the museum and "returned them to daily life" where they originated.[12]

The fact that many of the Art Nouveau items residing in Hélène's house are museum-worthy highlights the fact that, though initially denigrated, works in this style eventually achieved high status—despite their popularity having waxed and waned.[13] Significantly, Hélène's daughter Adrienne is a designer who rejects ornamentation. The dinnerware she produces (which was actually created for the film by an established artist) is white, geometric, and stripped of all decoration. Nonetheless, after her mother's death Adrienne takes the Jensen tea set and the Christofle tray, having earlier noted that "modern or antique, beauty is beauty."

Clearly, as one of the design movements pioneered in France, Art Nouveau has a privileged place in French heritage and patrimony—not simply in the history of the fictional Berthier clan. Modernism at the turn of the century through Art Deco in the 1930s was associated with France—and one would be hard-pressed to find a subsequent design movement so sourced. The subject of national legacy is directly referenced in the film in discussions of the tax break the state gives to people who donate inherited artworks to it. It is also suggested when Adrienne talks of selling her uncle's sketchbooks in the United States and a lawyer remarks that it would be difficult to get an export license to do so (since France protects its cultural heritage).

Finally, it seems significant that a documentary film has been made focusing on the relation between the Musée d'Orsay and the production of *Summer Hours*; it accompanies the feature on the DVD release. In *Inventory*, which is directed by Olivier Goinard, we shuttle between interviews with museum personnel, art experts, dealers, historians, and Assayas himself, who is posed amidst the museum collection, standing by the Majorelle desk or near an Art Nouveau stained-glass panel (see figure 5.7).

Intermittently, we view relevant clips from *Summer Hours*. Thus, after a curator discusses the Christofle tray, we cut to the scene in the film that features it. Interestingly, one curator complains about the fact that useful objects are worth less in the art market than useless ones.[14] As he asserts, sardonically, "If it's useless people think it's more spiritual."[15] Clearly, he disagrees.

Assayas himself feels that something is lost in the "transmutation" of objects from home to museum. It involves a separation from "roots" and "origins"—and a metamorphosis into the "abstract idea of art history."[16]

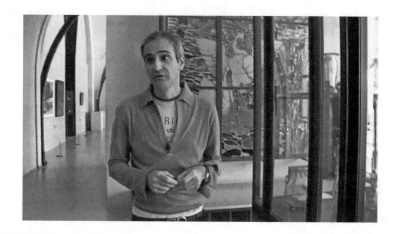

**5.7** In *Inventory* (2008, Olivier Goinard), filmmaker Olivier Assayas stands in the Musée d'Orsay's Art Nouveau collection, some of which he used as props in his film *Summer Hours* (2008).

While I understand this view, I beg to differ. Given Art Nouveau's brief period of popularity, its rapid fall from grace, its associations with kitsch, Camp, and consumerism, I am glad that design museums exist to give the movement its due. Interestingly in *Summer Hours*, Hélène doubts that her children will want the "residue" of her life—"weighted down" as it is "by the past"—and she disparagingly calls her collection "museum pieces."

However, if the only alternative to material neglect is historical contextualization, it seems a preferable option. If the only alternative to deprecation is monumentalization, it seems a good choice. If the only alternative to being ignored is being "caged," it seems a fair sentence.

## ARCHITECTURAL HISTORY AND *SULLIVAN'S BANKS*

It is interesting that the final resting place for some of Hélène's precious objects is the Musée d'Orsay. The building was previously the site of the Orsay railway station and hotel, built for the 1900 Paris Exposition that introduced Art Nouveau. As the museum's website claims, "the building itself could be seen as the [institution's] first 'work of art.' "[17] Designed by

Victor Laloux, it was conceived in the academic style so as to blend in with the surrounding neighborhood. Given the building's birth in the modern era, however, the museum's charge has been to collect art created between 1848 and 1914, thus encompassing the era of Art Nouveau.

In the post-World War II period, the Orsay station was almost razed in order to replace it with a modern hotel. This plan was thwarted, however, when it was listed as a historical monument in 1973. Four years later, the building was slated for renovation as the site of the Musée d'Orsay. In 1979, the architectural firm ACT was chosen to oversee the transformation, which "would respect Laloux's architecture while nonetheless reinterpreting it according to its new function."[18] So the creation of the Musée d'Orsay was an act of architectural patrimony and restoration—a desire to preserve a grand Parisian building for a new and equally impressive purpose. As we know, however, many important architectural sites in the world have not been reclaimed in this manner (for example, the Villa Scott, mentioned in the previous chapter). Furthermore, even when buildings remain standing, they have often been forgotten or surrounded by ones of lesser majesty.

German experimental filmmaker Heinz Emigholz confronts this issue by examining numerous buildings designed by modernist architect Louis Sullivan (1856–1924) in the early years of the twentieth century. His work is significant for being one of the few American architectural oeuvres to be identified with the Art Nouveau style. As described by the National Gallery of Art, the exteriors of his buildings "were decorated with intricate ornaments inspired by forms in nature and by Celtic art. With these designs, Sullivan brought elements of nature into the urban landscape."[19]

After Sullivan studied architecture at MIT as well as the École des Beaux-Arts in Paris, he joined Dankmar Adler's Chicago firm in 1879 and two years later became a full partner. He also served as a mentor to Frank Lloyd Wright who worked as a draftsman at his firm. Among Sullivan's most famous buildings are the Auditorium Building in Chicago (1889), the Wainwright Building in St. Louis (1890), and the Guaranty Building in Buffalo (1894). Some monumental edifices still stand (e.g., the Carson, Pirie & Scott Company Store in Chicago [1899–1904]—which is now the Sullivan Center). Others, however, are lost (e.g., Chicago's Kehilath

Anshe Ma'ariv Synagogue [1890], which later became the Pilgrim Baptist Church) or repurposed in unimpressive ways.

Specifically, in *Sullivan's Banks* (2000), Emigholz examines a series of Midwestern banks built by Sullivan from commissions that he accepted during a period of career decline, when he was no longer offered prestige urban projects. Thus, they are not his premier works. He struggled with alcoholism and died alone in a Chicago hotel room in 1924—largely overlooked and poor. Hence, there is some irony to the film's focus on his banks—buildings that house wealth. While only a modest headstone originally marked Sullivan's grave, a monument in his honor was added later—decorated with a facsimile of one of his intricate ornaments. Interestingly, it is a German who has trekked to see a group of Sullivan's buildings and immortalized them on film, not an American—underscoring clichés of European respect for heritage and American disregard of it.

Perhaps the most impressive building Emigholz visits (and one that maintains its splendor) is the National Farmer's Bank in Owatonna, Minnesota, which was constructed between 1906 and 1908. Emigholz starts by documenting its elaborate exterior, with its arched stained-glass windows, its green-and-blue sculpted borders, and its complex ornaments (see figure 5.8).

He then moves inside where much of the interior décor remains intact, with its patterned arches, intricate light fixtures, and decorative clock frame.

A second noteworthy building that Emigholz tours is the Merchants' National Bank in Grinnell, Iowa, erected between 1913 and 1915. Its facade is graced by a huge ornament that houses a circular stained-glass window that we later see illuminated from the interior (Plate 19). Another side of the building contains a panel of rectangular stained-glass windows, which Emigholz again shows us from inside, with light shining through it.

In general, Emigholz's shots are motionless, more like a series of still photographs than moving images, but the ambient noise we hear (of street sounds, cars, or commercial activity) gives a sense of live action. Emigholz mostly follows the same static pattern in his examination of each bank—though on one occasion he employs a pan shot and on another begins with a bank's interior before moving outside. Emigholz frames many of his images askew—as though to work against the notion of the "picture perfect."

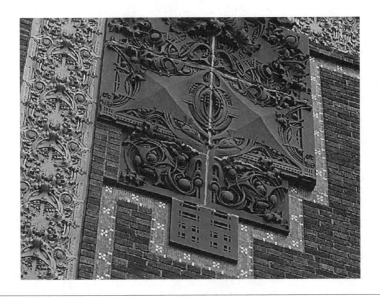

**5.8** An elaborate decorative ornament on the facade of Louis Sullivan's National Farmer's Bank in Owatonna, Minnesota, as pictured in *Sullivan's Banks* (2000, Heinz Emigholz).

What is poignant about the film is the context in which Sullivan's buildings now reside. First, there are the very names of the banks that seem to speak less of today's impersonal corporate capitalism than of individuals who once saved there—through hard work and frugality: National Farmer's Bank, People's Savings Bank, Land and Loan Office, Home Building Association Bank. The facade of a bank in Sidney, Ohio, boasts the word "Thrift," a slogan that seems unimaginable today.

While the buildings are monuments to Beauty, they are now surrounded by small-town architectural banality. Thus, today the Merchants' National Bank stands next to an ugly drugstore whose design is hackneyed neo-Art Deco. Similarly, the Sidney bank abuts a nondescript shop called "Seeds of Elegance," which seems unintentionally ironic. Finally, part of the Home Building Association Bank of Newark, Ohio, now houses Tiffany's Ice Cream Parlor—another reference to faux refinement in the land of middle America—and a reminder of the era in which the name Tiffany meant Art Nouveau.

Sadly, important old buildings cannot be housed in museums, unless, like the Orsay station, they become one. Instead they are destroyed and, if we are lucky, some fragments of them will remain and get accessioned by museums, where they reside, synecdochically, as parts of a vanished whole. One of Sullivan's greatest buildings was the Chicago Stock Exchange (constructed by Adler and Sullivan in 1894 and razed in 1972). Thanks to the Art Institute of Chicago, some of its features have been preserved there: a reconstruction of the trading floor and the building's elaborate elevator grill. Furthermore, its entrance arch now stands on a street near the museum. There is even a dramatic story attached to the building's razing—one worthy of a feature film. Photographer and preservationist Richard Nickel, who had opposed the building's obliteration, was killed while photographing its demolition when a staircase toppled on him—so he literally gave his life for Sullivan's art.

In contemplating the destruction of the majestic man-made environment, one is reminded of Georg Simmel's 1919 meditation on the "ruin." Simmel sees architecture as humanity's "sublime victory over the spirit of nature" in molding matter to its own artistic forms.[20] However, "this unique balance—between inert matter and informing spirituality . . . breaks . . . the instant a building crumbles."[21] At that point, human will, which "has led the building upward," disappears.[22] What remains and gives the building "its present appearance is the brute, downward-dragging, corroding, crumbling power of nature."[23]

Simmel distinguishes between deserted (mostly ancient) ruins and those desolate structures that we find today in urban spaces. In those cases, people—not Nature—are responsible for the edifices' decay. As he comments, "The inhabited ruin loses for us the sensuous-suprasensuous balance of the conflicting tendencies of existence which we see in the abandoned one. This balance, indeed gives it its problematical, unsettling, often unbearable character. Such places, sinking from life, still strike us as settings of a life."[24] The true ruin, on the other hand, "conveys the impression of peace."[25]

While the Sullivan banks that Emigholz considers are neither deserted ruins nor entirely decayed structures—they fall somewhere in between—as buildings they have lost their former glory due to age and societal neglect. This seems especially true of the Home Building Association Bank

that has been repurposed as a lowly ice cream parlor. The tiles on its facade read "Old Home," which firmly positions it in the past and has associations with "old age home." While Simmel finds ruins "tragic" (but never "sad"), this building, in particular, leaves us feeling disquieted and melancholy, thinking: "How the mighty have fallen!" Its fate reflects the "indifference" of people who, in letting such sites decline, have become "the accomplice[s] of nature" in a way that is "dramatically opposed to [their] own essential interests."[26]

This is certainly the case for Sullivan's banks, which are due more reverence than they have thus far received.

## GUSTAV KLIMT AND THE BIOPIC

*Klimt* (2006) by the Chilean director Raúl Ruiz is a different type of film about the art world, specifically a biopic concerning the famous Viennese painter who lived between 1862 and 1918 and was part of the Secession group related to Art Nouveau. However, it is not a traditional work of this type but an experimental art film that combines fact and fiction, fantasy and reality, all in an attempt to raise broader questions about the place of art and the artist in modern society. Truth be told, it is not a successful movie—in part because of the wooden performance of John Malkovich as Klimt, the mélange of performers' accents, and the stilted quality of much of the dialogue. As Paul Julian Smith writes, it "is a film of glittering fragments that fail to cohere into a satisfying whole."[27] Nonetheless, as one of the few movies that directly confronts the nature and politics of Art Nouveau, it is worthy of consideration.

Structurally, *Klimt* shuttles between scenes of the artist dying in a sanatorium and images of the last decades of his life, which coincide with the heyday of the Secession. Occasionally, the past and present seem to merge, as when we hear Klimt's heavy breathing (likely his death gasps) on the soundtrack linked to earlier events. Finally, there are sequences that are so bizarre as to seem the hallucinations of a dying man. Ruiz has, in fact, described the film as "phantasmagoric," echoing a term used by Walter Benjamin to describe Art Nouveau.[28]

As for other historic individuals referenced in the film, they include Egon Schiele (Nikolai Kinski), Klimt's protégé and another member of

the Secession group. It is he who repeatedly visits Klimt in the sanatorium and is pictured there at the moment of his death. Painter James McNeil Whistler and philosopher Ludwig Wittgenstein are mentioned in passing, and Oskar Kokoschka (Nico Bartholy) makes a brief appearance, but he is not clearly identified by name. Another important figure represented is architect Adolf Loos (Denis Petkovic) whom we discussed in the introduction as an opponent of Art Nouveau. In the film, he encounters Klimt in the famous Café Central and a discussion about art ensues. Loos calls Klimt "a model ornamentalist—a real pathological case," and complains that "he never stops switching styles." Loos picks up a mirror and declares that its decorative frame is useless, giving "unproductive work to craftsmen." On the other hand, its looking glass is useful and, therefore, expressive. Klimt responds to these provocations by shoving a piece of cake into Loos's face—stating that what Loos has said is "ornamental and therefore useless." Conversely, the cake, he opines, "lets me shut your mouth" and is therefore useful. Though it is unlikely that such a confrontation ever took place, the men's opposing positions square with historical fact. Furthermore, the men's highly dramatic encounter coincides with Tag Gronberg's notion that "performativity" was an important aspect of Viennese culture. As she notes, "the artist . . . was always simultaneously the object as well as the subject of a public gaze."[29] In this sequence and another depicting cakes shaped like Viennese buildings, we are also reminded of Salvador Dalí's article on Art Nouveau entitled "Concerning the Terrifying and Edible Beauty of Art Nouveau Architecture."[30]

Other conversations occur in the film that replicate debates about Art Nouveau. At a Klimt exhibition, we overhear negative comments about his work; and, in a café scene, we hear reference to his "hideous art." Furthermore, someone mentions the scandals surrounding his style. This likely refers to the rejection of his three commissioned murals for the University of Vienna (1900–1907). After seeing one of them, which sought to represent Philosophy but included the figure of a nude woman, authorities requested an image that was "more decent, less objectionable and less inclined to provoke obscene jokes."[31] In another scene of Klimt in a café, a stranger asks him "What is beauty? What is ugly? What is functional?"—questions that haunted artists and critics of the era.

It is no accident that several scenes of *Klimt* take place in cafés, since as Gronberg has noted, it "was an important site for the representation of the city's intelligentsia."[32] Significantly, some of the cafés (the newer ones) sported Art Nouveau interiors. Jeremy Aynsley, for instance, discusses the Café Lurion, with its "sideboard decorated with a running carved Secessionist floral motif border, an abstraction of a rose and thistle."[33] Its poster, created by Emil Ranzenhofer and reminiscent of work by Henri de Toulouse-Lautrec, was also marked by an Art Nouveau graphic idiom. A few other coffee houses of the era bore the stamp of the movement, for instance the Café Eiles and the Café Lebmann;[34] and Josef Hoffman published a sketch of another one in the first issue of the design magazine *Das Interieur*.[35]

Toward the end of the film, Klimt walks down a snowblown street and encounters an art world official who reveals that he voted against the painter's receipt of a prize. The man says, "Too much beauty is far worse than too little" since "the old would have to be demolished for the new." Clearly, this stance contrasts with Klimt's valorization of Beauty and innovation. As for the latter, one episode speaks to his interest in science. Klimt visits his physician and peers at a slide of bacteria through the lens of a microscope. "It's wonderful. It really is very beautiful," he observes. In another sequence, Schiele remarks on Klimt's new "Chinese" painting style—invoking Art Nouveau's experimentation with Orientalism.

While some of the individuals that populate the film are not historical figures, they frequently refer to ones who are. The fictional character of Midi (Veronica Ferres), Klimt's female friend, probably alludes to his real companion, Emilie Flöge, a famous fashion designer who, along with her sisters, opened a Viennese salon in 1904. They became known for promoting the "rational dress" style, associated with the New Woman—clothing worn without a corset, draped loosely from the shoulders, with comfortable, wide sleeves. According to Wolfgang C. Fischer, Flöge was a "living figurine embodying the zeitgeist" of the early 1900s.[36] Klimt painted a portrait of her in 1902, and *The Kiss* is believed to depict the two of them as a couple. Moreover, the women in many of Klimt's works wear dresses that reflect Flöge couture. In a few scenes in the film, we see Midi in her atelier. (In actuality, her shop was outfitted by the Wiener Werkstätte group—also the source of much of the jewelry that Klimt gifted her.)[37]

Throughout the narrative Klimt is shown in pursuit of a vamp named Lea de Castro (Saffron Burrows), whom he first encounters in a movie projected by Georges Méliès at the 1900 Paris Exposition. Of course, Méliès is an historical figure who shot documentary footage there. Lea de Castro, however, is not, though she is believed to have been modeled on Cléo de Mérode, a famous dancer who fascinated Klimt and who was immortalized in a sculpture by Alexandre Falguière, masks by Georges Despret, and a painting by Toulouse-Lautrec.

The treatment of Lea, however, makes clear that much of the film is invested with fantasy—a nod to Art Nouveau's caprice and to Klimt's dying visions. Lea has a doppelganger and Klimt refers to the pair as the "false" and "true" Leas—evocative of the two Marias in Fritz Lang's *Metropolis* (1927). Perhaps, this doubling is also a nod to the split existence of Lea's physical self and her ethereal on-screen presence. Klimt also repeatedly encounters a spectral man known as the Secretary (Stephen Dillane), a representative of the Viennese bureaucracy seen only by him. In fact, at one point, when Klimt converses with the man in the sanatorium, his doctor passes by and asks if he is all right since he is talking to himself.

Other moments in the film seem equally unreal. At one point, Klimt meets a man in a café who invites him to his house where the man's son makes an appearance dressed like Mozart. Another time, a derelict man (who seems straight out of an Expressionist play) barges into the Café Central shouting news about the war and chastising the customers for their "coffee house philosophy." Finally, in some sequences, snow falls in interior spaces; and during one visit to a doctor, Klimt peers into a microscope and sees a proleptic image of himself as a dying man. As though to sum up the illusory world of the film, Klimt hears the Secretary asking him: "Why should it surprise you that there are so many layers? Why do you keep wondering which is the real one?" Significantly, Ruiz has compared his film to an onion, composed of "very fine leaves, skins that form a spherical figure."[38]

Still other moments of the film are decidedly "over the top." A sequence takes place in an upscale brothel in which women wear mustaches (a nod to the era's androgyny) and various exotic scenarios are acted out. Klimt and his companion choose the African Salon and enter a cage, putting on gorilla masks. Finally, Lea (and her double) live with Duke Octave (Paul

Hilton) who watches the women perform sexual acts through a two-way mirror. In a sense, Ruiz's film offers spectators a similarly voyeuristic outlook, as they peek unseen at views of risqué fin de siècle Vienna.

Both the brothel and Duke Octave's ménage make clear that the sexual world of bohemian Vienna is seen as libertine and depraved—reminding us that Art Nouveau was often considered debauched. (As the Secretary tells Klimt, in Paris his art would be seen as poetic, while in Vienna it is deemed decadent.) Here one might consider the lesbian implications of Klimt's *Water Snakes* (1904–1907) or the suggestive portrayal of a pregnant woman in his *Hope I* (1903). As though to emphasize dissolute sexuality, an early shot in the film depicts a one-legged soldier humping a woman as his bloody prosthetic lies on the sanatorium floor. Klimt is shown to have numerous lovers and countless children whom he does not even know. Moreover, nude women sit on fabric swings in his studio to inspire eroticism in his canvases. (Interestingly, the only thing that Adolf Loos liked about Klimt's work was its sensuality.) In many ways Klimt's view of sex was consonant with the age. As Stefan Zweig wrote (emphasizing how, ironically, repression can lead to licentiousness), "Illicit ways were found everywhere for the inhibited. Thus in the last resort the generation that was denied sexual instruction or any relaxed association with the opposite sex was a thousand times more erotically disposed than the youth of today with their greater freedom of love and sex."[39] As for Klimt's mistresses, in a conversation with his mother and sister the latter two decry the fact that his women are mostly Jewish; and in one scene, a former lover tells him that she wishes to raise their child as a Jew. In addition, many of Klimt's upper-class patrons were Jewish, for instance Adele Bloch-Bauer, the subject of one of his most famous paintings. Clearly, anti-Semitism was rampant in Austria and the fact that Jews championed the avant-garde only added to their negative characterization. Despite this, they continued to support artists like Klimt, because, according to Wolfgang G. Fischer, they were "made secure" about their aesthetic choices by his use of "allegory, symbolism and ornament" to mollify the "electrifying erotic effect of [the] individual portraits" they commissioned.[40]

Not only were Jews devotees of contemporary art, they were also part of the Viennese café circles in which painting, literature, and politics were discussed. According to Charlotte Ashby, the coffee house did not begin

as a Jewish institution but came to be associated with the group since it was consonant with their "world view."[41] It was a quintessentially modern, urban space and one known for its "inclusiveness and informality"—traits that commended it to an assimilated population.[42] For this reason, Ashby notes that "the café was constructed, often antisemitically, as Jewish in contemporary journalism."[43]

In the catalog of Art Nouveau's alleged offenses its penchant for morbidity figured high—as in Klimt's painting *Death and Life* (1910), or Aubrey Beardsley's drawing of Salome holding John the Baptist's head (1893)—and the film takes pains to highlight this theme. Of course, starting the movie with the artist on his death bed is the clearest indication of this perspective, but another scene portrays him examining the syphilis bacteria (that eventually infect him) under a microscope. Moreover, several episodes in the sanatorium include skeletons; as Schiele remarks, standing next to one, there was no shortage of corpses at this time (the era of World War I). One skeleton seems almost Frankensteinian, since we are told that its legs came from Romania, its head from Russia, and other body parts from elsewhere. Finally, toward the end of the film, Klimt meets a veiled woman dressed entirely in black who ushers him into a strange room. When he asks her what time it is while holding a skull, she responds, "Late, I'm sure," whereupon he asks for the "way out." Earlier, Klimt had said that his paintings were allegorical and clearly Ruiz has taken this trope to heart.

What is especially noteworthy about *Klimt*, in comparison to other films discussed, is that beyond including Art Nouveau elements within the mise-en-scène (e.g., the modernist costumes worn by Midi, Lea, or Klimt and created by Birgit Hutter), *it actively attempts to translate Art Nouveau aesthetics into cinematic style*—a fact that separates it from other works and redeems its many failures (see figure 5.9).

As Ruiz says, the film involves an "exuberance of colours, distortion of space, [and] extreme complexity of camera movement."[44]

Indeed the cinematography, supervised by Ricardo Aronovich, continually traces circular (and even 360-degree) arcs—imitating the relentless curves or Art Nouveau, as well as the shape of the waltz, a Viennese favorite.[45] Even the opening title image—the word "Klimt" superimposed over one of his paintings—eventually starts to spin (see figure 5.10).

**5.9** Gustav Klimt (John Malkovich) and his lover Midi (Veronica Ferres) wear modernist costumes designed by Birgit Hutter in *Klimt* (2006, Raúl Ruiz).

**5.10** The opening title of *Klimt* (2006, Raúl Ruiz) displays a section of one of the artist's paintings.

Other curvilinear moving shots occur in scenes of Schiele in the sanatorium, of Klimt's entrance into Lea's abode, and of people at an art show. Alternately, actors are periodically placed on a rotating platform, so it is they who mark circles and not the camera (e.g., in one scene in a café). Moreover, many images are rendered with a blurry, distorted focus that tends to imitate the indistinct lines of Art Nouveau. We see this in shots of models in Klimt's studio, people at an exhibition, and the artist himself (see figure 5.11).

When Klimt drips water onto a glass pane, the camera looks through it, mimicking the hazy version of reality that the artist utilizes in his paintings. Numerous images in the film are also shot askew (e.g., those involving Midi and Klimt), highlighting their abstraction. Significantly, certain shot transitions are accomplished through the fracturing of mirrors, underscoring the mosaic quality of Klimt's art, Ruiz's direction, and Valeria Sarmiento's editing. Finally, in a beautiful episode, Klimt works with gold leaf in his studio while talking with Midi. Suddenly, she is shown with gold leaf on her lips and face, as though a figure on one of his canvases (Plate 20). For Janet Stewart, Midi's body here is "a projection screen for the art nouveau patterning that clads the wall behind her."[46] Later, Midi becomes angry and slams the studio door as she exits, and the particles of gold leaf fly through the air. Thereafter, the room itself seems overlaid with a Klimtian metallic patina.

At the end of the film, following his death, Klimt is seen on-screen reciting a poem as leaves fall and cover his face, a reference to Art Nouveau's love of Nature. Significantly, the last word he utters is "flowers." Interestingly, Susanna Partsch remarks on how Klimt's landscape paintings have generally been ignored. Evidently, he produced fifty-four such canvases, which show the influence of both Impressionism and Pointillism.[47]

In conclusion, we return to the figure of Georges Méliès—an historical personage that Ruiz embeds in his film. On one level, this is not surprising, since Ruiz is a fellow filmmaker and it would interest him to draw on Méliès's presence at the Paris Exposition. But we need to dig deeper. For it seems significant that Ruiz selects Méliès and not the Lumières, who were at the event as well, as a nod to his predilection for fantasy over documentary, and to the parallels between magic and Art Nouveau. Moreover, in Ruiz's film, Méliès screens an *actualité* that purports to depict

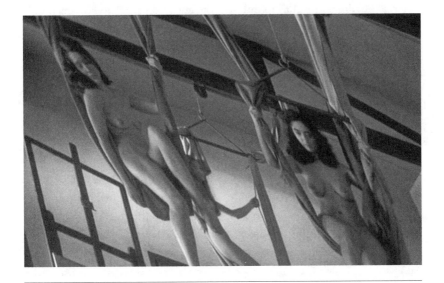

**5.11** Images of Klimt's models on swings in his studio in *Klimt* (2006, Raúl Ruiz) rendered in blurry focus, approximating aspects of the artist's pictorial style.

Klimt receiving an Exposition medal. The movie surprises the artist since, even within the film's narrative, no such recording ever took place. Rather, an actor has impersonated Klimt, once more raising issues of doubling and the fluid border between illusion and reality. Though there is no historical evidence of an encounter between Klimt and Méliès, Ruiz believes that "the meeting could have happened: Klimt was a celebrity, Méliès at the time made the news, he invented news, he made films about the coronation of the King of England, in Paris with actors in his studio."[48]

There is, however, another reason that Ruiz imagines the assignation of Méliès and Klimt and that is to make clear the ties between the Viennese painter and Ruiz's own cinema, with Méliès functioning as a stand-in for him. There are numerous reasons why Ruiz sees parallels between himself and Klimt. James Norton finds the director attracted to Klimt since the painter's "figures have the frontal flatness that Ruiz has admired in Russian icons." Here, in particular, we think of the scene in which Méliès "magically" transforms a paper cutout of Lea into a projection of

her real shadow, one that Klimt approaches and caresses. Furthermore, for Norton, both Klimt and Ruiz "favour Byzantine mosaic effects, in Ruiz's case in both the pictorial and narrative registers."[49] Ruiz also identifies with Klimt's fluctuation between experimental and mainstream modes. As the director notes, "I move from one extreme to the other, and Klimt was like that, he was in the centre of all the artistic quarrels."[50] Moreover, Ruiz sees himself as a creator caught between forces of art and business: "The situation of Klimt . . . is the situation of the filmmaker in our times . . . who tries to escape the dictatorship of [the] market . . . tries to make his way, [and] at the same time not to forget about the market."[51] Therefore, Ruiz defends Art Nouveau's maligned commercialism, its failure to be "pure" art. As though to highlight the comparison between painting and cinema, Ruiz depicts Klimt looking through an ersatz "viewfinder" (ostensibly to frame a picture)—one that seems identical to that of a camera. Furthermore, two flip books (predecessors to the cinema) appear in the film and both are associated with Klimt. One contains his erotic drawings. The other holds photographs of his altercation with Adolf Loos. Both are riffled and shown as an ersatz movie.

Finally in considering *Klimt*, we recall Walter Benjamin's famous essay "The Work of Art in the Age of Mechanical Reproduction." On the one hand, in order to portray Klimt's canvases in his film, Ruiz was required to have craftsmen reproduce them, since the originals could not be obtained. On the other hand, the copying process itself was doubled in the filming process since the movie serves as a mechanical reproduction of Klimt's life—one lived in the age of cinema. For, as Janet Stewart explains, Ruiz's *Klimt* expresses the director's desire to explore the relationship between cinema and the history and theory of art.[52]

In truth, this is my desire as well—as registered in the pages of this volume.

# Epilogue

## THE 1960S AND THE ART NOUVEAU REVIVAL

In 1969 a French film was released entitled *Hibernatus*—directed by Édouard Molinaro and starring Louis de Funès. It is a comedy about a man, Paul Fournier (Bernard Alane), who died in 1905 while exploring the North Pole and is discovered some sixty years later frozen intact in a block of ice. Scientists are able to thaw him and bring him back to life, but do not want to shock him by revealing that it is now 1970. So instead, Fournier is taken to a home that dates from 1905 and is owned by industrialist Hubert Barrère de Tartas (Louis de Funès), whose wife is Fournier's granddaughter.

The only problem is that the mansion has been scrupulously and expensively modernized. But, in the interest of scientific research, the government orders Tartas to return the building to its original state so as to provide a soothing atmosphere for Fournier. Not surprisingly, the restoration (achieved through comparisons with period photographs) involves decorating the house in an Art Nouveau style with appropriate stained-glass windows, wooden furniture, lamps, and objets d'art (see figures E.1 and E.2).

Furthermore, all those who attend to or visit Fournier must don period dress, and the streets that he observes through his windows are replete with horses and carriages as well as turn-of-the-century cars.

The ruse, of course, leads to a comedy of errors—an excuse for broad, slapstick humor. In the narrative of *Hibernatus* one sees foreshadowed several later films, most notably *Sleeper* (1973) and *Encino Man* (1992), both

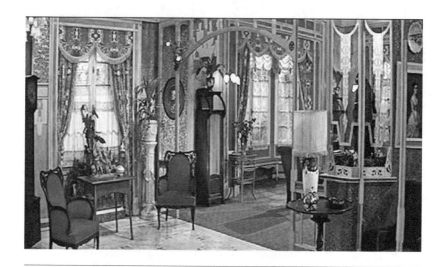

E.1 A room from a modern home in *Hibernatus* (1969, Édouard Molinaro) that has been brought back to its turn-of-the-century Art Nouveau state.

E.2 Another restored room in a home in *Hibernatus* (1969, Édouard Molinaro) with its Art Nouveau windows, furniture, and lamp.

about men found frozen in the past, and *Goodbye Lenin* (2003), about a staunch Communist woman who awakens from a coma after the unification of Germany, and whose family tries to convince her that she is still residing in the German Democratic Republic. But that is not the reason that I open this final chapter with a reference to *Hibernatus*. Rather, it is because the film offers a kind of parable for the renewal of Art Nouveau in the era in which the film was made—the 1960s.

In 2010, in retrospective recognition of this resurgence, the Musée d'Orsay in Paris launched an exhibition entitled "Art Nouveau Revival" curated by Philippe Thiébaut. The press release for the show stated that while "forgotten, discredited even, for many decades, Art Nouveau was rehabilitated in the 1960s in a way that affected the history of art and the art market as much as contemporary creative work (design and graphics)."[1] The museum gave several reasons for this resurgence, some dating back to decades earlier than the 1960s: "tributes paid by the Surrealists in the 1930s, the *Organic Design in Home Furnishings* competition organised by the MoMA in 1940, major exhibitions put on in New York (*Art Nouveau. Art and Design at the Turn of the Century*, MoMA, 1959), and in Paris (*Les sources du XXe siècle*, Musée National d'Art Moderne, 1960)."[2] Additionally, other scholars have pointed to an influential show of Aubrey Beardsley drawings at London's Victoria and Albert Museum in 1966.[3] The goal of the Musée d'Orsay exhibition was not so much to catalog the causes of Art Nouveau's renaissance but to "compar[e] Art Nouveau creations with creative output from 1950 to 1970, in order to highlight the influences expressed in very varied and sometimes unexpected areas, such as furnishings, fashion, advertising, films and even the psychedelic aesthetic."[4]

Clearly, writers in the heyday of the resurgence were also aware of this trend. A *Time* magazine "Graphics" column from April 7, 1967, states:

> In the decade since the turn-of-the-century's sinuous art-nouveau style first began to stage a comeback, its tendrils have crept into every phase of graphic design, from TV logos to caftan prints. Of late, its variations have grown increasingly bizarre. Like a butterfly bombarded by gamma rays, art nouveau is mutating, intermarrying with the eye-jarring color schemes of op and the gaudy commercialism of pop. A naked woman, body-painted like a Tiffany lamp shade, decorates the latest ads for *Casino Royale*; dust jackets

for *Madame Sarah* and Louis Auchincloss' *Tales of Manhattan* look like so much leftover Alfons Mucha. From coast to coast, be-ins, folk-rock festivals, art galleries and department-store sales are now advertised in posters and lay-outs done in a style that is beginning to be called Nouveau Frisco.[5]

What is most intriguing about this reawakening is the different valence that Art Nouveau holds in the 1960s as compared to the turn of the twentieth century. While at the fin de siècle the movement was considered dissolute in a threatening way, in the 1960s its associations with profligacy met the valo-rization of a counterculture. While in early modernity, Art Nouveau's eroti-cism was viewed as immoral, in the 1960s it supported the nascent sexual revolution—as exemplified in the 1967 San Francisco "Summer of Love."

## SEX, DRUGS, AND ROCK AND ROLL

> It's a very salutary thing to realize that the rather dull universe in which most of us spend most of our time is not the only universe there is. I think it's healthy that people should have this experience.
> —Aldous Huxley, *Moksha*

One of the central ways in which Art Nouveau found new life in the 1960s was through production of the rock poster—and here we recall Art Nou-veau's earlier association with advertising. Building on the use of LSD by the hippie generation, the new graphic mode was deemed the "psyche-delic style." Nonetheless, when historians catalogued the influences upon it, they routinely mentioned Jugendstil and Art Nouveau as well as artists like Mucha and Beardsley.[6]

It seems significant that Art Nouveau in this period should be associ-ated with hallucinatory drug culture, previously tied to such Beat Gen-eration figures as William Burroughs and Allen Ginsberg. During the 1960s, Aldous Huxley's *Doors of Perception* (1954) also became popular, chronicling his experimentation with peyote. The link between Art Nou-veau and illegal substance use at this time was only one way in which the mode—rather than being allied with the bourgeoisie (as previously claimed by Walter Benjamin)—was identified with the Underground. Furthermore,

its purpose was not to facilitate quotidian existence but to allow entrance into a transcendent realm—one incompatible with "productive" daily life.

The two major locales for rock and roll music in the 1960s were the United States and England, and poster art followed suit. Rock graphics drew on Art Nouveau techniques in its use of dense, swirling lines as well as fantastic or erotic subject matter. Furthermore, the hippie generation, with which such posters were associated, celebrated "flower power" and a return to preindustrial conditions (communal living, organic foods, nonsynthetic clothing, Lamaze childbirth)—so the Natural (fêted in Art Nouveau) was part of its ideology.

In particular, psychedelic artists were known for imposing an Art Nouveau aesthetic on print text—one influenced by such Viennese Secessionist designers as Alfred Roller.[7] As Mick Farren and Dennis Loren note, 1960s poster artists "used custom-created letterforms that were more fanciful than legible and were made even more hard to read by the use of optically vibrating color combinations . . . and swirling light-show/acid-hallucination underlays."[8] Thus, the posters defied their commercial function, making it difficult for the viewer to grasp the name of the rock group or concert venue being promoted. Thus, for Farren and Loren, such posters "turned the entire concept of advertising upside down."[9] They presented more of a puzzle than a promotion.

Among the most well-known American artists were Rick Griffin, Victor Moscoso, Stanley Mouse, and Wes Wilson.[10] Wilson was known for iconic "New Nouveau" posters for groups like the Jefferson Airplane and the Grateful Dead, both of which pictured a woman's head amidst curvilinear, flowing lines (Plate 21). In another poster for the Byrds, Wilson resurrected a popular Art Nouveau symbol—the peacock.

In England, Hapshash and the Coloured Coat (consisting of Michael English and Nigel Waymouth) was also a prominent producer of rock posters. Among their Art Nouveau-inspired works were prints for Soft Machine and UFO. Both works featured romanticized visions of Woman, and the one for UFO turned her into a butterfly-female in the manner of jewelry by Tiffany, Masriera, and films by Chomón. Influenced by Gustav Klimt, Hapshash and the Coloured Coat often made use of expensive gold and silver metallic inks not commonly employed in advertising.

Almost immediately, rock posters were torn down from walls and tele-
phone poles and collected as art. As evidence of this legacy, in 2000 the
Victoria and Albert Museum in London mounted a retrospective exhibi-
tion entitled "Cosmic Visions—Psychedelic Posters from the 1960s."
Ultimately, the graphics movement was short-lived, like Art Nouveau
itself, ending in the early 1970s.

## "NOUVEAU NOUVEAU" AND THE CINEMA

Beyond psychedelic graphics, there were other forms through which an
Art Nouveau renaissance was evident in the 1960s, and some of them
touched on film. An article in the "Styles" section of *Time* magazine for
August 21, 1964, was entitled "New Look at Art Nouveau" and mentioned
the upcoming release of *My Fair Lady* (1964)—noteworthy for its fin de siè-
cle décor and wardrobe: "When the movie *My Fair Lady* opens in October,
it will hammer into the public consciousness a new appreciation of an old
art style that was known in its day as art nouveau—new art. In planning
the film's sets and 1,000 period costumes, complete with white lace, pink
muslin, and ostrich feathers sprouting from extravagant hats, British De-
signer Cecil Beaton drew on childhood memories of Edwardian England
at the turn of the century."[11] As the author asserts, the film's mise-en-scène
would be especially timely since it related to "the current stylistic swim":
"For a decade the revival of art nouveau has been building in nostalgic
museum shows in London, Munich and New York; now it has burst on
Western Europe and is spreading to the U.S."[12] Finally, the article con-
jectures that this renaissance is "a revolt against the grim, stark, formless,
spiritless expression of much abstract art and modern architectures."[13]

While *My Fair Lady* may be interesting for its period setting and antique
fashion and props, it in no major way utilizes Art Nouveau to reflect the
youth culture of the era in which it was made. In contrast, numerous films
of the 1960s and 1970s do—taking a variety of approaches to the task. On
the one hand, the hallucinatory drug craze of the era, coupled with a grow-
ing interest in Eastern religion and Transcendental Meditation, led to
films that chronicled an individual's personal quest. Ken Russell's *Altered
States* (1980), for instance, used the classic "mad scientist" trope to tell the
tale of a university researcher who experiments with mind-bending

substances in order to attain new states of consciousness, only to find himself plagued by horrific physical and mental symptoms. Other films (mostly experimental) avoided plot entirely and instead tried to mimic or induce altered states through abstract imagery and suggestive music. Among these were works by Jordan Belson (e.g., *Samadhi* [1967], *Momentum* [1968], *Cosmos* [1969], *World* [1970], *Meditation* [1971], or *Chakra* [1972]) that critic Gene Youngblood deemed "cosmic."[14] (Significantly, avant-garde filmmaker Scott Bartlett had served as a consultant on *Altered States*.) Finally, some movies offered symbolic, enigmatic narratives that one "had to see stoned"—films like Stanley Kubrick's *2001: A Space Odyssey* (1968) or Alejandro Jodorowsky's *El Topo* (1970). None of these films, however, referenced the period's Art Nouveau rebirth. Those that did were few and far between but, nonetheless, are worth noting. In fact, the 2010 Musée d'Orsay show catalogued several—including *What's New Pussycat?* (1965).

Directed by Clive Donner with screenplay by Woody Allen, *What's New Pussycat?* is a contemporary bedroom farce that fails on every level. Nonetheless, its appropriation of Art Nouveau is tied to a theme of sexual liberation and speaks to the youth culture in which it was released. Significantly, the *Time* article that heralded the movement's renaissance spoke of the style's "almost erotic character."[15]

Writing in the *New York Times*, Bosley Crowther savagely (and justifiably) pans the film: "Woody Allen, the nightclub comedian, is formally charged with the minor offense of having written what is alleged to be the screenplay of 'What's New Pussycat?' But Mr. Allen can deny it, if he wants to, and he is bound to be believed. He can simply state that no one in his right mind could have written this excuse for a script."[16] Similarly, the *Time* reviewer notes: "*What's New Pussycat?* is a comedy built on so many shaky assumptions that it ought to sue for nonsupport."[17] Nonetheless, it was a commercial success, grossing some $18,820,000 domestically and launching Allen's cinematic career.

To the extent that the film has any story at all, it concerns Michael James (Peter O'Toole), a fashion magazine editor who lives in Paris and consults a psychiatrist, Dr. Fritz Fassbender (Peter Sellers), regarding his travails as a womanizing Don Juan. He wishes to settle down with his fiancée Carole (Romy Schneider), but cannot resist the temptation of the countless beauties he meets—including Renée (Capucine), Liz (Paula Prentiss),

**E.3**  An Art Nouveau-inspired title from *What's New Pussycat?* (1965, Clive Donner).

and Rita (Ursula Andress). Woody Allen pens a role for himself as Victor, an awkward young painter who is entirely inept in the female department.

The film adopts Art Nouveau-inspired psychedelia ostensibly to lend it an aura of "hipness." This appropriation begins with the graphics of the title sequence whose typography is reminiscent of rock posters. Clearly, an Art Nouveau influence is present and attaches particularly to the announcement of female stars. Fittingly, the title for art director and set decorator (Jacques Saulnier and Charles Merangel, respectively) is adorned with a peacock, the ultimate Art Nouveau icon (see figure E.3).

The opening shot of the film depicts a villa. The building used for this locale is the Castel Henriette, designed by Art Nouveau architect Hector Guimard in 1899 (and demolished in 1969) (see figure E.4). In later scenes, we see some of its interiors, including stained-glass windows and ornate furniture.

Aside from signifying France, the setting for the film, the house is the residence of Dr. Fassbender, a dissolute psychiatrist with a German accent—seemingly a parody of Dr. Freud, whose work was associated with

**E.4** Dr. Fassbender (Peter Sellers) in *What's New Pussycat?* (1965, Clive Donner) lives in an Art Nouveau villa that is actually the Castel Henriette, designed by Hector Guimard in 1899.

the "dementia" of Art Nouveau. Fassbender is an adulterer, is lascivious with female patients, holds bogus group therapy sessions in which he suggests that people take off their clothes, and seems sexually maladjusted. While at a strip club with Michael, he lurks in the corner, hugging the wall, voyeuristically watching the Lothario score with the ladies while claiming he is there "as a scientist, plumbing the depths of the soul." In one session, his remark to Michael seems entirely inappropriate. Thus, he asks: "I like thighs. Do you like thighs?"

Fassbender's outfit in the opening scene is peculiar and difficult to decode. He wears a red velvet suit and his hair is done in a kind of page boy. Some have referred to his attire as "Mod" (a British trend of the era)[18] and to his hair as resembling that of the Beatles.[19] I would offer another model for his look, closer to the era of Art Nouveau—that of the dandy Oscar Wilde.

Other locations in the film also display an Art Nouveau aura. In Michael's apartment, there are pictures reminiscent of those from the era.

E.5 In *What's New Pussycat?* (1965, Clive Donner), a house occupied by Renée (Capucine) bears the traces of Art Nouveau design in its stained-glass front door.

In Victor's flat there are reproductions of fin de siècle advertising posters; and, to pick up women, he invites them to an exhibition of the work of Toulouse-Lautrec. Moreover, a house occupied by Renée bears the traces of Art Nouveau design in its stained-glass front door (see figure E.5).

Even a steam room frequented by Victor and Michael has a similar antique window. What is crucial is that the Art Nouveau ambience of the film is not arbitrary but relates to a narrative about promiscuity—a theme tied to the sexual revolution and women's movement of the "Swinging Sixties."

Michael's lasciviousness is exacerbated by his job ("a lecher's dream"), in which he is introduced to endless gorgeous women. Beyond that, all the females he encounters aggressively pursue him with an assertiveness that defies the old double standard. In one scene, when a group of people dance at a nightclub, they periodically lie down together as though suggesting the mythic orgies of the era. (The word "orgy" is actually mentioned at the end of the movie when the characters meet at the Chateau Chantal—whose rooms are named for figures like the Marquis de Sade.)

E.6 Liz's (Paula Prentiss) costume in this scene from *What's New Pussycat?* (1965, Clive Donner) seems straight out of a Gustav Klimt painting.

Also referenced in the film is the social consciousness of the 1960s. When Michael spends an evening with the stripper Liz, she reveals that she is a poet. One of her works is entitled "Ode to a Pacifist Junkie" and concerns "peaceful coexistence." She is also a "health nut" and appears at the start of her strip act wearing a coat that seems straight out of a Gustav Klimt painting (see figure E.6).

*What's New Pussycat?* is a bad film that tries to rationalize its formlessness as "cool" absurdity. (Bosley Crowther, in fact, uses the terms "wacky" and "kookie" to describe it—though not in a good way.) Furthermore, it draws on Art Nouveau merely to be trendy—mining the revival of the style and its association with permissive youth culture. Interestingly, Crowther draws on the word "campy" to characterize the film—a term that will be negatively associated with Art Nouveau in years to come. Crowther also pans the movie in ways that echo earlier critiques of Art Nouveau. He talks of its "curious nervous tempo" and states that it is ultimately "neurotic and unwholesome."[20] Interestingly, one of the only features of the work

that he praises is its décor, which is "colorful" and "stimulating" and suggests "that somewhere in the proceedings there were sane and skillful artisans at work."

In sum, while a film's employment of the Art Nouveau style in the 1960s might have been an auspicious sign (given the mode's newfound popularity), in the case of *What's New Pussycat?* it is not. Rather, the film is cynically and disingenuously derivative—leading Crowther (for other reasons) to suggest that its title should have been *What's New Copycat?*[21]

Another 1960s film with an Art Nouveau aura (and not on the Musée d'Orsay's list) is *Yellow Submarine* (1968), directed by George Dunning and made in England. Like Lotte Reiniger's *The Adventures of Prince Achmed* from the 1920s, it is an animated movie, which allows it a particular affinity with the graphic mode. The title of the film, of course, derives from a famous Beatles song on the *Sgt. Pepper's Lonely Hearts Club Band* album, and the movie stars animated versions of the Fab Four. In fact the rock group had little to do with the project except to lend their names to it, provide the music, and give final approval. The story was written by Erich Segal, Lee Minoff, Al Brodax, and Jack Mendelsohn, and even the Beatles' voices were rendered by actors. Like *Prince Achmed* it is also a fantasy/fairy tale (it begins with "Once upon a time" after all) and concerns a wonderful place called Pepperland in which everything is peaceful and beautiful. Trouble occurs when the country is attacked by a hostile group called the Blue Meanies who are particularly averse to music and the power of positive thinking. The Lord Mayor of Pepperland sends an elderly sailor, Old Fred, to Liverpool to find the Beatles and enlist their help. When he locates them, they all sail back to Pepperland in a yellow submarine through a variety of fanciful seas (the Sea of Time, the Sea of Science, the Sea of Holes, etc.). Here, we are reminded of the thief's adventures in the 1920s version of *The Thief of Bagdad*. When Fred and the Beatles arrive in Pepperland, they find the landscape and inhabitants entirely frozen and drained of color. By the end of the story, the Beatles triumph over the Blue Meanies, convincing them that "yes" is better than "no," and that "All You Need Is Love."

Clearly, the plot of the film projects basic values of the 1960s—that war is bad, and that a Wonderland is characterized by art, beauty, amity, and peace. The Beatles' bizarre journey in a yellow submarine (a ship that travels below the ocean's surface) has all the qualities of a voyage into the

subconscious or of a drug-induced delusion, with the song "Lucy in the Sky with Diamonds" possibly signifying LSD. Hence, it is the perfect narrative (a "head trip") for the psychedelic style.

Art direction was accomplished by Heinz Edelmann, a German graphic designer born in Czechoslovakia in 1934. He was contacted because of his imaginative work illustrating the German magazine *Twen* and because the Beatles wanted to avoid making the film look "Disneyfied." According to Steven Heller, "In the 1960s [Edelmann] was experimenting with a stylized, soothingly fluid, neo-Art Nouveau manner. That caught the eye of Al Brodax, producer of a successful animated Beatles television cartoon series for children."[22]

So, how is the design of the film consonant with both psychedelia and Art Nouveau? Unlike *What's New Pussycat?* which reserves such imagery for the credit sequence, *Yellow Submarine* is suffused with it. First, color is an important element of Pepperland and its hues are vibrant and saturated. This is also true of psychedelic art (with its Day-Glo tones) and of many Art Nouveau artifacts. Hence, we feel the loss when all of Pepperland is turned gray (see figure E.7).

E.7 In *Yellow Submarine* (1968, George Dunning), whose graphics are influenced by "psychedelic Art Nouveau," we feel the loss of color and vitality when all of Pepperland is turned gray.

If Nature is central to both hippies of the 1960s and Art Nouveau prac-
titioners of the fin de siècle, it is also to the setting for Pepperland, as
opposed to the industrial world of Liverpool from which the Beatles hail.
Thus, certain scenes seem imbued with "flower power" (Plate 22). Even
the "blue bird of happiness" makes an appearance.

The female figure (decorating so many rock posters and Art Nouveau
objects) is also present in *Yellow Submarine*, though not with the urgency that
characterizes those other forms. The most interesting episode in this re-
gard takes place during the submarine journey when "Lucy in the Sky with
Diamonds" explodes on the soundtrack, accompanied by images of a
woman. She is rendered in an abstract, romanticized manner that draws
on Art Nouveau. In all of the film's graphics, we find the kind of grace-
ful, biomorphic, curving lines so typical of that mode.

What is also noteworthy about *Yellow Submarine* (given its homage to an
earlier art movement) is its "antique" pictorial quality—witness its con-
tinual use of the "pointing hand" so common in Victorian advertisements.
Moreover, some of Edelmann's drawings seem reminiscent of those of
Winsor McCay or Émile Cohl.[23]

Finally, all of Pepperland seems to exist in the past, as evidenced by
peoples' outmoded dress. Specifically, it bears the traces of the late nine-
teenth century, the period of Art Nouveau's birth. Significantly, when the
Beatles arrive there, they take on the personae of an earlier musical group—
Sgt. Pepper's Lonely Hearts Club Band—wearing their old-fashioned
uniforms. The Lord Mayor tells them that they are much like the "origi-
nals." Even the Beatles' submarine voyage has been explicitly an experi-
ence of time travel—as marked by their discussion of Einstein's theory of
relativity, or by the shot in which Ringo looks through a porthole in a
wall decorated with Art Nouveau paper and sees a vintage black and white
photograph of a man holding a watch.

## CONCLUDING THOUGHTS

In a sense, this book has been an excursion in time travel as well, and,
like the Beatles, it has moved both backward and forward. It began by
examining cinematic Art Nouveau during the era of the movement's
ascendancy at the fin de siècle and moved on to explore its periodic

resurgence in the 1920s, the 1960s, the 1970s, the 1990s, and the 2000s. In each era, the style has been an artistic Rorschach blot—taking on the meaning of the moment—be it nature (vs. industry), ornamentation (vs. austerity), decadence (vs. wholesomeness), femininity (vs. masculinity), interiority (vs. exteriority), beauty (vs. ugliness), conventionality (vs. eccentricity), or artistry (vs. commerce). Hence, the fluidity of its signification has matched the mutability of its line—ever-changing, resonant, and polymorphous perverse.

We can glean numerous insights from this critical exploration:

(1) Art Nouveau design has been a far more prevalent influence in film history than one might have supposed by the dearth of references to it in the academic literature, and includes not only films set in the period of its popularity but in later eras too. *Cinema by Design* has concentrated only on films in which its appearance transcends being superficial or incidental, and is profoundly tied to the work's narrative and themes. A far greater number of movies are marked by the style in more minor ways.

(2) The lack of attention to Art Nouveau in film history is a result of several factors: (a) the style's short-lived popularity that coincided with the early years of cinema, prior to the development of the sophisticated feature film; (b) the tendency of American cinema (the major industry of that era) to be a bit "behind the curve" in terms of experimentation, in contrast to Europe which had a significant cinematic avant-garde; (c) the general lack of consideration in film scholarship of questions of design and art history in relation to cinematic art direction.

(3) Art Nouveau design has often been unfairly maligned—ranging from Walter Benjamin's skewering of it for being bourgeois, hermetic, and perversely female, to Adolf Loos's argument that it was lowbrow and "criminal," to Bosley Crowther's assertion that it was purely Camp. This cultural dismissal has arisen from numerous factors: prejudice against the applied arts; opposition to the merging of art and commerce (as though "fine art" has no monetary element); suspicion of beauty; and denigration of the feminine and the ethnic Other. In particular, there has sometimes been a subtle anti-Semitism involved in the disparagement of Art Nouveau and its imagined "decadence."

(4) Art Nouveau's cinematic influence, like the movement itself, has been international—cropping up in works from the United States, France, Spain, England, Italy, Germany, and Belgium to name only a few locales. While *Cinema by Design* has examined works from most of these places, it has not claimed to be exhaustive, and additional scholarship will reveal other instances of the style's global reach.

(5) Art Nouveau design has appeared in works of diverse cinematic genres— the trick film, the musical, the animated film, the melodrama, the horror film, the documentary, and the biopic—so it has proved a highly malleable and adaptable style.

(6) The influence of Art Nouveau on cinema has drawn on various other arts in which it has been expressed—literature (e.g., the work of Oscar Wilde), architecture (e.g., the work of Antoni Gaudí), painting (e.g., the work of Gustav Klimt), dance (e.g., the Ballets Russes). Hence it is a truly intermedial style, and cinema is only one of the modes it has harnessed.

(7) The cinematic reach of Art Nouveau has occasionally transcended the screen itself to include the setting in which movies were shown: the ornate picture palaces (such as the Tuschinski in Amsterdam) designed in that mode.

Recently there have been some encouraging signs that a rediscovery of Art Nouveau has begun once more. An October 2015 article by J. S. Marcus in the *Wall Street Journal* proclaims that museums are "taking a new look" at the style; specifically, he focuses on exhibits at Hamburg's Museum of Arts and Crafts and at Paris's Musée d'Orsay. Marcus also asserts that Art Nouveau artifacts are once again fetching high prices at auctions (e.g., the works of Viennese craftsman Josef Hoffmann). He notes that this resurgence stands in contrast to the days when it was considered "old fashioned" or "downright obscure."[24]

I can only hope that, on a scholarly level, *Cinema by Design* contributes to this phenomenon by affirming the historic import of Art Nouveau to film—the quintessential art of the century and one whose birth was contemporaneous with it.

# Notes

## INTRODUCTION

1   Lucy Fischer, *Designing Women: Cinema, Art Deco, and the Female Form* (New York: Columbia University Press, 2003).

2   Anne-Marie O'Connor, *The Lady in Gold: The Extraordinary Tale of Gustav Klimt's Masterpiece, Portrait of Adele Bloch-Bauer* (New York: Knopf, 2012).

3   Ken Johnson, "A Painting Rich in History Draws Renewed Interest," *New York Times*, April 3, 2015; my emphasis.

4   Ayelet Waldman, *Love and Treasure* (New York: Knopf, 2014).

5   Ibid., 12.

6   James Cameron, "*Titanic*: A Screenplay by James Cameron," Internet Movie Script Database, http://www.imsdb.com/scripts/Titanic.html.

7   Lucy Fischer, ed., *Art Direction and Production Design* (New Brunswick, N.J.: Rutgers University Press, 2015).

8   See note 202 below for a detailed list of authors who have mentioned Art Nouveau in their work.

9   Roland Barthes, *Mythologies*, trans. Annette Lavers (New York: Hill and Wang, 1972), 112.

10  Geoffrey Nowell-Smith, "How Films Mean, or From Aesthetics to Semiotics and Half-Way Back Again," in *Reinventing Film Studies*, ed. Christine Gledhill and Linda Williams (London: Arnold, 2000), 8–17.

11  Patrick Bade, *Mucha* (New York: Parkstone, 2011), 88.

12  Debora Silverman, *Art Nouveau in Fin-de-Siecle France: Politics, Psychology and Style* (Berkeley: University of California Press, 1989), 8.

13  Andrew Benjamin, *Style and Time: Essays on the Politics of Appearance* (Evanston, Ill.: Northwestern University Press, 2006), 56.

14  Walter Benjamin, *The Arcades Project*, trans. Howard Eiland and Kevin McLaughlin (Cambridge, Mass.: Harvard University Press, 1999), 551.

15   Bade, *Mucha*, 90; my emphasis.

16   Umberto Eco, ed., *History of Beauty*, trans. Alastair McEwen (New York: Rizzoli, 2004), 369.

17   Ibid.

18   Bade, *Mucha*, 98.

19   William J. R. Curtis, *Modern Architecture Since 1900* (Oxford: Phaidon, 1987), 26.

20   John Heskett, *Design in Germany: 1870–1918* (London: Trefoil, 1986), 46.

21   Silverman, *Art Nouveau*, 75.

22   György M. Vajda, "Some Aspects of Art Nouveau in Arts and Letters," *Journal of Aesthetic Education* 14, no. 4 (October 1980): 74.

23   "Parisian Metro and Hector Guimard," Paristep, November 12, 2012, http://www .paristep.com/en/articles/architecture/guimard.html. Furthermore, "In 1900 he started with the metro entrance 'Porte Dauphine' and then dozens of other stations followed: Palais-Royal-Musée du Louvre, Chatelet, Abbesses, Nation, Tuileries, Louvre Rivoli, Victor Hugo, Monceau, Réamur-Sébastopol, Sentier, Bastille, Raspail, Pasteur, Saint-Marcel, Saint-Michel, Cité. . . . Today Paris boasts 86 Guimard metro stations entrances, which from 1978 are registered as historical sights of the national heritage" (ibid.).

24   Stephen Smith, "British Cities," *Sex and Sensibility: The Allure of Art Nouveau*, episode 2, directed by Mary Downes, first aired March 29, 2012 (London: BBC, 2008), DVD.

25   Quoted in Silverman, *Art Nouveau*, 8.

26   Ibid., 75.

27   Quoted in Ben Singer, *Modernity and Melodrama* (New York: Columbia University Press, 2001), 29.

28   Eco, *History of Beauty*, 369.

29   "The World of Art: The Problem of Art and Industries," *New York Times*, October 2, 1921.

30   Quoted in Walter Benjamin, *Arcades*, 549.

31   Singer, *Modernity and Melodrama*, 34.

32   Siegfried Kracauer, *The Mass Ornament: Weimar Essays*, trans. Thomas Y. Levin (Cambridge, Mass.: Harvard University Press, 1995), 76.

33   Ernst Haeckel, *Generelle Morphologie der Organismen: allgemeine Grundzüge der organischen Formen-Wissenschaft, mechanisch begründet durch die von Charles Darwin reformirte Descendenz-Theorie* (Berlin: De Gruyter, 1988); Ernst Haeckel, *The History of Creation, or, The Development of the Earth and Its Inhabitants by the Action of Natural Causes: A Popular Exposition of the Doctrine of Evolution in General and of That of Darwin, Goethe, and Lamarck in Particular*, rev. trans. E. Ray Lankester, 5th ed., 2 vols. (New York: D. Appleton, 1913); translated from the 8th German ed.

34   See Eugène Grasset, *La Plante et Ses Applications Ornementale* (Paris: E. Lévy, 1898); or Eugène Grasset, *Plants and Their Application to Ornament: A Nineteenth-Century Design Primer* (San Francisco: Chronicle Books, 2007).

35  Rita Reif, "Photo of an Early-20th-Century Spider-Web Lamp from the Tiffany Studios, 28 1/2 Inches High and 19 Inches in Diameter; Tiffany Lamps Make a Comeback," *New York Times*, August 6, 1989.

36  "In the Shops," *New York Times*, July 26, 1904.

37  "In the Shops," *New York Times*, April 29, 1902.

38  "Of Interest to Women: Paris Decorators Produce Strange New Furniture and Fittings Under Cubist Influences," *New York Times*, May 18, 1913.

39  The spiritual side of Art Nouveau was emphasized in an exhibit at the Pinocathèque de Paris entitled "L'Art Nouveau—La Révolution Décorative," June 2013.

40  Charles Darwin, *The Descent of Man and Selection in Relation to Sex*, 2 vols. (New York: P. F. Collier and Son, 1902); Charles Darwin, *The Origin of Species by Means of Natural Selection*, 6th (last) ed. repr. (Buffalo, N.Y.: Prometheus Books, 1991).

41  Vajda, "Some Aspects of Art Nouveau," 75.

42  "New Things in Furniture," *New York Times*, November 26, 1899.

43  "Art Notes," *New York Times*, December 29, 1903.

44  "In the Shops," *New York Times*, September 26, 1904.

45  Eco, *History of Beauty*, 342.

46  Walter Benjamin, *Arcades*, 557.

47  Walter Benjamin, "Paris: Capital of the Nineteenth Century," *Perspecta* 12 (1969): 169.

48  Walter Benjamin, *Arcades*, 553.

49  Ibid., 345. Benjamin uses the German term for Art Nouveau in his writing on the topic.

50  Ibid., 553.

51  *The Poems and Prose Poems of Charles Baudelaire, with an Introductory Preface by James Huneker* (New York: Brentano's Publishers, 1919), 106.

52  Walter Benjamin, *Arcades*, 557. He was referencing the following poems: "Bénédiction," "Delphine et Hippolyte," and "Les Litanies de Satan."

53  Zara Ellis, *Symbolism in Art Nouveau: The Work of Emile Galle* (Book Treasury, 2013), Kindle edition, 2.

54  Vajda, "Some Aspects of Art Nouveau," 83.

55  Silverman, *Art Nouveau*, 229, 234.

56  Ibid., 233.

57  Ellis, *Symbolism in Art Nouveau*, 7–8.

58  Silverman, *Art Nouveau*, 233.

59  Ibid., 300.

60  Ellis, *Symbolism in Art Nouveau*, 6.

61  Ibid., 7. Marc Restellini, Victor Arwas, Paul Greenhalgh, and Dominique Morel, *L'Art Nouveau—La Révolution Décorative* (Milan: Pinacothèque de Paris and Skira, 2013), exhibition catalog published in conjunction with the exhibition of the same name.

62  Marc Restellini, "Director's Words," Handout and translation into English of wall legend for the exhibit "L'art Nouveau: La Révolution Décorative," Pinacothèque de Paris, April 18–September 8, 2013.

63  Roland Barthes, " 'THAT-HAS-BEEN'; The Pose; The Luminous Rays, Colour; Amazement; Authentification," in *Stardom and Celebrity: A Reader*, ed. Sean Redmond and Su Holmes (Los Angeles: Sage, 2007), 51.

64  Walter Benjamin, "Paris," 169.

65  Paul Verlaine, "Amour: Lucien Létinois III," in *His Absinthe-Tinted Song*, trans. Bergen Applegate (Chicago: Alderbrink Press, 1916), 155.

66  "In the Shops," *New York Times*, October 30, 1901.

67  "Art Takes Up the Seal: It Finds Profit in Adorning an Almost Useless Article to Please My Lady's Eye," *New York Times*, April 28, 1901.

68  "In the Shops," *New York Times*, May 12, 1902.

69  "In the Shops," *New York Times*, April 19, 1902.

70  "In the Shops," *New York Times*, March 12, 1902.

71  "In the Shops," *New York Times*, December 29, 1903.

72  "The Architectural League," *New York Times*, February 26, 1902.

73  Restellini, "Director's Words."

74  Walter Benjamin, *Arcades*, 558.

75  Ibid., 551.

76  Ibid.

77  Silverman, *Art Nouveau*, 30.

78  Marc Restellini, "L'Art Nouveau: La Révolution Décoorative," in Marc Restellini, Victor Arwas, Paul Greenhalgh, and Dominique Morel, *L'Art Nouveau—La Révolution Décorative* (Milan: Pinacothèque de Paris and Skira, 2013), 6–7; and also Restellini, "Director's Words."

79  Silverman, *Art Nouveau*, 186.

80  Ibid., 1.

81  Walter Benjamin, *Arcades*, 556. Rosalind Galt also speaks of this linkage in *Pretty: Film and the Decorative Image* (New York: Columbia University Press, 2011).

82  Tag Gronberg, *Vienna, City of Modernity 1890–1914* (Bern: Peter Lang, 2007), 122.

83  Alexandre Cirici, *1900 en Barcelona* (Barcelona: Ediciones Polígrafa, 1967), 42.

84  Galt, *Pretty*, 99, 109, 111.

85  "Old Furniture," *New York Times*, December 27, 1902.

86  "Marvels in Book Covers," *New York Times*, May 7, 1906.

87  Carroll Beckwith, "The Workshop of Ugliness," *New York Times*, October 4, 1915.

88  "The World of Art: Art in the House and in the Galleries," *New York Times*, July 20, 1924.

89  "Art Notes," *New York Times*, August 19, 1901.

90  "L'Art Nouveau in Paris: Miss Warrick's Exhibit—G. de Feure to Show the Scheme of Applied Art to New Yorkers," *New York Times*, July 6, 1902.

91  Anne O'Hare McCormick, "A Government of Professors: Prague Most Medieval City in Europe, the Laboratory of Twentieth Century Politics," *New York Times*, November 4, 1923.

92  Silverman, *Art Nouveau*, 75.

93 Walter Benjamin, *Arcades*, 558.

94 Silverman, *Art Nouveau*, 79.

95 Ibid., 78.

96 Ibid., 82, 84, 100.

97 Ibid., 92.

98 Ibid., 96.

99 Ibid., 93–94.

100 Ibid., 83; my emphasis.

101 Salvador Dalí, *The Collected Writings of Salvador Dalí*, trans. Haim Finkelstein (Cambridge: Cambridge University Press, 1998), 200.

102 Silverman, *Art Nouveau*, 30.

103 Eco, *History of Beauty*, 371; and Chris Snodgrass, *Aubrey Beardsley, Dandy of the Grotesque* (New York: Oxford University Press, 1995), 80–81.

104 Henry F. Lenning, *The Art Nouveau* (The Hague: Martinus Nijhoff, 1951), 3.

105 Walter Benjamin, "Paris," 169.

106 Quoted in Andrew Benjamin, *Style and Time*, 49–50.

107 Walter Benjamin, "Paris," 169.

108 Ibid.

109 Gronberg, *Vienna*, 38.

110 Walter Benjamin, "Paris," 169.

111 Ibid.

112 Ibid., 168.

113 Ibid., 167.

114 Walter Benjamin, *Arcades*, 172.

115 Ibid., 176.

116 Ibid., 186.

117 Ibid., 176.

118 Singer, *Modernity and Melodrama*, 11, 29.

119 In this era the ground-floor apartments were larger and for the wealthy.

120 Stephen Smith, "Paris," *Sex and Sensibility: The Allure of Art Nouveau*, episode 1, directed by Mary Downes, first aired March 22, 2012 (London: BBC, 2008), DVD.

121 Vajda, "Some Aspects of Art Nouveau," 78; and *Wikipedia*, s.v. "Victor Horta," last modified May 14, 2015, http://en.wikipedia.org/wiki/Victor_Horta.

122 Alan Riding, "Beyond Kitsch: A New Look at Art Nouveau," *New York Times*, April 30, 2000.

123 Stephen Smith, "Vienna," *Sex and Sensibility: The Allure of Art Nouveau*, episode 3, directed by John MacLaverty, first aired April 5, 2012 (London: BBC, 2008), DVD.

124 Heskett, *Design in Germany*, 46.

125 Adolf Loos, *Ornament and Crime: Selected Essays*, trans. Michael Mitchell (Riverside, Calif.: Ariadne, 1998), 117. Loos continues: "Uncultivated people . . . greet it rapturously" (ibid.).

126 Wendy Steiner, *The Trouble with Beauty* (London: William Heinemann, 2001), 57.

127    Walter Benjamin, *Arcades*, 558.

128    Steiner, *Trouble with Beauty*, xiii.

129    Gaudí quoted in Nikos Sideris, *Architecture and Psychoanalysis: Fantasy and Construction* (Athens: Nikos Sideris and Editions Futura, 2006), Kindle edition.

130    Walter Benjamin, *Arcades*, 172.

131    Adolf Loos, *Ornament and Crime*, 167–169.

132    Ibid., 169, 173.

133    Ibid., 175.

134    Ibid., 169.

135    "Art Events Here and There," *New York Times*, November 20, 1904.

136    Riding, "Beyond Kitsch."

137    Eran Guter, *Aesthetics A–Z* (Edinburgh: Edinburgh University Press, 2010), 114.

138    Clement Greenberg, "Avant-Garde and Kitsch," in *The Collected Essays and Criticism*, vol. 1, *Perceptions and Judgments, 1939–1944*, ed. John O'Brian (Chicago: University of Chicago Press, 1988), 17.

139    Ibid., 14.

140    Ibid., 14–17.

141    Susan Sontag, "Notes on 'Camp,'" in *Essays of the 1960s and 70s*, ed. David Rieff (New York: Library of America, 2013), 265, 270–271.

142    Ibid., 273.

143    Ibid., 272–273.

144    Ibid., 274.

145    Cirici, *1900 en Barcelona*, 35.

146    Restellini, "Director's Words."

147    Richard Gilman, *Decadence: The Strange Life of an Epithet* (New York: Farrar, Straus and Giroux, 1975), 75.

148    Eco, *History of Beauty*, 342; my emphasis.

149    Gilman, *Decadence*, 97.

150    Ibid., 103.

151    Ibid., 97; my emphasis.

152    Georg Simmel, "'Beyond Beauty' (10 April 1897)," in "Selections from Simmel's Writings for the Journal *Jugend*," trans. Thomas M. Kemple, *Theory, Culture and Society* 29, nos. 7–8 (2012): 268–269.

153    Pierre Bourdieu, *Distinction: A Social Critique of the Judgment of Taste*, trans. Richard Nice (Cambridge, Mass.: Harvard University Press, 1984), 6.

154    David Helge, "August Endell: The Spirit and the Beauty of the City," in *Modernism and the Spirit of the City*, ed. Boyd White (London: Routledge, 2003), 88.

155    Gronberg, *Vienna*, 60.

156    Ibid., 61.

157    Ibid.

158    Curtis, *Modern Architecture*, 25.

159    "New Things in Furniture."

160  "In the Shops," *New York Times*, April 3, 1902.

161  "In the Shops," *New York Times*, April 25, 1902.

162  "Gifts for the Season," *New York Times*, December 16, 1900.

163  A curtain hung over a door or doorway.

164  "In the Shops," *New York Times*, September 26, 1904.

165  Marc Restellini mentions the anti-Semitic and xenophobic nature of French society at the time. See Restellini, "Director's Words."

166  Bade, *Mucha*, 100.

167  Kala Court, "Alphonse Mucha's Jewelry Shop at the Musée Carnavalet," Untapped Cities, February 14, 2013, http://untappedcities.com/2013/02/14/alphonse -mucha-jewelry-shop-replica/.

168  See the Metropolitan Museum of Art website for a picture of a brooch from 1900 that Mucha designed for Fouquet: "Brooch," Heilbrunn Timeline of Art History, http://www.metmuseum.org/toah/works-of-art/2003.560.

169  Republished as David M. H. Kern, ed., *The Art Nouveau Style Book of Alphonse Mucha* (Mineola, N.Y.: Dover, 1980).

170  Vajda, "Some Aspects of Art Nouveau," 83.

171  "That Manchester Company," *New York Times*, February 7, 1915.

172  "The New Plays," *New York Times*, November 12, 1916.

173  "When Sir Herbert Tree Played Shakespeare in Berlin," *New York Times*, March 19, 1916.

174  "Throng Welcomes Chicago Opera," *New York Times*, January 24, 1918.

175  Quoted in Silverman, *Art Nouveau*, 8.

176  Ibid.

177  G. Dureau, "La Cinématographe," *Ciné-Journal* 5 (September–October, 1912): 622, 694; my translation.

178  Melanie Paquette Widmann, *212 Days: The Paris Exposition of 1900* (Torrance, Calif.: CTG Publishing, 2013), Kindle edition.

179  Gabriel Weisberg, *Art Nouveau Bing: Paris Style 1900* (New York: Abrams, 1986), 164.

180  Ibid., 163.

181  Ibid., 164.

182  Ibid.

183  Ibid., 185.

184  Ibid., 191.

185  Ibid.

186  Silverman, *Art Nouveau*, 287.

187  Paul Greenhalgh, *Ephemeral Vistas: The Expositions Universelles, Great Exhibitions and World's Fairs, 1851–1939* (Manchester: Manchester University Press, 1988), 161.

188  Emmanuelle Toulet, "Le cinéma a l'Exposition universelle de 1900," *Revue d'histoire moderne et contemporaine* 33, no. 2 (April–June 1986): 179; my translation.

189  Ibid., 207.

190  Ibid., 186.

191   Ibid., 207.

192   Another sound film theater was the Phonorama.

193   Toulet, "Le cinéma a l'Exposition universelle de 1900," 201.

194   Library of Congress, "Inventing Entertainment: The Early Motion Pictures and Sound Recordings of the Edison Companies," https://www.loc.gov/collections /edison-company-motion-pictures-and-sound-recordings/?q=paris%20exposi tion&st=list.

195   Toulet, "Le cinéma a l'Exposition universelle de 1900," 194. Cineorama is also discussed in John Fell, ed., *Film Before Griffith* (Berkeley: University of California Press, 1984), 362.

196   Mark Trompeteler, "The Origins of Cinerama," *In70mm.com*, December 6, 2013, http://www.in70mm.com/news/2013/origins/index.htm.

197   "Photo Gallery," *Motion Picture Story Magazine*, February 1914, 8. Thanks to Sumiko Higashi for sharing this with me.

198   When the show traveled to Washington, D.C., the National Gallery ran a film series in conjunction with it.

199   Widmann, *212 Days*, 145.

200   Rhonda K. Garelick, *Electric Salome: Loie Fuller's Performance of Modernism* (Princeton N.J.: Princeton University Press, 2007), 81.

201   Ibid.

202   See Angela Dalle Vacche, *Diva: Defiance and Passion in Early Italian Cinema* (Austin: University of Texas Press, 2008); Galt, *Pretty*; Scott Bukatman, *The Poetics of Slumberland: Animated Spirits and the Animating Spirit* (Berkeley: University of California Press, 2012); Sumiko Higashi, *Cecil B. DeMille and American Culture: The Silent Era* (Berkeley: University of California Press, 1994); Tom Gunning, "Light, Motion, Cinema! The Heritage of Loïe Fuller and Germaine Dulac," *Framework* 46, no. 1 (Spring 2005): 106–129; and Thomas Elsaesser, *Weimar Cinema and After: Germany's Historical Imaginary* (London: Routledge, 2000).

203   Restellini, "L'Art Nouveau," 6.

## 1. ART NOUVEAU AND THE AGE OF ATTRACTIONS

1   Tom Gunning, "The Cinema of Attraction[s]: Early Film, Its Spectator and the Avant-Garde," in *The Cinema of Attractions Reloaded*, ed. Wanda Strauven (Amsterdam: Amsterdam University Press, 2006), 390.

2   Charles Musser, "A Cinema of Contemplation, A Cinema of Discernment: Spectatorship, Intertextuality and Attractions in the 1890s," in Strauven, *Cinema of Attractions Reloaded*, 161; my emphasis.

3   Ibid., 162.

4   Ibid., 166.

5   Ibid.; my emphasis.

6   Quoted in Musser, "Cinema of Contemplation," 164–165.

7   Joshua Landy and Michael Saller, eds., *The Re-Enchantment of the World: Secular Magic in a Rational Age* (Stanford, Calif.: Stanford University Press, 2009), 112.

8   Ibid., 113.

9   Méliès purchased the famous Théâtre Robert Houdin when it was put up for sale in 1888. See Rémi Fournier Lanzoni, *French Cinema: From Its Beginnings to the Present* (London: Bloomsbury Academic, 2004), 19.

10   Graham M. Jones, "The Family Romance of Modern Magic: Contesting Robert-Houdin's Cultural Legacy in Contemporary France," in *Performing Magic on the Western Stage: From the Eighteenth Century to the Present*, ed. Francesca Coppa, Lawrence Hass, and James Peck (New York: Palgrave Macmillan, 2008), 36.

11   Ibid., 56.

12   Ibid., 54.

13   Landy and Saller, *Re-Enchantment of the World*, 106–107.

14   Ibid., 109.

15   Ibid., 110.

16   Stephen Smith, "Art Nouveau—a Magical Style," *Guardian*, March 23, 2012, http://www.theguardian.com/artanddesign/2012/mar/23/art-nouveau-magical-style.

17   Victor Arwas, *Art Nouveau: The French Aesthetic* (Wingfield, Berkshire: Andreas Papadakis, 2002), 202.

18   Klaus-Jürgen Sembach, *Art Nouveau* (Cologne: Taschen, 2007), 68.

19   Jeremy Howard, *Art Nouveau: International and National Styles in Europe* (Manchester: Manchester University Press, 1996), 114.

20   Karla J. Nielson, *Interior Textiles: Fabrics, Application and Historic Style* (Hoboken, N.J.: John Wiley, 2007), 410.

21   Albert A. Hopkins, *Magic: Stage Illusions and Scientific Diversions* (New York: Benjamin Bloom, 1897), 488–516.

22   Stanley Cavell, "The Idea of Origins," in *Film Theory and Criticism: Introductory Readings*, 7th ed., ed. Leo Braudy and Marshall Cohen (New York: Oxford University Press), 313.

23   Ibid., 214.

24   The material on Chomón's biography is taken from Joan Minguet Batllori, *Segundo de Chomón: The Cinema of Fascination* (Barcelona: Institute Català des les Indústries Culturals, 2010), 20–24.

25   Maxim Gorky, "The Kingdom of Shadows," in *Authors on Film*, ed. Harry M. Geduld (Bloomington: Indiana University Press, 1972), 3.

26   Batllori, *Segundo de Chomón*, 18.

27   Ibid., 19.

28   The Internet Movie Database credits both men.

29   See Alicia Marie Fletcher, "Framing Early Cinema: The Davide Turconi Nitrate Frame Collection at George Eastman House" (PhD diss., Ryerson University, 2011).

30   Batllori, *Segundo de Chomón*, 44.

31   Ibid., 56.

32    Of course we cannot be entirely sure that the prints we view today have precisely the same coloration as the originals. Nonetheless all color prints of the period suffer that problem and yet Chomón's remain distinctive in comparison to others. Recently, Lobster Films released a version of Méliès' *A Trip to the Moon* (1902) that was laboriously restored to what they believe to be the hue of (at least) one original release print.

33    Batllori, *Segundo de Chomón*, 55.

34    Joshua Yumibe, "'Harmonious Sensations of Sound by Means of Colors': Vernacular Colour Abstractions in Silent Cinema," *Film History* 21, no. 2 (2009): 165.

35    Color processes of the era involved hand coloring, stenciling, tinting, and toning. For a good description of these processes see ibid.

36    Richard Abel, *The Ciné Goes to Town: French Cinema, 1896–1914* (Berkeley: University of California Press, 1998), 284.

37    Paul Greenhalgh, ed., *Art Nouveau 1890–1914* (New York: Harry Abrams, 2000), 54.

38    Ibid., 59.

39    Ibid., 240.

40    Ibid., 238.

41    Fiona Gallagher, *Christie's Art Nouveau* (New York: Watson Guptill, 2000), 42.

42    Alexandre Cirici, *1900 en Barcelona* (Barcelona: Ediciones Polígrafa, 1967), 41.

43    I put quotes around words designating ethnic or racial categories since these roles seem to have been played by Caucasian actors.

44    Marketa Uhlirova, "Costume in Early 'Marvellous' Cinema: The Aesthetic of Opulence and the Teasing Image," in *Birds of Paradise: Costume as Cinematic Spectacle*, ed. Marketa Uhlirova (London: Koenig, 2014), 123.

45    Umberto Eco, ed. *History of Beauty*, trans. Alastair McEwen (New York: Rizzoli, 2004), 342.

46    "A Moritz Hacker 'Shell' Table Lamp," Christie's: The Art People, http://www.christies.com/lotfinder/furniture-lighting/a-moritz-hacker-shell-table-lamp-fl1900-5378951-details.aspx.

47    I saw this film on a website dedicated to "Pathé Baby" nonstandard-gauge (9.5mm) films. This was released in 1923 as *Miss Flutter Metamorphoses*. See http://www.youtube.com/watch?v=ONuU-xZK88Q and http://www.cinerdistan.co.uk/index.htm.

48    Greenhalgh, *Art Nouveau*, 24.

49    Ibid., 213.

50    Gallagher, *Christie's Art Nouveau*, 46.

51    The film is designed by Hein Heckroth with art direction by Arthur Lawson. The costumes are attributed to Ivy Baker, Hein Heckroth, and Josephine Boss.

52    See Lucy Fischer, "The Lady Vanishes: Women, Magic, and the Movies," *Film Quarterly* 22, no. 1 (1979): 30–40.

53    Greenhalgh, *Art Nouveau*, 86–87.

54    Gallagher, *Christie's Art Nouveau*, 13, 91, 134.

55    Greenhalgh, *Art Nouveau*, 451.

56   Uhlirova, "Costume in Early 'Marvellous' Cinema," 105.

57   Ibid., 115.

58   Ibid., 106.

59   Ibid., 110.

60   Ibid., 121.

61   Ibid., 127.

62   Rosalind Galt, *Pretty: Film and the Decorative Image* (New York: Columbia University Press, 2011), 99.

63   Debora Silverman, *Art Nouveau in Fin-de-Siecle France: Politics, Psychology, and Style* (Berkeley: University of California Press, 1989), 186.

64   Abel, *Ciné Goes to Town*, 284.

65   See Clay Lancaster, "Oriental Contributions to Art Nouveau," *Art Bulletin* 34, no. 4 (1952): 297–310.

66   Ann Jackson quoted in Greenhalgh, *Art Nouveau*, 110.

67   Lancaster, "Oriental Contributions," 307.

68   Francesca Vanke quoted in Greenhalgh, *Art Nouveau*, 115–116, 123.

69   Galt, *Pretty*, 109, 111.

70   I have not commented on color in this film since I have only seen a black and white version.

71   My quotes signify that the performers are most likely not ethnically Arab but only dressed as such.

72   Greenhalgh, *Art Nouveau*, 122.

73   Ibid. See also Antonia Lant, "The Curse of the Pharaoh, or How Cinema Contracted Egyptomania," *October* 59 (Winter 1992): 86–112.

74   Urszula Szulakowska, *Alchemy in Contemporary Art* (Farnham, Surrey: Ashgate, 2011), 1.

75   Roland Barthes, "'THAT-HAS-BEEN'; The Pose; The Luminous Rays, Colour; Amazement; Authentification," in *Stardom and Celebrity: A Reader*, ed. Sean Redmond and Su Holmes (Los Angeles: Sage, 2007), 51.

76   Cirici, *1900 en Barcelona*, 43.

77   Jean Snitzer Schoenfeld, "André Breton, Alchemist," *French Review* 57, no. 4 (March 1984): 494.

78   Anna Balakian, *André Breton, Magus of Surrealism* (New York: Oxford University Press, 1971), 38.

79   Anna Balakian, "André Breton as Philosopher," *Yale French Studies* 31 (1964): 39.

80   André Breton, *Manifestoes of Surrealism*, trans. Richard Seaver and Helen R. Lane (Ann Arbor: University of Michigan Press, 1972), 14.

81   Ibid., 15.

82   Ibid., 16.

83   Elizabeth Ezra, *Geoges Méliès: The Birth of an Auteur* (Manchester: Manchester University Press, 2000), 20.

84   Emile Cailliet, *The Themes of Magic in Nineteenth Century French Fiction*, trans. Lorraine Havens (Philadelphia: Porcupine, 1932), 148.

85    Ibid., 164.

86    György M. Vajda, "Some Aspects of Art Nouveau in Arts and Letters," *Journal of Aesthetic Education* 14, no. 4 (October 1980): 80.

87    William H. Robinson, Jordi Falgàs, and Carmen Belen Lord, eds., *Barcelona and Modernity: Picasso, Gaudí, Miró, Dalí* (New Haven, Conn.: Yale University Press, 2006), 3.

88    All information on the Sala Mercè is either from Batllori, *Segundo de Chomón*, 74–77; "The Sala Mercè (1904–1913): Pioneer Hall in the Cinematography of Barcelona," Gaudí and Barcelona Club, http://www.gaudiclub.com/ingles/i_vida /smerce.asp; or Antoni González Moreno-Navarro, "La Restauración Póstuma de la Sala Mercè," http://www.diba.cat/documents/429042/69532203/I_gaudi+i+spal .pdf/e4d35bc0-4c32-4c42-ac98-3b2502b01205.

89    "The Sala Mercè (1904–1913)."

90    Batllori, *Segundo de Chomón*, 75.

91    Ibid., 76.

92    Ibid., 75.

93    Ibid., 74–75.

94    See Jean-Louis Baudry, "The Apparatus," *Camera Obscura* 1, no. 1 (1976): 104–126. On the lower cave-like level of the building, faux stalactites and stalagmites protruded.

95    Batllori, *Segundo de Chomón*, 77.

96    Ivo Bloom, *Jean Desmet and the Early Dutch Film Trade* (Amsterdam: University of Amsterdam Press, 2003), 38, 53–55.

97    Ken Roe, "Animatografo do Rossio: 225–229 Rua dos Sapateiros, Lisbon," Cinema Treasures, http://cinematreasures.org/theaters/13272.

98    Ibid.

99    Ibid.

100   Ibid.

101   "Animatografo do Rossio," *Lisbon Close-Ups: Lisbon Photos* (blog), n.d., http://www .lisbonlux.com/photo-blog/animatografo-do-rossio/.

102   Roe, "Animatografo do Rossio."

103   James Traub, *The Devil's Playground: A Century of Pleasure and Profit in Times Square* (New York: Random House, 2004), 24.

104   See Joel Lobenthal, "The New Amsterdam Theatre," in Joel Lobenthal, Harry C. Lines, and Bruce Weber, *The New Amsterdam Theatre, New York City* (Alameda, Calif.: Theatre Historical Society, 1978), 2.

105   See Charles R. Bevington, *New York Plaisance* 1, no. 1 (1908), https://archive.org /details/newyorkplaisance00bevi.

106   Mary C. Henderson, *The New Amsterdam: The Biography of a Broadway Theatre* (New York: Hyperion, 1997), 28.

107   Lobenthal, "New Amsterdam Theatre," 2.

108   Traub, *Devil's Playground*, 24; my emphasis.

109   Ken Bloom, *Broadway—Its History, People, and Places: An Encyclopedia* (New York: Routledge, 2004), 375.

110   Quoted in ibid.

111   Charles De Kay, "Sculpture and Painting in a Theatrical Environment," *New York Times*, November 1, 1903.

112   "New Amsterdam Opened," *New York Times*, October 27, 1903.

113   Ibid.

114   De Kay, "Sculpture and Painting," 21.

115   Ibid.

116   Ibid.

117   Ibid.

118   Ibid.

119   Ibid.

120   Ibid.

121   Ibid.

122   Ibid.

123   I toured the New Amsterdam Theatre and many details mentioned come from my own experience of it.

124   Bruce Weber, "Robert Blum and the New Amsterdam Murals," in Joel Lobenthal, Harry C. Lines, and Bruce Weber, *The New Amsterdam Theatre, New York City* (Alameda, Calif.: Theatre Historical Society, 1978), 24.

125   Ibid.

126   Lobenthal, "New Amsterdam Theatre," 10.

127   Traub, *Devil's Playground*, 40.

128   "New Amsterdam Opened."

129   Traub, *Devil's Playground*, 25.

130   Ibid.

131   Heather Hester, "Florenz Ziegfeld Jr.," in *Immigrant Entrepreneurship: German-American Business Biographies, 1720 to the Present*, vol. 4, ed. Jeffrey Fear, German Historical Institute, February 19, 2014, http://www.immigrantentrepreneurship.org/entry.php?rec=194.

132   Elizabeth Haas, "The Ziegfeld Follies," in *St. James Encyclopedia of Popular Culture*, 2nd ed., vol. 5, ed. Thomas Riggs (Detroit: St. James, 2013), 488.

133   Lobenthal, "New Amsterdam Theatre."

134   Rudolph Carter and Robert Reed Cole, *Urban: Architecture, Theatre, Opera, Film* (New York: Abbeville Press, 1992), 73.

135   Ibid.

136   Ibid., 84.

137   Ibid., 76.

138   Christopher Innes, *Designing Modern America: Broadway to Main Street* (New Haven, Conn.: Yale University Press, 2005), 9.

139   Ibid., 13.

140   John Loring, *Joseph Urban* (New York: Abrams, 2010), 10.

141   Ibid.

142   Ibid., 18.

143   Ibid., 10.

144   Ibid. See Gesetz Von W. Labler, *Kling Klang Gloria*, illustrated by H. Lefler and Joseph Urban (Vienna: F. Tempsky, 1907).

145   Ibid., 21.

146   Ibid., 106.

147   Traub, *Devil's Playground*, 34–35.

148   Quoted in Carter and Cole, *Urban*, 95.

149   Ibid., 76.

150   Randy Bryan Bigham, *Lucile—Her Life by Design: Sex, Style and the Fusion of Theatre and Couture* (San Francisco: MacEvie, 2012), 26.

151   Ibid., 24.

152   Ibid., 28.

153   Quoted in ibid., 15.

154   Ibid., 150.

155   Ibid.

156   Wilhelm Hortmann and Michael Hamburger, *Shakespeare on the German Stage: The Twentieth Century* (Cambridge: Cambridge University Press, 1998), 31.

157   Janice W. McNellis, "Max Reinhardt and *A Midsummer Night's Dream*" (Master's thesis, Indiana University, 1991), 13.

158   Scott MacQueen, "Commentary," *A Midsummer Night's Dream*, directed by William Dieterle and Max Reinhardt (Burbank, Calif.: Warner Home Video, 2007), DVD.

159   Hortmann and Hamburger, *Shakespeare on the German Stage*, 36.

160   *Encyclopedia Britannica Online*, s.v. "Theatre: The Evolution of Modern Theatrical Production," by Clive Barker, George C. Izenour, and Howard Bay, http://www .britannica.com/EBchecked/topic/590239/theatre/39420/The-influence-of -Reinhardt.

161   This information was provided to me by a tour guide when I toured the New Amsterdam Theatre in July 2014.

162   Bruce Weber, "Disney Unveils Restored New Amsterdam Theater," *New York Times*, April 3, 1997.

## 2. ART NOUVEAU AND AMERICAN FILM OF THE 1920S

1   Fredericks Scenic Studio, advertisement, *Variety* 49, no. 2 (December 1917): 38. Cretonne is a heavy floral fabric generally used for upholstery.

2   Walter K. Hill, "Second Reel," Rambles 'Round Filmtown, *Moving Picture World* 36, no. 9 (June 1, 1918): 1302.

3   Beulah Livingston, "Madame Olga Petrova This Christmas and Ten Years Ago," *Photo-Play Journal* 2, no. 8 (December 1917): 24, http://archive.org/stream/photo playjournal02lave#page/12/mode/2up; my emphasis.

4   "Sleuthing as a Fine Art," *Photoplay Magazine* 15, no. 4 (March 1919): 60, http://
    archive.org/stream/phojanjun16chic#page/n291/mode/2up.

5   "Notes Written on the Screen," *New York Times*, August 16, 1914.

6   "The Screen," *New York Times*, July 4, 1921.

7   George McAdam, "Our New Art for Export," *New York Times*, April 13, 1924.

8   Martha Gruening, "European Revolt Against Our Films," *New York Times*, October 31,
    1926.

9   Benjamin De Casseres, "Our Domestic Movies and the Germans," *New York Times*,
    March 26, 1922.

10  Ibid.

11  Sumiko Higashi, *Cecil B. DeMille and American Culture: The Silent Era* (Berkeley: University
    of California Press, 1994); and Robert S. Birchard, *Cecil B. DeMille's Hollywood*
    (Lexington: University Press of Kentucky, 2004).

12  Deborah Nadoolman Landis, *Dressed: A Century of Hollywood Costume Design* (New York:
    Harper Collins, 2007), 6.

13  Ibid., 7.

14  Mary E. Davis, *Ballets Russes Style: Diaghilev's Dancers and Paris Fashion* (London: Reaktion,
    2010), 131–132.

15  Higashi, *Cecil B. DeMille*, 167.

16  Ibid., 155.

17  The Handschiegl process produced motion picture film prints with color artificially
    added to selected areas of the image. Aniline dyes were applied to a black and white
    print using gelatin imbibition matrices.

18  Higashi, *Cecil B. DeMille*, 167.

19  Lucy Fischer, *Designing Women: Cinema, Art Deco and the Female Form* (New York: Columbia
    University Press, 2003).

20  Rosalind Galt, *Pretty: Film and the Decorative Image* (New York: Columbia University
    Press, 2011), 136.

21  Higashi, *Cecil B. DeMille*, 149.

22  R. L. Giften, "Nazimova a Motion Picture Enthusiast," *Motion Picture Story Magazine*
    (June 1912): 25. Thanks to Sumiko Higashi for passing this reference on to me.

23  Lillian Montayne, "A Half Hour with Nazimova," *Photoplay Classic* (July 1917): 36.

24  Herbert Howe, "Nazimova Speaks," *Picture-Play Magazine* 13, no. 1 (September
    1920): 27.

25  Gavin Lambert, *Nazimova* (New York: Random House, 1997), 260.

26  *Encyclopaedia Britannica Online*, s.v. "Alla Nazimova," http://www.britannica.com
    /EBchecked/topic/407257/Alla-Nazimova.

27  Jennifer Horne, "Profile: Alla Nazimova," Women Film Pioneers Project, https://
    wfpp.cdrs.columbia.edu/pioneer/ccp-alla-nazimova/#ccp.

28  William Tydeman and Steven Price, *Wilde: Salome* (Cambridge: Cambridge University
    Press, 1996), 159.

29   Stanley Weintraub, *Aubrey Beardsley: Imp of the Perverse* (University Park: Pennsylvania State University Press, 1976), 76.

30   *Encyclopaedia Britannica Online*, s.v. "Salome," http://www.britannica.com/EBchecked /topic/519575/Salome.

31   Petra Dierkes-Thrun, *Salome's Modernity: Oscar Wilde and the Aesthetics of Transgression* (Ann Arbor: University of Michigan Press, 2011), 134.

32   Ibid.

33   Inga Fraser, "Born Fully Clothed: The Significance of Costume for the Silent Cinema Vamp," in *Birds of Paradise: Costume as Cinematic Spectacle*, ed. Marketa Uhlirova (Cologne: Verlag der Buchhandlung Walther König, 2015), 184.

34   Lambert, *Nazimova*, 237.

35   Dierkes-Thrun, *Salome's Modernity*, 140.

36   Ibid., 157.

37   Ibid, 144.

38   Lambert, *Nazimova*, 255.

39   Dierkes-Thrun, *Salome's Modernity*, 146. Lambert, in *Nazimova*, talks of her affair with Mercedes de Acosta, 175; Dorothy Arzner, 224–225; Jean Acker, 11; Eva La Gallienne, 11; and of her longtime relationship with Glesca Marshall, 11.

40   Ibid., 142, 143.

41   Tydeman and Price, *Wilde*, 165.

42   Lambert, *Nazimova*, 251.

43   Arwas, *Art Nouveau: The French Aesthetic* (London: Andreas Papadakis, 2002), 178.

44   David S. Shields, *Still: American Silent Motion Picture Photography* (Chicago: University of Chicago Press, 2013), 192.

45   Lambert, *Nazimova*, 255.

46   Walter Benjamin, *The Arcades Project*, trans. Howard Eiland and Kevin McLaughlin (Cambridge, Mass.: Harvard University Press, 1999), 360.

47   Ibid., 9.

48   Female entertainers.

49   Ibid., 551.

50   Ibid., 556.

51   Ibid., 557.

52   Chris Snodgrass, *Aubrey Beardsley, Dandy of the Grotesque* (New York: Oxford University Press, 1995), 79.

53   Ibid., 80–81.

54   Ibid., 79, 81.

55   Ibid., 79.

56   Ibid.

57   Ibid.

58   Ibid.

59   See the work of Petra Dierkes-Thrun.

60  Patricia White, "Nazimova's Veils: *Salome* at the Intersection of Film Histories," in *A Feminist Reader in Early Cinema*, ed. Jennifer Bean and Diane Negra (Durham, N.C.: Duke University Press, 2002), 60–87.

61  Marcia Landy, "1923: Movies and the Changing Body of Cinema," in *American Cinema in the 1920s: Themes and Variations*, ed. Lucy Fischer (New Brunswick, N.J.: Rutgers University Press, 2009), 95–119.

62  Lotte Reiniger's *The Adventures of Prince Achmed* comes in 1927.

63  Bosley Crowther, "Alla Nazimova's 1922 Film, 'Salome,' at the Museum," *New York Times*, February 15, 1967.

64  White, "Nazimova's Veils," 67.

65  Jokanaan is the name given to the John the Baptist character in the film.

66  Tydeman and Price, *Wilde*, 16.

67  Jennifer Horne, "Profile: Alla Nazimova," Women Film Pioneers Project, https://wfpp.cdrs.columbia.edu/pioneer/ccp-alla-nazimova/; and Michael Morris, *Madame Valentino: The Many Lives of Natacha Rambova* (New York: Abbeville, 1991), 92.

68  Lambert, *Nazimova*, 146.

69  Ibid., 256.

70  Rhonda K. Garelick, *Electric Salome: Loie Fuller's Performance of Modernism* (Princeton N.J.: Princeton University Press, 2007), 90, 92.

71  Gaylyn Studlar, "Out Salome-ing Salome: Dance, the New Woman, and Fan Magazine Orientalism," in *Visions of the East: Orientalism in Film*, ed. Matthew Bernstein and Gaylyn Studlar (New Brunswick, N.J.: Rutgers University Press), 113.

72  Fischer, *Designing Women*, 91–121.

73  Lambert, *Nazimova*, 256.

74  Diana Donald and Jane Munro, eds., *Endless Forms: Charles Darwin, Natural Science and the Visual Arts* (New Haven, Conn.: Yale University Press, 2009), 266.

75  I have seen an incomplete print from the Cinémathèque Royale de Belgique. Thanks to them for allowing me to purchase a study copy DVD.

76  "Madame Peacock," Catalogue of Feature Films, American Film Institute, http://www.afi.com/members/catalog/DetailView.aspx?s=&Movie=17789.

77  See Susan Brown's discussion of a dress from 1928 whose skirt is composed of dyed ostrich plumes in her *Fashion: The Definitive History of Costume and Style* (London: Dorling Kindersley, 2012), 247.

78  Fraser, "Born Fully Clothed," 190.

79  Christine E. Jackson, *Peacock* (London: Reaktion Books, 2006), 162.

80  Brown, *Fashion*, 232.

81  Ibid., 237.

82  Ibid., 246.

83  Donald and Munro, *Endless Forms*, 237, 266, 276.

84  "Historic Tour: From Statement to Epicurean Event," Peacock Alley, http://peacockalleyrestaurant.com/historic-tour.

85   Carl Sandburg, *"The Movies Are": Carl Sandburg's Film Reviews and Essays, 1920–1928*, ed. and with historical commentary by Arnie Bernstein (Chicago: Lake Claremont, 2000), 23.

86   Brown, *Fashion*, 237, 236.

87   Clare Rose, "Art Nouveau Fashion 1890–1914," Academia, http://www.academia .edu/6106331/Art_Nouveau_Fashion_1890-1914.

88   Francois Baudot, *Fashion: The Twentieth Century* (New York: Universe, 1999), 41–42.

89   Alice Mackrell, *Paul Poiret* (New York: Homes and Meier, 1990), 30.

90   Ibid., 3.

91   Ibid.

92   Baudot, *Fashion*, 51. See also Susie Ralph, "Margaine-Lacroix and the Dresses That Shocked Paris," *RBKC Libraries Blog*, July 12, 2013, http://rbkclibraries.wordpress .com/2013/07/12/margaine-lacroix-and-the-dresses-that-shocked-paris/.

93   Nancy J. Troy, *Couture Culture: A Study in Modern Art and Fashion* (Cambridge, Mass.: MIT Press, 2002), 31, 33.

94   "Mariano Fortuny y Madrazo (1871–1949): Spanish Dress and Fabric Designer-Artist," Senses: Art Nouveau, http://www.senses-artnouveau.com/biography.php ?artist=FOR.

95   Marcel Proust, *In Search of Lost Time, Vol. 5: The Fugitive and the Captive*, trans. C. K. Scott Moncrieff and Terence Kilmartin (New York: Modern Library, 2003), 34.

96   "Quotes," Liberty, http://www.liberty.co.uk/quotes/article/fcp-content.

97   Kim Wahl, "Fashioning the Female Artistic Self: Aesthetic Dress in Nineteenth-Century British Visual Culture" (PhD diss., Queen's University at Kingston [Canada], 2004), 1.

98   Fiona McCarthy, "The Aesthetic Movement," *Guardian*, March 25, 2001, http://www .theguardian.com/artanddesign/2011/mar/26/aestheticism-exhibition-victoria -albert-museum.

99   Sainsbury Centre for Visual Arts, "Teacher's Notes on Art Nouveau," https://www .yumpu.com/en/document/view/4478610/teachers-notes-on-art-nouveau -sainsbury-centre-for-visual-arts/7.

100  Siegfried Kracauer, *The Mass Ornament: Weimar Essays*, trans. and ed. Thomas Y. Levin (Cambridge, Mass.: Harvard University Press, 1995), 80.

101  *The Palace of Arabian Nights*.

102  Arsène Alexandre, *The Decorative Art of Léon Bakst* (New York: Benjamin Blom, 1971), 13.

103  Ibid., 7.

104  "Ballets Russes: The Art of Costume: Shéhérazade," National Gallery of Australia, http://nga.gov.au/Exhibition/balletsrusses/Default.cfm?MnuID=3&GalID=5.

105  Troy, *Couture Culture*, 102.

106  I learned of this film through a presentation by Mary Simonson at the meeting of Women and the Silent Screen VIII in Pittsburgh, Pennsylvania, in September 2015. The talk was entitled "Laboring Bodies: The Ballets Russes Onscreen." She later graciously sent me a print copy of it.

107 "Where Bargaining Is the Soul of Trade," *Shadowland* (September 1922–February 1923): 233.

108 Gaylyn Studlar, "Douglas Fairbanks: Thief of the Ballets Russes," in *Bodies of the Text: Dance as Theory, Literature as Dance*, ed. Ellen W. Goellner and Jacqueline Shea Murphy (New Brunswick, N.J.: Rutgers University Press, 1995), 115.

109 Ibid., 109.

110 Cathy Whitlock, *Designs on Film: A Century of Hollywood Art Direction* (New York: It Books, 2010), 46.

111 Robert S. Sennett, *Setting the Scene: The Great Hollywood Art Directors* (New York: Harry N. Abrams, 1994), 45.

112 Sandburg, *"The Movies Are,"* 242.

113 Vachel Lindsay, "The Thief of Bagdad," *Michigan Quarterly Review* 31, no. 2 (Spring 1992): 231, 232.

114 Ibid., 232, 235.

115 Ibid., 232.

116 Paul Hammond, ed., *The Shadow and Its Shadow: Surrealist Writings on Cinema* (London: British Film Institute, 1978), 20.

117 William Cameron Menzies, "Pictorial Beauty in the Photoplay," in *Introduction to the Photoplay: 1929: A Contemporary Account of the Transition to Sound in Film*, ed. John C. Tibbets, with the assistance of Gregory D. Black (Shawnee Mission, Kans.: National Film Society, 1977), 163.

118 Ibid., 179.

119 "AFI's 10 Top 10: Top 10 Fantasy," American Film Institute, http://www.afi.com /10top10/category.aspx?cat=6.

120 Ibid., 174.

121 Ibid., 162.

122 Whitlock, *Designs on Film*, 46.

123 Patrick Downing and John Hambley, *The Art of Hollywood: A Thames Television Exhibition at the Victoria and Albert Museum* (London: Thames Television, 1979), 91.

124 Whitlock, *Designs on Film*, 46.

125 Sennett, *Setting the Scene*, 40. Other members of the Art Department included Park French, Harold Grieve, H. R. Hopps, Edward M. Langley, Irvin J. Martin, William Utwich, and Paul Youngblood. Paul Burns was property manager (uncredited).

126 Downing and Hambley, *Art of Hollywood*, 91.

127 Sennett, *Setting the Scene*, 40.

128 Downing and Hambley, *The Art of Hollywood*, 93.

129 Ibid., 93.

130 James Curtis, *William Cameron Menzies, The Shape of Films to Come* (New York: Pantheon, 2015), 35.

131 Juan Antonio Ramirez, *Architecture for the Screen: A Critical Study of Set Design in Hollywood's Golden Age* (Jefferson, N.C.: McFarland, 2004), 147.

132   Thanks to Steven Jacobs (University of Ghent) for pointing out to me the comparison between the style of Art Nouveau in *The Thief* and the work of August Endell.

133   David Helge, "August Endell: The Spirit and the Beauty of the City," in *Modernism and the Spirit of the City*, ed. Boyd White (London: Routledge, 2003), 87.

134   Lindsay, "Thief of Bagdad," 233.

135   Whitlock, *Designs on Film*, 46.

136   Lindsay, "Thief of Bagdad," 233.

137   Ibid., 48.

138   Menzies, "Pictorial Beauty in the Photoplay," 170.

139   Sennett, *Setting the Scene*, 45.

140   Whitlock, *Designs on Film*, 48.

141   Menzies, "Pictorial Beauty in the Photoplay," 170.

142   "$40,000 Theatre in St. Louis," *Motion Picture News* 10, no. 1 (July–October 1914): 338, http://archive.org/stream/motionpicturenew10iunse#page/n337/mode/2up.

143   T. S. Mead, "The Theatre Beautiful Is Big Asset to Good Pictures," *Motion Picture News* 12, no. 11 (September 18, 1915): 140, http://archive.org/stream/motionpictu renew12iunse#page/n1/mode/2up.

144   "Theater St. Francis, San Francisco," *Moving Picture World* 30, no. 9 (December 2, 1916): 1,328, http://archive.org/stream/movingpicturewor30newy#page/1328 /mode/2up.

145   "The Lyceum Theatre, Newark, N.J.," *Motion Picture News* 8, no. 22 (December 6, 1913): 19, http://archive.org/stream/motionpicturenew82unse#page/n437/mode /2up.

146   Alaricus Delmard, "Cinematograph Theatres in Sophia," *Cinema News and Property Gazette* 1, no. 6 (July 1912): 8, http://lantern.mediahist.org/catalog/cinenewgaz01cine _0206.

147   All information about the Tuschinski Theater comes from the following sources: (1) a tour of the theater on July 10, 2015, with audio tour and pamphlet; and (2) the following web pages: "Theater Tuschinski," Eye, https://www.eyefilm.nl/en /collection/film-history/article/theater-tuschinski; "Ontworpen voor Abraham Tuschinski," Anno 1900, http://anno1900.nl/2015/02/13/ontworpen-voor-abraham -tuschinski/; and "Pathé Tuschinski: Amsterdam," Pathe!, https://www.pathe.nl /bioscoop/tuschinski.

148   "Theater Tuschinski."

149   Ibid.

150   "Ontworpen voor Abraham Tuschinski."

151   "Theater Tuschinski."

152   "Ontworpen voor Abraham Tuschinski."

153   Ibid.

154   "Theater Tuschinski."

155   Ibid.

## 3. ARCHITECTURE AND THE CITY

1   I am referring to *Empire*, directed by Andy Warhol (1964).

2   For a very different take on the subject of Barcelona on-screen see Brian Bergen-Aurand, "Barcelona: City of Refuge," in *A Companion to Woody Allen*, ed. Sam B. Girgus and Peter J. Bailey (Chichester, West Sussex: Wiley-Blackwell, 2013), 424–440. As the title of his essay indicates, Bergen-Aurand sees Barcelona as a "city of refuge with its complex *topos* of escape and exile" (432). Occasionally he mentions Gaudí buildings in a film (*The Passenger; Vicky Cristina Barcelona*), but provides no real analysis and does not relate them to Catalan modernism or Art Nouveau.

3   Julie Burchill, "Patriotism Is for Reactionaries . . . Nationalism Is the Way Forward," *Observer*, September 8, 2012, https://www.theguardian.com/commentisfree/2012/sep/09/julie-burchill-nationalism-beats-patriotism.

4   See the work of Gayle Rogers for a discussion of literary modernism in Spain.

5   Carmen Belen Lord, "The New Art: Modernisme," in William H. Robinson, Jordi Falgas, and Carmen Belen Lord, *Barcelona and Modernity: Picasso, Gaudí, Miró, Dalí* (New Haven, Conn.: Cleveland Museum of Art/Yale University Press, 2006), 35.

6   Teresa-M. Sala, "Images of the City of Modern Life: Ideals, Dreams, and Realities," in *Barcelona 1900*, ed. Teresa-M. Sala (Ithaca, N.Y.: Cornell University Press, 2007), 37.

7   Lord, "New Art," 37.

8   Ibid., 35.

9   Maiken Umbach, "The Modernist Imagination of Place and Politics of Regionalism: Puig i Cadafalch and Early Twentieth-Century Barcelona," in *The Re-Enchantment of the World: Secular Magic in a Rational Age*, ed. Joshua Landy and Michael Saler (Stanford, Calif.: Stanford University Press, 2009), 83.

10  Ibid., 81.

11  Ibid., 82.

12  Ibid., 99.

13  Borja de Riquer, "Modernismo: A Cultural Adventure," in Borja de Riquer et al., *Modernismo: Architecture and Design in Catalonia*, trans. Richard Lewis Reed, with photographs by Jordi Cuxart et al. (New York: Monacelli, 2003), 13.

14  I am thinking of Utrillo, Rusinol, and Casas; see Lord, "New Art," 36.

15  Lourdes Figueras, "Art and Industry in Modernismo," in de Riquer et al., *Modernismo*, 201.

16  Lord, "New Art," 35.

17  Francesc M. Quilez i Corella, "Graphic Art of the Quatre Gats," in William H. Robinson, Jordi Falgas, and Carmen Belen Lord, *Barcelona and Modernity: Picasso, Gaudí, Miró, Dalí* (New Haven, Conn.: Yale University Press, 2006), 93–94.

18  Sala, "Images of the City," 40.

19  "The House," Casa Lleó i Morera, http://www.casalleomorera.com/en/casa-lleo-i-morera/the-house/.

20  *Modernisme Route: Barcelona* (Barcelona: Institut Municipal del Paisatge Urbá i la Quali-
    tat de Vida, Ajuntament de Barcelona, 2005).

21  Josep M. Huertas Clavería, "Modernisme, Between Love and Hate," in *Modernisme
    Route: Barcelona* (Barcelona: Institut Municipal del Paisatge Urbá i la Qualitat de
    Vida, Ajuntament de Barcelona, 2005), 21–27.

22  Clavería, "Between Love and Hate," 21.

23  *Wiktionary*, s.v. "Gaudy," last modified May 24, 2014, http://en.wiktionary.org/wiki
    /gaudy.

24  Clavería, "Between Love and Hate," 26.

25  Ibid., 26.

26  Henry-Russell Hitchcock, *Gaudí*, illustrated by Antonio Gaudí (New York: Museum
    of Modern Art, 1937), 7.

27  Ibid., 10.

28  Ibid.

29  Ibid., 11.

30  Ibid.

31  Umbach, "Modernist Imagination," 96, 98.

32  Hitchcock, *Gaudí*, 11.

33  Ibid.

34  Ibid.

35  Sala, "Images of the City," 40–41.

36  Isabel Segura Soriano, "Barcelona, City of Art Nouveau," trans. Robin Wil-
    liams, pp. 2–3, http://www.artnouveau-net.eu/portals/0/data/PROCEEDINGS
    _DOWNLOAD/NANCY/Barcelona,%20City%20of%20Art%20Nouveau%20
    Women.pdf.

37  Hitchcock, *Gaudí*, 11.

38  Ibid.

39  Ibid.

40  Ibid., 9.

41  Ibid., 12.

42  Ibid.

43  "Art Nouveau Revival: 1900. 1933. 1966. 1974," Musee d'Orsay, http://www.musee
    -orsay.fr/en/events/exhibitions/in-the-musee-dorsay/exhibitions-in-the-musee
    -dorsay-more/article/art-nouveau-revival-23208.html?tx_ttnews%5BbackPid%5D
    =649&cHash=20c8b95acc.

44  Salvador Dalí, "Concerning the Terrifying and Edible Beauty of Art Nouveau
    Architecture," in *The Collected Writings of Salvador Dalí*, trans. Haim Finkelstein (Cam-
    bridge: Cambridge University Press, 1998), 198.

45  Ibid., 195, 198.

46  Ibid., 200.

47  Debora Silverman, *Art Nouveau in Fin-de-Siècle France: Politics, Psychology and Style* (Berke-
    ley: University of California Press, 1989), 78.

48   Ibid., 83.

49   Dalí, "Concerning," 198, 200.

50   Ibid., 198.

51   Ned Rifkin uses the word "roller coaster" in his *Antonioni's Visual Language* (Ann Arbor, Mich.: UMI Research Press, 1982), 126.

52   Jack Nicholson, "Audio Commentary," *The Passenger*, directed by Michelangelo Antonioni (Culver City, Calif.: Sony Pictures, 2006), DVD.

53   Joan Bassegoda Nonell, *Antonio Gaudí: Master Architect* (London: Abbeville Press, 2000), 26.

54   Betty Jeffries Demby and Larry Sturhahn, "Antonioni Discusses *The Passenger*," in Michelangelo Antonioni, *The Architecture of Vision: Writings and Interviews on Cinema*, ed. Carlo Di Carlo and Giorgio Tinazzi, trans. Marga Cottino-Jones (New York: Marsilio, 1996), 335.

55   Frank Tomasulo, "The Architectonics of Alienation: Antonioni's Edifice Complex," *Wide Angle* 15, no. 3 (July 1993): 3.

56   Demby and Sturhahn, "Antonioni Discusses *The Passenger*," 334.

57   Dalí, "Concerning," 194.

58   Rifkin, *Antonioni's Visual Language*, 126.

59   Dalí, "Concerning," 194.

60   Baroque and Indian influences are mentioned not by Dalí but in James Johnson Sweeney and Josep Lluís Sert, *Antoni Gaudí* (New York: Praeger, 1960), 7.

61   Dalí, "Concerning," 195.

62   Ibid.

63   Ibid., 196, 200.

64   Ibid., 196.

65   Ibid., 198, 200.

66   Arthur Drexler, foreword to Hitchcock, *Gaudí*, 3.

67   Quoted in Nikos Sideris, *Architecture and Psychoanalysis: Fantasy and Construction* (Athens: Nikos Sideris and Editions Futura, 2013), Kindle edition, 22.

68   So do Sweeney and Sert, *Antoni Gaudí*, 8.

69   Dalí, "Concerning," 196, 200.

70   Tomasulo, "Architectonics of Alienation," 15.

71   Camille Paglia, *Sexual Personae: Art and Decadence from Nefertiti to Emily Dickinson* (New Haven, Conn.: Yale University Press, 1990), 497.

72   I read this statement on a website about Barcelona, but cannot now relocate it. Perhaps the site was taken down.

73   Liz Castro, "CBS De-Catalanizes Gaudí," *News Catalonia* (blog), March 11, 2013, http://www.newscatalonia.com/2013/03/cbs-de-catalanizes-gaudi.html.

74   Dalí, "Concerning," 198.

75   Walter Benjamin, *The Arcades Project*, trans. Howard Eiland and Kevin McLaughlin (Cambridge, Mass.: Harvard University Press, 1999), 557; Benjamin quoted in Andrew Benjamin, *Style and Time: Essays on the Politics of Appearance* (Evanston, Ill.: Northwest University Press, 2006), 50.

76   Gideon Bachmann, "Antonioni After China: Art Versus Science," in *Michelangelo Antonioni: Interviews*, ed. Bert Cardullo (Jackson: University Press of Mississippi, 2008), 126.

77   William Arrowsmith, *Antonioni: The Poet of Images* (New York: Oxford University Press, 1995), 161–162.

78   Theodore Price, "Michelangelo Antonioni: The Truth About *The Passenger*," *Senses of Cinema*, no. 74 (March 2015), http://sensesofcinema.com/2015/feature-articles/michelangelo-antonioni-the-truth-about-the-passenger/.

79   Peter Wollen and Antonioni collaborated on the screenplay.

80   This is actually documentary/newsreel footage inserted into the film as though filmed by Locke.

81   Hiroshi Teshigahara, "My First Trip to the West," in Hiroshi Teshigahara, Sofu Teshigahara, Ken Domon, and Dore Ashton, *Antoni Gaudí: A Film by Hiroshi Teshigahara* (New York: Criterion Collection, 2008). Booklet accompanying DVD.

82   Dalí, "Concerning," 196, 197.

83   Hitchcock, *Gaudí*, 13.

84   Dalí, "Concerning," 198.

85   Sweeney and Sert, *Antoni Gaudí*, 50.

86   Seymour Benjamin Chatman and Paul Duncan, *Michelangelo Antonioni: The Investigation* (Cologne: Taschen, 2004), 91.

87   Bachmann, "Antonioni After China," 126.

88   Jack Nicholson recalled that Antonioni built the hotel set in two parts that could be separated (Nicholson, "Audio Commentary").

89   Thanks to Joan M. Minguet Battlori for suggesting this film to me.

90   David Bordwell, *Narration in Fiction Film* (Madison: University of Wisconsin Press, 1985).

91   Anna Cox, "From the Barcelona School to Pere Portabella's Workshop: The Film Loop as Political Strategy in Late Francoist Spain" (PhD diss., University of Pennsylvania, 2011), 158, 163.

92   Ibid., 163.

93   Ibid., 181.

94   Susan Seidelman, "Audio Commentary," *Gaudí Afternoon*, directed by Susan Seidelman (Los Angeles: First Look Media, 2002), DVD.

95   Walter Benjamin, "Surrealism: The Last Snapshot of the European Intelligentsia," in *Critical Theory and Society: A Reader*, ed. and with an introduction by Stephen Eric Bronner and Douglas MacKay Kellner (New York: Routledge, 1989), 176.

## 4. ART NOUVEAU, CHAMBERS OF HORROR, AND "THE JEW IN THE TEXT"

1   "Art Events Here and There," *New York Times*, November 20, 1904; my emphasis.

2   "A New Vision in Design Has Gripped Germany," *New York Times*, July 17, 1927; my emphasis.

3   Thomas J. Holmes, "Bookbinding," *New York Times*, January 26, 1907; my emphasis.

4   Of course for Benjamin (as Tom Gunning has noted), that term referred to the consumer item under capitalism transformed into an illusionistic, quasi-magical object, divorced from use value and signs of labor. See Tom Gunning, "Illusions Past and Future: The Phantasmagoria and Its Specters," http://www.mediaarthistory .org/refresh/Programmatic%20key%20texts/pdfs/Gunning.pdf.

5   Mel Gordon, *The Grand Guignol: Theatre of Fear and Terror* (New York: Amok Press, 1988), 2.

6   György M. Vajda, "Some Aspects of Art Nouveau in Arts and Letters," *Journal of Aesthetic Education* 14, no. 4 (October 1980): 78.

7   Ibid., 19.

8   Ibid., 18.

9   See "Theatre du Grand Guignol," L'Exposition Universelle de Paris 1900, http:// exposition-universelle-paris-1900.com/THEATRE_DU_GRAND_GUIGNOL.

10  Vajda, "Some Aspects of Art Nouveau," 21, 37.

11  Tom Gunning, "The Horror of Opacity: The Melodrama of Sensation and the Plays of André de Lorde," in *Melodrama: Stage Picture Screen*, ed. Jacky Bratton, Jim Cook, and Christine Gledhill (London: BFI Publishing, 1994), 53.

12  Ibid., 2, 24.

13  Posters in Holmes, "Bookbinding," 19, 25, 103.

14  Gunning, "Horror of Opacity," 60.

15  There is a sequel entitled *Dr. Phibes Rises Again* (1972), but it is not as interesting since most of the film is set in the Egyptian desert rather than early twentieth-century Europe. Its design style is also more influenced by Art Deco than Art Nouveau, though touches of the original film's mise-en-scène remain.

16  "Art Events Here and There," 6.

17  "Thrillpeddler's GrandGuignol.com/What is Grand Guignol?" GrandGuignol, accessed September 29, 2014, http://www.grandguignol.com/tri_2.htm; Gunning, "Horror of Opacity," 57.

18  Sander L. Gilman, "Salome, Syphilis, Sarah Bernhardt, and the Modern Jewess," in *The Jew in the Text: Modernity and the Construction of Identity*, ed. Linda Nochlin (London: Thames and Hudson, 1995), 104–105.

19  Michèle C. Cone, "Vampires, Viruses and Lucien Rebatel: Anti-Semitic Art Criticism During Vichy," in *The Jew in the Text: Modernity and the Construction of Identity*, ed. Linda Nochlin (London: Thames and Hudson, 1995), 175.

20  Patrick Bade, *Mucha* (New York: Parkstone, 2011), 98.

21  J. Stewart Barney, Whitney Warren, and Francis H. Kimball, "Is There an American Architecture?," *New York Times*, April 18, 1909; my emphasis.

22  Lloyd Schwartz, "'Degenerate' Exhibit Recalls Nazi War on Modern Art," NPR, radio broadcast, May 29, 2014.

23  Elana Shapira, "Jewish Identity, Mass Consumption and Modern Design," in *Longing, Belonging and the Making of Jewish Consumer Culture*, ed. Gideon Reuveni and Nils Roemer (Leiden: Brill, 2010), 61.

24   Ibid., 86.

25   Ibid., 88.

26   Regarding Rathenau see "Peter Behrens," Art Directory, http://www.behrens -peter.com; and Joan M. Marter, ed., *Grove Encyclopedia of American Art*, vol. 1 (Oxford: Oxford University Press, 2011), 589. Regarding Waerndorfer see Elana Shapira, " 'The Rathenau Charisma': Modern Design and Art in the Service of the Rathenaus," in *German Jewry: Between Hope and Despair*, ed. Nils Roemer (Boston: Academic Studies Press, 2013), 143–166.

27   Daniel T. McGee, "Dada Da Da: Sounding the Jew in Modernism," *English Literary History* 68, no. 2 (Summer 2001): 509, 510; emphasis mine.

28   Rebecca Tinsley, "Art Nouveau, Born Again in Budapest," *Huffington Post*, June 27, 2012, http://www.huffingtonpost.com/rebecca-tinsley/born-again-art-nouveau_b _1606859.html.

29   "Riga—an Art Nouveau Metropolis," La Belle Epoque, http://www.la-belle-epoque .de/riga/rigaelie.htm.

30   *Lambiek Comiclopedia*, s.v. "Thomas Theodor Heine," http://www.lambiek.net/artists/h /heine_thomas-theodor.htm.

31   Henry Wassermann, "Jews in Jugendstil: The Simplicissimus, 1896–1914," *Leo Baeck Institute Yearbook* 31, no. 1 (1986): 71–104, 76.

32   Michael Brenner, *The Renaissance of Jewish Culture in Weimar Germany* (New Haven, Conn.: Yale University Press, 1996), 170.

33   M. S. Levussove, *The New Art of an Ancient People: The Work of Ephraim Mose Lilien* (New York: B. W. Huebsch, 1906), 13–14.

34   Ibid., 49.

35   Ibid., 50–51.

36   Milly Heyd, "Lilien and Beardsley: 'To the Pure All Things Are Pure,' " *Journal of Jewish Art* 7 (1980): 58–69, 58.

37   Ibid., 58.

38   Ibid., 59.

39   Ibid., 59, 60.

40   Ibid., 58–59.

41   Levussove, *New Art of an Ancient People*, 50.

42   Ibid., 46.

43   Morris Rosenfeld, *Songs from the Ghetto*, trans. and with an introduction by Leo Wiener (Upper Saddle River, N.J.: Literature House, 1970); first published 1889 by Copeland and Day.

44   Heyd, "Lilien and Beardsley," 64.

45   Rosenfeld, *Songs from the Ghetto*, 9.

46   Yaron Peleg, *Orientalism and the Hebrew Imagination* (Ithaca, N.Y.: Cornell University Press, 2005), 5.

47   Ibid.

48   Ibid., 6.

49   Erwin Rosenberger quoted in ibid., 7.

50   L. Andrew Cooper, *Dario Argento* (Urbana: University of Illinois Press, 2012), 52.
     "Giallo is an Italian 20th-century genre of literature and film, which in Italian
     indicates crime fiction and mystery. In English, it refers to a genre similar to the
     French fantastique genre and includes elements of horror fiction and eroticism.
     The word 'giallo' is Italian for 'yellow' and comes from a series of cheap paperback
     mystery novels with trademark yellow covers" (*Wikipedia*, s.v. "Giallo," last modi-
     fied September 25, 2015, http://en.wikipedia.org/wiki/Giallo).

51   Gunning, "Horror of Opacity," 53.

52   Cooper, *Dario Argento*, 87.

53   "The European Belle Epoque," La Belle Epoque, http://www.la-belle-epoque.de
     /italien/torindxe.htm.

54   "Villa Scott (Torino)," Piemonte Italia, http://www.piemonteitalia.eu/en/gestoredati
     /dettaglio/445/beni-architettonici/222/villa-scott-torino.html.

55   Ibid.

56   *Wikipedia* (Italian version), s.v. "Villa Scott," last modified April 28, 2014, http://it
     .wikipedia.org/wiki/Villa_Scott.

57   Adolf Loos, *Ornament and Crime: Selected Essays*, trans. Michael Mitchell (Riverside, Calif.:
     Ariadne Press, 1998), 170.

58   "Art Events Here and There," 6; my emphasis.

59   Cooper, *Dario Argento*, 53.

60   Vajda, "Some Aspects of Art Nouveau," 77.

61   Laura Lombard, *From Realism to Art Nouveau* (New York: Sterling, 2009), 160. See also
     *Encyclopedia Britannica Online*, s.v. "Edvard Munch," by Gray F. Watson, http://www
     .britannica.com/EBchecked/topic/397389/Edvard-Munch/5076/Paintings-of
     -love-and-death.

62   Linda Nochlin, *The Jew in the Text: Modernity and the Construction of Identity* (London:
     Thames and Hudson, 1995).

63   IMDb lists no art director or production designer, just a list of individuals in the
     Art Department.

64   Simon Abrams, review of *The Strange Color of Your Body's Tears*, directed by Helene
     Cattet and Bruno Forzani, RoberEbert.com, August 29, 2014, http://www.rogerebert
     .com/reviews/the-strange-color-of-your-bodys-tears-2014.

65   "The Strange Color of Your Body's Tears," Rotten Tomatoes, http://www
     .rottentomatoes.com/m/the_strange_color_of_your_bodys_tears/; Abrams, review of
     *The Strange Color of Your Body's Tears*.

66   "Strange Color of Your Body's Tears."

67   Michael Atkinson, review of *The Strange Color of Your Body's Tears*, directed by Helene Cattet
     and Bruno Forzani, *Film Comment* 50, no. 5 (September–October 2014), http://www
     .filmcomment.com/article/review-the-strange-color-of-your-bodys-tears.

68   Antonin Artaud, "To Have Done with the Judgment of God," in *Selected Writings*, ed.
     Susan Sontag (Berkeley, Calif.: University of California Press, 1976), 571.

## 5. ART NOUVEAU, PATRIMONY, AND THE ART WORLD

1   The Dutch painter Pieter Huys lived from c. 1519 to 1584, but it is not clear that the painter in the film is supposed to be the same one or a fictional artist.

2   Geoffrey O'Brien, "The Secret Life of Objects," in *Olivier Assayas*, ed. Ken Jones (Vienna: Austrian Film Museum, 2012), 186.

3   Assayas interviewed in the documentary *Inventory*, directed by Olivier Goinard, which is included on *Summer Hours*, directed by Olivier Assayas (New York: Criterion Collection, 2008), DVD.

4   O'Brien, "Secret Life," 185.

5   Quoted in Kristi McKim, *Love in the Time of Cinema* (Basingstoke: Palgrave Macmillan, 2011), 153.

6   Georg Simmel, "The Handle," in *Georg Simmel, 1858–1918*, ed. Kurt H. Wolff (Columbus: Ohio State University Press, 1959), 267–268.

7   Assayas interviewed in *Inventory*.

8   McKim, "Love in the Time of Cinema," 167–168.

9   Ibid., 167.

10  Assayas interviewed in *Inventory*.

11  Ibid.

12  Ibid.

13  Ibid.

14  Ibid.

15  Ibid.

16  Ibid.

17  "History of the Museum," Musée d'Orsay, http://www.musee-orsay.fr/en/collections /history-of-the-museum/home.html.

18  "The Architecture," Musee d'Orsay, http://www.musee-orsay.fr/en/collections /history-of-the-museum/the-architecture.html?S=3.

19  "Art Nouveau, 1890–1914," National Gallery of Art, https://www.nga.gov/feature /nouveau/exhibit_city.shtm.

20  Georg Simmel, "The Ruin," in *Georg Simmel, 1858–1918*, ed. Kurt H. Wolff (Columbus: Ohio State University Press, 1959), 259.

21  Ibid.

22  Ibid., 261.

23  Ibid.

24  Ibid.

25  Ibid., 264.

26  Ibid., 261.

27  Paul Julian Smith, "Review of *Klimt*, directed by Raul Ruiz," *Sight and Sound* (July 2007): 57–58.

28  Michael Goddard, *The Cinema of Raúl Ruiz: Impossible Cartographies* (New York: Wallflower Press, 2013), 151.

29 Tag Gronberg, *Vienna, City of Modernity 1890–1914* (Bern: Peter Lang, 2007), 200.

30 Salvador Dalí, "Concerning the Terrifying and Edible Beauty of Art Nouveau Architecture," in *The Collected Writings of Salvador Dalí*, trans. Haim Finkelstein (Cambridge: Cambridge University Press, 1998), 193–200.

31 Susanna Partsch, *Klimt: Life and Work* (Munich: P. Verlagsgesselschaft, 1993), 110. Note: the panels do not survive; they were burned in 1945 in Schloss Immendorf (ibid., 314).

32 Gronberg, *Vienna, City of Modernity*, 73.

33 Jeremy Aynsley, "Graphic and Interior Design in the Viennese Coffeehouse Around 1900," in *The Viennese Café and Fin-de-Siècle Culture*, ed. Charlotte Ashby, Tag Gronberg, and Simon Shaw-Miller (New York: Berghahn, 2013), 166.

34 Ibid., 185.

35 Ibid., 184.

36 Wolfgang C. Fischer, *Gustav Klimt and Emilie Flöge: An Artist and His Muse* (London: Lund Humphries, 1992), 8.

37 Ibid., 7, 28.

38 Quoted in Goddard, *Cinema of Raúl Ruiz*, 153.

39 Quoted in Fischer, *Gustav Klimt and Emilie Flöge*, 107.

40 Ibid., 108.

41 Charlotte Ashby, "Introduction," in Ashby et al., *Viennese Café and Fin-de-Siècle Culture*, 4.

42 Ibid.

43 Ibid.

44 Goddard, *Cinema of Raúl Ruiz*, 152.

45 Ibid., 151 (refers to the waltz).

46 Janet Stewart, "Filming Vienna 1900: The Poetics of Cinema and the Politics of Ornament in Raúl Ruiz's *Klimt*," *Journal of Austrian Studies* 46, no. 2 (Summer 2013): 55.

47 Partsch, *Klimt*, 279, 281.

48 James Norton, "The Mystery, as Always: Raúl Ruiz, Klimt and the Poetics of Cinema," *Vertigo* 3, no. 6 (Summer 2007), http://www.closeupfilmcentre.com/vertigo_magazine/volume-3-issue-6-summer-2007/makers-the-mystery-as-always-raul-ruiz/.

49 Ibid.

50 Ibid.

51 Ibid.

52 Stewart, "Filming Vienna 1900," 72.

## EPILOGUE

1 "Art Nouveau Revival: 1900. 1933. 1966. 1974," Musée d'Orsay, http://www.musee-orsay.fr/en/events/exhibitions/in-the-musee-dorsay/exhibitions-in-the-musee-dorsay/article/art-nouveau-revival-23208.html?tx_ttnews%5BbackPid%5D=649&cHash=20c8b95acc.

2   Ibid.

3   Mentioned by a scholar interviewed in Stephen Smith, "British Cities," *Sex and Sensibility: The Allure of Art Nouveau*, episode 2, directed by Mary Downes, first aired March 29, 2012 (London: BBC, 2008), DVD.

4   "Art Nouveau Revival."

5   "Graphics: Nouveau Frisco," *Time* magazine, April 7, 1967.

6   Mick Farren and Dennis Loren, *Classic Rock Posters: Sixty Years of Posters and Flyers: 1952 to Today* (New York: Sterling, 2013), 15, 68; Mike Evans, *The Art of British Rock: 50 Years of Rock Posters, Flyers and Handbills*, with the assistance of Paul Palmer-Edwards (London: Frances Lincoln, 2010), 48.

7   Farren and Loren, *Classic Rock Posters*, 13.

8   Ibid., 12.

9   Ibid., 15.

10  Ibid., 62.

11  "Styles: New Look at Art Nouveau," *Time*, August 21, 1964.

12  Ibid.

13  Ibid.

14  Gene Youngblood, *Expanded Cinema*, with an introduction by R. Buckminster Fuller (New York: E. P. Dutton, 1970), 157.

15  "Styles."

16  Bosley Crowther, "The Screen: 'What's New Pussycat?': Wild Comedy Arrives at Two Theaters," *New York Times*, June 23, 1965.

17  "Tired Tabby," *Time*, July 2, 1965.

18  Sander H. Lee, *Woody Allen's Angst: Philosophical Commentaries on His Serious Films* (Jefferson, N.C.: McFarland, 1997), 15.

19  Crowther, "Screen."

20  Ibid.

21  Ibid.

22  Steven Heller, "Heinz Edelmann, 'Yellow Submarine' Artist, Dies at 75," *New York Times*, July 23, 2009.

23  See Scott Bukatman's work on Winsor McCay in which he mentions Art Nouveau: *The Poetics of Slumberland: Animated Spirits and the Animating Spirit* (Berkeley: University of California Press, 2012).

24  J. S. Marcus, "Museums Take a New Look at Art Nouveau," *Wall Street Journal*, October 23, 2015.

# Index

FILM AND CULTURE

*A series of Columbia University Press*

EDITED BY JOHN BELTON